OLGA MICHI

VULNERABLE

VERLETZLICH

teNeues

FOREWORD
THE SPIRAL OF THE ARTS

„*Isn't life a series of images*
that change as they repeat themselves?"
Andy Warhol

Over the course of several millennia of our world's history, the most intimate and cherished dreams, expectations, aspirations and fears of humankind found their expression in art. Prehistoric tribes worshipped their idols representing the forces of nature; this was done to obtain much-needed support for the tribe members' search for food and social interactions. Many centuries later, temple priests ordered skilled artisans to create large-scale works of art that glorified the miraculous deeds of saints and guardian heroes so as to set an example for all believers. Even during times of global transition from religious to secular culture, modern art in all its various genres and forms still displays visible traces of cultural memories of the past.

Society and environment are indeed changing; but the essence, the foundation of humanity remains the same. People still need clear goals, certainty and confidence in tomorrow; they require support from their loved ones and they crave protection against ill-wishers. The world is changing and the paradigms of our perception of this world are shifting as well; we find the visual manifestation of these changes in fashion and art, but people continue following their nature and inexorably return to the beginning of the eternal cycle of life. The spiral of culture continues to expand with every new turn; it surprises us with new creations that were unimaginable before—but the turns of that spiral, comprised of a myriad of artefacts pertaining to the art world, still spin around the original axis, positioned a dualism of extremes: the finality of human existence and the eternity of the cosmos.

In her project *Vulnerable*, Olga Michi underscores the universal links between modern life and art heritage from bygone ages, going back to prehistoric, ancient, and medieval periods. The list of art works referenced in this project could be split into groups which in their composition cite well-known iconographic traditions: images of guardian saints, holy warriors in ceremonial attire holding their weapons of defense; well-known paintings of motherhood, signifying the continuation of the human race; and many more. We can find many of the respective references in the history of European art—including the works of ancient Greek sculptors, Byzantine icon-painters and Renaissance artists. We can clearly see the cultural impact of popular subjects such as Madonna and child and the images of warrior saints such as St. George the Victorious. Portraits offer a modern perspective, a rethinking of subjects such as *David* by Michelangelo, *Mona Lisa* by Da Vinci, *The Thinker* by Rodin, and many others. Together with easily recognizable attributes of indigenous culture, the importance of the circle (the symbol of eternity and rebirth) frequently appears in many cultures, especially in Asia and in Africa. At the same time, the multitude of subjects displayed reinforces this project's main objective—to demonstrate the common nature of human communities in a global, modern world; to show that these communities are, in fact, a single entity, even though they are composed of multiple elements that vary between each other.

In Olga Michi's project, the heroes are not so much individual representatives of certain 'vulnerable' ethnic groups, but rather the fate of all of humankind, which is similarly "vulnerable" and which has to encounter a multitude of problems and which has to make difficult decisions on a daily basis. The aim of the project is to demonstrate how humankind uses modern methods to progress along the eternal path of self-perception, and how modern artistic means of digital photography and computer-based image processing make it possible to comprehend and express the modern interpretation of fundamental philosophical concepts. Thus, *Vulnerable* has made its contribution to the treasure trove of the world's arts and culture; this project stands out for its inimitable modern nuances of meaning, its visual appeal and deftly executed references to iconic works of art that delve deep in studying the essence of human nature.

—Artem Loginov, project curator

VORWORT

DIE SPIRALE DER KUNST

*„Ist das Leben nicht eine Serie von Bildern,
die sich wiederholen und gleichzeitig verändern?"*
Andy Warhol

Seit Anbeginn der Menschheit wurden die größten Träume, Erwartungen, Sehnsüchte und Ängste in Kunstwerken ausgedrückt. Prähistorische Stämme beteten zu ihren Göttern, welche die Naturgewalten symbolisierten, in der Hoffnung, ihre Gunst und Unterstützung bei der Nahrungssuche und im sozialen Zusammenleben zu gewinnen. Jahrhunderte später wandten sich hochrangige religiöse Machthaber an die besten Künstler und Handwerker und gaben beeindruckende Kunstwerke in Auftrag, welche die Wunder der Heiligen und der Schutzheiligen abbildeten und Gläubigen als Vorbild dienen sollten. Auch in Zeiten des globalen Umschwungs von religiöser zu säkulärer Kultur finden wir noch immer deutliche Spuren des kulturellen Gedächtnisses der Vergangenheit in allen Genres und Formen der modernen Kunst. Die Gesellschaft und ihre Umwelt sind im Wandel; doch die Essenz, das Fundament der Menschheit bleibt gleich. Menschen brauchen weiterhin Ziele, Sicherheit und Glauben an die Zukunft, sie brauchen Unterstützung von denen, die ihnen nahestehen, und sehnen sich nach Schutz vor Widrigkeiten. Die Welt verändert sich und die Paradigmen unseres Weltverständnisses ändern sich mit ihr; wir finden visuelle Manifestationen dieser Veränderungen in der Mode und in der Kunst, doch die Menschheit folgt weiterhin ihrer Natur und kehrt unweigerlich wieder an den Anfang des unendlichen Kreises des Lebens zurück. Die Spirale der Kultur wächst mit jeder Umdrehung, sie überrascht uns mit stets neuen Ideen, die kurz davor noch undenkbar gewesen wären — doch die Spirale, die aus zahllosen Artefakten der Kunstwelt besteht, dreht sich stets um die ursprüngliche Achse, an deren beiden Enden zwei Extreme stehen: die Endlichkeit der menschlichen Existenz und die Unendlichkeit des Kosmos.

In *Verletzlich* betont Olga Michi die universalen Verbindungen zwischen modernem Leben und überlieferter Kunst aus vergangenen Zeiten, bis zurück ins Mittelalter, in die Antike und in die Prähistorik. Viele Fotografien in dieser Sammlung verweisen in ihrer Komposition auf bekannte Kunstwerke: Bilder von Schutzheiligen, heilige Krieger in zeremonieller Kleidung, die Waffen zur Verteidigung gezückt; berühmte Bildnisse von Müttern als

Symbol für das Fortbestehen der Menschheit; und viele mehr. Einige dieser Bezüge verweisen auf die europäische Kunstgeschichte, unter anderem auf Skulpturen aus dem alten Griechenland, byzantinische Ikonenmalerei oder die Künstler der Renaissance. Der kulturelle Einfluss von populären Abbildungen wie der Madonna mit Kind oder von Schutzheiligen wie dem heiligen Georg wird hier deutlich. Die Portraits bieten eine moderne Interpretation von Motiven wie, unter anderem, *David* von Michelangelo, *Mona Lisa* von Da Vinci oder *Der Denker* von Rodin. Der Kreis, zusammen mit anderen markanten Symbolen indigener Kulturen, steht für die Unendlichkeit und die Wiedergeburt, und kommt in vielen Kulturen, vor allem in Asien und Afrika, vor. Die Vielfältigkeit der Abbildungen unterstreicht die Absicht dieses Projektes — die Gemeinsamkeiten menschlicher Gesellschaften in einer globalen, modernen Welt aufzuzeigen. Es wird gezeigt, dass diese Gesellschaften tatsächlich eine Einheit, eine einzige Gesellschaft, sind, auch wenn sie sich in manchen Elementen unterscheiden.

In Olga Michis Projekt sind die Helden nicht nur die individuellen Repräsentantinnen und Repräsentanten einer bestimmten „verletzlichen" ethnischen Gruppe, sondern vielmehr das Schicksal der Menschheit, welche ebenso „verletzlich" ist und sich täglich zahlreichen Problemen stellen und schwierige Entscheidungen treffen muss. Das Ziel des Projekts ist zu zeigen, wie die Menschheit auf unterschiedliche Weise auf dem endlosen Weg der Selbsterkenntnis fortschreitet, und wie moderne Kunstformen wie die Fotografie und digitale Bildbearbeitung eine zeitgenössische Interpretation von grundlegenden philosophischen Konzepten ermöglicht. Somit hat *Verletzlich* seinen Beitrag zu den Schätzen der Kunst- und Kulturwelt geleistet; es besticht durch seine unvergleichbaren, modernen Nuancen, seine visuelle Anziehungskraft sowie seine versteckten, tiefgründigen Verweise auf die Kunstgeschichte, die dazu einladen, tief in das Studium der menschlichen Natur einzutauchen.

Artem Loginov, Kurator des Projekts

SOUTH

010

EAST

128

NORTH

198

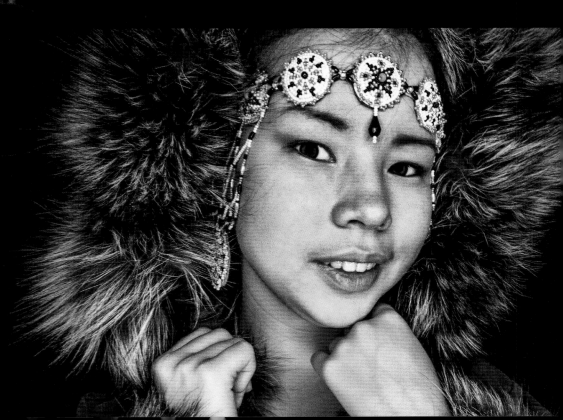

INTRODUCTION

Vulnerable offers a series of glimpses into my travels and the people—peoples—I have encountered on them. That's to say that these photographs are works of personal art, and by no means intended as political statements. Of course, no art can be entirely separate from politics and history, and the 2020s especially are a fraught global moment in which the prospect of a book such as this—a Caucasian photographer's portraits of indigenous subjects—might seem questionable. Yet it is my hope that the individual perspective *Vulnerable* offers may find a place in that moment, and though it makes no particular political arguments can raise questions that are relevant to it. Among them: even if many of us in the West now sense that indigenous cultures offer ways of life more fulfilling and sustainable than our own, how can we engage with those cultures in a way that affords them full respect and agency? How can we in the contemporary West reckon with our dark and continuing legacy of exploitative attitudes towards cultures that have seemed to us less developed than our own? What does it mean to be vulnerable, not only as the object of a gaze, but as the gazer as well?

An inexhaustible interest in the world's plethora of cultures has been one engine of my own journey, both as a human being and as a photographer. Like so many young people, for as long as I can remember I have sensed vistas of meaning beyond the horizons of contemporary Western life. We have been taught to think of much of the rest of humanity as 'developing', as if no people could be fully legitimate and equal unless it looked something like us. But we are also heir to a rich tradition of seeking wisdom further afield, and increasing numbers of us are turning in that direction. Ways of life that in the past have been deemed backwards now appear far wiser and more sustainable than our own, and to offer ways to live in increased harmony: with ourselves, with one another, and with the ecosystem of which we are not masters but only one single part.

Possibly, it was inevitable that I would be drawn in such directions. Running in my Russian blood is a wanderlust and love for the wilderness that comes both from my mother, one of life's true adventurers, and from my father, whose various postings as a career military officer meant that we were a nomadic family which rarely stopped in one place for long. Since we were a close and nurturing unit, in a sense as a child I was always at home—and of course for the born traveler the world is home! But sometimes for this kind of life you need grit and toughness, and that as well I'm thankful to inherit: from my grandfather, who helped to defend Moscow and to liberate Belgorod and Belarus during World War II, and from my grandmother who survived the horrors of the blockade of Leningrad.

Over the course of my adult life curiosity and work have taken me from the Nile Delta to the wild expanse of the steppes to the densely wooded hills of Myanmar; I have swum with great white sharks and Nile crocodiles and come within arm's length of gorillas and polar bears. But most importantly to me, I have lived among and learned from the way of life of indigenous peoples from the Kalahari to the Arctic tundra. Few people, I think, have been given more opportunities to be humbled by the awe-inspiring variety of the world and its inhabitants, nor to become aware of the wisdom, capacities and value of cultures on which we have historically looked down.

This book documents some of that journey of learning: it is the story of the diverse and often humbling education I have received from the world and some of its most fascinating peoples.

Why *Vulnerable*?

There's no denying that in any number of ways the world's indigenous peoples are acutely vulnerable. Industrialization and globalization have had their benefits. But their negative outcomes have mounted fast —untrammeled and irresponsible tourism, cultural colonization, environmental damage and climate change— and these burdens have fallen most heavily upon those most excluded from the benefits. The unique environments upon which jungle-dwelling cultures depend are on the verge of disappearing as loggers encroach ever further; island nations watch as rising seas threaten not merely to change or damage their worlds but to swallow them whole. For the indigenous peoples of the Americas

and Antipodes, devastation has been visited upon ancestral lands by industry and upon younger generations by the cultural plagues of alcohol and narcotics. For other aboriginal peoples, the painful irony is that the tourism industry that fetishizes authentic traditions has at the same time eroded or corrupted those traditions by incentivizing conformity with the preconceptions and demands of the white or Western imagination.

But my title—*Vulnerable*—is not only a statement. It is also a question that might prompt us to rethink some of our most basic attitudes and intuitions. If the West has too often been accustomed to think of indigenous cultures not as fully achieved forms of human living but as merely 'developing', too often our art has been complicit in these attitudes, framing indigenous subjects in clichéd and manipulative ways that render them exotic objects of what is now known as our white gaze. But while the photographs in *Vulnerable* may echo and evoke those discredited aesthetic traditions, they are intended very differently indeed. 'Vulnerable' comes from the Latin 'vulner', to wound, and means susceptible to wounding. But in fact 'vulnerable' could once mean the precise opposite—having the power to wound—and a number of other uncommon related words such as 'vulnerary' and 'vulneration' can have that opposite implication as well. These usages are vanishingly rare. But nevertheless they bring to the surface the ambiguity I want to convey.

For one question the reader might ask as they encounter the photographs in this book is just how vulnerable its subjects really are. To be sure, many indigenous peoples are in serious jeopardy. But those peoples are not undifferentiated, anonymous masses, mere statistics: they are groups of individuals, and the individuals that appear in these pages are very far from helpless. Some wear the trophies of a lifetime spent hunting animals that in the West we encounter only at a safe remove. Many display on their very bodies the marks of long, dangerous, creative life-paths and of vibrant, complex cultural traditions. Each face, each body discloses a rich and unknowable inner life, and many bespeak kinds of resourcefulness and robustness that most of us can hardly even imagine. To view these individuals with a condescending sense of their helplessness would be deluded indeed.

The reader might also consider their own vulnerability in these encounters between viewer and viewed. It's my hope that to meet and be penetrated by the startling, direct and challenging gazes of these subjects —vulner, to wound, to penetrate—will be to have unsettled the patronizing assumptions that we so often bring to encounters with the cultural other. For I should make absolutely clear that we are seeing these people as they have chosen to be seen. The white gaze of Western art, implicated in centuries-long projects of abuse, appropriation and disenfranchisement, has typically sought to capture a Rousseauvian 'noble savage' in an environment that purports to authenticity but often in fact only fulfills the expectations of the white audience. Some are dressed exclusively in the traditional garb of their ancestors, while others hold guns or sit astride motorcycles; here we have traditional jewelry and textiles cohabiting with boomboxes, AK-47s, iPhones and keyrings. In Vulnerable we are not in an exploitative theme-park but rather the real presence of cultures and individuals in flux, whose attitudes to the past and present alike are complex and dynamic—and even appropriative like our own. In a sense it is they who are calling the shots here, insisting that we see them not as we imagine them but as they are, and we in our assumptions and complacency who are the vulnerable ones.

Finally, I want the title to prompt us to consider our shared vulnerabilities. If these photographs insist that the lines of vulnerability run both ways, if they try to destabilize the conventional relationship between 'modern' viewer and 'primitive' subject, they also remind us of something else: that a danger to one of us is a danger to all, not only because the loss of biodiversity and rising global temperatures will affect us all but more fundamentally because of our shared humanity itself. 'No man is an island,' wrote the preacher and poet John Donne in the seventeenth century. 'Every man is a piece of the continent, a part of the main. Therefore never send to know for whom the bell tolls; it tolls for thee.'

—*Olga Michi*

EINLEITUNG

Verletzlich bietet eine Reihe von Einblicken in meine Reisen und die Völker, denen ich auf diesen Reisen begegnet bin. Das heißt, dass diese Fotografien persönliche Kunstwerke und keineswegs als politische Aussagen gedacht sind. Natürlich kann keine Kunst völlig losgelöst von Politik und Geschichte sein, und gerade die 2020er-Jahre sind ein brisanter globaler Moment, in dem die Aussicht auf ein Buch wie dieses – Porträts einer russischen Fotografin indigener Individuen – fragwürdig erscheinen mag. Dennoch ist es meine Hoffnung, dass die individuelle Perspektive, die dieses Buch bietet, auch in der heutigen Zeit ihren Platz finden kann. Denn obwohl *Verletzlich* keine politischen Argumente vorbringt, kann es Fragen aufwerfen, die relevant sind. Darunter: Selbst wenn viele von uns im Westen jetzt das Gefühl haben, dass indigene Kulturen erfülltere und nachhaltigere Lebensformen bieten als unsere eigenen, wie können wir mit diesen Kulturen in einer Weise umgehen, die ihnen vollen Respekt und Handlungsfähigkeit gewährt? Wie können wir im heutigen Westen mit unserem dunklen und fortdauernden Erbe ausbeuterischer Haltung gegenüber Kulturen, die uns weniger entwickelt erscheinen als wir selbst, umgehen? Nicht zuletzt: Was bedeutet es, verletzlich zu sein, nicht nur als Objekt des Blicks, sondern auch als Betrachter?

Mein intensives Interesse an den vielfältigen Kulturen dieser Welt hat mich auf meinem persönlichen sowie professionellen Werdegang als Fotografin angetrieben. Wie viele junge Menschen spürte ich intuitiv, dass jenseits meines Horizonts wichtige Wahrheiten liegen müssen. Von klein auf lernen wir, andere Kulturen als „Entwicklungsländer" zu sehen, als ob alles, was andersartig erscheint und uns nicht völlig gleicht, weniger legitim und nie gleichwertig sein könnte. Gleichzeitig haben wir traditionell immer schon fremde Weisheiten gesucht, und immer mehr Menschen wenden sich diesen nun wieder zu. Lebensweisen, die früher als primitiv galten, scheinen uns nun weiser und nachhaltiger als unsere eigenen, und sie verweisen auf Harmonie: mit uns selbst, miteinander, und mit dem natürlichen Kreislauf, den wir nicht beherrschen, sondern dem wir unterliegen.

Mein Interesse an diesen Themen war vielleicht unvermeidbar. Durch mein russisches Blut fließt Wanderlust und eine Liebe zur Wildnis, die ich sowohl von meiner Mutter, einer echten Abenteuerin, als auch von meinem Vater, einem Offizier, dessen Beruf uns zu einer Nomadenfamilie mit ständig wechselndem Wohnort machte, habe. Da wir eine eng verbundene Familie waren, fühlte ich mich als Kind gewissermaßen überall daheim – und der geborenen Reisenden ist ohnehin die Welt ein Zuhause! Doch für diese Art von Leben braucht man Kraft und Belastbarkeit, und auch diese Eigenschaften habe ich glücklicherweise geerbt: von meinem Großvater, der während des Zweiten Weltkriegs Moskau verteidigte und Belgorod und Belarus befreite, und von meiner Großmutter, die die Blockade Leningrads überlebte.

Meine Neugier und meine Arbeit führten mich vom Nildelta über die weite Steppe bis in die dicht bewaldeten Berge von Myanmar; ich schwamm mit weißen Haien und Nilkrokodilen und stand nur einen Schritt weit entfernt von Gorillas und Eisbären. Doch meine wichtigste Erfahrung war das Leben mit und das Lernen von indigenen Völkern, von der Kalahari-Wüste bis in die arktische Tundra. Ich glaube, nicht viele Menschen haben das Glück, eine solch atemberaubende Vielfalt an Orten und Einwohnern dieser Welt bestaunen zu dürfen. Wir müssen die Weisheit, Fähigkeiten und Werte von Kulturen, auf die wir meist herabblicken – oder die wir sogar noch schlimmer behandeln – anerkennen. Dieses Buch zeigt einige Schritte auf diesem Weg des Erkennens: Es ist das Produkt meines eigenen Bildungswegs und der Lektionen, die ich lernen musste.

Warum *Verletzlich*?

Es ist unbestreitbar, dass die indigenen Völker dieser Welt auf verschiedenste Art und Weise äußerst verletzlich sind. Industrialisierung und Globalisierung brachten ihre Vorteile, doch ungezügelter, verantwortungsloser Tourismus, kulturelle Kolonialisierung, die Zerstörung der Umwelt sowie der Klimawandel und seine Folgen werden als Probleme immer dringender, und die Nachteile betreffen hauptsächlich diejenigen, die von den Vorteilen wenig zu spüren bekommen. Die einzigartige Umwelt, in der Dschungelvölker leben, verschwindet rapide, während die Industrie sich immer weiter ausbreitet. Inselvölker müssen dabei zusehen, wie der steigende Meeresspiegel ihrer Welt nicht nur schadet, sondern

droht, sie zu verschlingen. Gebiete, die traditionell den Vorfahren von indigenen Völkern in Süd- und Nordamerika, Australien und Neuseeland gehörten, wurden sowohl von der Industrie als auch von der kulturellen Pest des Alkoholismus und des Drogenkonsums eingenommen. Indigene Völker aus anderen Regionen sehen sich mit der furchtbaren Ironie konfrontiert, dass die Tourismusindustrie gerade jene authentischen Traditionen, die sie zum Fetisch gemacht hat, schädigt oder gar zerstört, indem sie zur Konformität mit den Erwartungen und Forderungen der weißen oder westlichen Vorstellung aufruft.

Der Titel *Verletzlich* ist keine Aussage. Es ist vielmehr eine Frage, die uns dazu auffordert, unsere grundlegenden Einstellungen und unser Bauchgefühl zu hinterfragen. Im Westen sind wir es lange schon gewohnt, indigene Kulturen als nicht vollständig „entwickelt", sondern als sich „entwickelnd" zu betrachten, und die Kunst hat solche Auffassungen oft noch verstärkt, indem sie indigene Völker als Klischees abbildete und sie somit zu exotischen Objekten des sogenannten weißen Blicks machte. Die Bilder in *Verletzlich* nehmen diese nun veraltete Ästhetik als Referenz, doch mit völlig anderer Absicht. Das englische Wort „vulnerable" kommt aus dem Lateinischen: vulner, verwunden, und bedeutet so viel wie „leicht verwundbar" oder „verletzlich". Früher jedoch konnte „vulnerable" auch die gegenteilige Bedeutung annehmen – vulnerable, die Fähigkeit, andere zu verletzen – und einige eher selten gebrauchte aber verwandte Wörter wie „vulnerity" und „vulneration" können noch immer diese gegenteilige Bedeutung tragen. Diese Worte werden kaum noch in dem Sinn gebraucht, und dennoch verweisen sie auf die Zweideutigkeit, die ich ausdrücken möchte.

Der Leser wird sich vielleicht auch seiner eigenen Verletzbarkeit in diesem Gegenübertreten von Betrachter und Betrachtetem bewusst. Ich hoffe, dass der stechende, direkte und herausfordernde Blick der hier Abgebildeten – vulner, verwunden, stechen – unsere überheblichen Vorurteile, die wir bei Kontakten mit dem kulturellen Anderen oft mitbringen, auf die Probe stellt. Denn ich möchte noch einmal betonen, dass wir diese Menschen genau so sehen, wie sie gesehen werden möchten. Der weiße Blick westlicher Kunst, der über Jahrhunderte hinweg zu Missbrauch, Aneignung und

Ausbeutung geführt hat, sucht immer automatisch nach Rousseaus „noblen Wilden" in augenscheinlich authentischer Umgebung, die jedoch meist nur die Erwartungen des weißen Publikums erfüllt. Die Bilder hier sind ganz offensichtlich gestellt, die Abgebildeten hatten Kontrolle über das mis-en-scene und die Art und Weise, wie sie abgebildet wurden. Einige von ihnen tragen nur die traditionelle Kleidung ihrer Vorfahren, andere halten Gewehre oder sitzen auf Motorrädern; traditionelle Kleidung und Schmuckstücke mischen sich unter Ghettoblaster, AK-47-Gewehre, iPhones und Schlüsselbunde. *Verletzlich* ist kein Freizeitpark der kulturellen Ausbeutung, sondern zeigt authentische Kulturen und Individuen im Wandel, mit einem komplexen und dynamischen Verhältnis zur Vergangenheit und Gegenwart. Sie geben hier gewissermaßen den Ton an, und sie bestehen darauf, dass wir sie nicht so sehen, wie wir sie uns vorstellen, sondern wie sie sind; mit unseren Vorurteilen und unserer Selbstgefälligkeit sind somit wir die eigentlich Verletzlichen.

Letztendlich möchte ich mit dem Titel auch auf die Verletzlichkeit, die uns alle gemeinsam betrifft, verweisen. Diese Bilder unterstreichen, dass beide Seiten verletzlich sind, und sie widerstreben der konventionellen Auffassung von „modernem" Betrachter und „primitivem" Subjekt. Darüber hinaus erinnern sie uns daran, dass die Bedrohung des Einzelnen auch gleichzeitig die Bedrohung aller ist, nicht nur, wenn es um die schwindende Biodiversität und die Erderwärmung geht, sondern auf noch fundamentalerer Ebene, aufgrund unserer Menschlichkeit, die wir mit allen teilen. „Niemand ist eine Insel", schrieb der Prediger und Dichter John Donne. „Jeder Mensch ist ein Stück des Festlands, ein Teil des Ganzen. [...] Darum frage nicht, wem die Stunde schlägt; sie schlägt dir."

Olga Michi

SOUTH

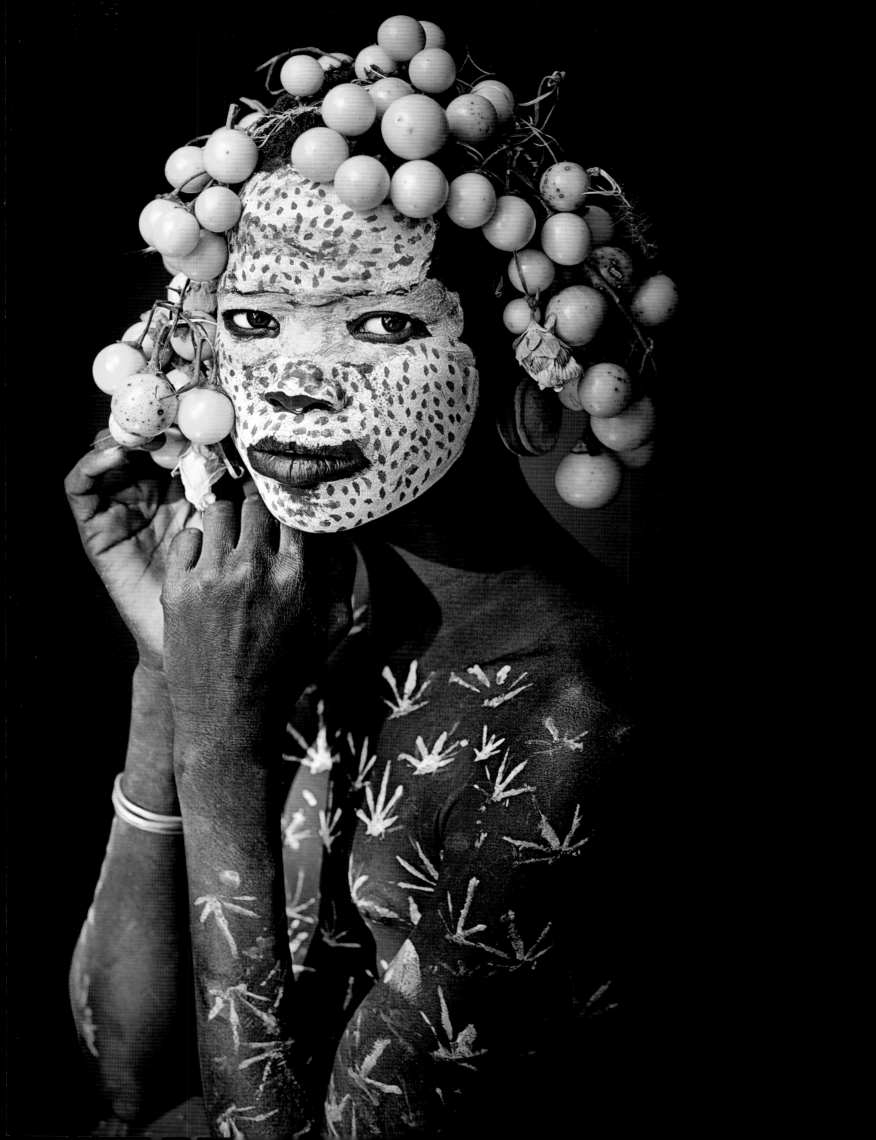

SOUTH

The Omo Valley cuts a nearly 500-mile path down through southern Ethiopia to the 'Southern Nations, Nationalities and People's Region' (SNNPR) and the Kenyan border; there the Omo River empties into Lake Turkana, the world's largest permanent desert lake. Homo sapiens —we—have made a home in this fertile pocket of Africa for tens of thousands of years, with a plethora of cultures and ethnicities migrating here either to settle, visit periodically or pass through. And in fact something very like human history in Omo reaches much further back. Our near ancestors Australopithecus afarensis lived here at least 2.5 million years ago, and in recent decades the discovery of some of the world's earliest recorded quartzite tools has led to the region's designation as a UNESCO World Heritage Site. Not for nothing is the Omo Valley known as a cradle of human life.

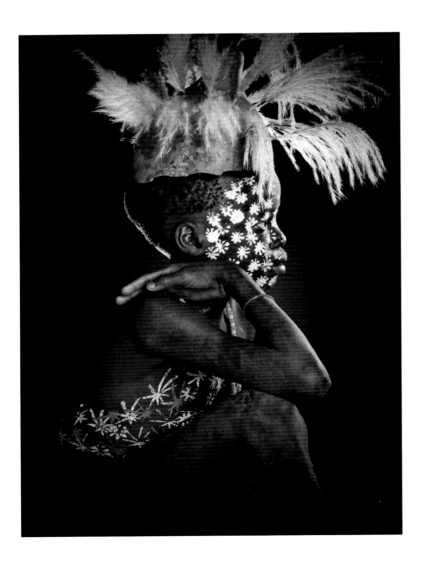

Experienced by relatively few outsiders even now, the topography here comprises savannah, expansive grasslands, riverine forests, volcanic outcrops, and running through it all the Omo River itself. It is the Omo's annual flood that bestows upon the region the fertility that has allowed human life to thrive here for millennia and

NOT FOR NOTHING IS THE OMO VALLEY KNOWN AS A CRADLE OF HUMAN LIFE.

given it its (admittedly now much reduced) biodiversity: among the valley's charismatic fauna are hippopotamuses, crocodiles, lions and elephants, as well as a vast abundance of birdlife including kingfishers, shrikes, woodpeckers and goliath herons. It is true that the peoples resident in the Omo Valley practice a range of agricultural methods, raising rain-fed crops, hunting game and fish, and keeping cattle, goats and sheep. But the river is the centre of life here. The real guarantee of food security in the region is a practice known as flood retreat cultivation, whereby crops are grown in the highly fertile soil freshly emerged from beneath receding floodwaters, and thus it is upon annual water-level rises that the peoples of the Omo Valley depend nearly entirely.

In the globalized modern 'First World' we often take pride in—or, sadly, regret and resist—what we see as the innovative multiculturalism of our cultures and cities. But for all the Omo Valley's remoteness and lack of modern amenities there is to be found here a concentration of human genetic and lingual diversity to rival anything on Earth. As many as 52 languages are spoken in the wider Turkana basin, and in the SNNPR itself there are no fewer than 45 distinct indigenous ethnic groups. These include the Bodi, Kara (or Karo), Kwegu and Daasanach peoples, and further from the river the Hamar, Suri and Tarkana. Though the names may sound alien to many readers, the striking scarification and face-painting practices of many of these cultures will likely be more familiar, with perhaps the most widely known of all such traditions being the lip plates that to this day are worn by many female members of the Mursi.

But this diversity today exists in the shadow of grave threats. Exploitative 'hit-and-run' tourism has been a baleful development, with many visitors who descend from the north contributing little to the local economy while nevertheless wreaking cultural havoc. The observer effect is in operation here, too: while the Mursi's lip plates may seem to signify a people existing beyond the reach of modern life, in fact many women now wear them for the benefit of tourists. Indeed, AK-47s and Chelsea Football Club jerseys jostle for space in the Omo Valley with spears and traditional textiles and practices, reminding us that these remote regions are not time-capsules that remain for the benefit of the outsider's gaze but rather societies in their own right, developing in their own complex ways in dynamic relations with the outside world. The lesson for us is that we must not let our ideas of a simpler historic or prehistoric past, and our desire to witness it, lead us to cast indigenous peoples in roles that distort what they are.

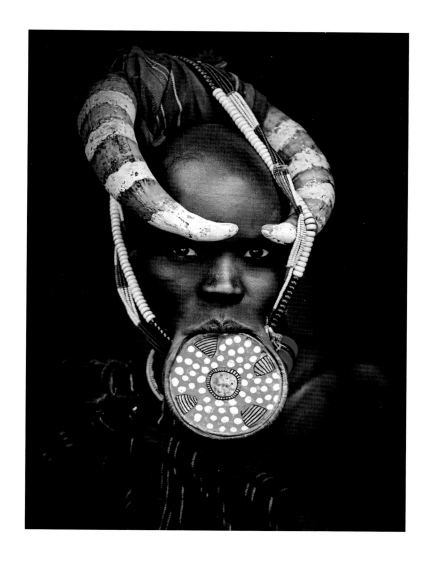

On the other hand, we must understand that we in what is known as the 'developed' world have grave responsibilities: ones that are ours not by virtue of greater civilization or cultural sophistication but as a result of accidents of history that have endowed us with outsized industrial and economic power. And this brings us to perhaps the most immediate and minatory of the threats facing the Omo Valley and its inhabitants. Vast dam-building projects have been undertaken in recent years, and these have had economic benefits for Ethiopia as a whole that are beyond debate. But at the same time they have already begun to disrupt the annual flooding upon which life here depends, threatening to obliterate the vibrant yet fragile ecosystem entirely; to disrupt the central rhythm around which all the rituals so central to life here orbit; and—as natural resources disappear— to destabilize as well the delicate system of alliances by which the many peoples of the Omo Valley organize their relationships and manage their conflicts. Without a voice of their own on the global stage, those peoples are relying on outsiders—us—to draw attention to the very real danger that their way of life will become an accidental casualty of the world's headlong rush into industrialized modernity.

SÜDEN

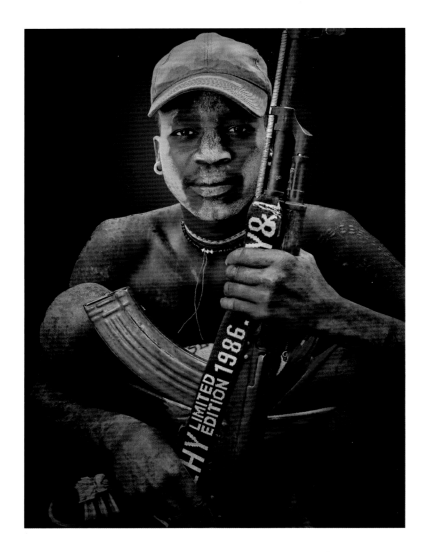

Nur wenige Außenstehende hatten bisher die Gelegenheit, die vielfältige Topografie zu erleben — die Savanne, das Grasland, Uferwälder, Vulkangestein — und mittendrin der Omo selbst. Die jährliche Überflutung des Flusses verleiht dieser Region ihre (inzwischen leider stark dezimierte) Artenvielfalt: Zur farbenfrohen Fauna des Tals zählen Nilpferde, Krokodile, Löwen, Elefanten sowie eine Vielfalt an Vogelarten, unter anderem Eisvögel, Sperlinge, Spechte und Goliathreiher. Menschen, die im Omo-Tal leben, nutzen das Land auf unterschiedliche Weise: Es gibt Feldfrüchte, die mit Regen bewässert werden, Fischerei und Jagd sowie Nutztierhaltung von Kühen, Ziegen und Schafen. Der Fluss ist das Herz des Omo-Tals. Nahrungssicherheit in der Region wird durch die Nutzung des vom Hochwasser fruchtbar gemachten Bodens garantiert, und somit sind die Menschen, die im Omo-Tal leben, stark von den jährlichen Überschwemmungen abhängig.

Im globalen und modernen Westen sind wir oft stolz auf den innovativen Multikulturalismus unserer Kulturen und Städte — auch wenn manche sich darüber beklagen und dagegen wehren. Doch das Omo-Tal bietet trotz seiner abgelegenen Lage und seines Mangels an modernen Vorrichtungen eine genetische und linguistische Diversität, die der vieler Metropolen in nichts nachsteht. Im Turkana-Becken werden bis zu 52 Sprachen gesprochen und

Das Omo-Tal zieht sich über mehr als 700 km hinweg, von Südäthiopien bis in die „Region der südlichen Nationen, Nationalitäten und Völker" (SNNPR) an der Grenze Kenias, wo der Omo in den Turkanasee, den größten permanenten Wüstensee der Welt, mündet. Der Homo sapiens — also unsere Vorfahren — hat sich in dieser fruchtbaren Gegend Afrikas über Jahrtausende hinweg ein Zuhause gemacht. Viele Kulturen und Ethnizitäten ziehen durch diese Region für regelmäßige Besuche, zur Zwischenrast, oder um sich dort niederzulassen. Und etwas ähnliches wie menschliche Geschichte kann man im Omo-Tal noch weiter zurückverfolgen. *Australopithecus afarensis*, ein enger Verwandter unserer Vorfahren, lebte hier vor 2,5 Millionen Jahren. In den vergangenen Jahrzehnten wurden die ersten Quarz-Werkzeuge der Welt hier gefunden, weshalb die Region zum UNESCO-Welterbe erklärt wurde. Nicht umsonst ist das Omo-Tal auch als die Wiege der Menschheit bekannt.

NICHT UMSONST IST DAS OMO-TAL AUCH ALS DIE WIEGE DER MENSCHHEIT BEKANNT.

in der südäthiopischen Verwaltungseinheit selbst gibt es 45 unterschiedliche indigene ethnische Gruppen, unter anderem die Bodi, Kara (oder Karo), Kwegu und Daasanach-Völker, und weiter entfernt vom Fluss die Hamar, Suri und Tarakana. Auch wenn die Leser und Leserinnen mit diesen Namen vielleicht nicht vertraut sind, so haben sie doch bestimmt die auffälligen Narben und die Gesichtsbemalung, die bei vielen dieser Kulturen üblich sind, schon einmal gesehen. Am berühmtesten sind vielleicht die Lippenteller der Mursi, die noch heute von vielen Mursi-Frauen getragen werden.

Doch diese Diversität ist heutzutage stark bedroht. Ein schnelllebiger, ausbeuterischer moderner Tourismus, bei dem Besucher von Norden einfallen, um kurz Fotos zu schießen und für kulturellen Aufruhr sorgen, ohne dabei tatsächlich zur Wirtschaft beizutragen, schadet der Region. Auch hier hat der westliche Blick einen spürbaren Effekt: Die Lippenteller der Mursi mögen wie ein Symbol für das Leben jenseits der Moderne erscheinen, aber viele Frauen tragen die Platten inzwischen hauptsächlich für Touristen. AK-47er-Gewehre und Chelsea-Fußballtrikots geben sich im Omo-Tal mit Speeren, traditionellen Bräuchen und Textilien die Hand und erinnern uns daran, dass diese abgelegenen Regionen keine Zeitkapseln sind, die für den Blick der Außenseiter existieren, sondern eigenständige Gesellschaften, die sich auf ihre eigene Art und Weise in dynamischem Austausch mit der Außenwelt entwickeln. Wir müssen aufhören, unsere voreingenommenen Vorstellungen einer einfacheren historischen oder prähistorischen Vergangenheit und unseren Wunsch, diese mit eigenen Augen zu sehen, auf indigene Völker zu projizieren und ihnen Rollen aufzuzwängen, die nichts mit ihrer gelebten Realität zu tun haben.

Gleichzeitig müssen wir in der sogenannten „entwickelten" Welt einsehen, dass wir eine große Verantwortung tragen: eine Verantwortung, die uns nicht aus unserer überlegenen Zivilisation oder kulturellen Überlegenheit erwächst, sondern die uns aufgrund von diversen Zufällen in der Vergangenheit, welche uns mehr industrielle und wirtschaftliche Macht verschafften, in den Schoß fiel. Das bringt uns zur vielleicht größten und dringendsten Bedrohung für das Omo-Tal und seine Einwohner. In den letzten Jahren wurden große Staudammprojekte begonnen, und ihre positiven wirtschaftlichen Einflüsse in Äthiopien sind unumstritten. Gleichzeitig haben sie aber die jährliche Überschwemmungen, die für das Leben im Tal so wichtig sind, unterbrochen, und bedrohen nun das facettenreiche und fragile Ökosystem. Der Rhythmus, an dem sich Rituale und das Leben hier orientieren, wird unterbrochen. Mit dem stetigen Verschwinden der natürlichen Ressourcen wird auch das prekäre System der Allianzen zwischen den Völkern, das zur Konfliktlösung hier im Omo-Tal beiträgt, gestört.

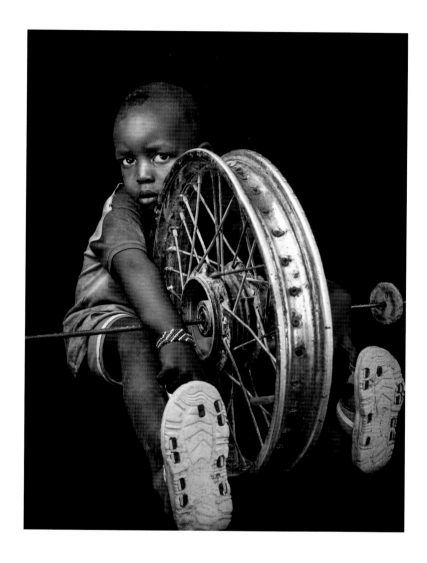

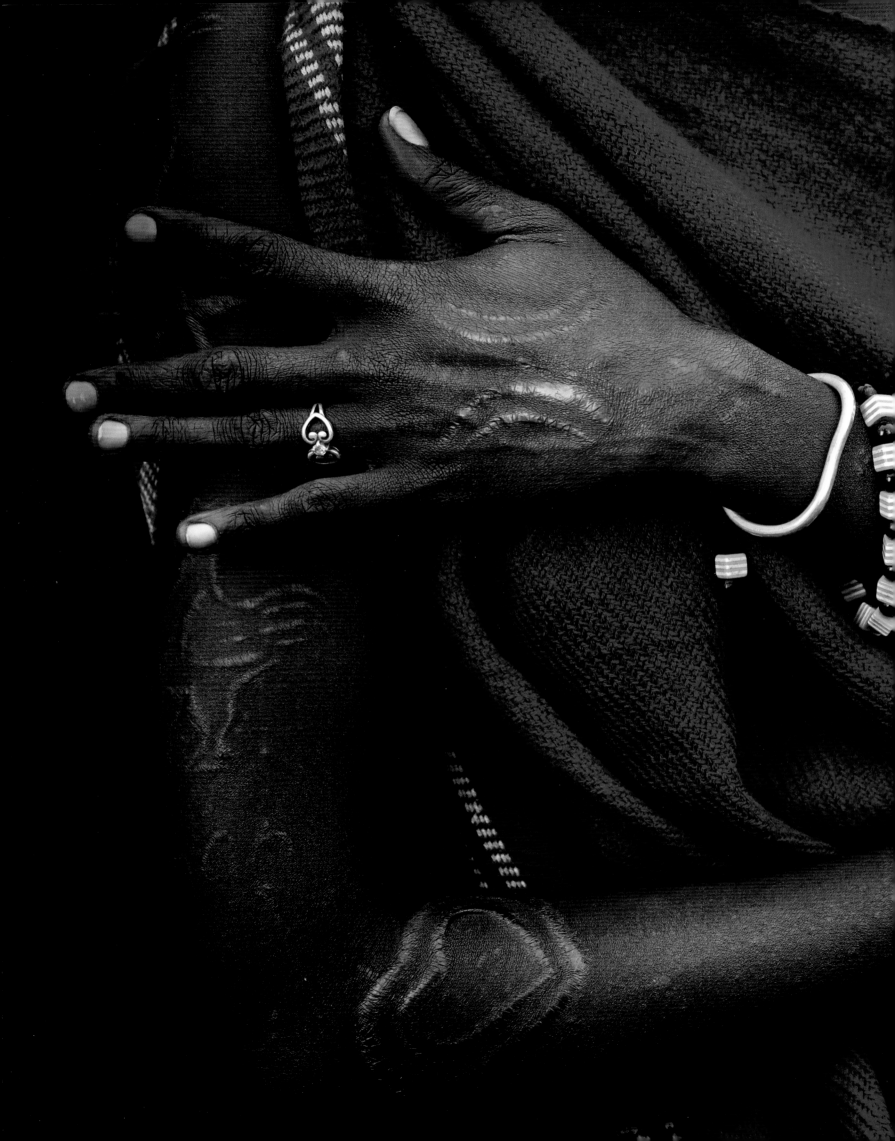

Surma and Mursi peoples believe that the more scars a woman's body has, the more robust and enduring she is—and the more attractive as well. In times of far greater insulation from external influences, the patterns with which girls decorate themselves were drawn from a local palette, but now they can pick up ideas and designs at the local markets and in neighbouring towns and villages.

In den Surma- und Mursi-Völkern glaubt man, dass eine Frau, die viele Narben auf dem Körper trägt, robust und belastbar ist – und auch attraktiver. Als die Stämme noch abgeschiedener lebten, kamen die Muster, mit denen junge Frauen sich zierten, aus dem Heimatdorf, doch heutzutage können die Frauen sich Ideen und Vorlagen von den Märkten in der Umgebung und in Nachbarorten holen.

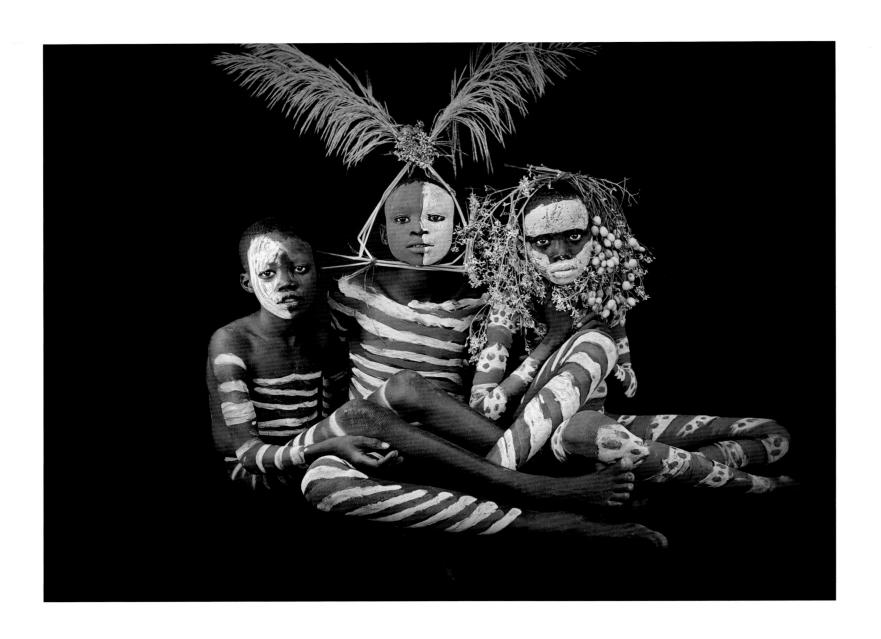

Rechts:
Der Blick und die Pose dieses Jungen wirken geheimnis-
voll und fremd; sie erinnern uns daran, dass wir die kul-
turelle Sprache nicht sprechen. Wissen wir zum Beispiel
irgendetwas über seinen Status? Er könnte (in unserer
Terminologie) ein Prinz oder ein Betteljunge sein — wir
wissen es nicht.

Right:

This boy's gaze and pose has an enigmatic quality that
beautifully alienates us, issuing a reminder that we don't
speak the cultural language here. Can we tell anything
about his status, for instance? He could be a prince or a
pauper (in our terms) as far as we can know.

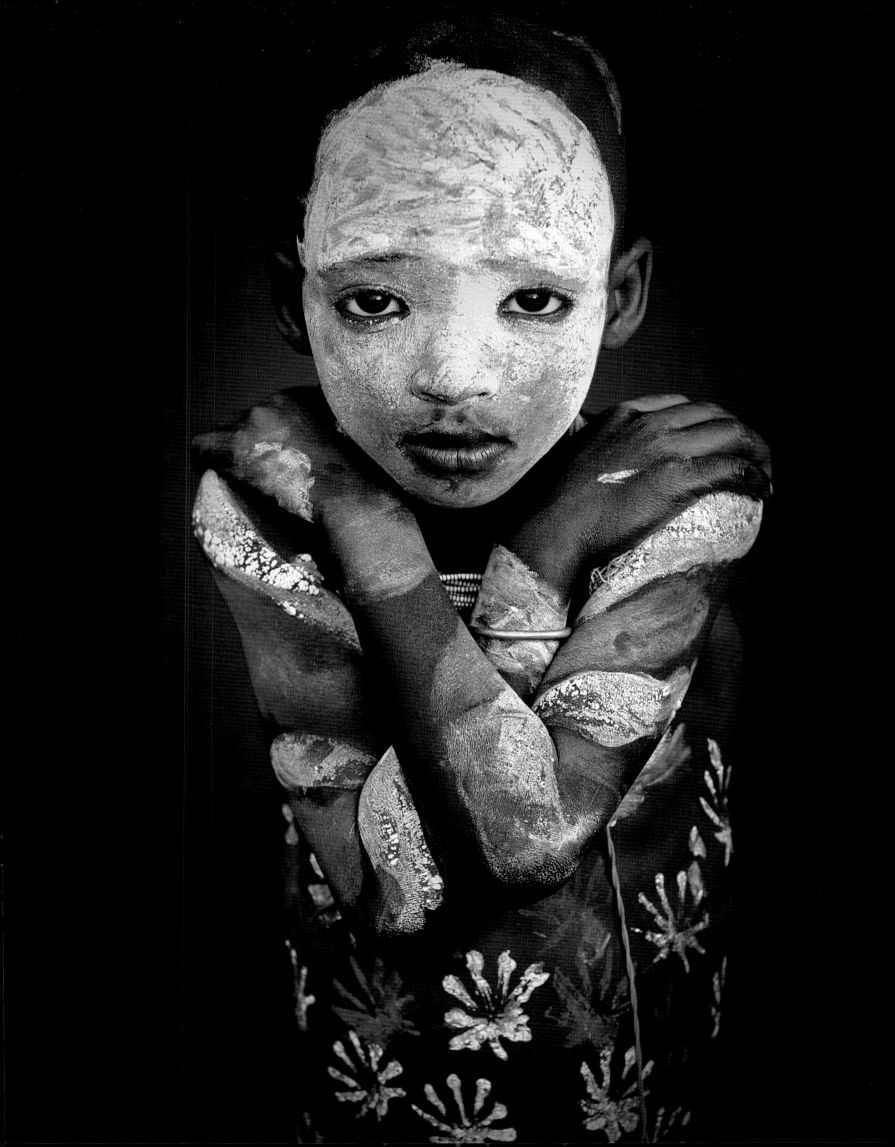

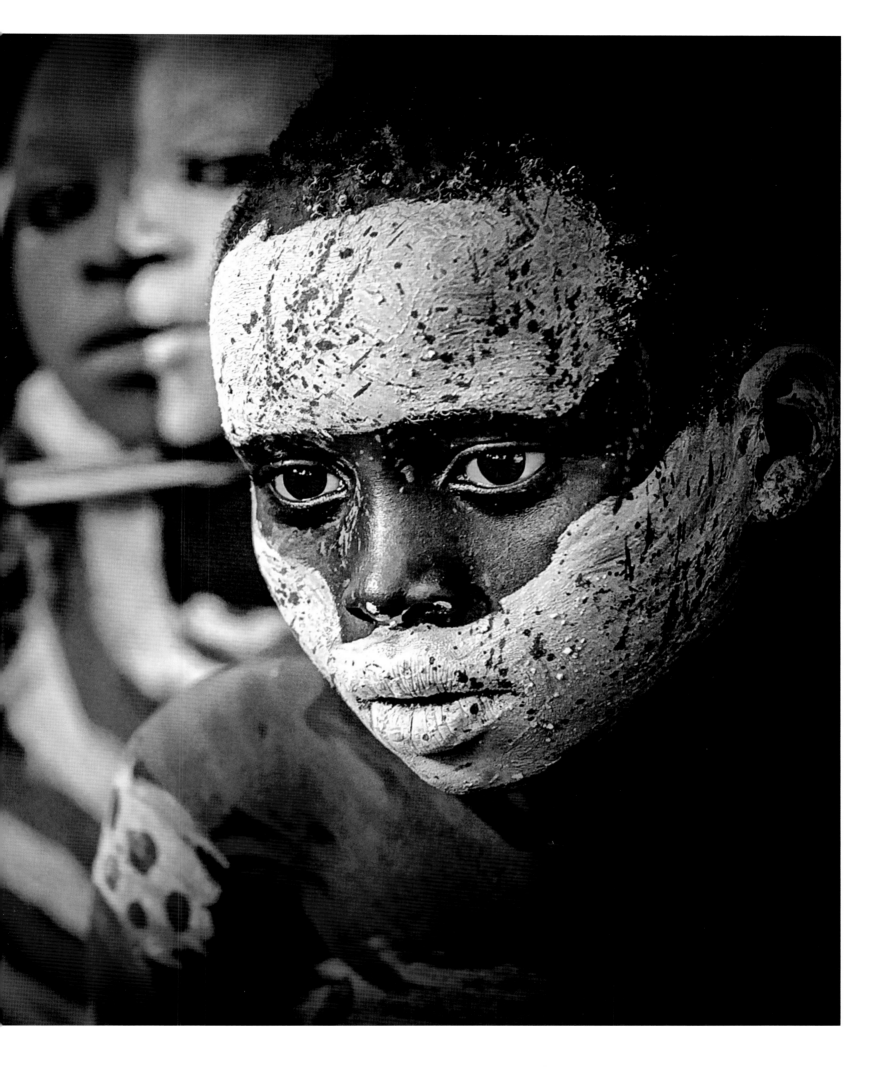

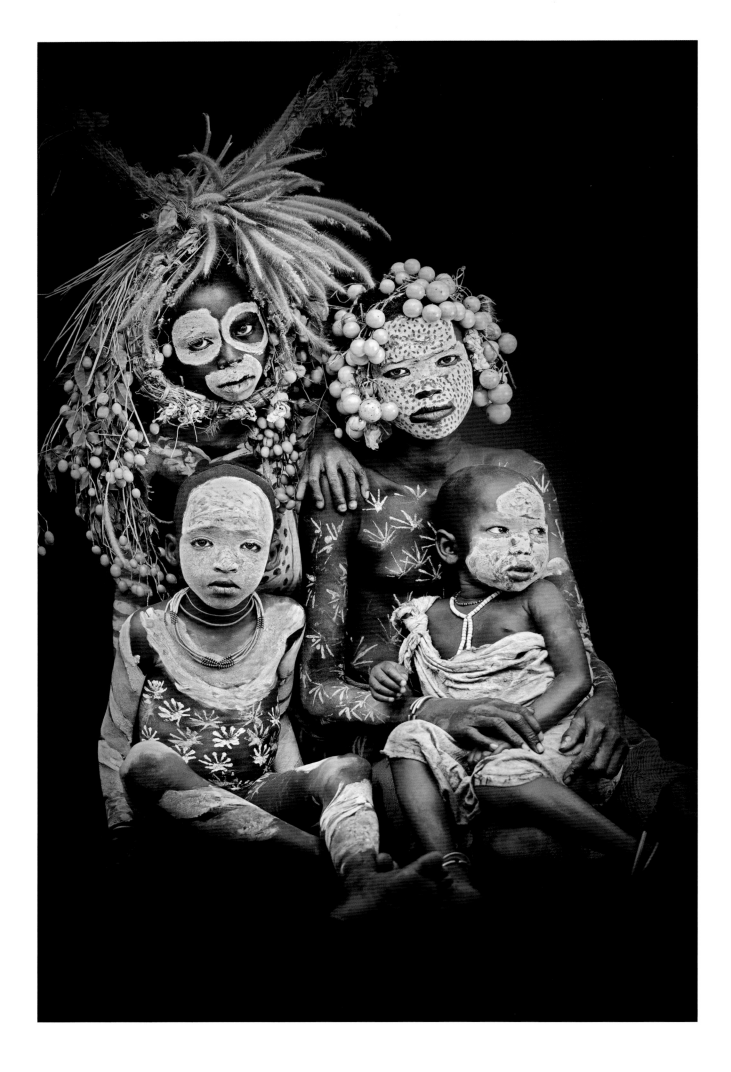

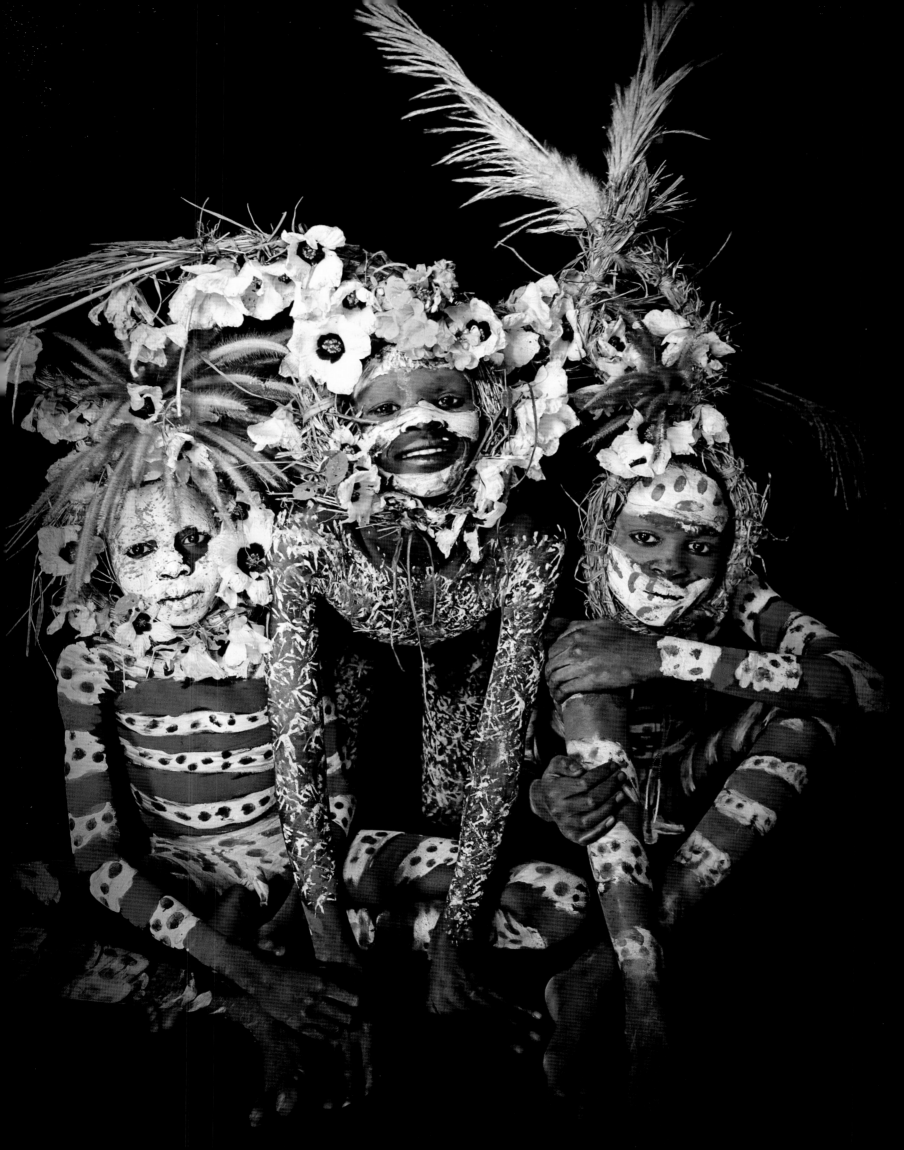

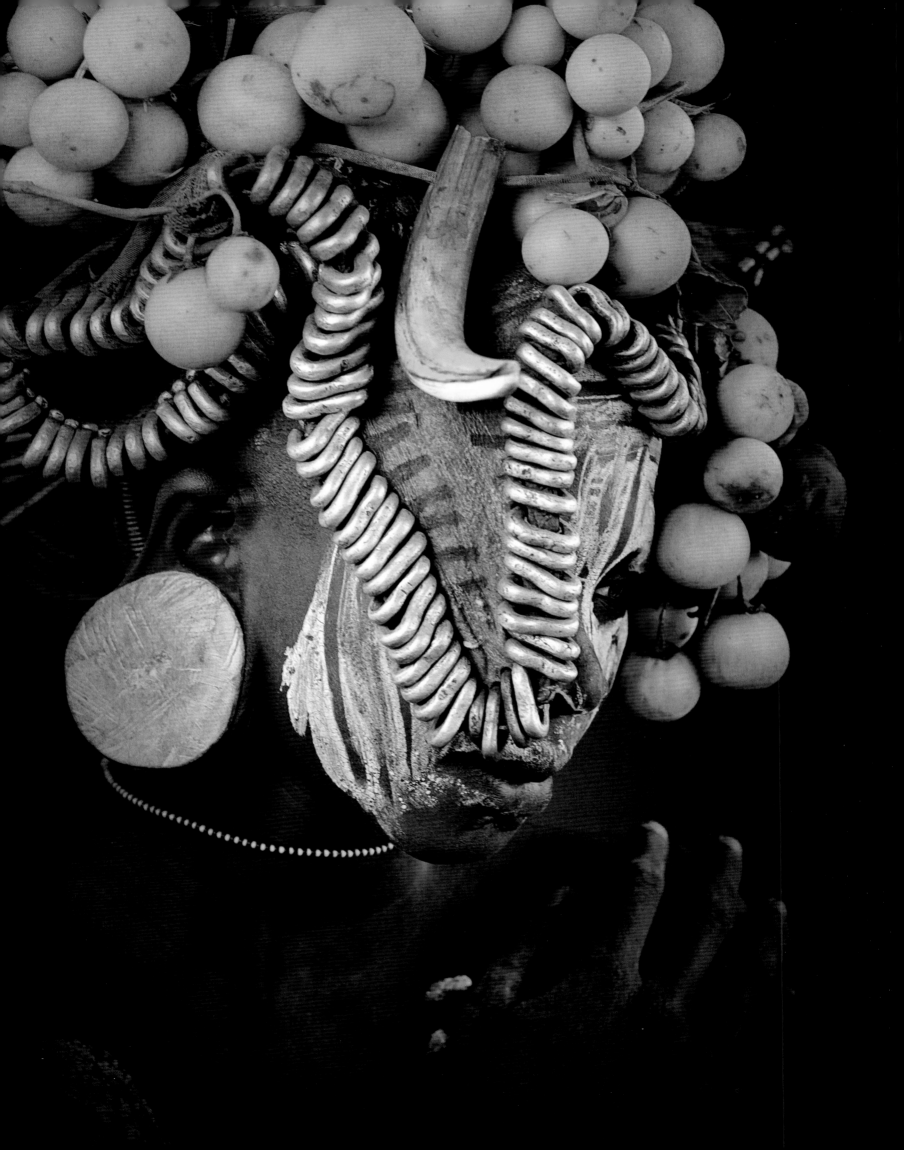

Previous page on the left:

To my mind this photo has it all: it's a striking display of the colorful face- and body-paint and elaborate ornaments that testify to the rich cultural inheritance of the Omo Valley peoples, as well as a reminder of the close bonds that unite families everywhere.

Previous page on the right:

To ensure the correct lighting and a calm and quiet work atmosphere, for my shoots with the Surma we set up a special tent and invited individuals or groups inside one by one; those who had not yet had their turn waited outside. But this gave some of the more mischievous boys the opportunity to play tricks. They would rush off to wash in the river and apply different face- and body-paint, and also created different wreaths and structures from flowers, pumpkins, animal skulls, beads and spent cartridges, all in order to return and rejoin the queue outside our tent as if they had not had their turn. At first I didn't recognize the boys in their new disguises, but with time I grew impressed by their inventiveness and resourcefulness!

Vorherige Seite links:

Für mich hat dieses Foto alles: Es ist eine eindrucksvolle Darstellung der farbenfrohen Gesichts- und Körperbemalung sowie der kunstvollen Ornamente, die vom reichen kulturellen Erbe der Völker des Omo-Tals erzählen. Aber auch eine Erinnerung an die engen Bande, die Familien überall miteinander verbinden.

Vorherige Seite rechts:

Um die richtige Beleuchtung und eine ruhige und stille Arbeitsatmosphäre zu gewährleisten, bauten wir für meine Fotoarbeiten mit den Surma ein spezielles Zelt auf und luden Einzelpersonen oder Gruppen nacheinander hinein. Diejenigen, die noch nicht an der Reihe waren, warteten draußen. Das aber gab einigen der Jungen die Gelegenheit, Streiche zu spielen. Sie eilten los, um sich im Fluss zu waschen und verschiedene Gesichts- und Körperbemalungen aufzutragen. Sie fertigten allerlei Kränze und Strukturen aus Blumen, Kürbissen, Tierschädeln, Perlen und verbrauchten Patronen an, um dann zurückzukehren und sich wieder vor unserem Zelt anzustellen — als wären sie noch nicht an der Reihe gewesen. Zuerst erkannte ich die Jungen in ihren neuen Verkleidungen nicht. Dann aber war ich von ihrem Einfallsreichtum beeindruckt!

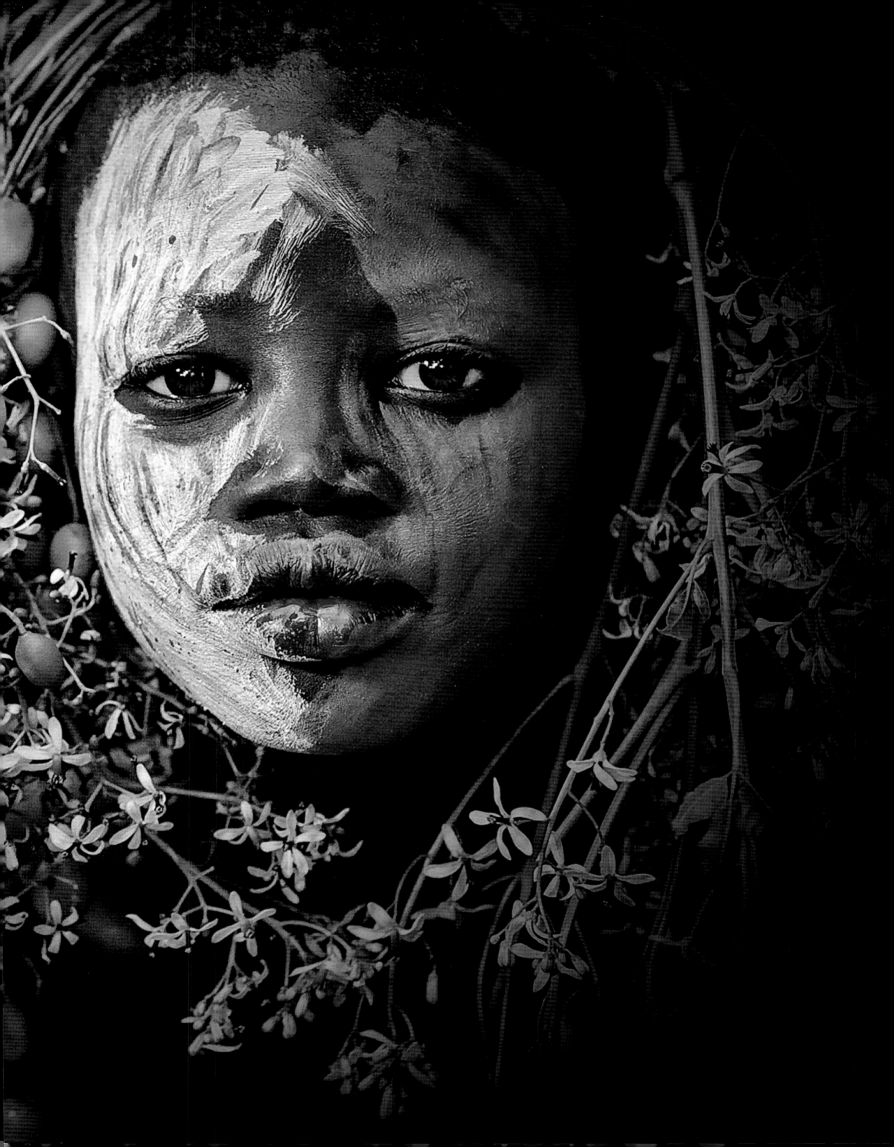

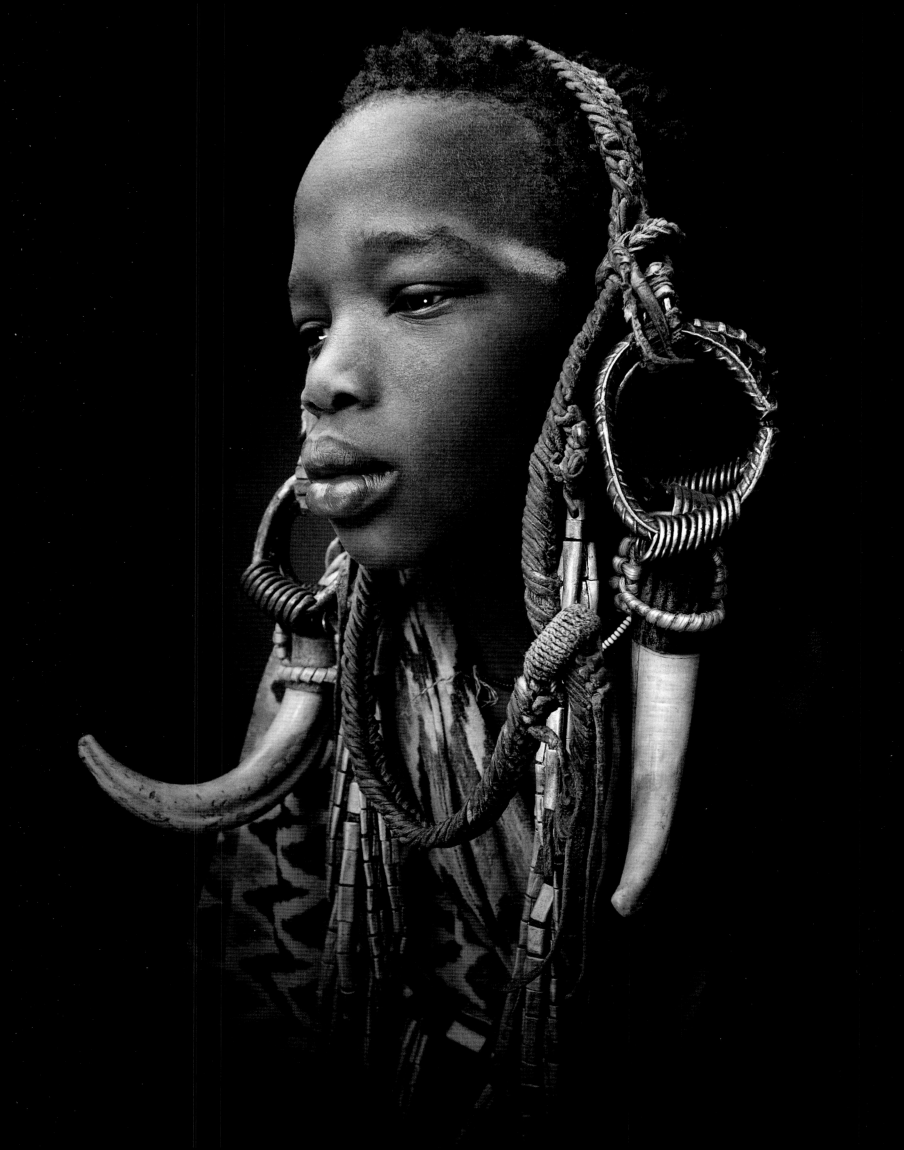

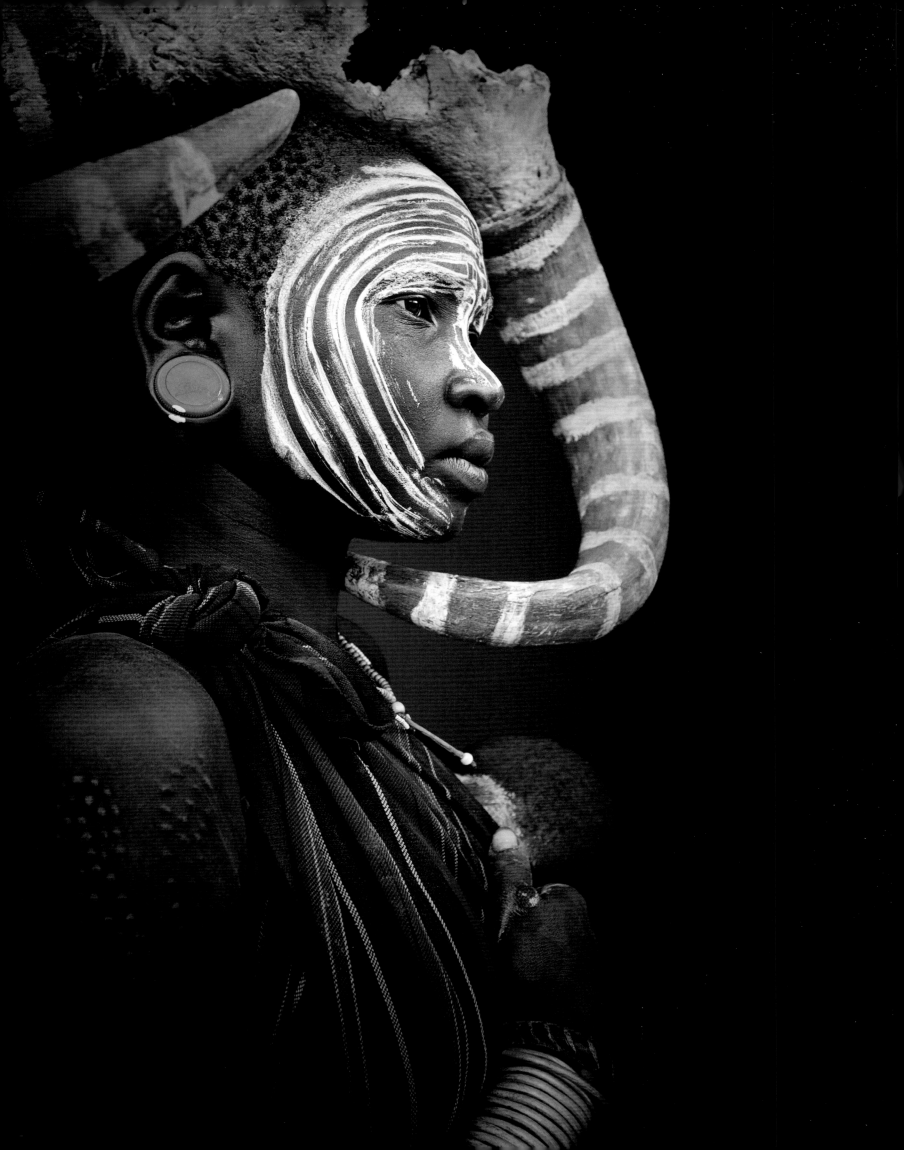

Left:

Left:

The horns worn by Mursi women are not simply decorative but also reflect their culture's attitude towards their cows, which play a crucial role in ensuring survival through hard times. Cattle breeding is one of the most important parts of Mursi and Surma culture.

Links:

Die Hörner, die von Mursi-Frauen getragen werden, sind nicht nur dekorativ, sondern reflektieren auch die Haltung des Stammes seinen Kühen gegenüber. Diese spielen vor allem in harten Zeiten eine zentrale Rolle für den Stamm. Die Viehzucht ist einer der wichtigsten Aspekte in der Kultur der Mursi und Surma.

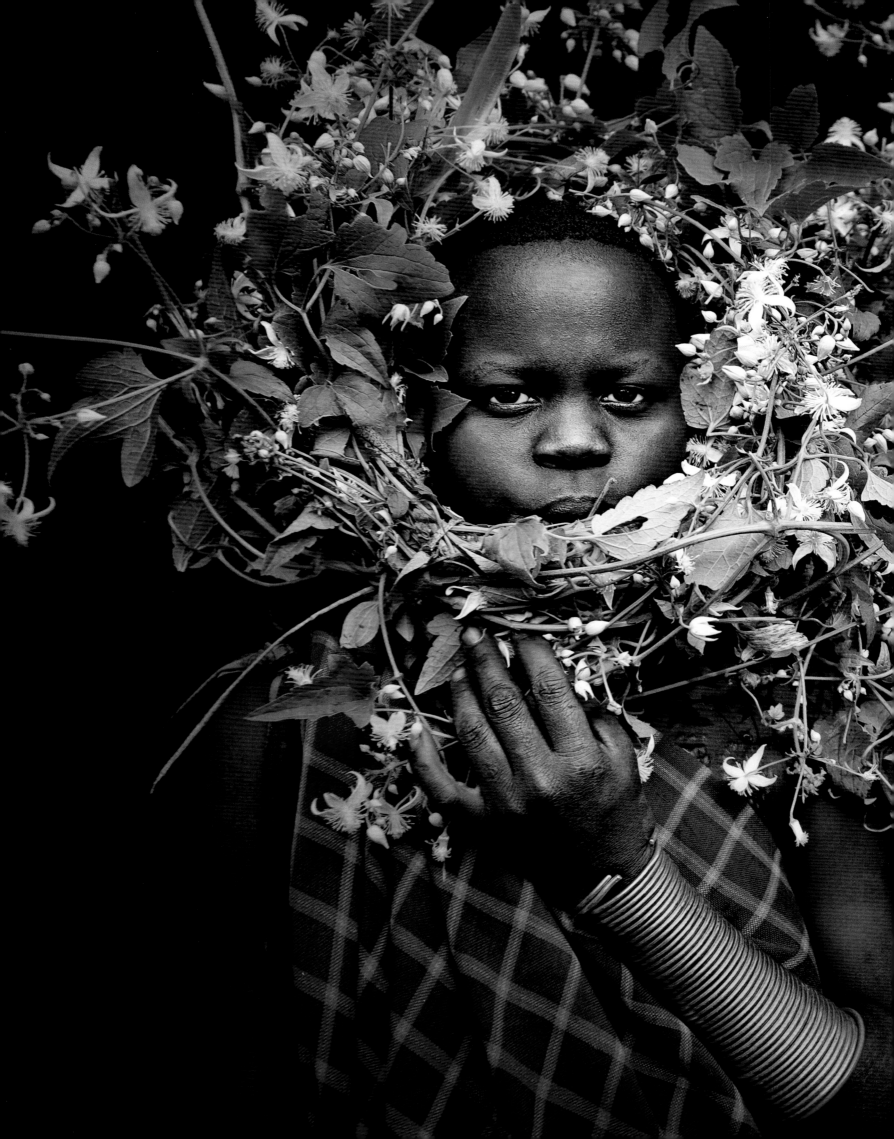

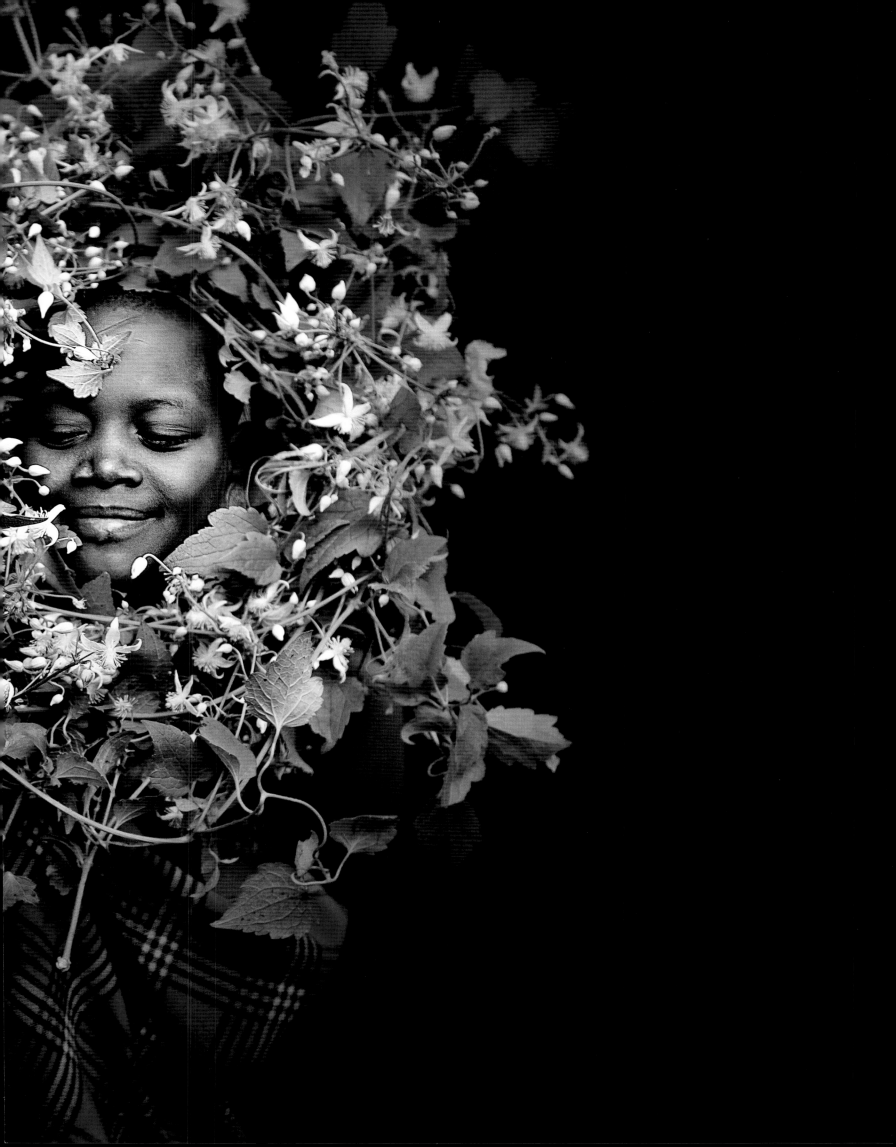

These Surma women with their wreaths provide a lovely reminder of our links with the nature that surrounds us—and indirectly of the necessity of treating those natural gifts with the utmost care if we do not wish to squander them.

Diese Mursi-Frauen und ihre Kränze sind ein schönes Symbol dafür, dass wir in der Natur, die uns umgibt, fest verwurzelt sind – und erinnert daran, dass wir mit den Geschenken der Natur vorsichtig umgehen müssen, wenn wir sie nicht verschwenden wollen.

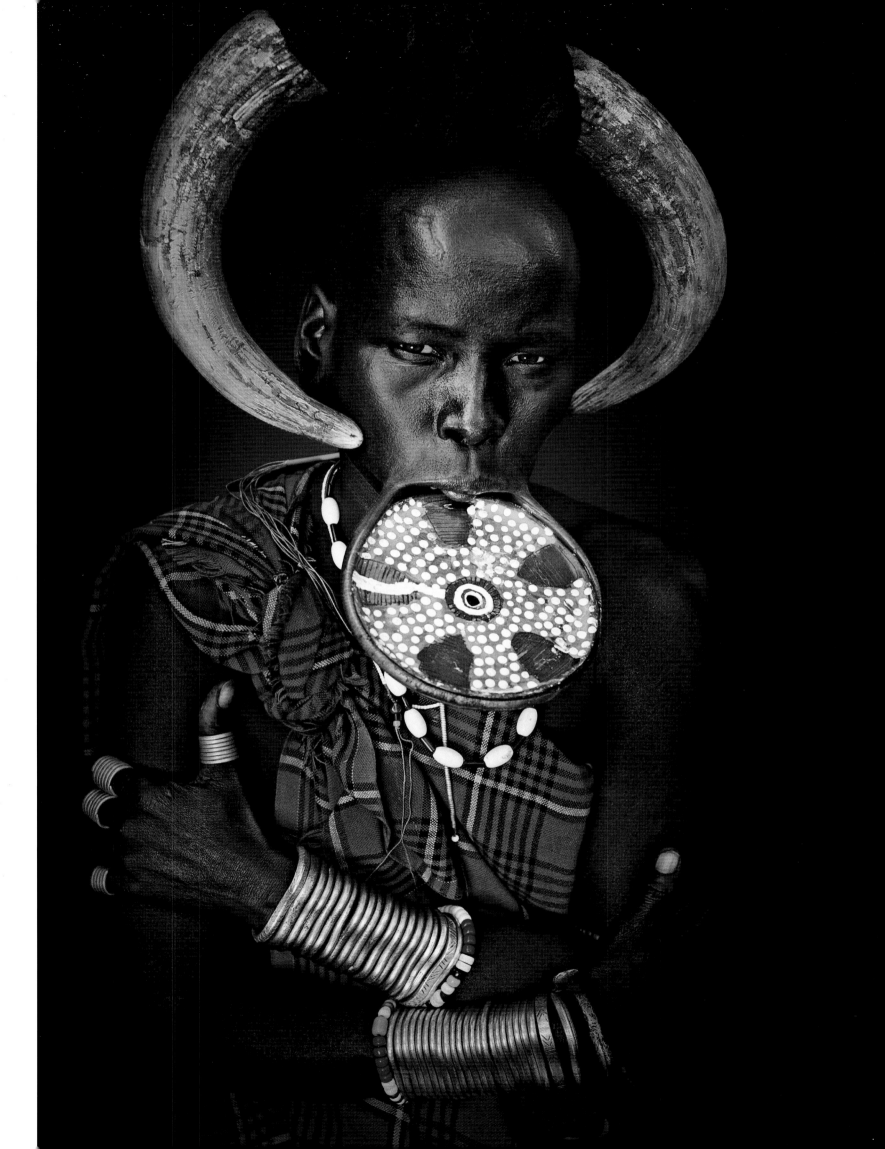

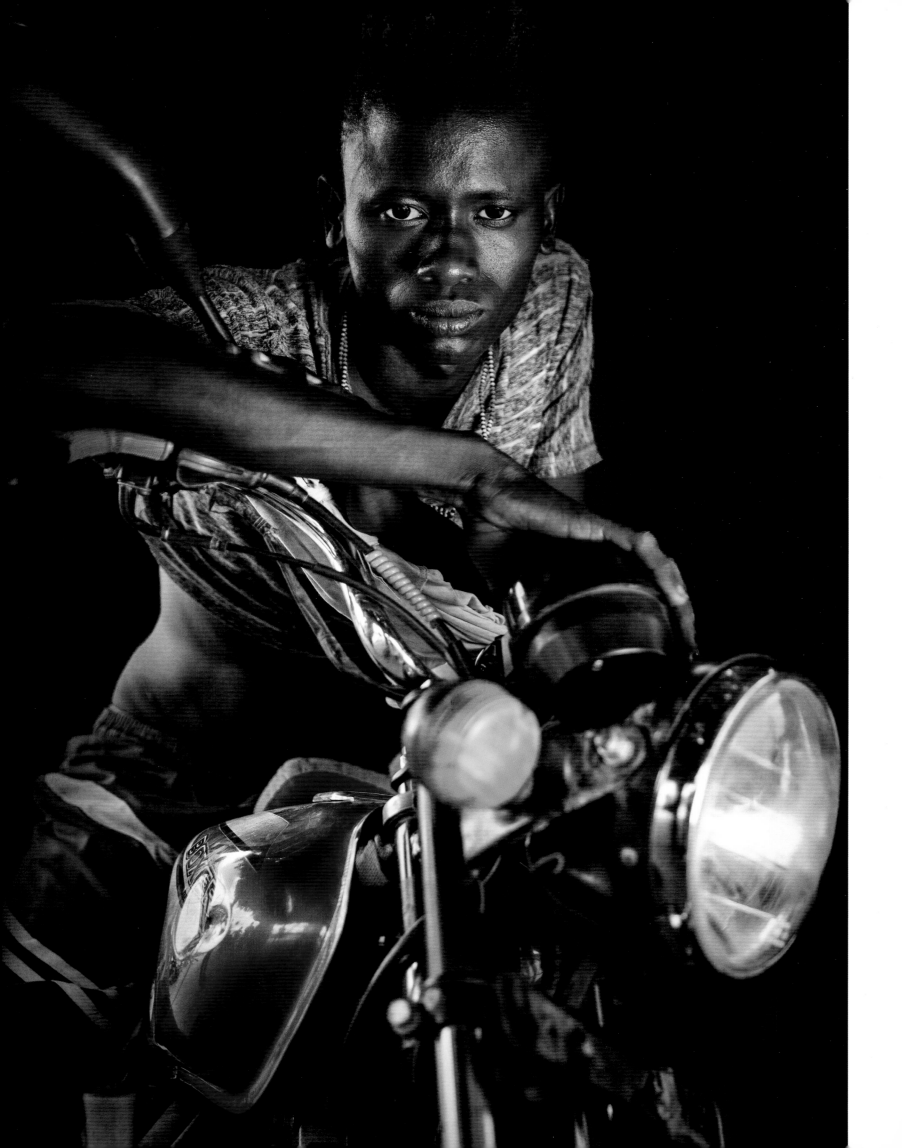

The generation gap, the difficulties that arise when a younger generation adopts different values to those who have come before them, is an issue in virtually all societies across the world. This can be especially acute today in traditional cultures such as the Karo, as young people seek to emulate not their elders, leaders and ancestors as they would have before but instead the icons of Western film and music.

Die Kluft zwischen den Generationen, die Schwierigkeiten, die entstehen, wenn eine jüngere Generation andere Werte annimmt als ihre Vorgänger, ist in praktisch allen Gesellschaften der Welt Thema. Besonders akut kann dies heute in traditionellen Kulturen wie der Karo-Kultur werden, da junge Menschen nicht wie früher ihren Ältesten, Führern und Vorfahren nacheifern wollen – sondern den Ikonen des westlichen Films und der westlichen Musik.

Right:

Here we see another striking image of tradition and modernity coexisting, the man's garb and face-painting of the traditional kind but over his shoulders the distinctly contemporary artefact of an AK-47. I was struck by the way the strap's position around his neck suggests the way that although people use weapons as their tools they can also become prisoners of them.

Rechts:

Hier sehen wir ein weiteres eindrucksvolles Beispiel der Koexistenz von Tradition und Moderne: das Gewand des Mannes und die Gesichtsbemalung in traditioneller Art, aber über seinen Schultern das deutlich zeitgenössische Artefakt, die AK-47. Ich war beeindruckt davon, wie der Riemen um seinen Hals die Art und Weise andeutet, wie Menschen, obwohl sie Waffen als Werkzeuge benutzen, auch zu ihren Gefangenen werden können.

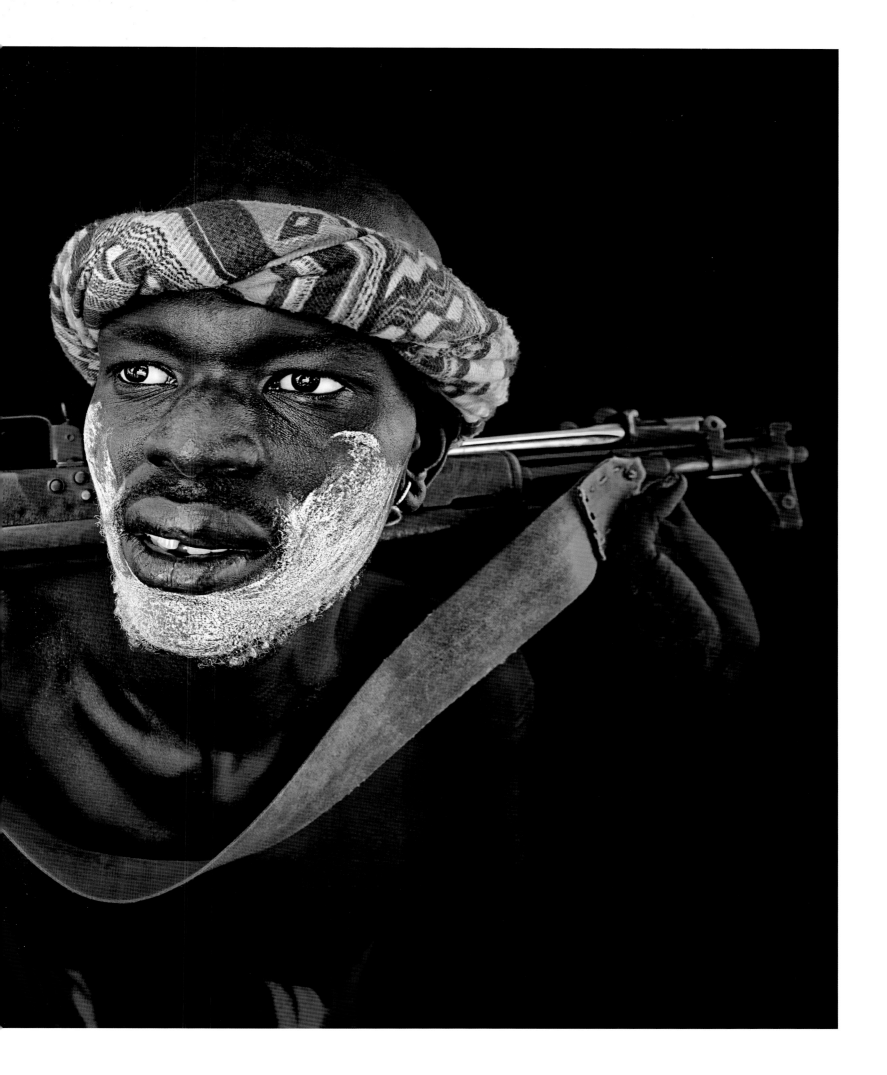

Alexey Uminsky, a Russian priest, said: "Speaking about beauty, one person would first think of the good qualities of a human soul; another about the beauty of a person's deeds. But most often when people mention beauty they mean external attractiveness. Modern-day people like never before are concerned with self-presentation and attracting attention to themselves." It is exactly this desire—to attract attention at any price—that unites people all over the world.

Alexej Uminsky, ein russischer Priester, sagte: „Wenn man über Schönheit spricht, denkt der eine zuerst an die guten Eigenschaften einer menschlichen Seele, ein anderer an die Schönheit der Taten eines Menschen. Häufig aber meint man vor allem äußere Attraktivität. Dem modernen Menschen geht es wie nie zuvor darum, sich zu präsentieren und die Aufmerksamkeit auf sich zu lenken." Obwohl die Art und Weise – oberflächlich betrachtet – von Kultur zu Kultur sehr unterschiedlich aussehen kann, legen die meisten Völker auf die eine oder andere Weise Wert auf Äußerlichkeiten.

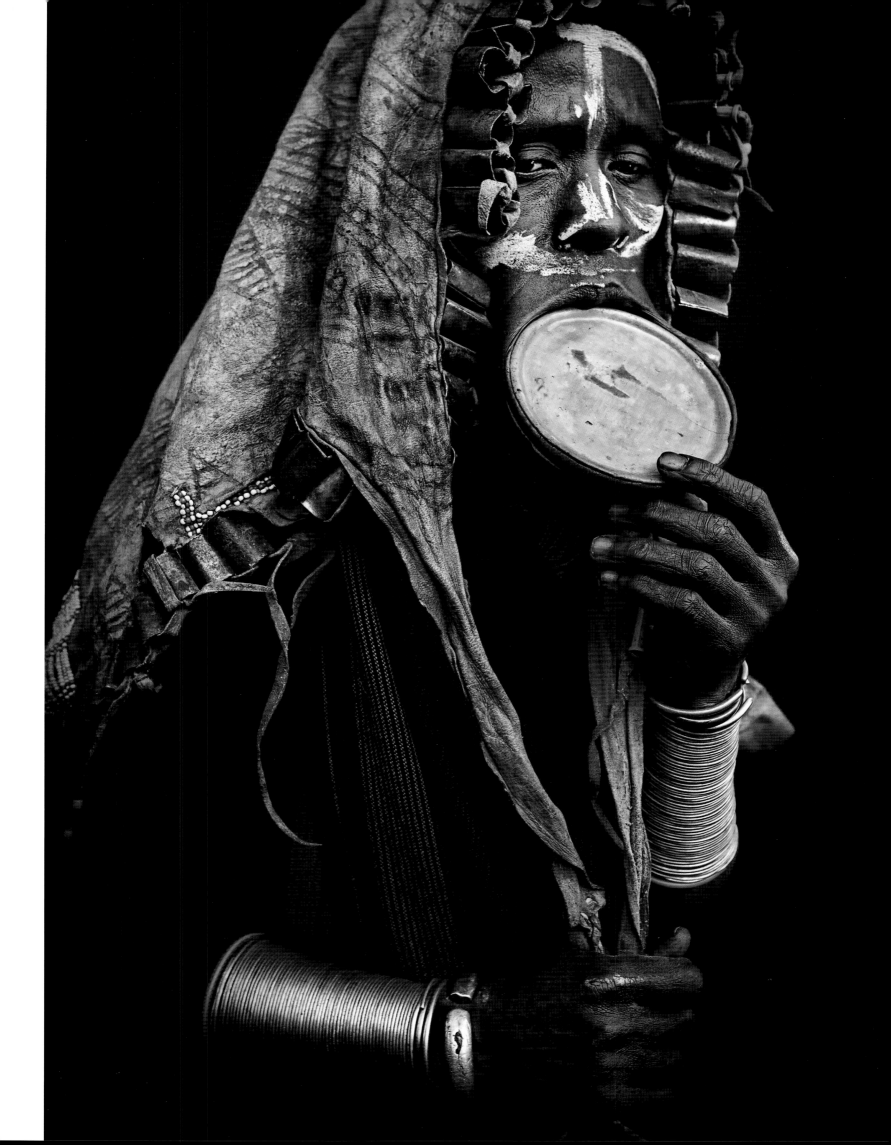

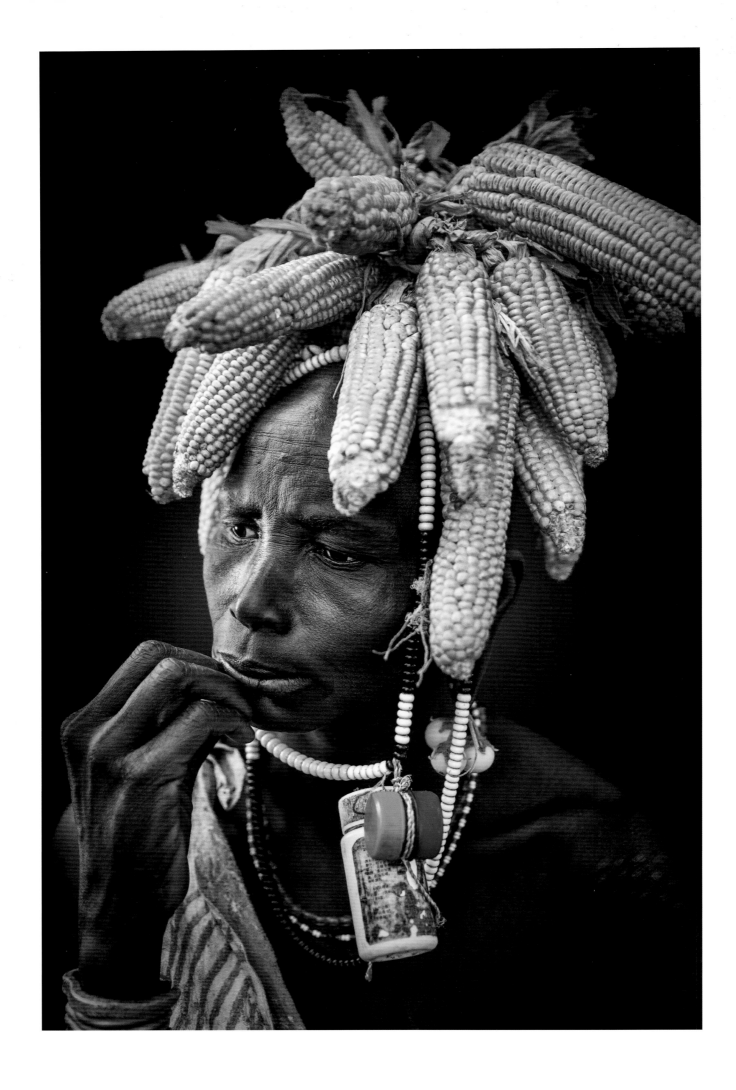

Left:

Left:
Like music, personal decoration and jewellery seem to be virtual constants in human life across all eras and continents, functioning as signs of status, as investments, as sources of pleasure—or, perhaps more rarely but as in this case, as the source of sustenance in lean times.

Links:
Wie die Musik, so ist auch dekorativer Schmuck eine Konstante, die sich durch alle Jahrhunderte und Kontinente zieht. Er symbolisiert Status, dient als Investment, zur Freude oder Unterhaltung — oder, wie in diesem eher unüblichen Fall, als Snack!

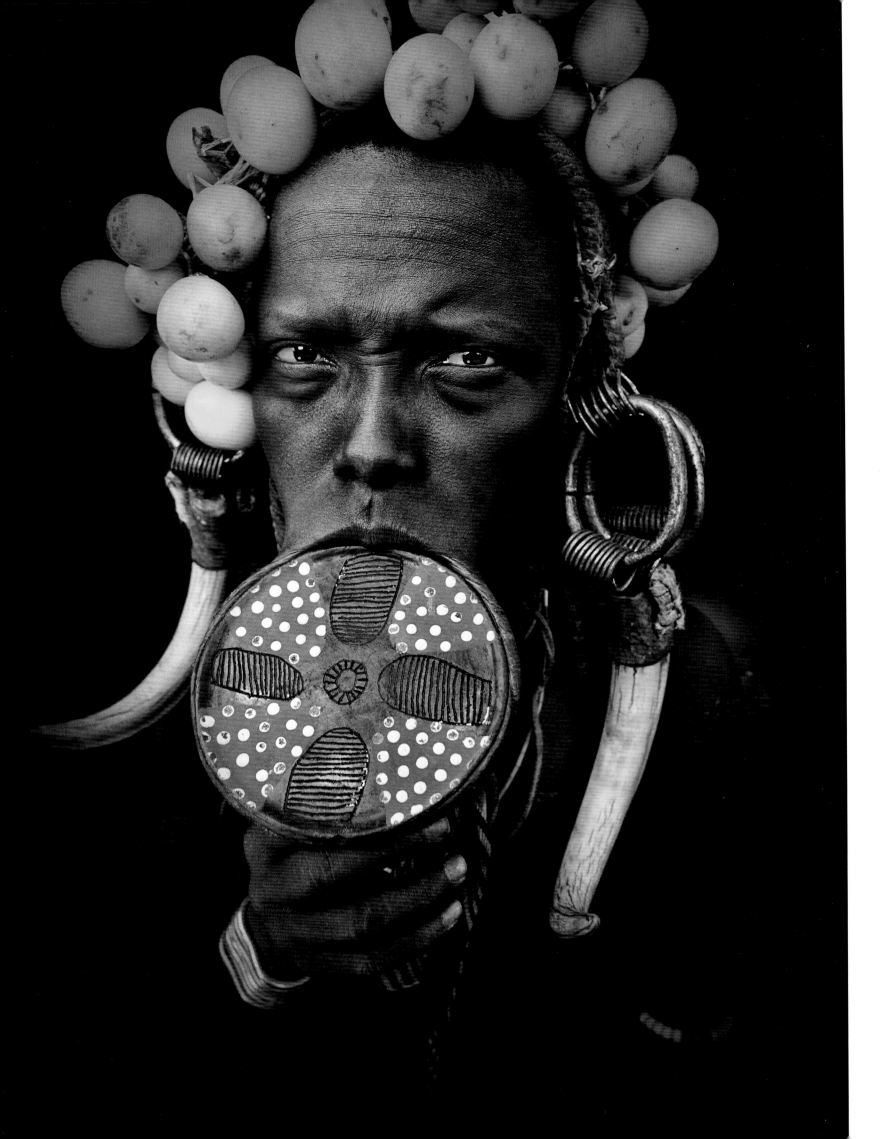

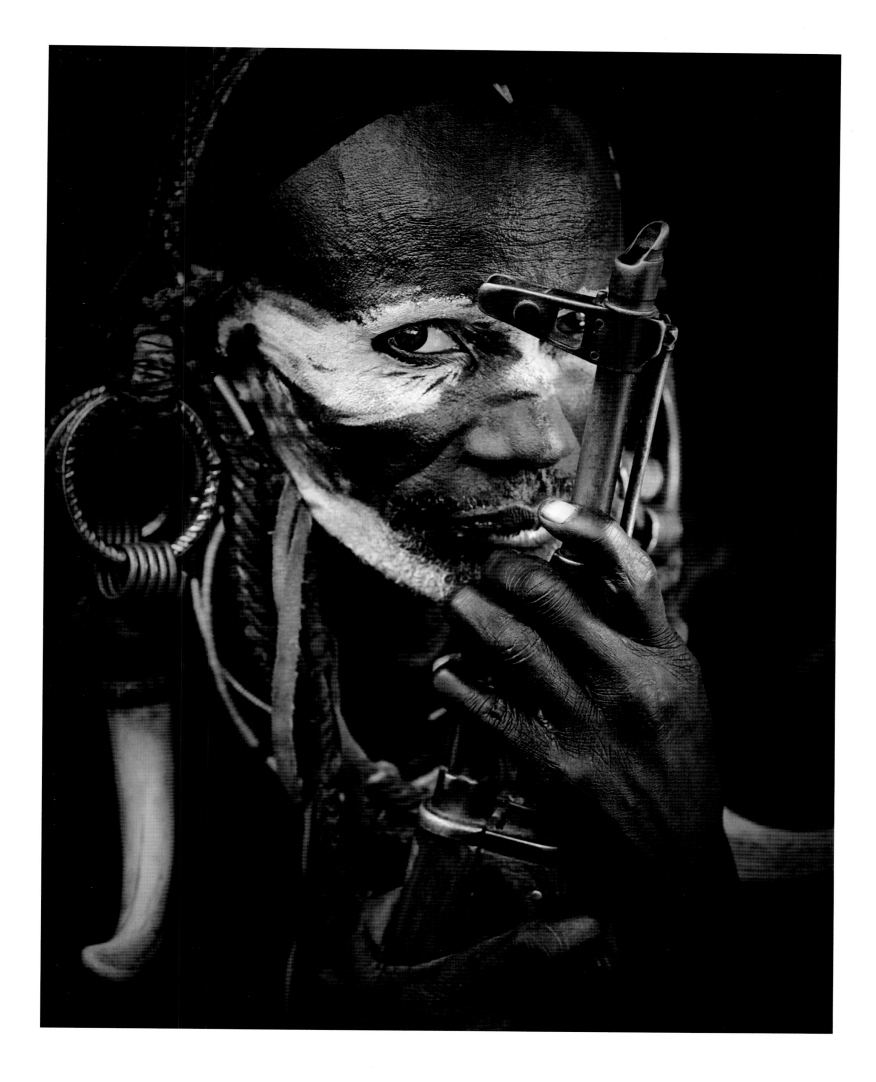

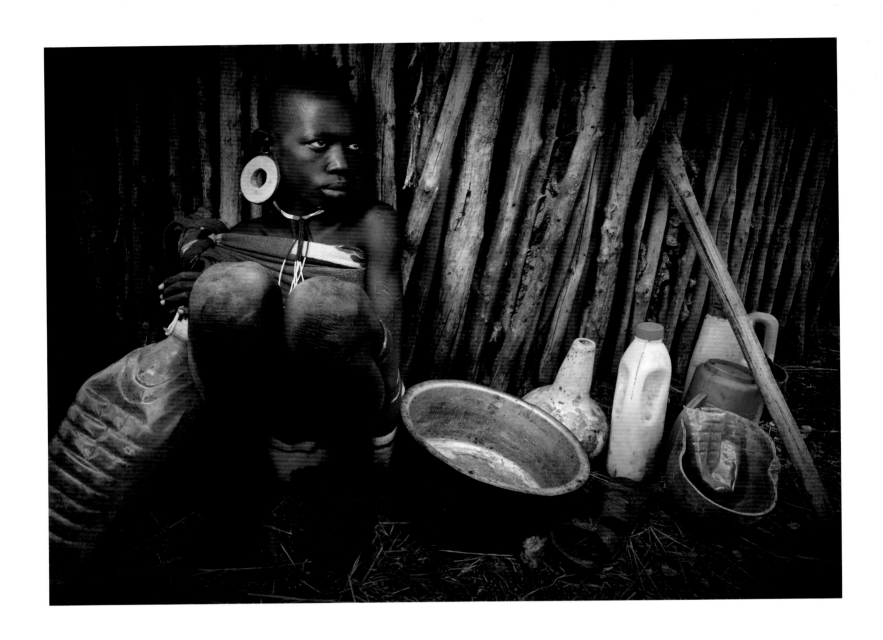

Right:

Right:

If the burdens of manhood are considerable in the Omo Valley, those that women must bear are no less heavy. A woman's duties traditionally include caring for the children, cooking food, keeping the house and carrying water—sometimes from nearby sources, but during the arid season sometimes from many miles away. The advent of plastic bottles has made life significantly easier in this regard, but for the action of scooping the water out of the well itself the old way—using a calabash, a traditional-jar-like vessel made out from a calabash pumpkin—remains best.

Rechts:

Die Männer des Omo-Tals mögen es schwer haben in ihren traditionellen Rollen, doch den Frauen geht es nicht besser. Es ist die Pflicht der Frau, sich um die Kinder zu kümmern, zu kochen, den Haushalt zu bestellen und Wasser zu tragen – manchmal von Quellen ganz in der Nähe, aber während der Trockenzeit auch von über dutzende Kilometer entfernten Orten. Plastikflaschen haben das Leben dahingehend etwas leichter gemacht, doch für das Schöpfen selbst ist und bleibt die traditionelle Kalebasse, der Flaschenkürbis, die beste Methode.

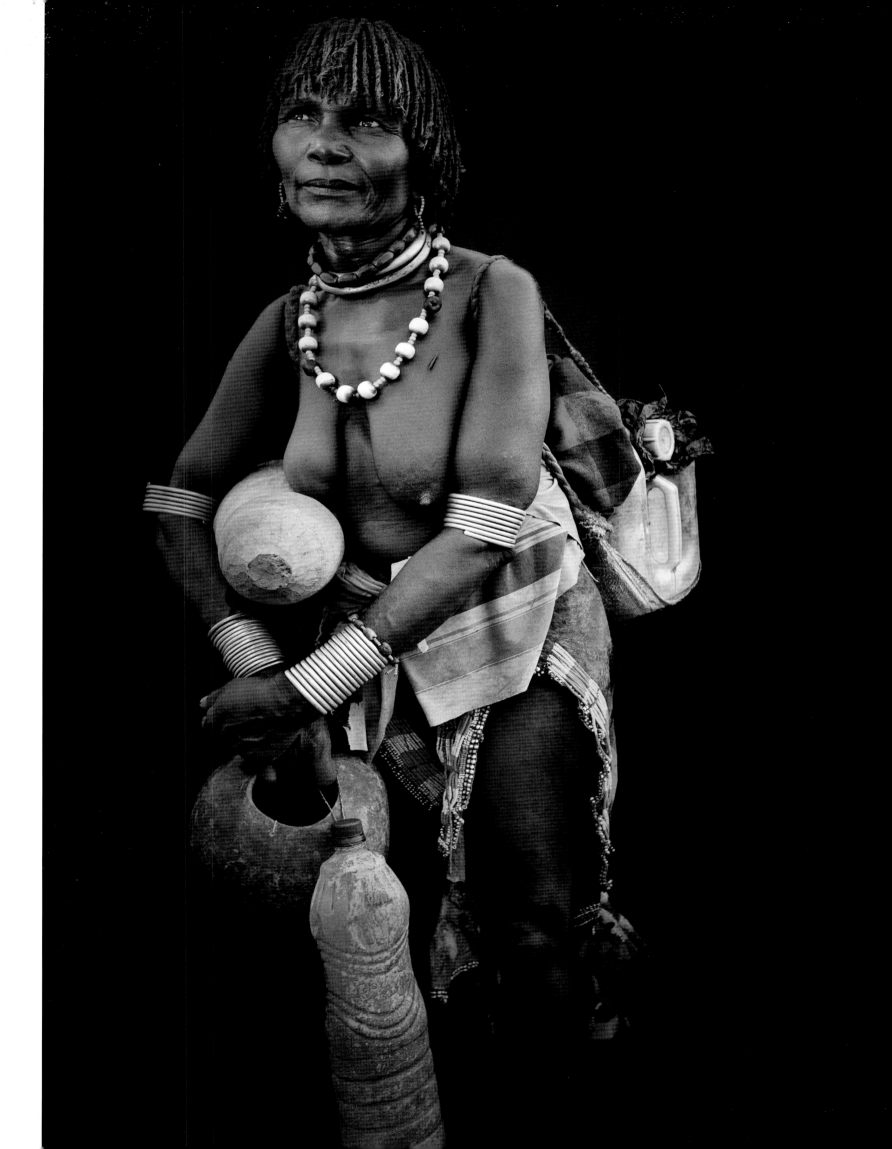

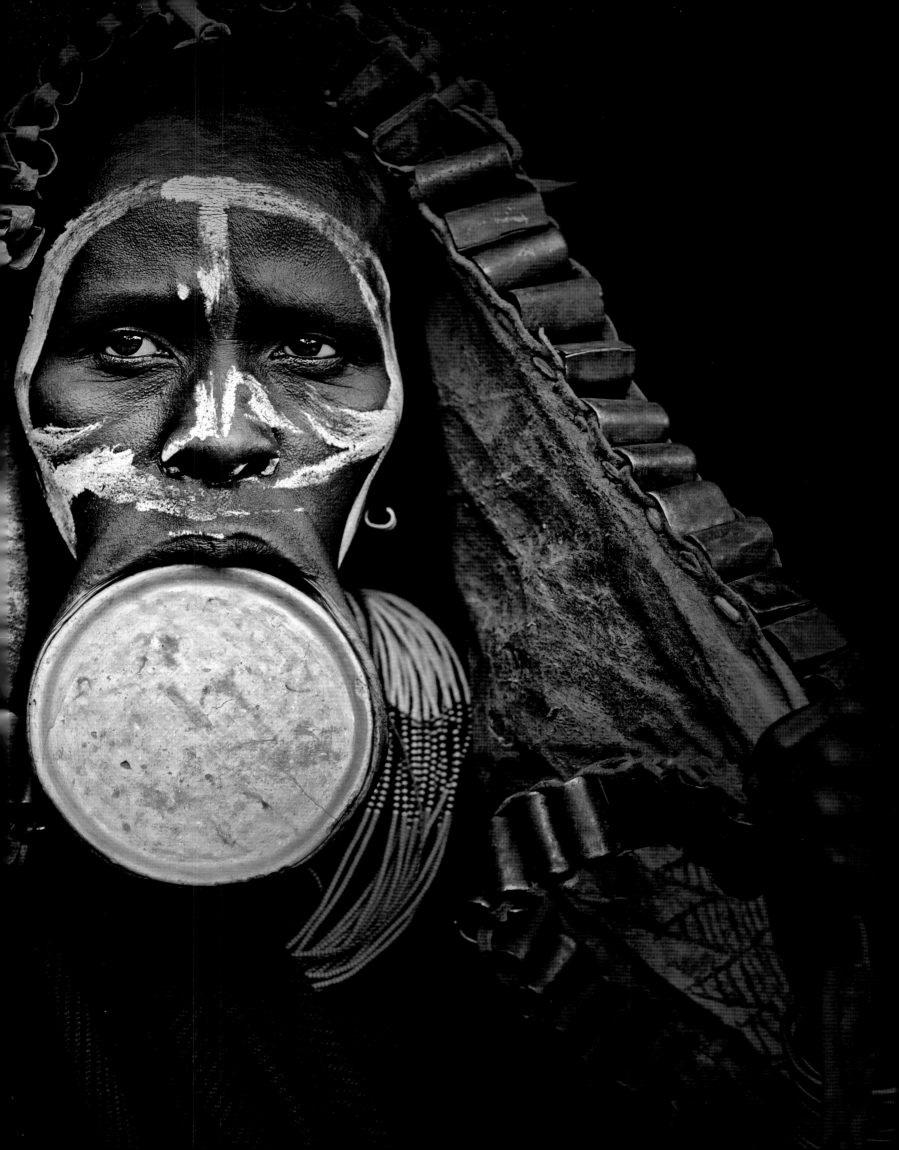

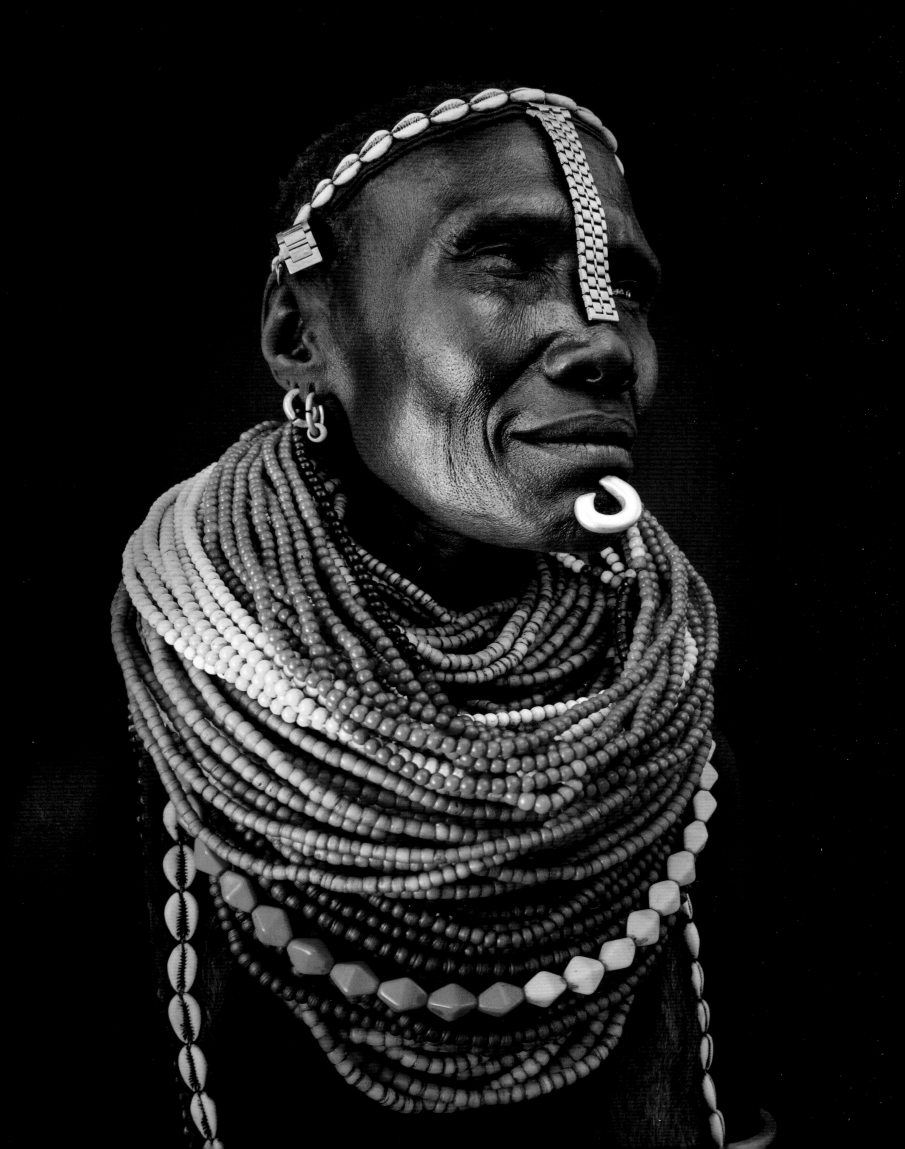

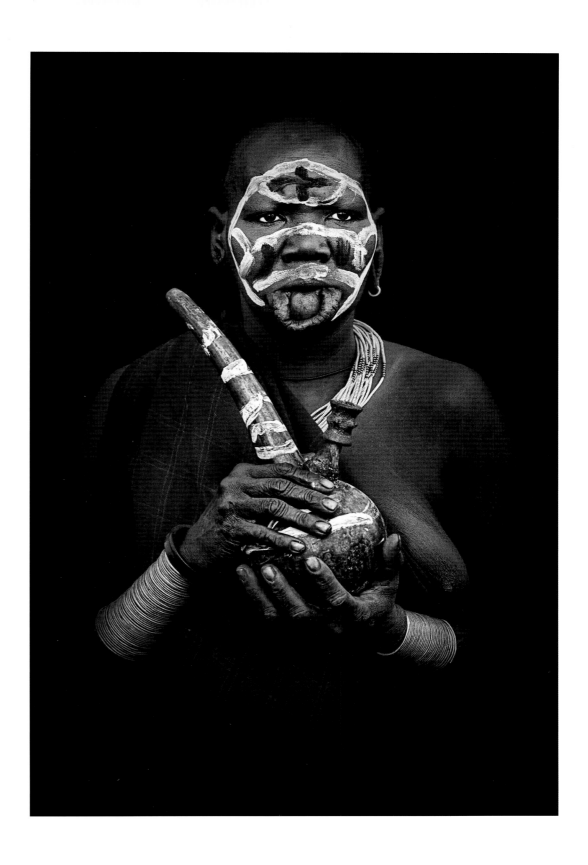

Left:
One of the values of jewellery in Karo culture is that it shows off the skill, creativity, and meticulous efforts of the wearer; alternatively, it can demonstrate (as it does here) social status, testifying to the efforts others have gone to on the wearer's behalf.

Links:
In der Kultur der Mursi wird Schmuck hoch geschätzt, da er das Talent, die Kreativität, die Mühe und das Geschick des Trägers reflektiert. Oder aber er signalisiert (wie zum Beispiel hier der Fall) den sozialen Status des Trägers und zeigt, wie viel Mühe sich andere seinetwegen gemacht haben.

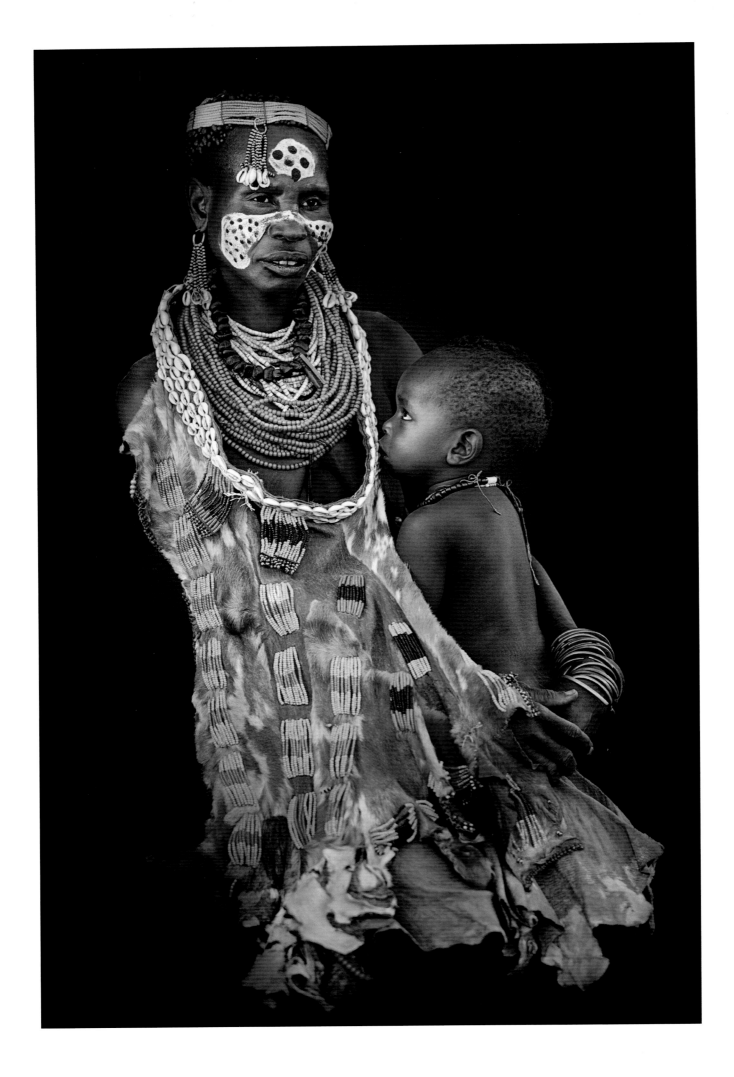

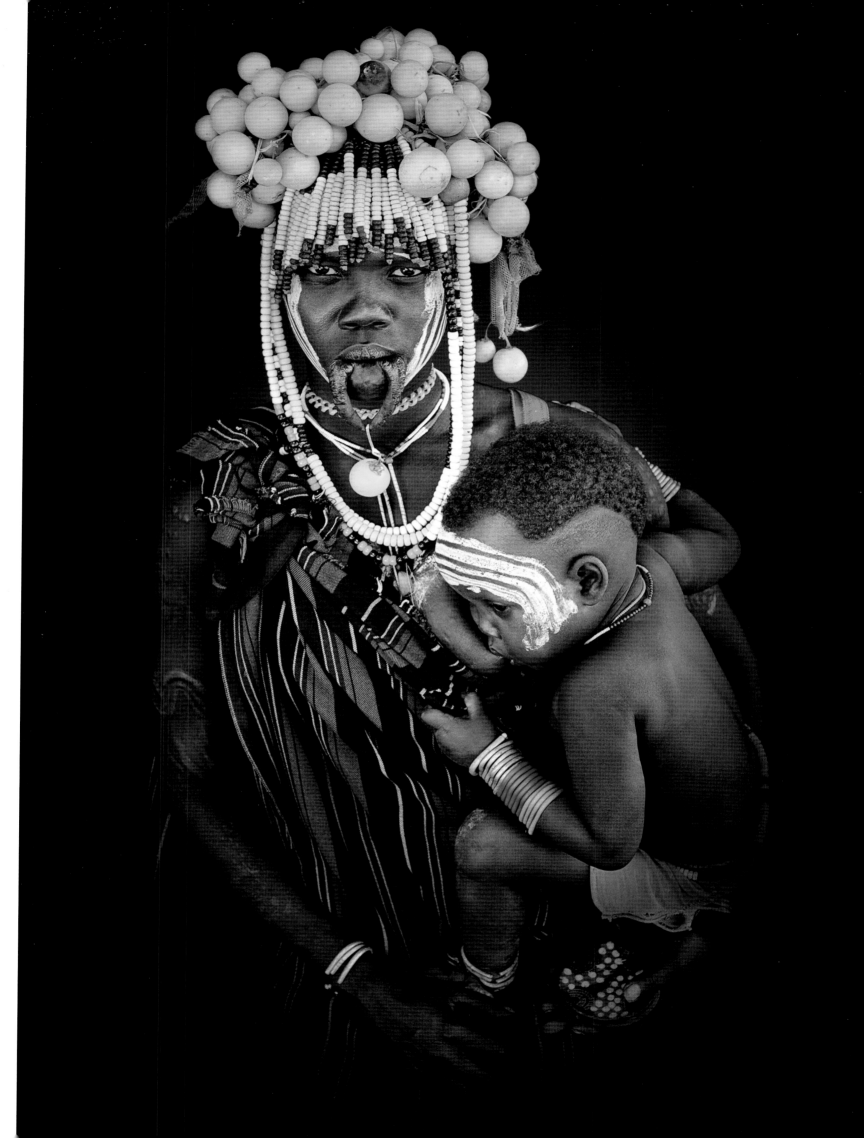

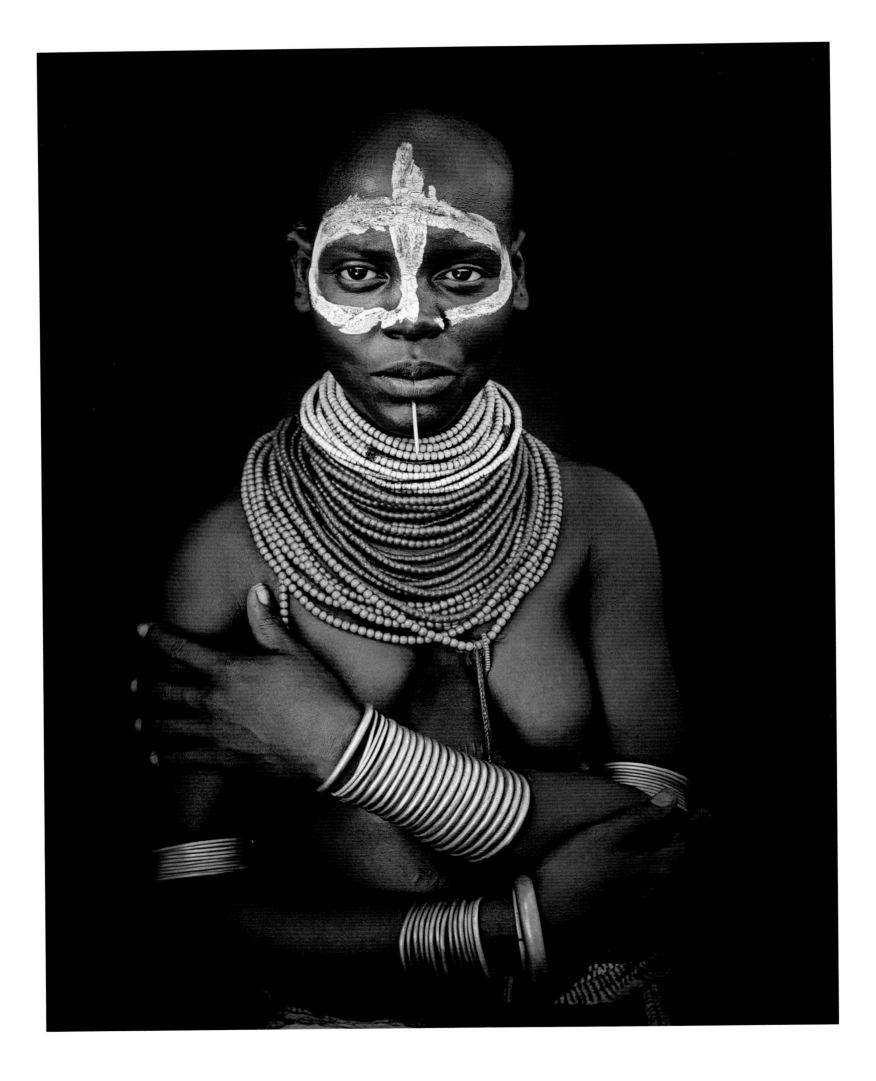

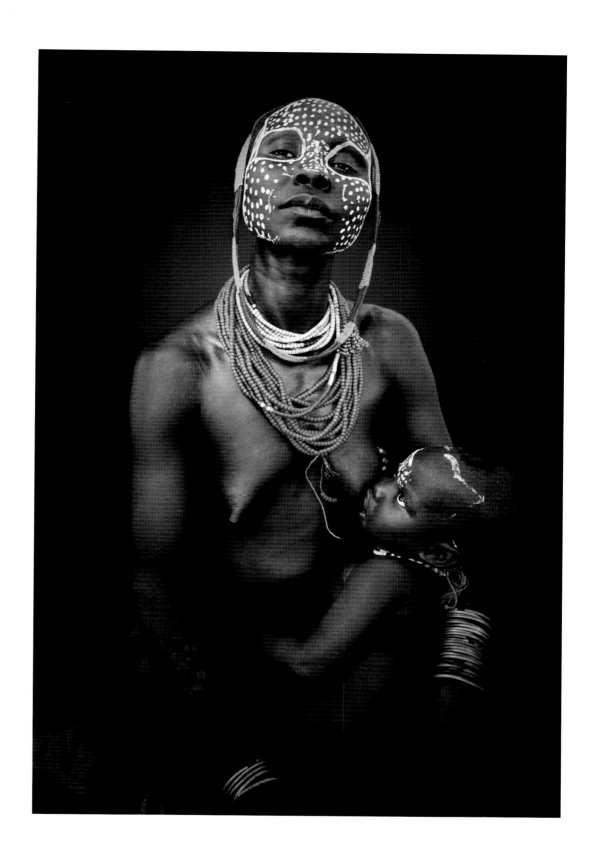

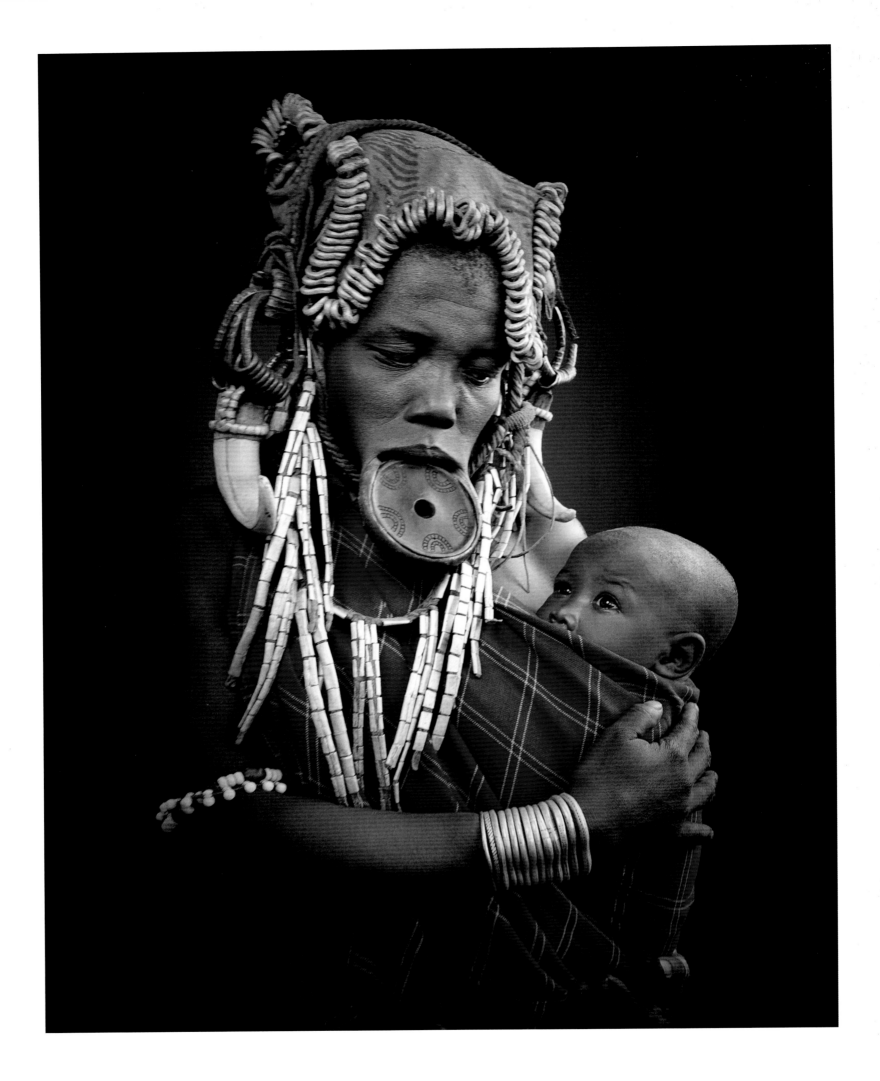

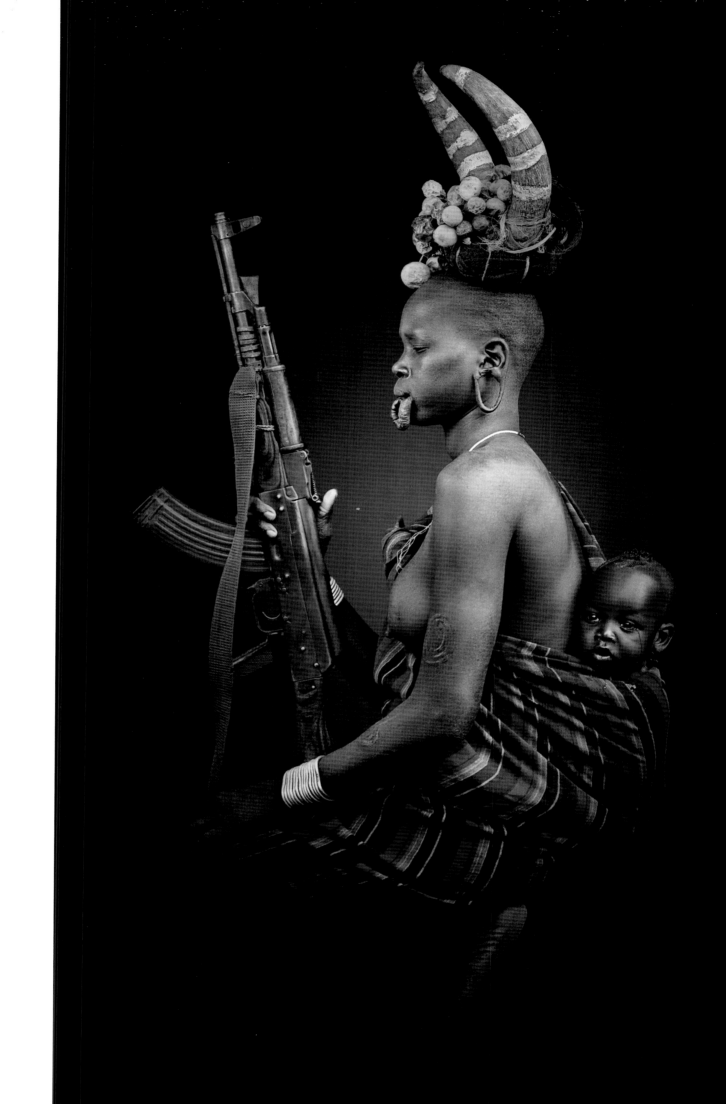

Previous page on the right:
This woman's self-presentation was especially powerful: the cow-horn headdress that is a sign of her faith in and adherence to cultural traditions; the infant that reminds us of her traditional role as mother; and the AK-47 that locates the image unignorably in the present and tells us that the woman is capable not only of conformity, faith and love but force as well.

Right:
The introduction to this book talks about the vulnerabilities shared by everyone on the planet. Of course, perhaps our most fundamental common vulnerability comes during infancy and childhood, a period when we have everything to learn and are entirely dependent on our parents and elders to guide us through and protect us from the world.

Vorherige Seite rechts:
Diese Selbstdarstellung einer Mursi-Frau war besonders beeindruckend: Die Kopfbedeckung aus Kuhhörnern steht für ihren Glauben und ihr Festhalten an kulturellen Traditionen. Das Baby erinnert uns an ihre traditionelle Rolle als Mutter – das AK-47 Gewehr verankert das Bild in der Gegenwart und unterstreicht, dass Frauen nicht nur zur Unterwürfigkeit, zum Glauben und zur Liebe, sondern auch zur Gewalt fähig sind.

Rechts:
In der Einleitung dieses Buches wird dargelegt, warum jeder Mensch auf der Erde verletzlich ist. Besonders verletzlich sind wir während der Kindheit, wenn wir noch so viel zu lernen haben und völlig von unseren Eltern und Erwachsenen, die uns aufziehen und beschützen, abhängig sind.

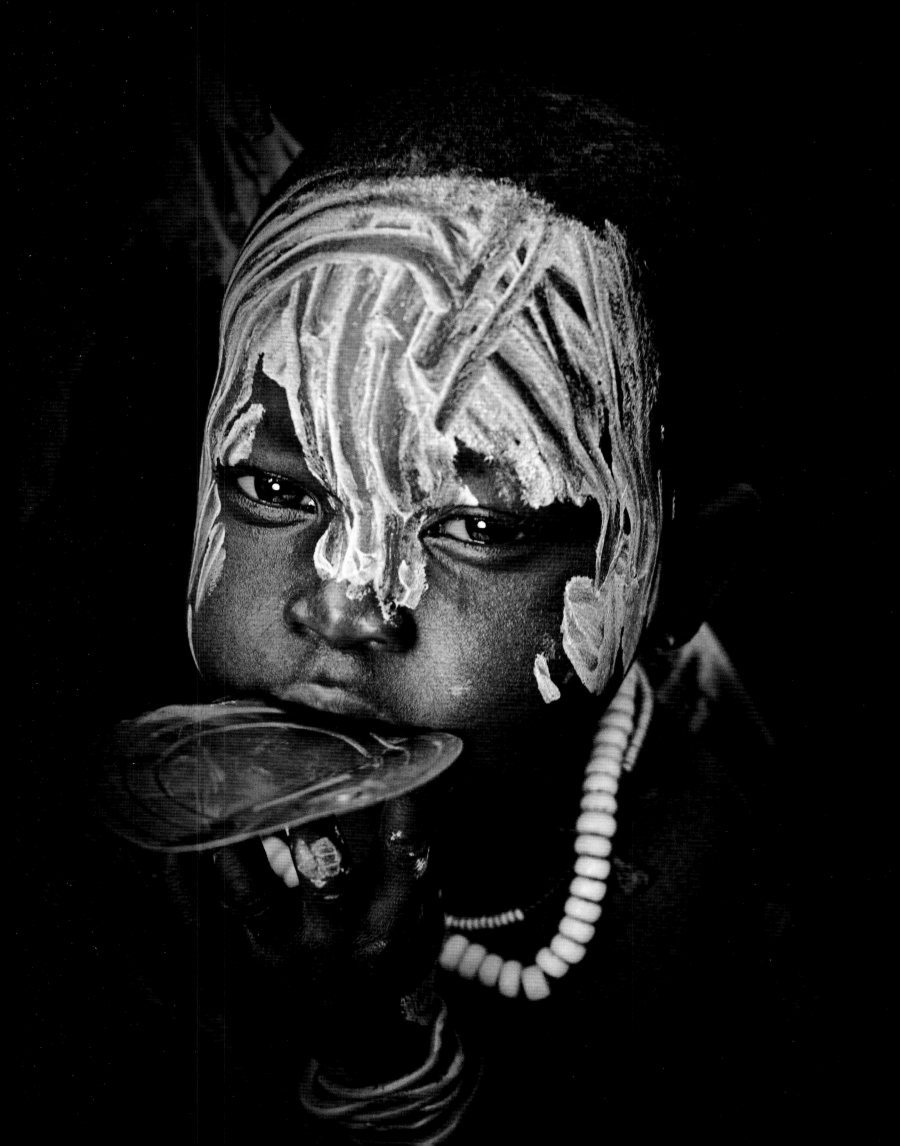

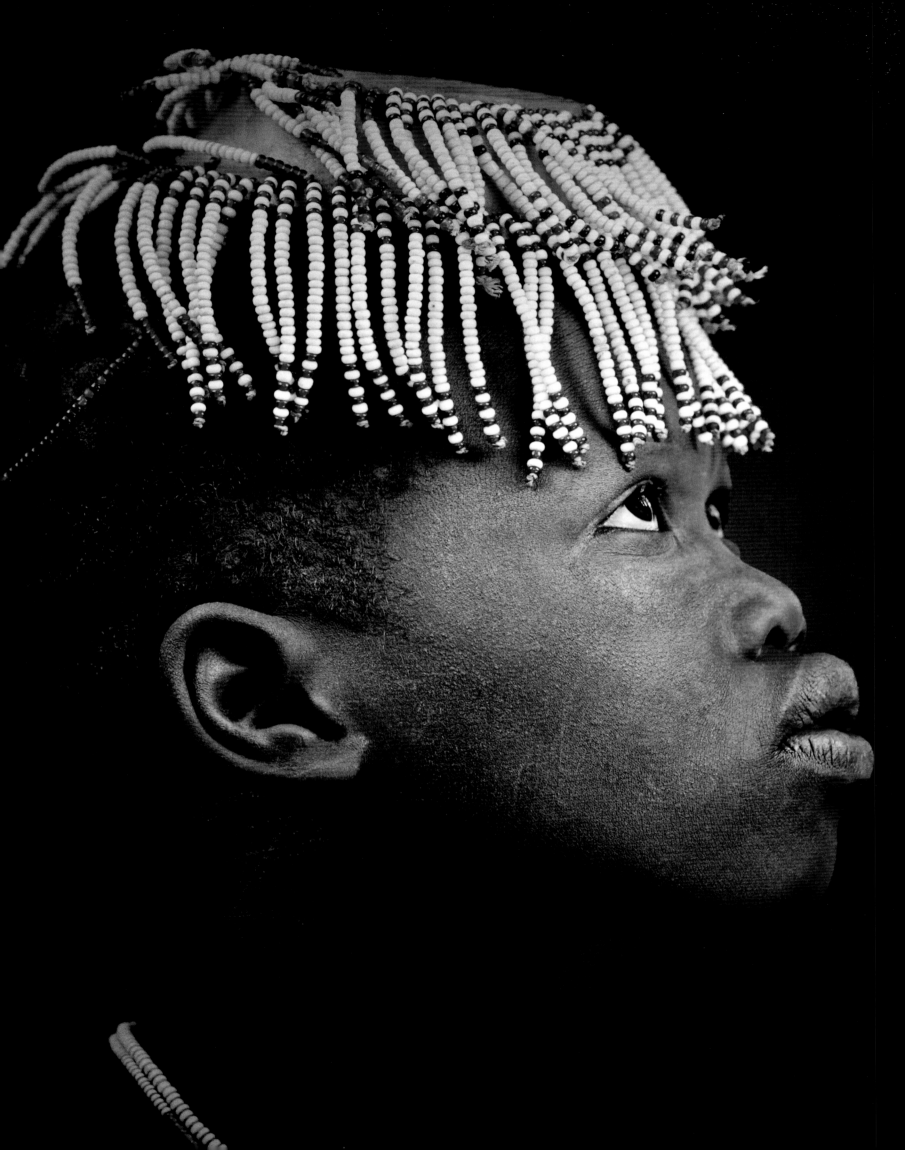

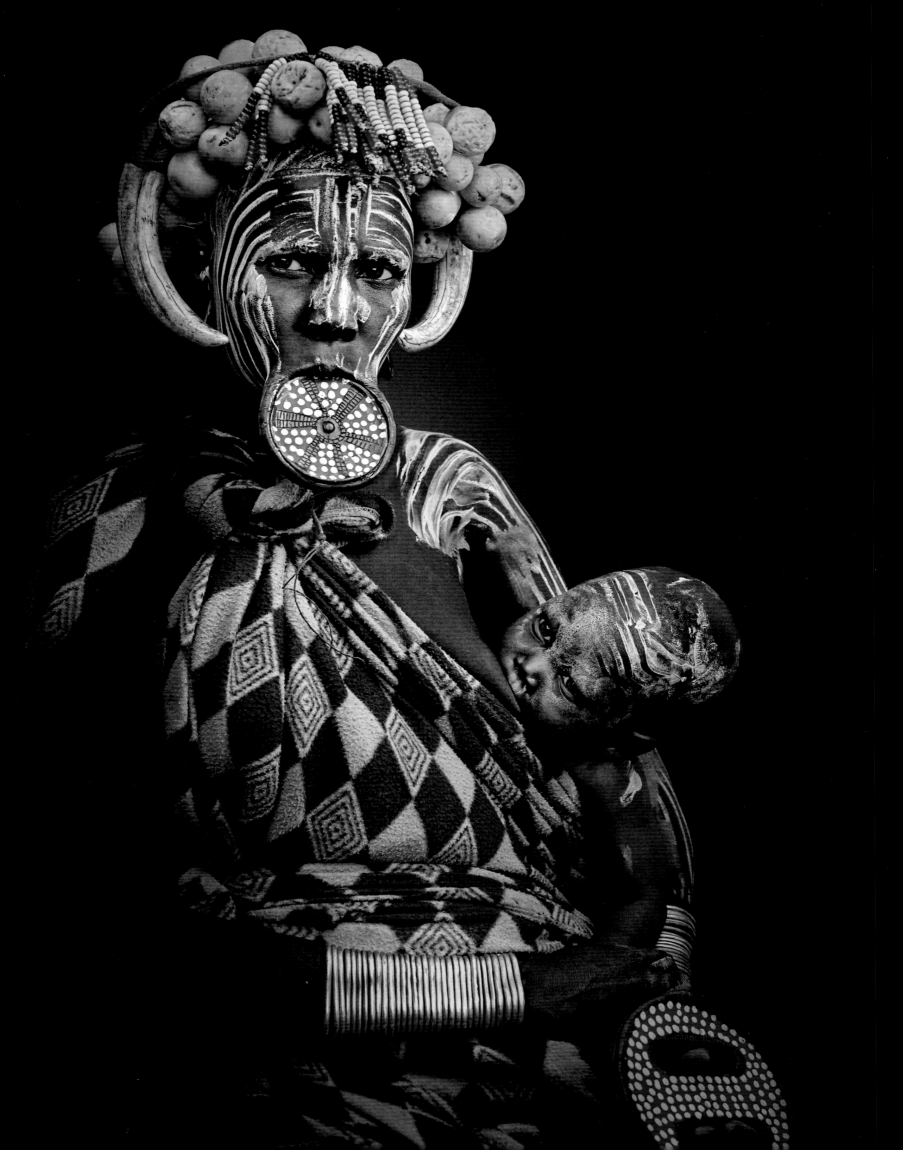

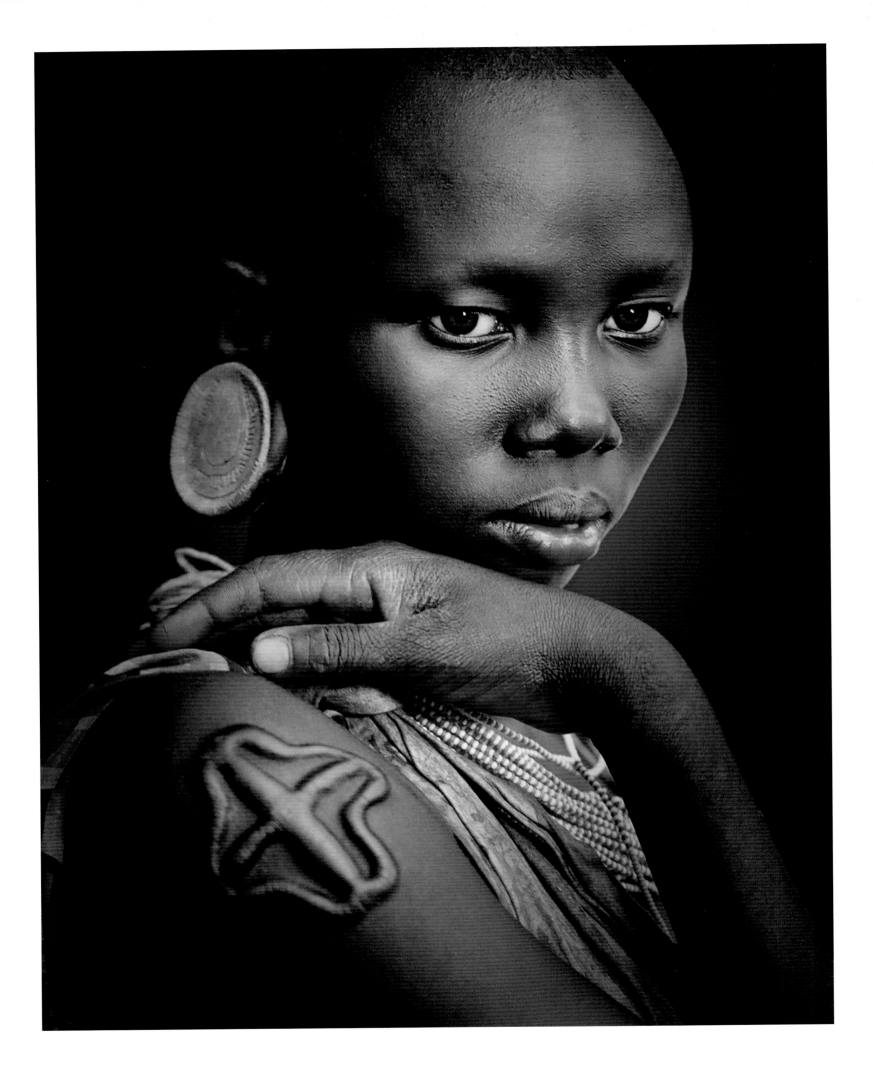

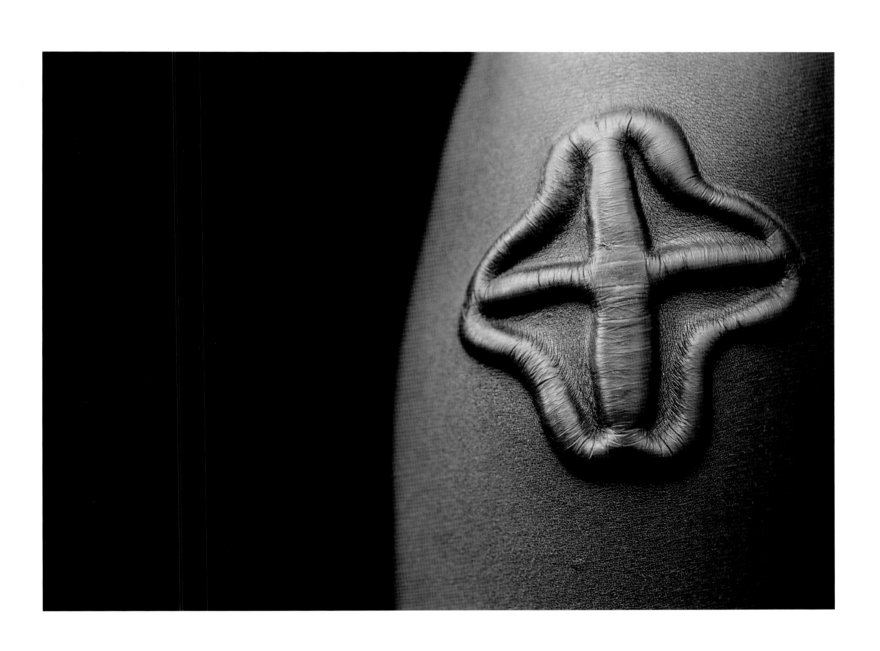

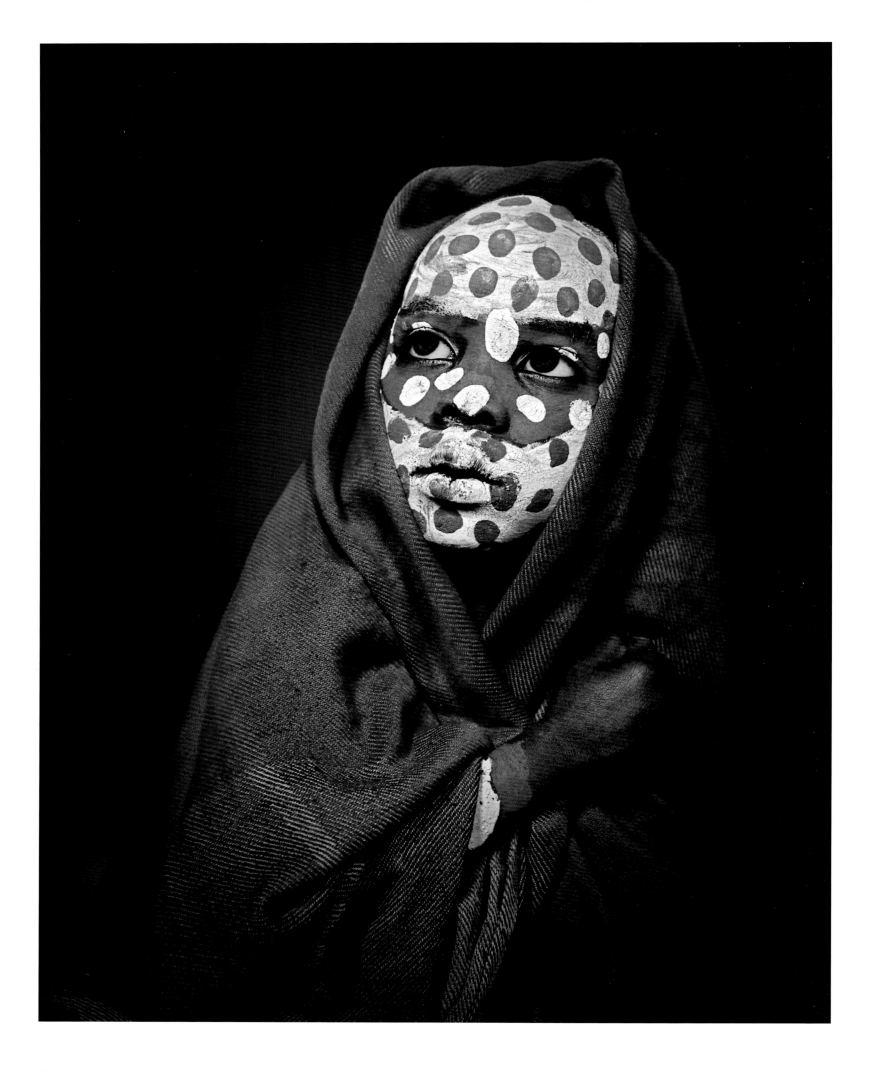

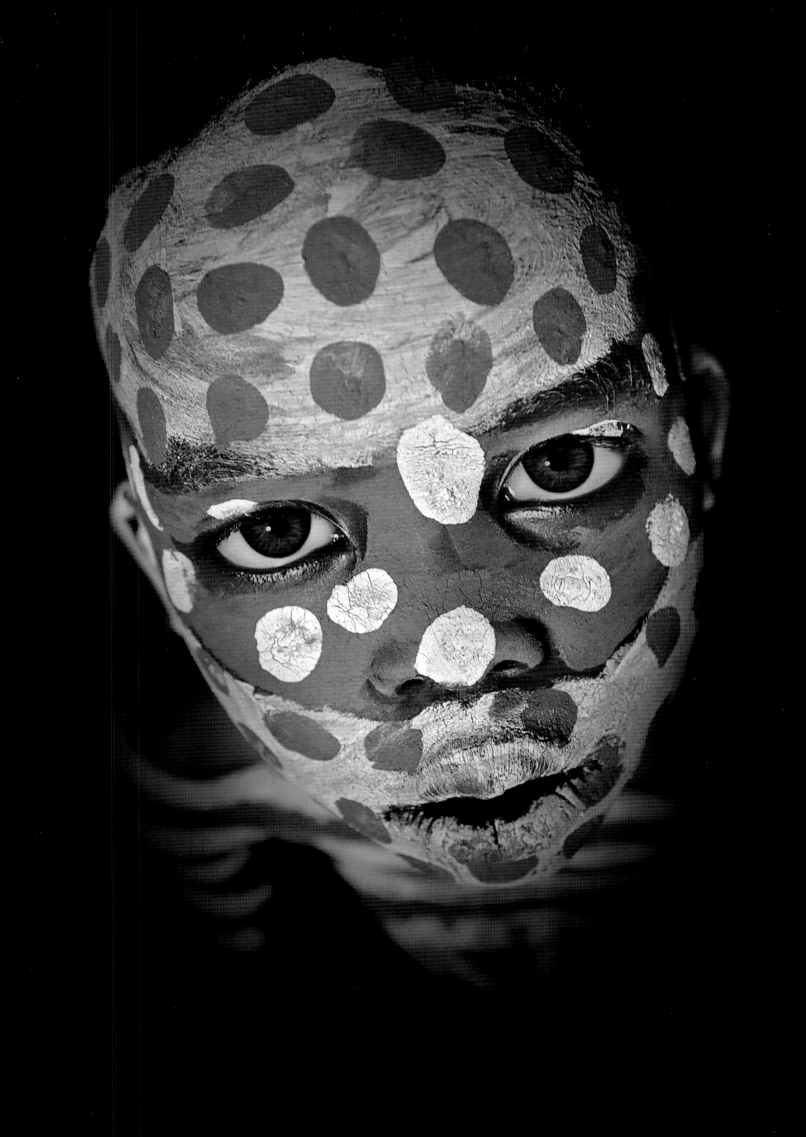

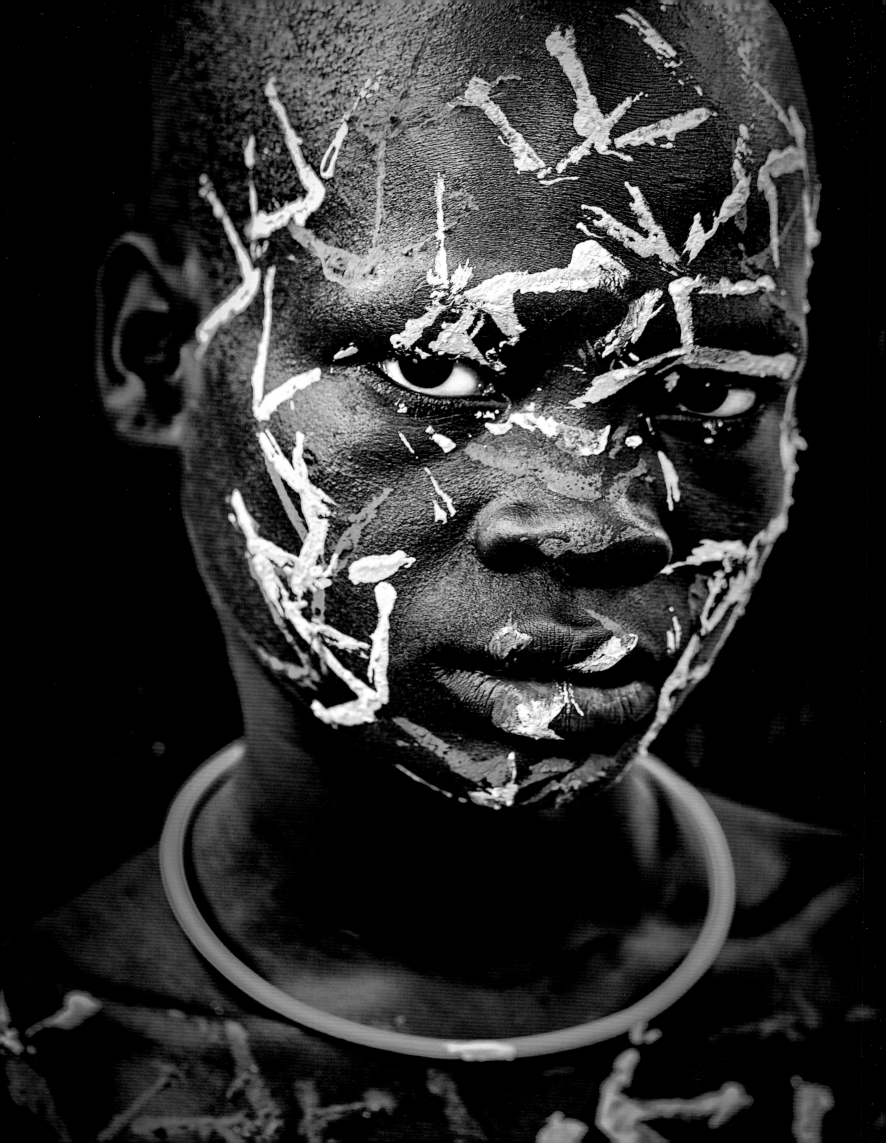

Previous page on the right:

The Person in this photo confronts the camera directly, looking straight at the viewer and reader. To me this is a powerful invitation to acknowledge and connect with the human being beneath the 'exotic' customs that can too easily in our eyes reduce cultures other than our own to curiosities.

Left:

To the Karo and Surma tribes, the most important of the minerals in which the banks of the Omo are rich are those that they crush into power and mix with animal fat or water to yield the vivid colours—white, red, yellow—used to paint their faces and bodies. This is done for any number of purposes: as a ritual to initiate a person into a new stage of their life, or as a way to display bravery or attract a partner. Painting is also a central part of each child's education from at least the age of four onwards, and during my time with the tribes each day would begin with the ritual of preparing and applying the paste (the adults would paint in complex conventional patterns, whereas the children would adopt more ad hoc approaches). Some of the conventions to which the adults adhere are passed from generation to generation and go back to prehistoric times: red often symbolizes energy and fertility, white provides the background that indicates the purpose of the ritual of which the painting is a part, and identical patterns are used to paint the faces and bodies of lovers or inseparable friends.

Vorherige Seite rechts:

Die hier abgebildete Person blickt den Betrachter und Leser direkt an. Für mich ist dies wie eine Einladung, sich mit dem Menschen und seinen „anderen" Bräuchen zu beschäftigen und sich mit ihm zu verbinden. In unseren Augen fremde Kulturen werden allzu oft auf Kuriositäten reduziert.

Links:

Das Omo-Ufer ist reich an intensiven Pigmenten – weiß, rot und gelb – welche für die Karo- und Surma-Stämme sehr wertvoll sind, da sie als Farbe für Gesichts- und Körperbemalung dienen. Dies geschieht aus vielerlei Absichten: als Ritual, um eine Person in einen neuen Lebensabschnitt einzuweihen, oder als Mittel, um Tapferkeit zu zeigen oder einen Partner zu beeindrucken. Die Körperbemalung ist auch ein zentraler Bestandteil der Erziehung jedes Kindes ab mindestens vier Jahren. Während meiner Zeit bei den Stämmen begann jeder Tag mit dem Ritual der Vorbereitung und des Auftragens der Paste (die Erwachsenen malten in komplexen Mustern, während die Kinder eher spontan vorgingen). Einige der Konventionen, an die sich die Erwachsenen halten, werden von Generation zu Generation weitergegeben und reichen bis in prähistorische Zeiten zurück: Rot symbolisiert oft Energie und Fruchtbarkeit. Weiß bildet den Hintergrund, der den Zweck des Rituals angibt, zu dem das Bild gehört. Die Gesichter und Körper von Liebenden oder unzertrennlichen Freunden werden mit identischen Mustern bemalt.

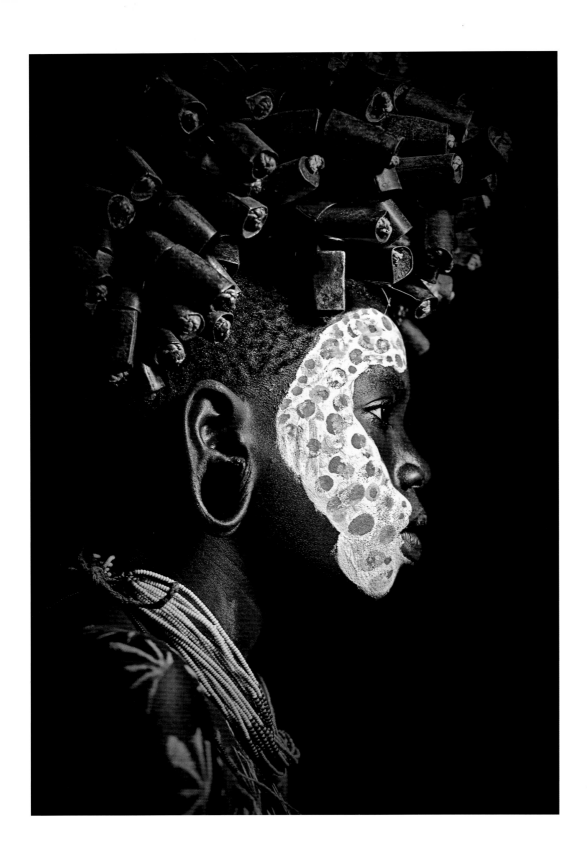

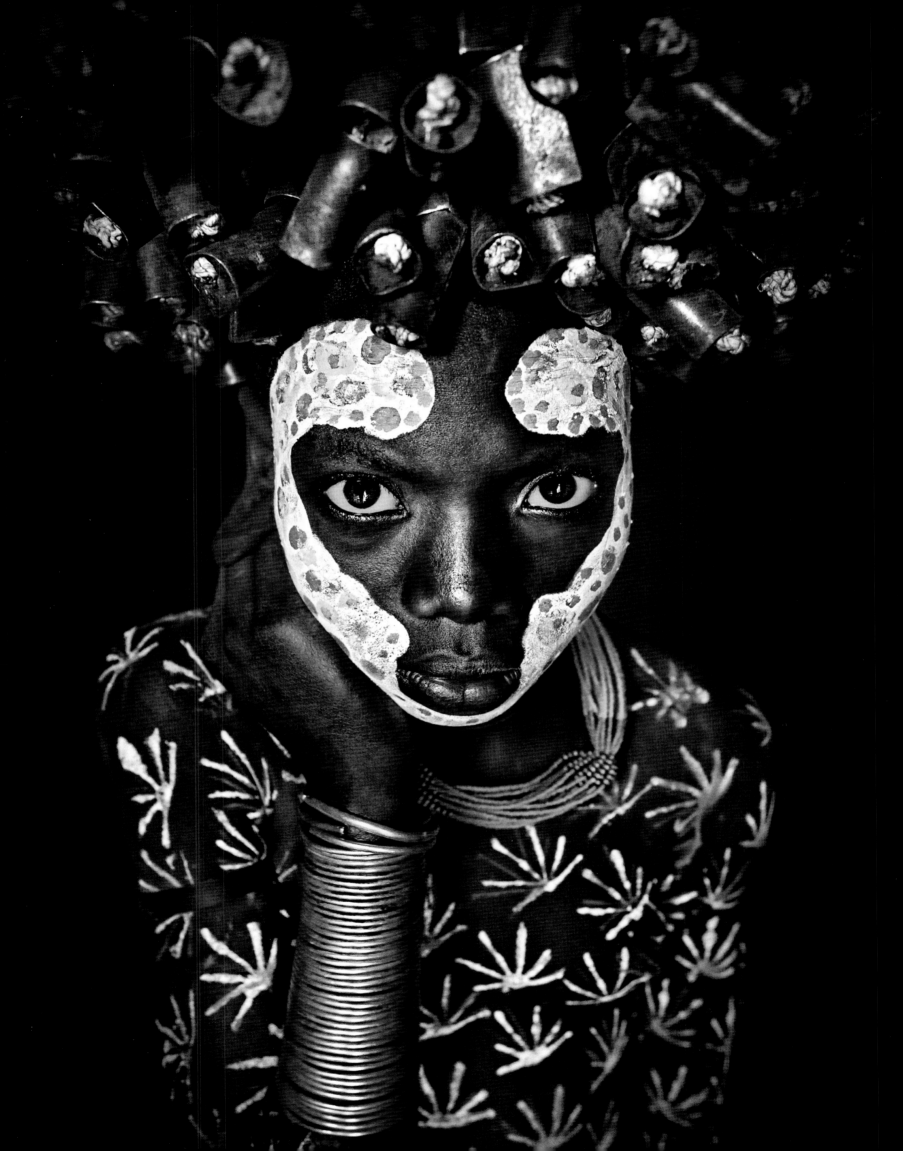

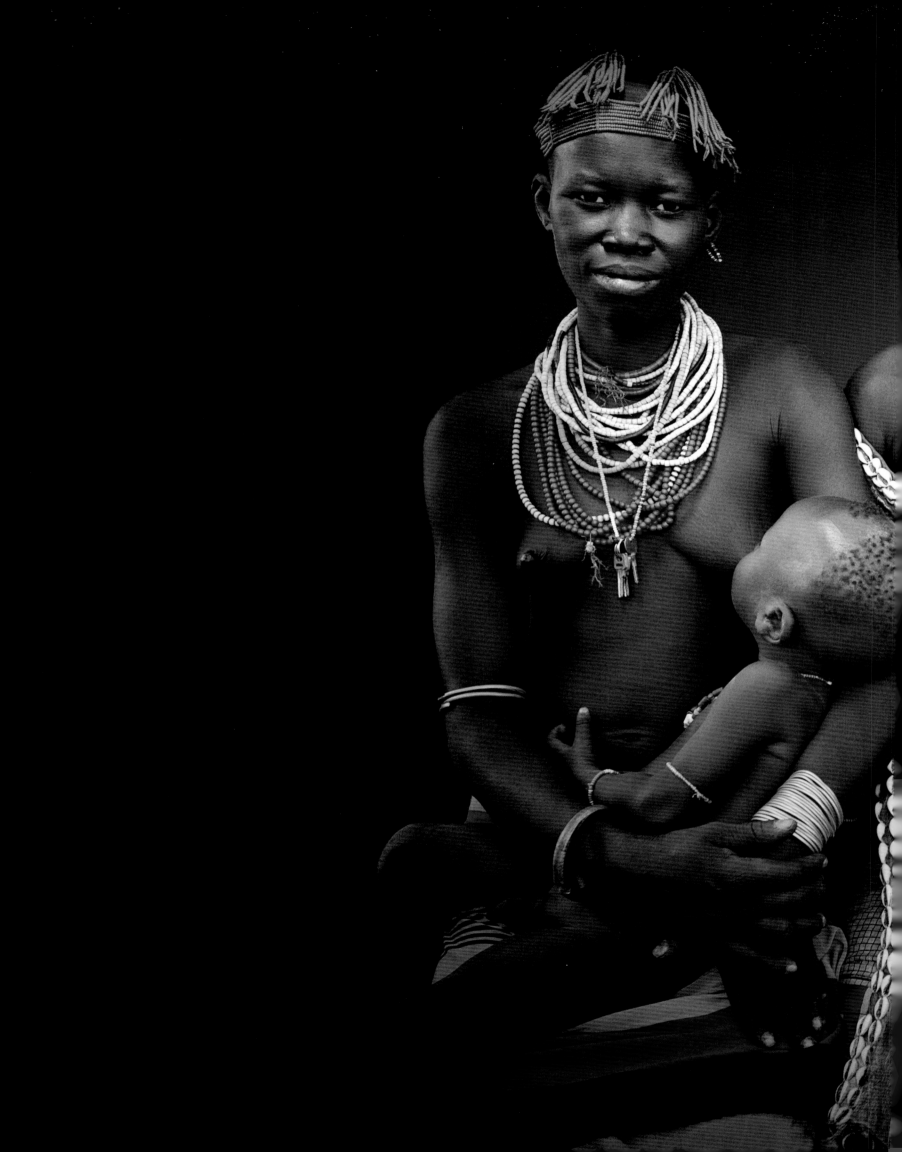

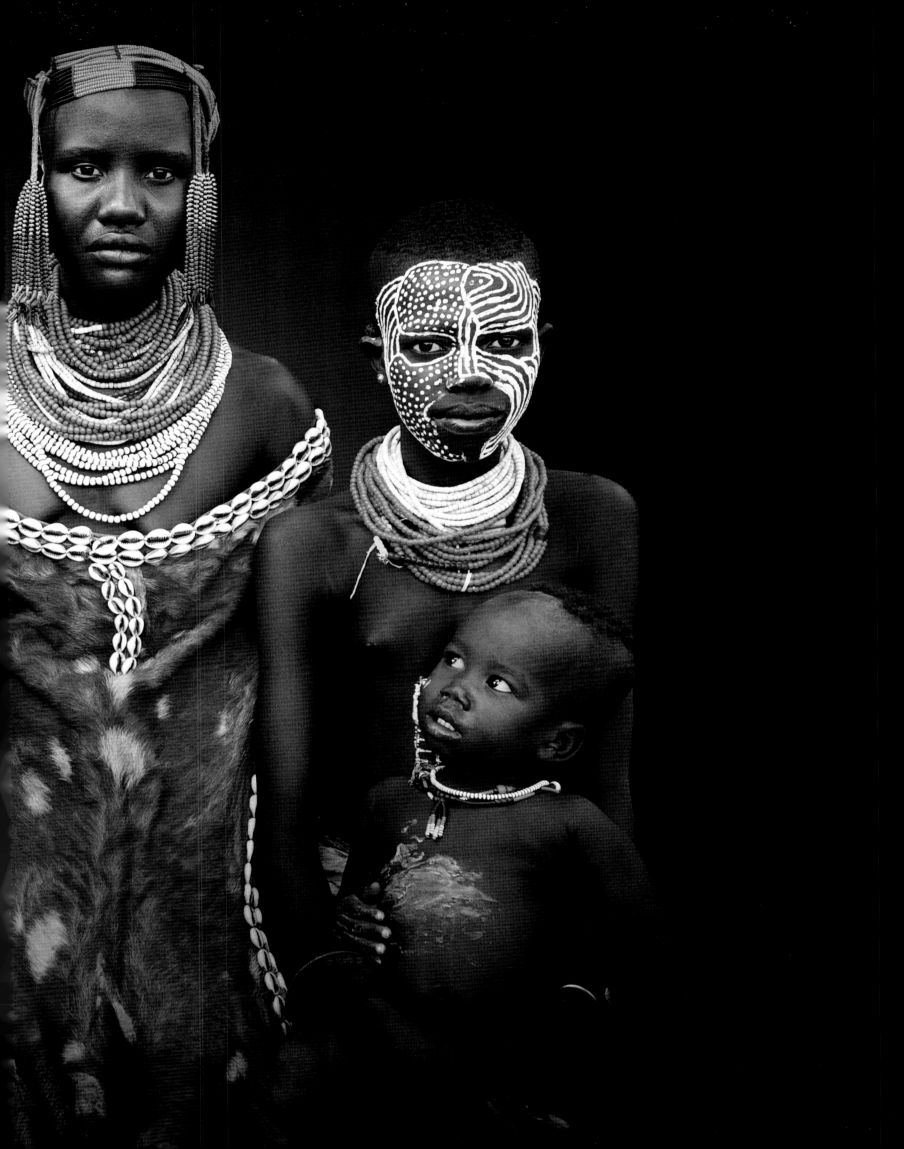

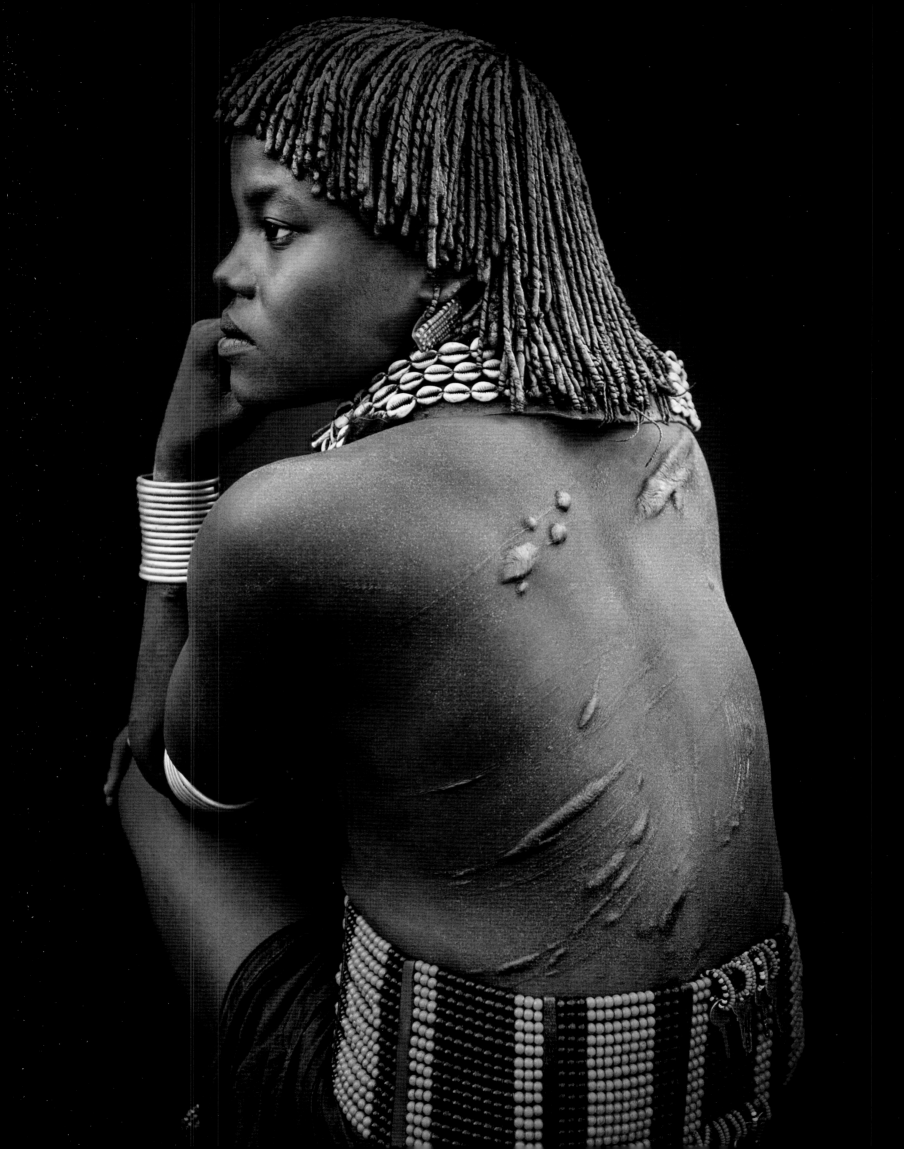

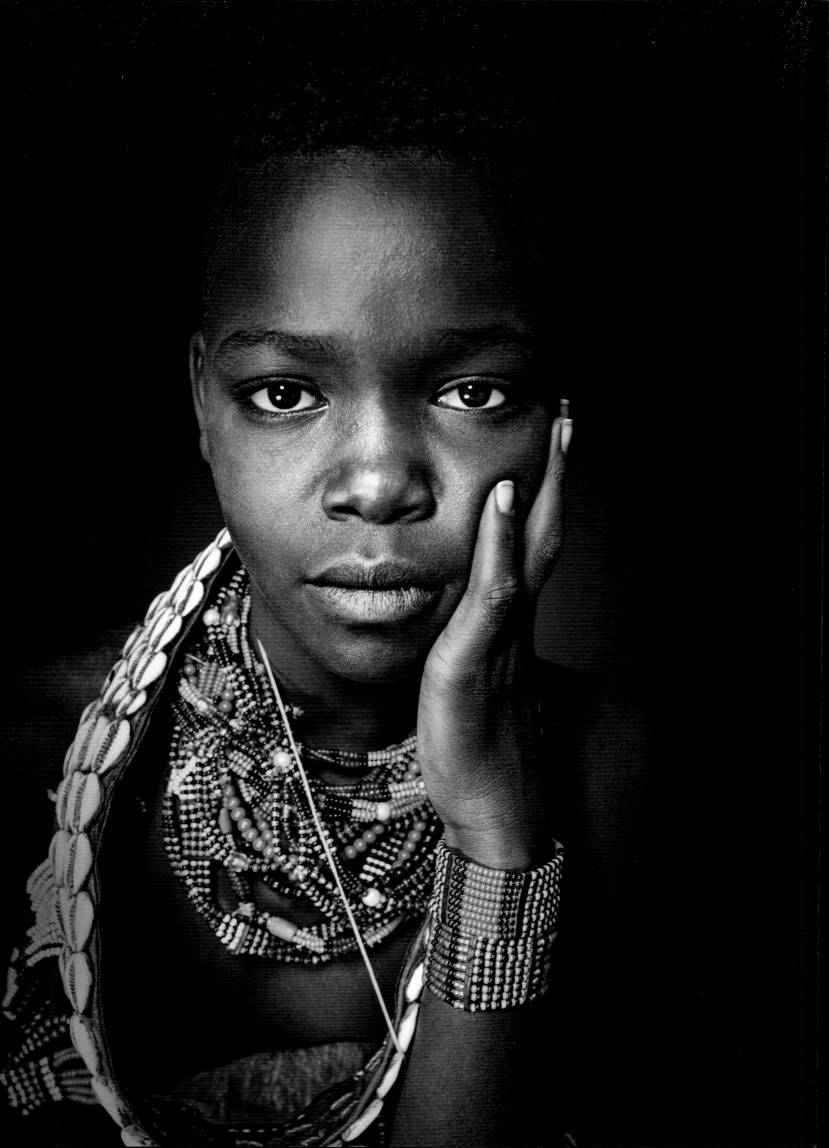

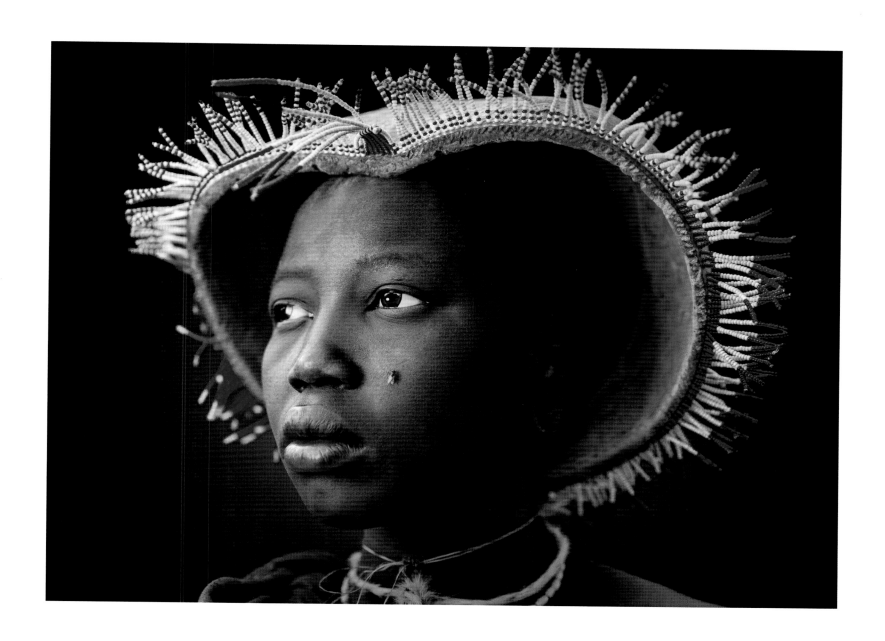

Top:

This Mursi woman is wearing a hat that doubles as a sumptuously decorated piece of kitchenware—most objects here have multiple functions—but that also struck me as having something of early modern Europe about it. The resemblance of the fly that landed on her face as this photograph was taken to the mouches (literally 'flies') worn by European women in the seventeenth and eighteenth centuries was purely a happy accident!

Oben:

Diese Mursi-Frau trägt einen Hut, der auch als prunkvoll dekoriertes Küchengerät zum Einsatz kommt — hier haben viele Dinge mehr als nur eine Funktion. Abgesehen davon erschien er mir fast schon klassisch europäisch. Die Fliege, die auf ihrem Gesicht landete, ähnelt auch den mouches (wörtlich „Fliegen"), die Europäerinnen im 17. und 18. Jahrhundert trugen — aber das war reiner Zufall!

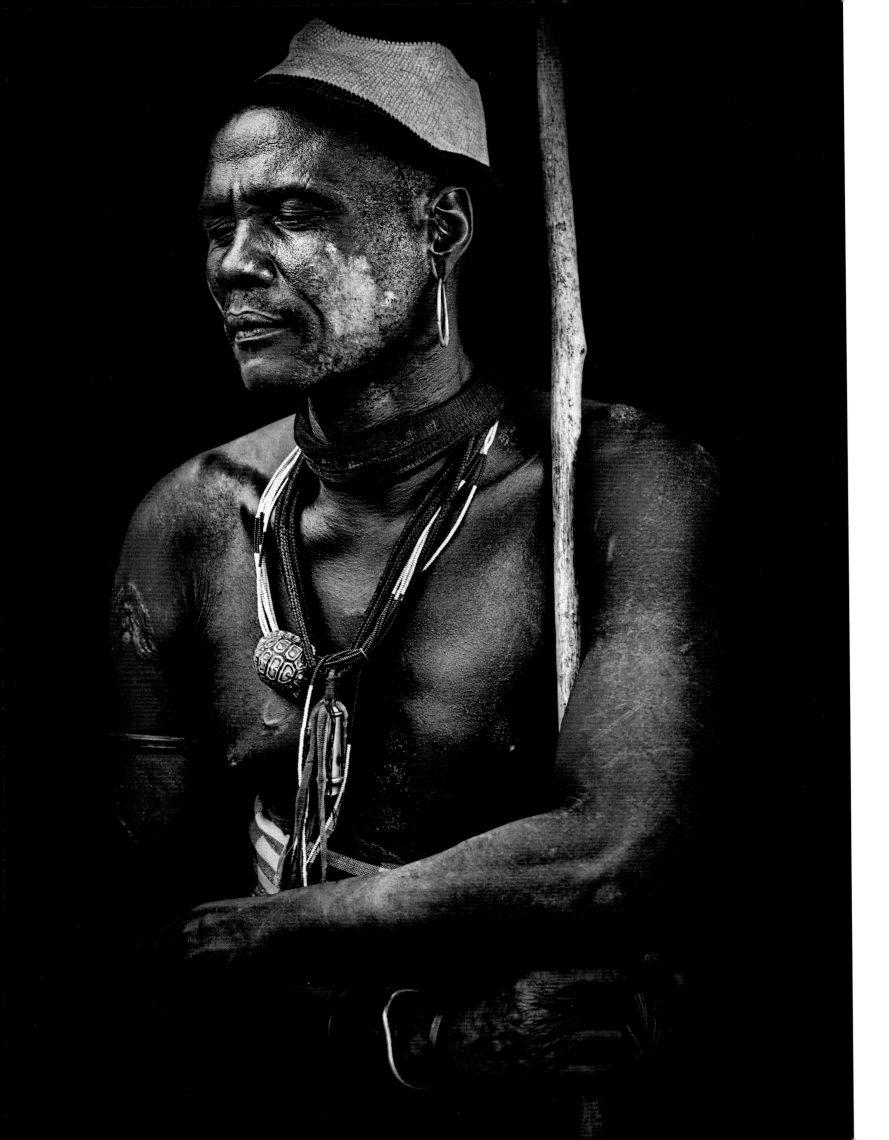

Left:

Left:

The father's role, traditionally and for the most part to this day, is to support and protect the family. This is challenging not only because of the frequent difficulty of natural conditions here in the Omo Valley. This man exudes both the strength required and the deep weariness that must sometimes result.

Links:

Links:

Die traditionelle sowie auch die kontemporäre Rolle des Vaters ist es, die Familie zu versorgen und zu beschützen. Dies ist oft schwierig, nicht nur aufgrund der oft widrigen natürlichen Umgebung hier im Omo-Tal. Dieser Mann strahlt sowohl die nötige Stärke als auch die wohl oft unvermeidbare Erschöpfung aus.

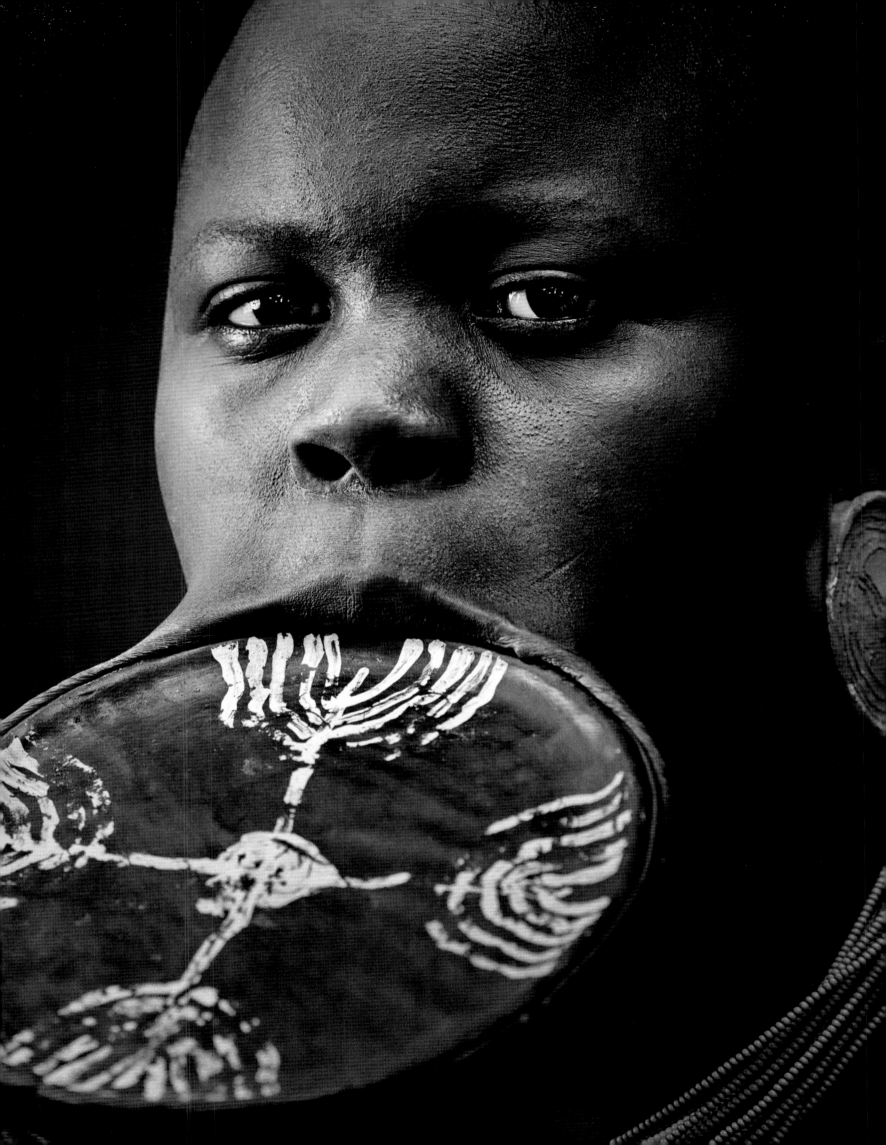

As we have seen already, and like innumerable other cultures across the globe, the peoples of the Omo Valley attach considerable symbolic significance to the colours in which they paint their faces and bodies and with which they dye their fabrics. Blue often denotes authority and is worn with great pride.

Wie wir bereits gesehen haben, haben die Farben der Gesichts- und Körperbemalung und der Kleidung eine wichtige symbolische Bedeutung für die Völker des Omo-Tals, wie auch in vielen anderen Orten und Kulturen. Blau steht oft für Autorität und wird mit Stolz getragen.

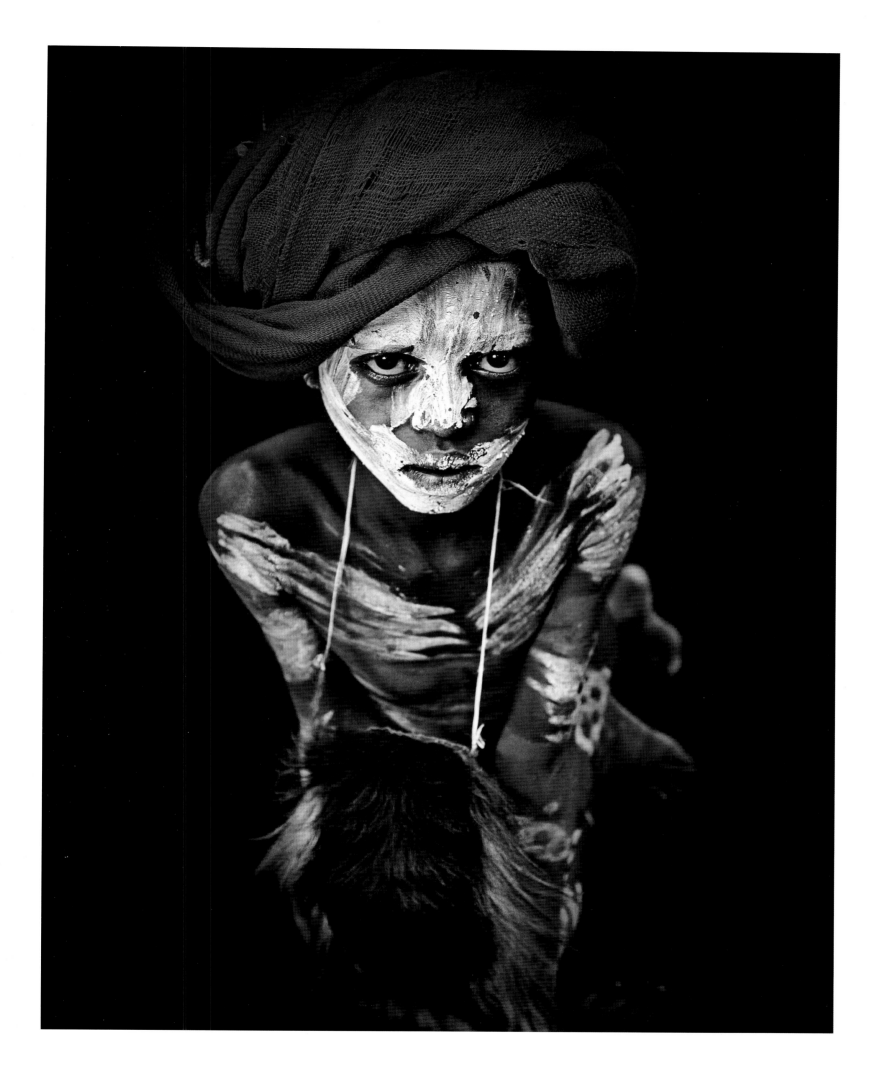

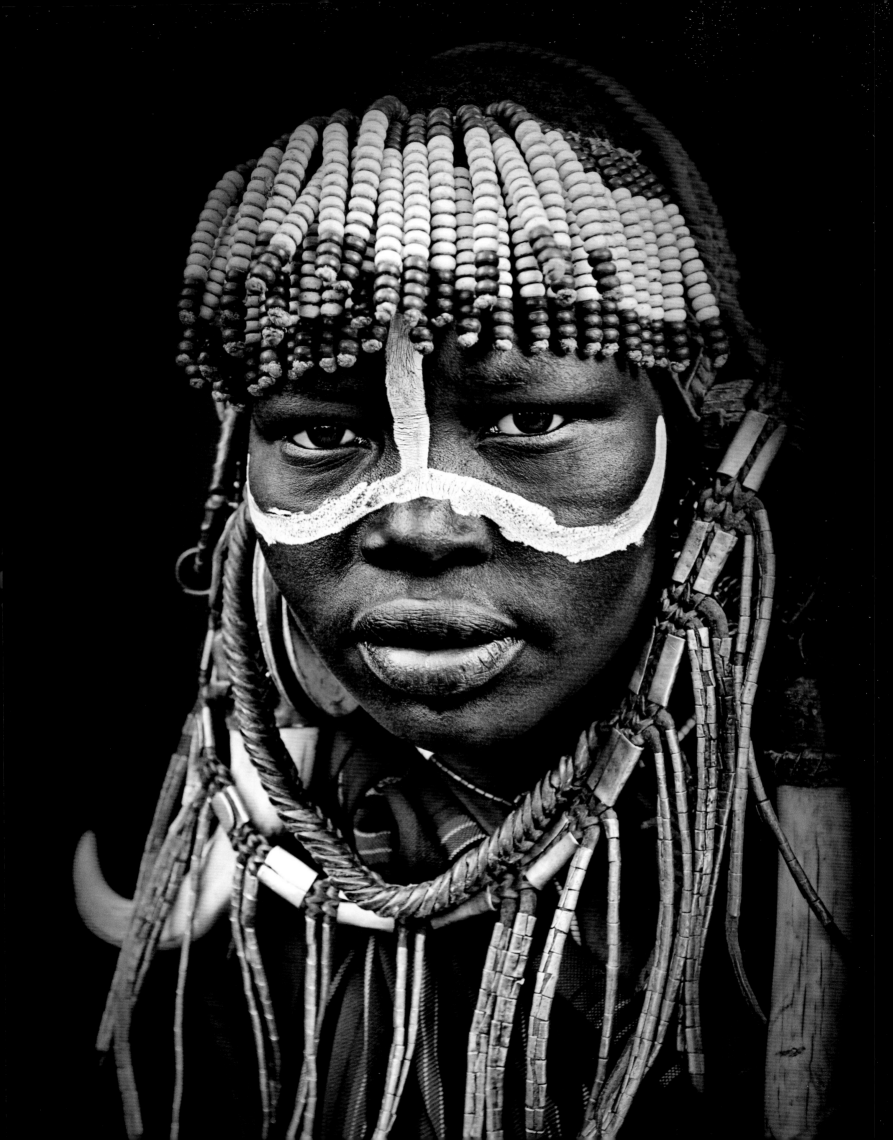

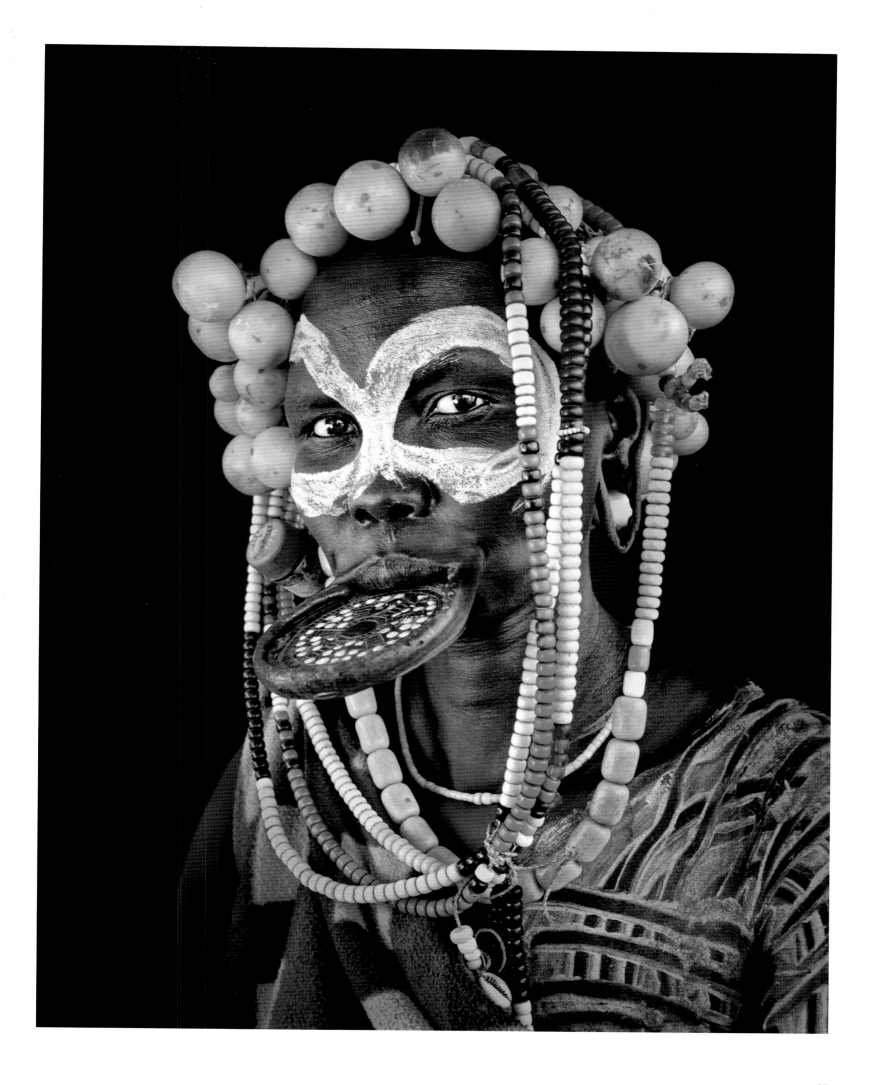

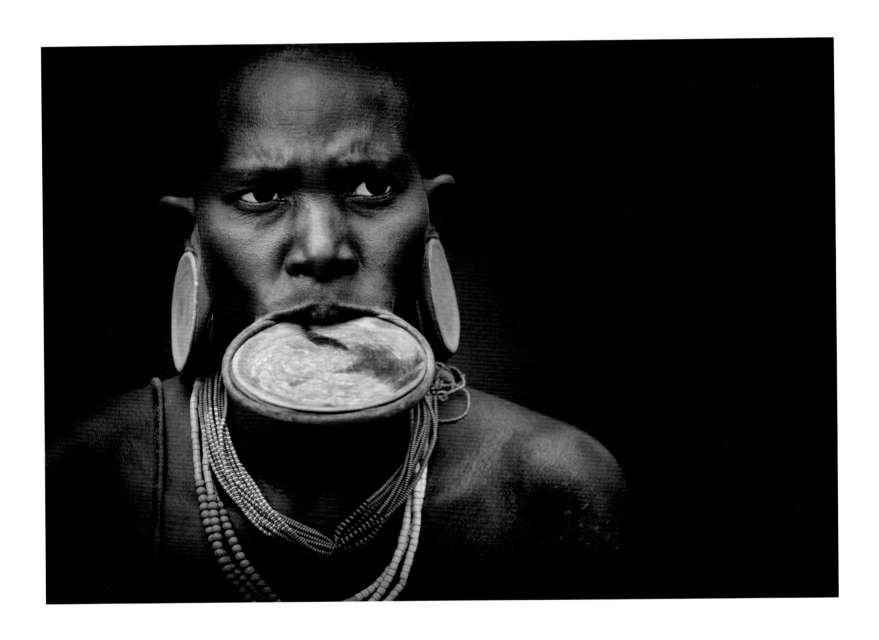

Right:
Though teeth may be lost to old age, this elder demonstrates that the teeth of others—those of animals a person has slain over their lifetime—can continue to testify to the wearer's past prowess and bravery.

Rechts:
Auch wenn man im Alter ein paar Zähne verlieren mag ... Dieser Mursi-Stammesältere sammelt die Zähne erlegter Tiere als Beweis für seine frühere jugendliche Kraft und Dominanz.

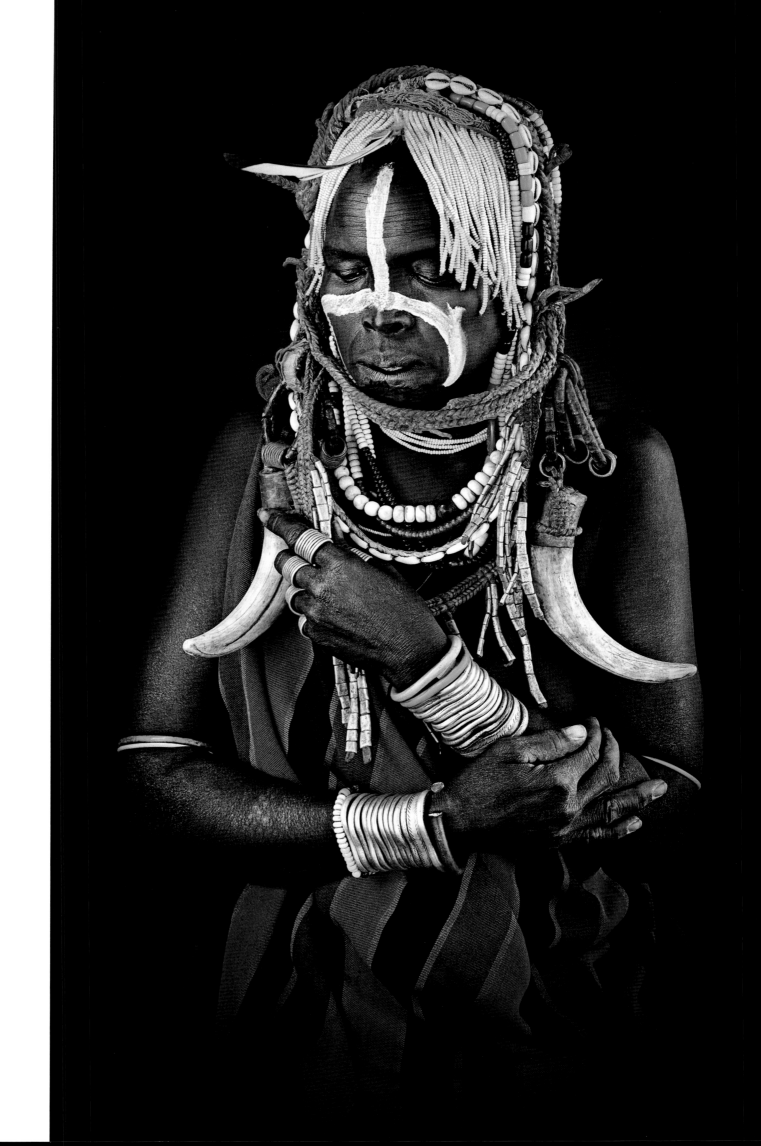

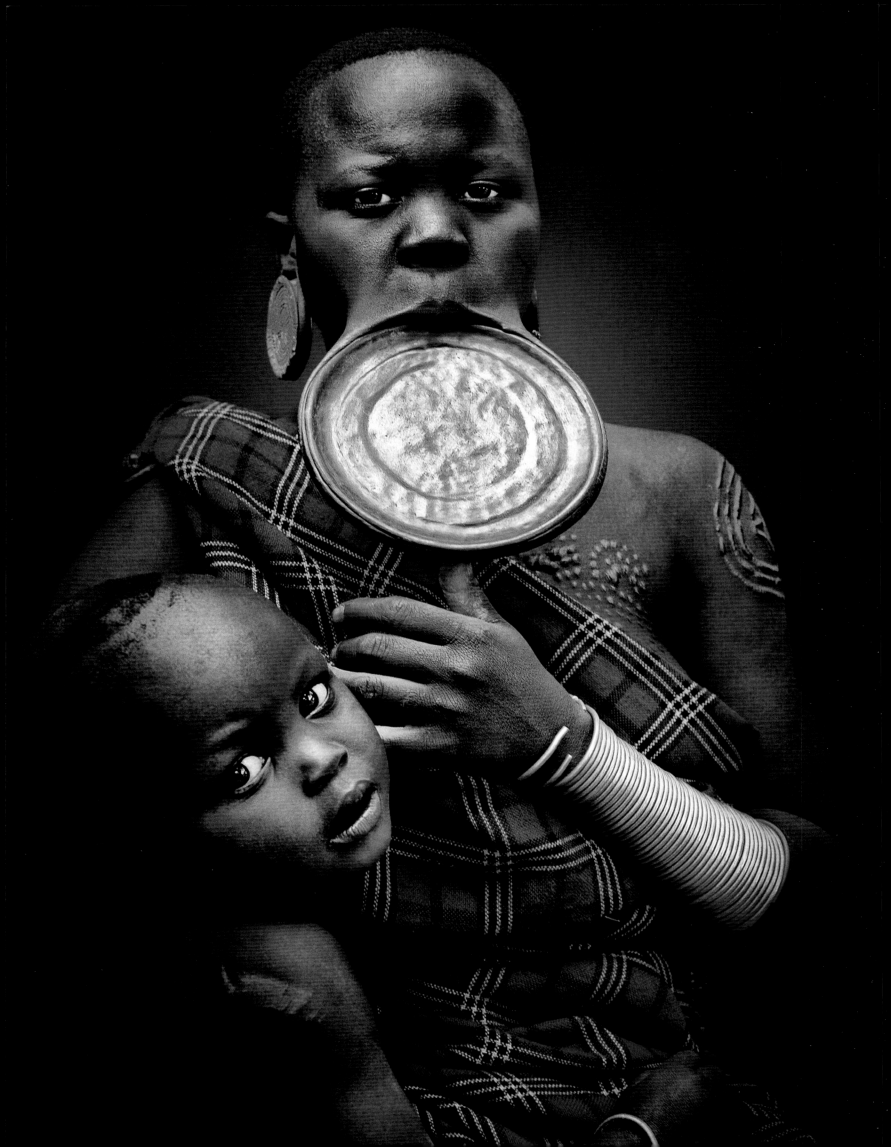

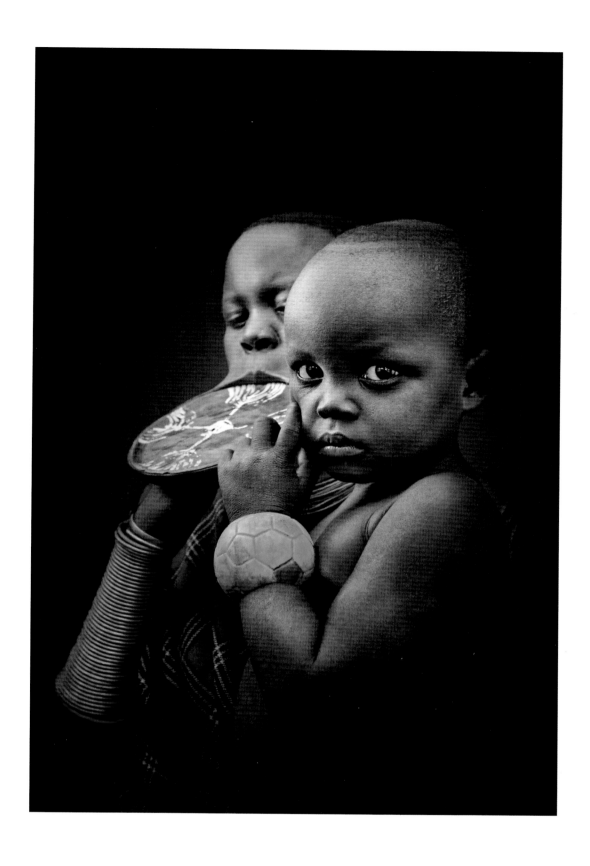

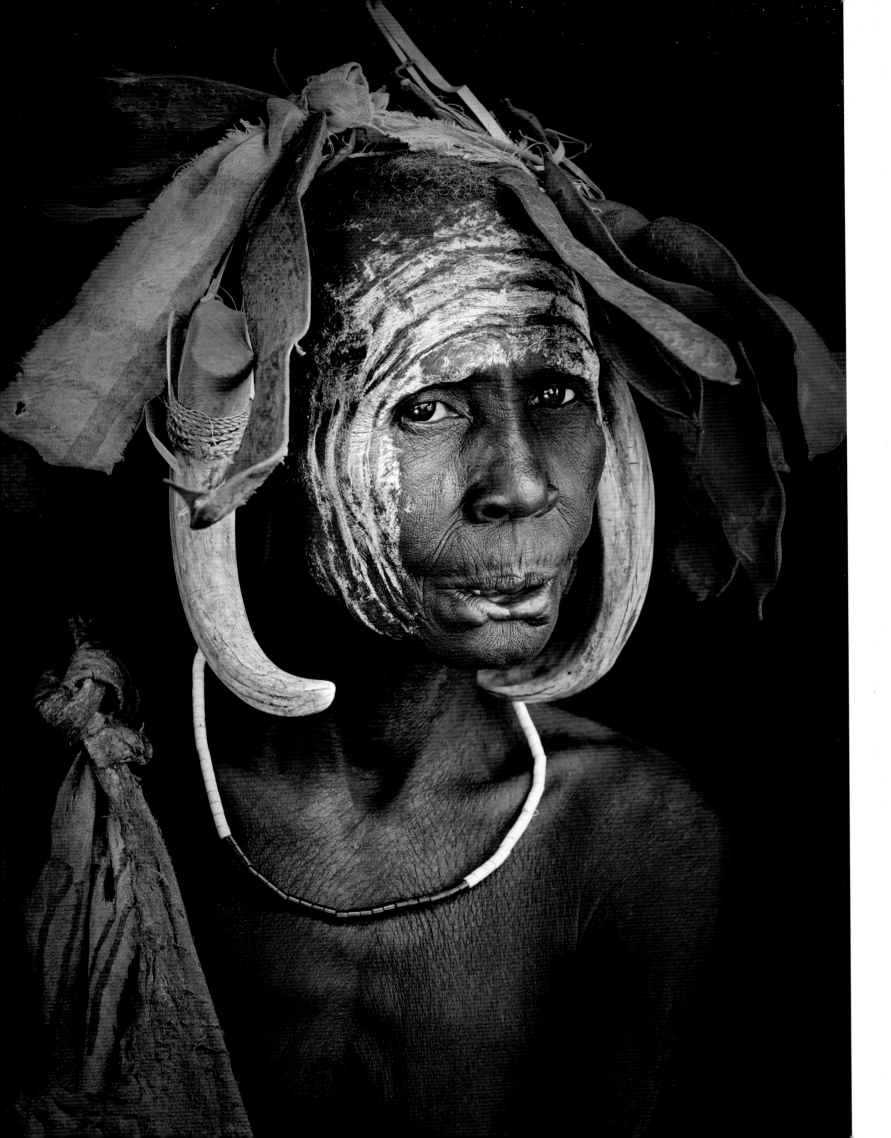

It's the norm in societies across the world for older generations to hold relatively conservative attitudes and for younger people to be more receptive to new styles and novelty. In Surma and Mursi tradition alike the face and body are painted only in black and white, and clothing and jewellery are similarly minimalist, which is why we see the marked difference in style in these photographs between older and younger members of these groups.

In vielen Gesellschaften der Welt haben die älteren Generationen konservativere Ansichten, während Jüngere neue Ideen und Stile bereitwilliger aufnehmen. In der Tradition der Surma und Mursi wurden Gesicht und Körper nur in schwarz und weiß bemalt, und Klamotten und Schmuck sind ebenso minimalistisch. Deshalb sehen wir einen deutlichen Unterschied zwischen Fotografien von älteren und jüngeren Stammesmitgliedern.

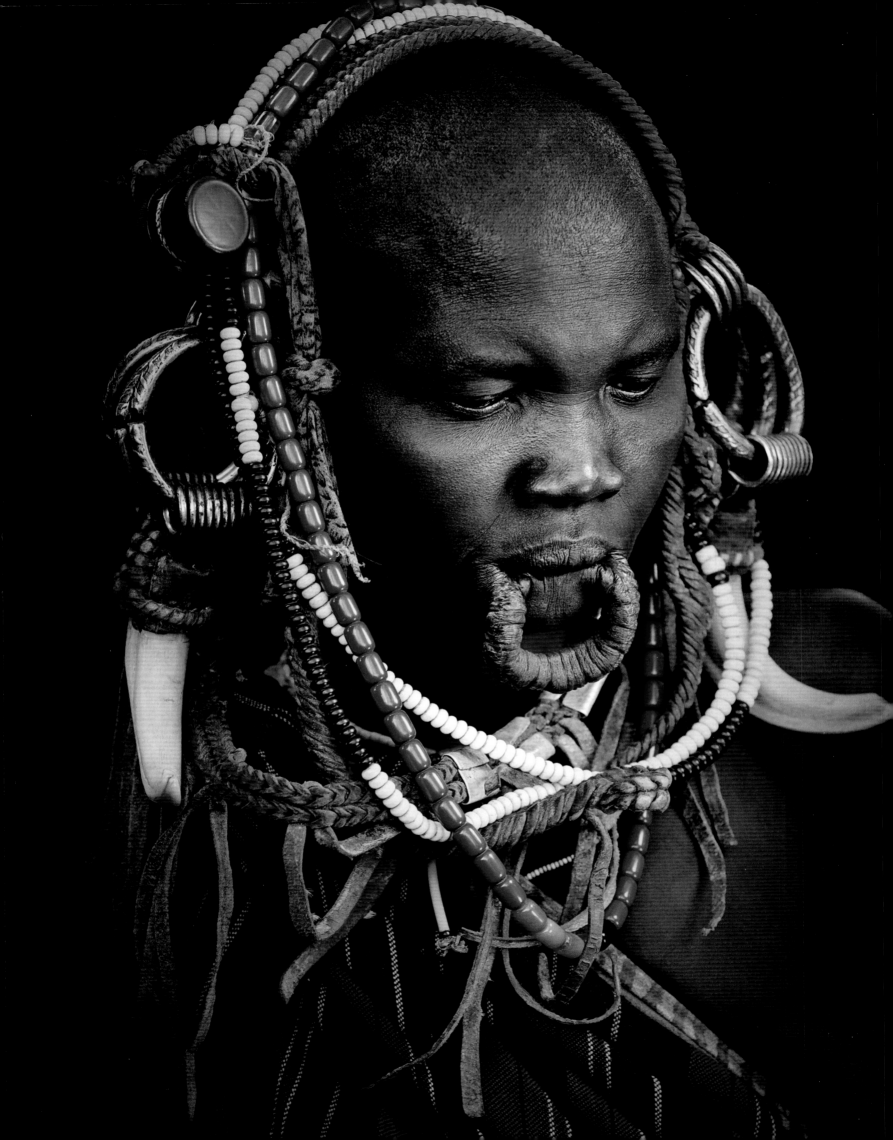

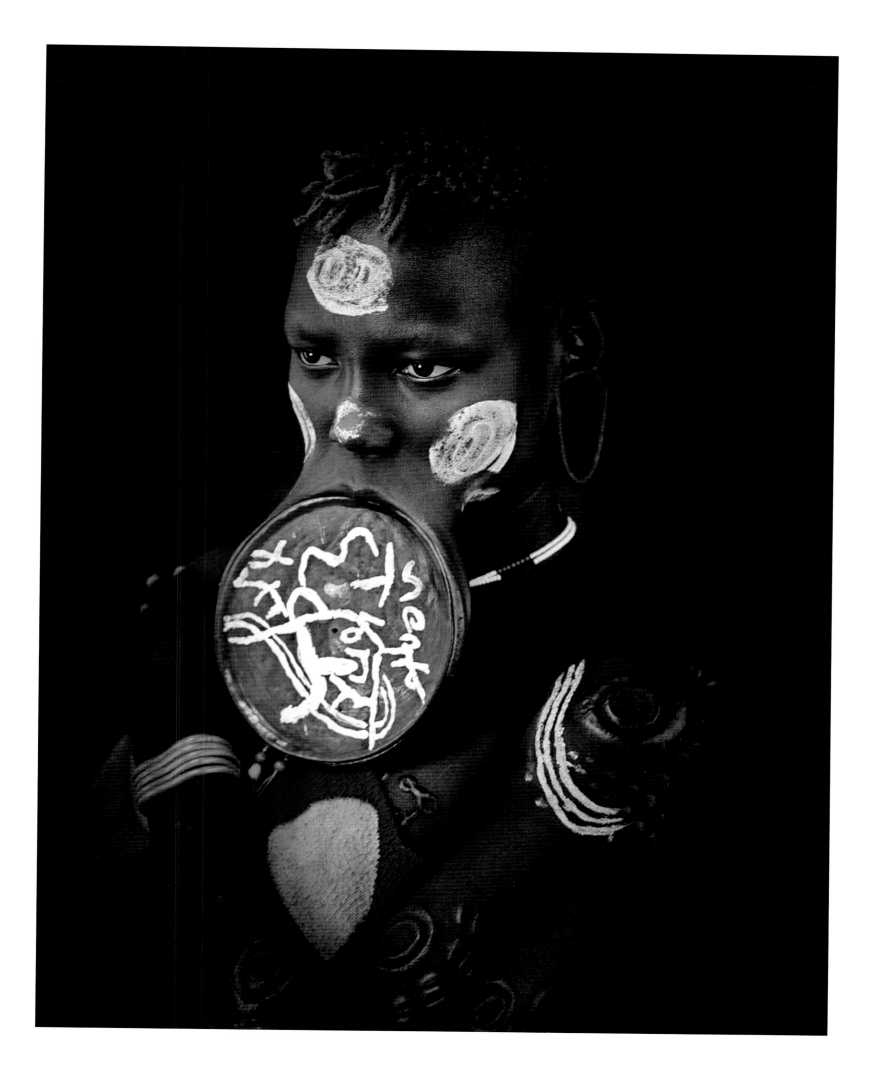

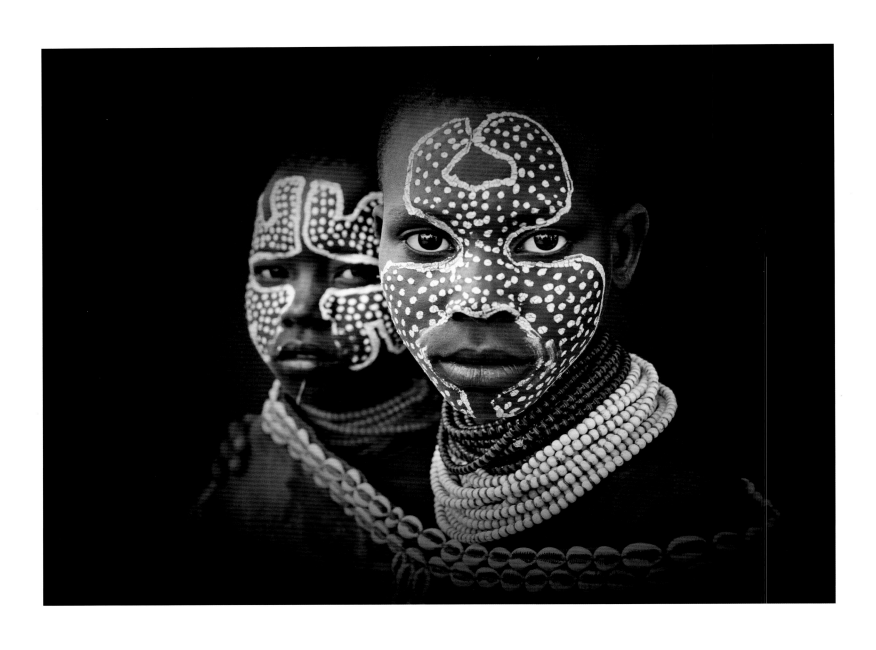

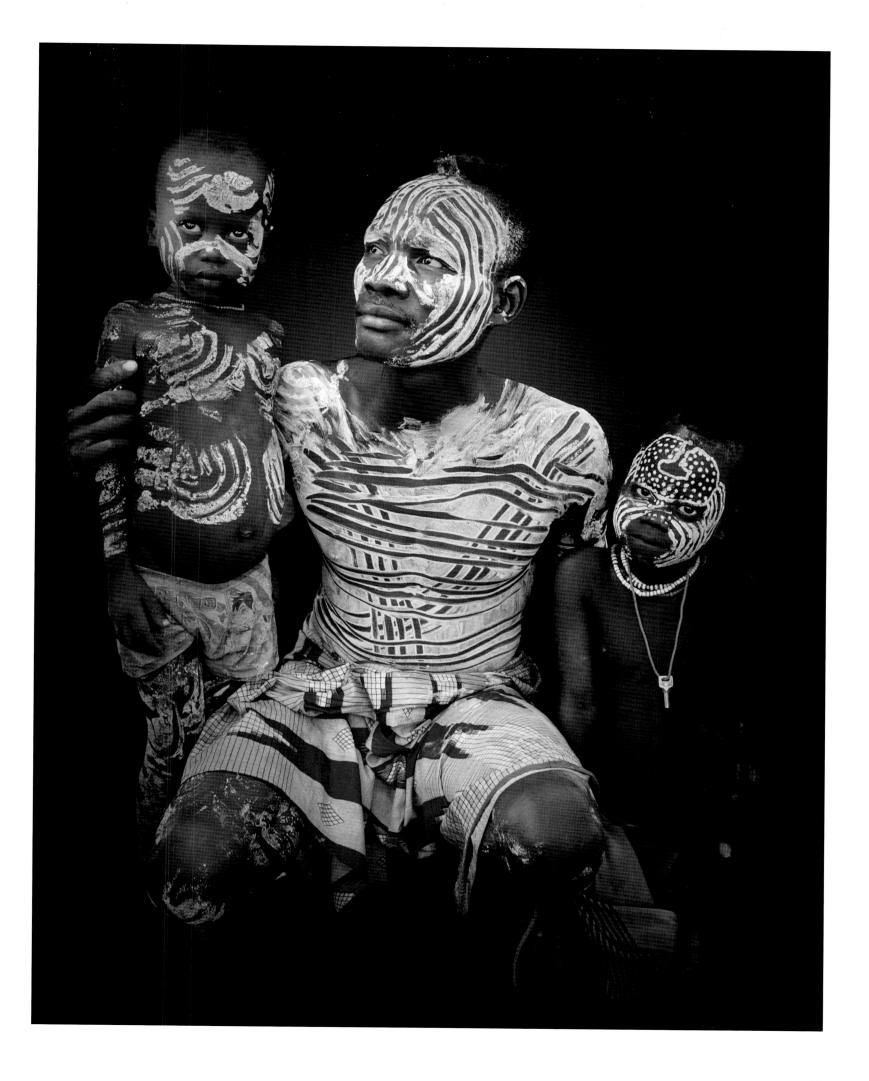

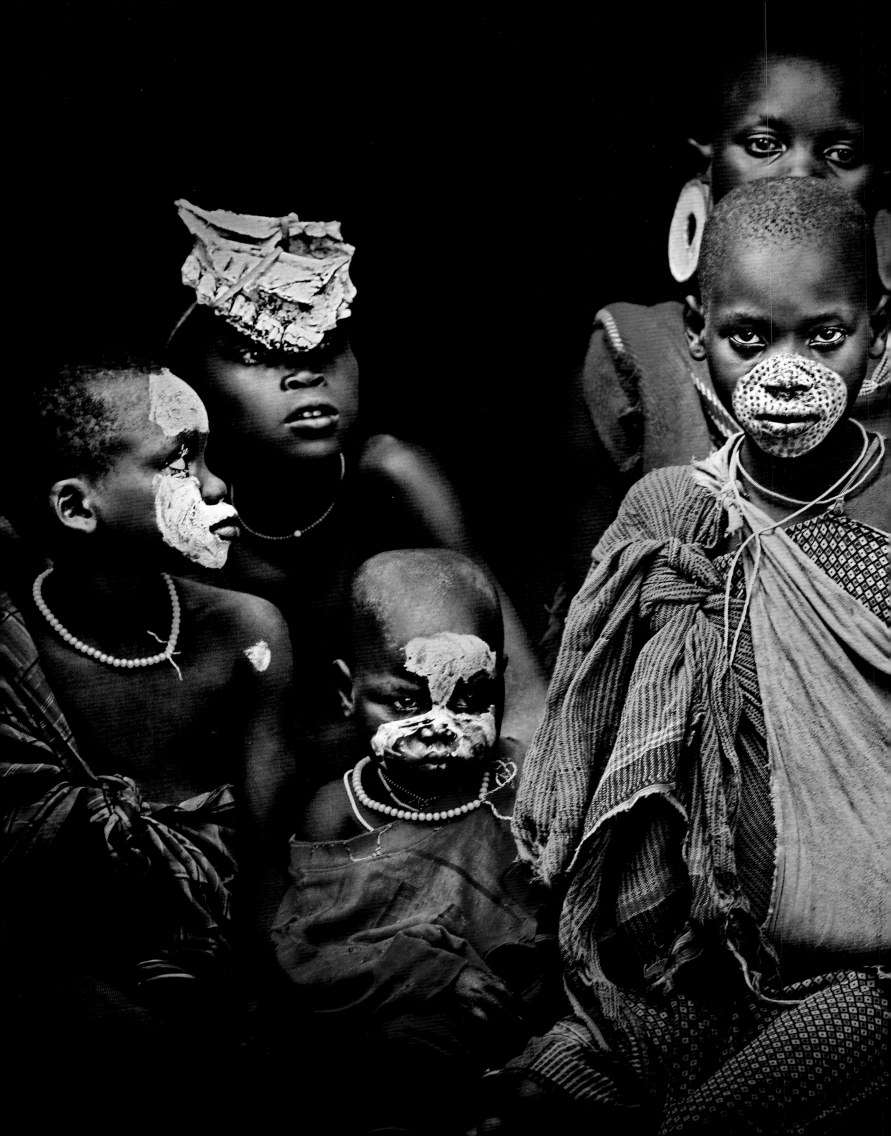

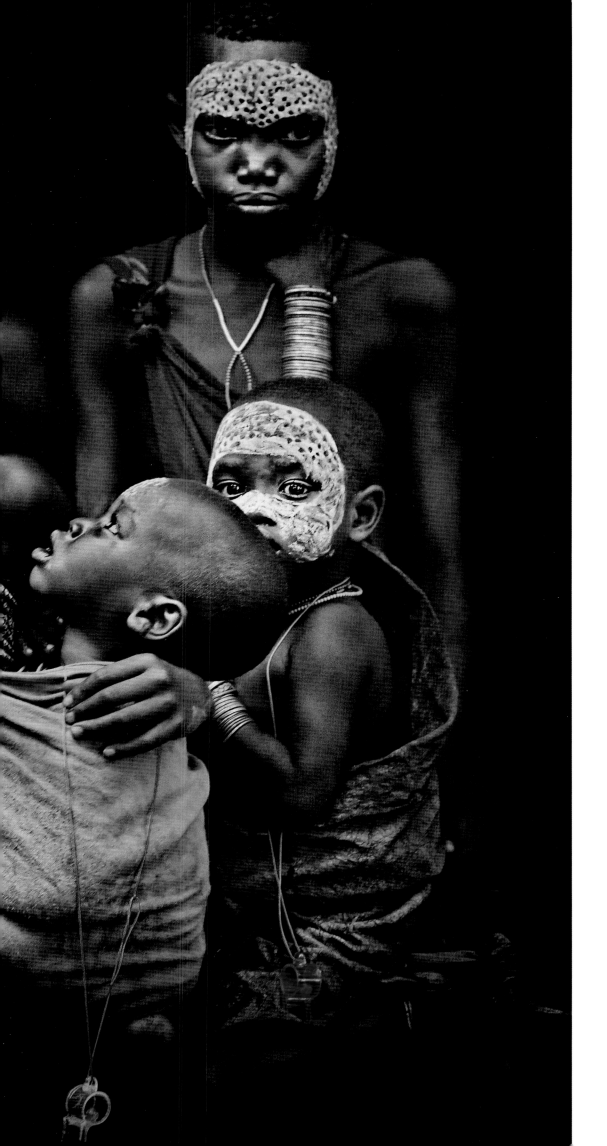

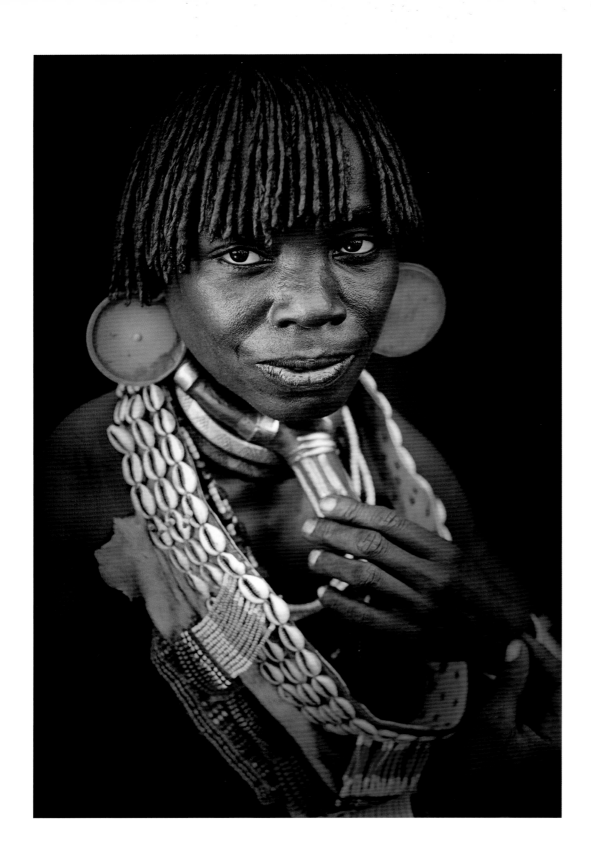

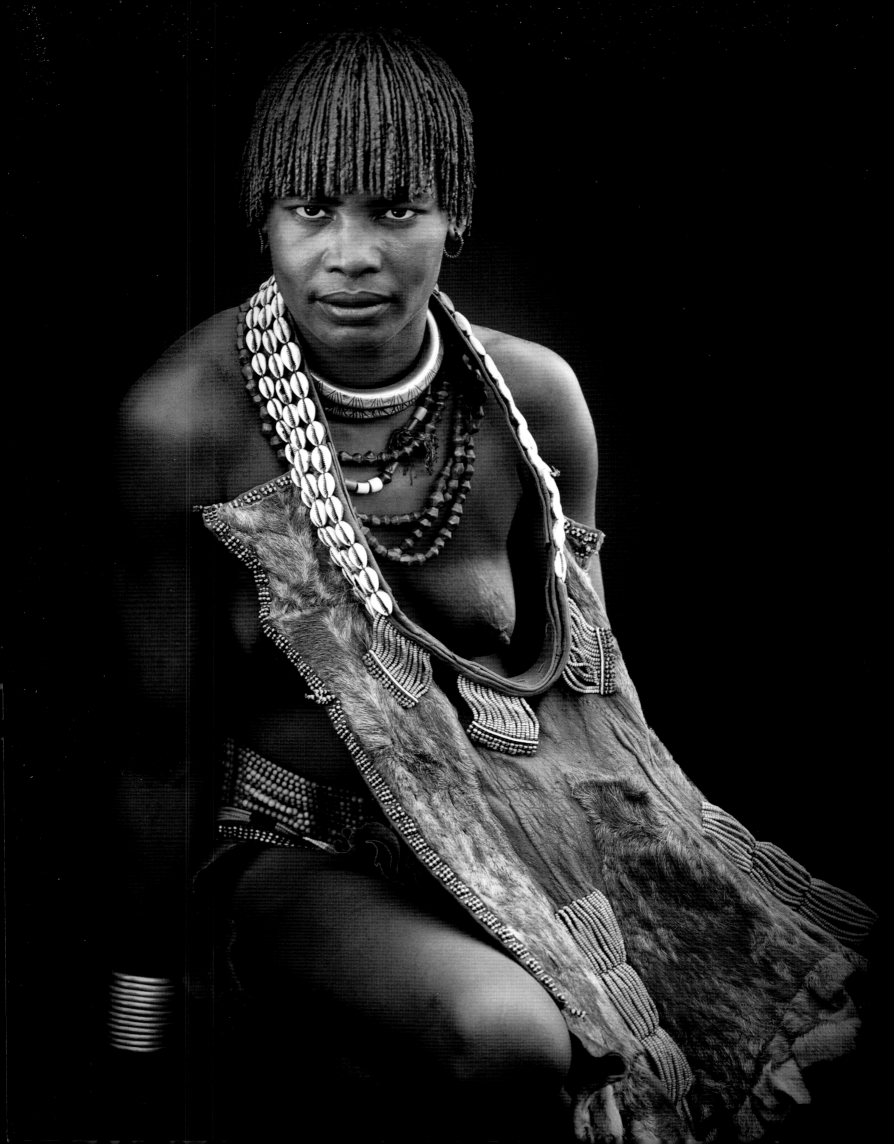

A conversation with a Mursi girl:

"Do you know your age?"

"I am 19."

"Why did you dye your hair?"

"I saw the hair dye at the Ari market and I decided that changing myself is also good."

"And why did you select such a bright hair color?"

"I want people to see me at the disco. I like modern music but I do not know how to dance. And this way it is easy to see me, even when I am standing away from the dance floor."

"Why don't you wear the disc in your lip, like the others do?"

"Well, I don't like it, that's why. I have beautiful ears and I have nice tattoos. That's enough."

"And what do you need your telephone for?"

"I can call my friends from the disco."

Unterhaltung mit einer jungen Mursi-Frau:

„Weißt du, wie alt du bist?"

„Ich bin 19."

„Warum hast du deine Haare gefärbt?"

„Ich hab die Färbung auf dem Ari-Markt gesehen und dachte, eine Veränderung wäre nicht schlecht."

„Und warum hast du so eine helle, intensive Farbe gewählt?"

„Ich wollte, dass die Leute mich in der Disko besser sehen. Ich mag moderne Musik, aber ich kann nicht gut tanzen. Jetzt sieht man mich besser, auch wenn ich nicht auf der Tanzfläche bin."

„Warum hast du keinen Lippenteller wie die anderen?"

„Weil ich sie nicht mag, darum. Ich habe schöne Ohren und tolle Tattoos. Das reicht doch."

„Was machst du mit deinem Handy?"

„Meine Freunde aus der Disko anrufen."

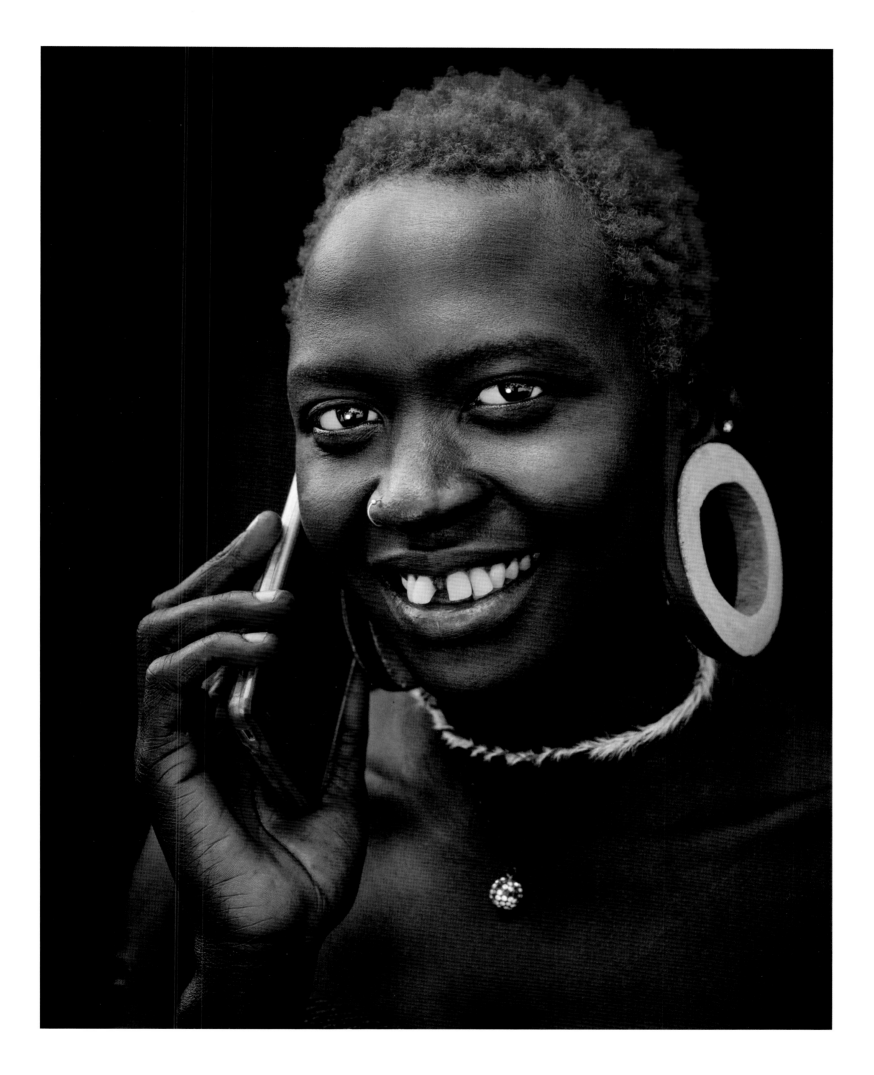

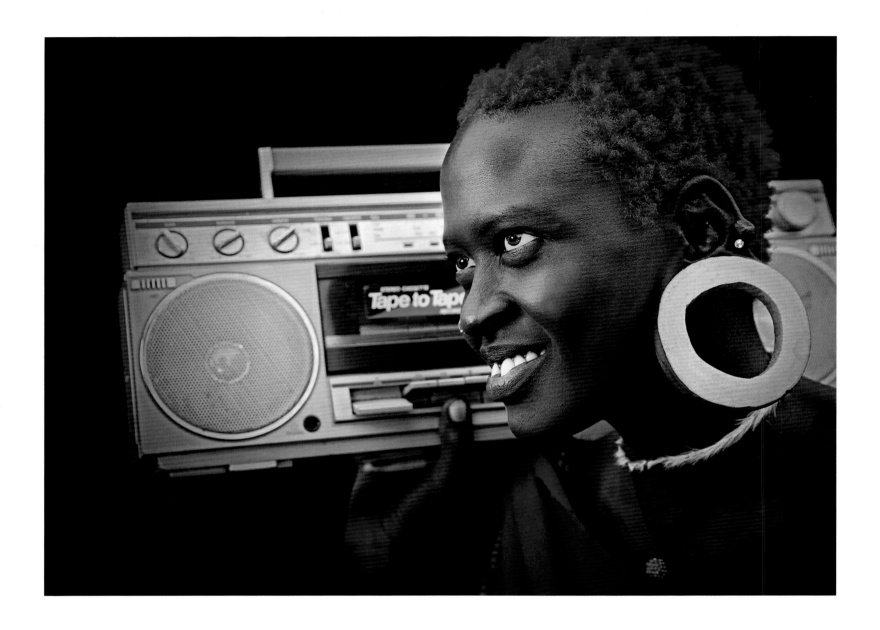

One of music's most fundamental functions is to bring people together across both time and space. One way that it does so is by adapting old forms and thereby preserving them. It is a common thread running through all peoples and cultures since prehistoric times: rudimentary flutes have been found that date to at least 41,000 years ago, and song itself certainly long predates the invention of instruments. Also modern Mursi music is often based on well-known traditional themes and motifs. This photograph illustrates music's ability to transform over time yet even in different forms and shapes to remain a human constant.

Eine der grundlegendsten Funktionen der Musik ist es, Menschen über Zeit und Raum hinweg zu verbinden. Eine Möglichkeit, dies zu erreichen, besteht darin, alte Melodien zu adaptieren und dadurch zu bewahren. Musik zieht sich wie ein roter Faden durch alle Völker und Kulturen seit prähistorischen Zeiten: Bei Ausgrabungen wurden rudimentäre Flöten gefunden, die mindestens 41.000 Jahre alt sind, und der Gesang selbst ist sicherlich lange vor der Erfindung der Instrumente entstanden. Auch die moderne Mursi-Musik basiert oft auf bekannten traditionellen Motiven. Dieses Foto veranschaulicht die Fähigkeit der Musik, sich im Laufe der Zeit zu verwandeln und trotzdem eine menschliche Konstante zu bleiben.

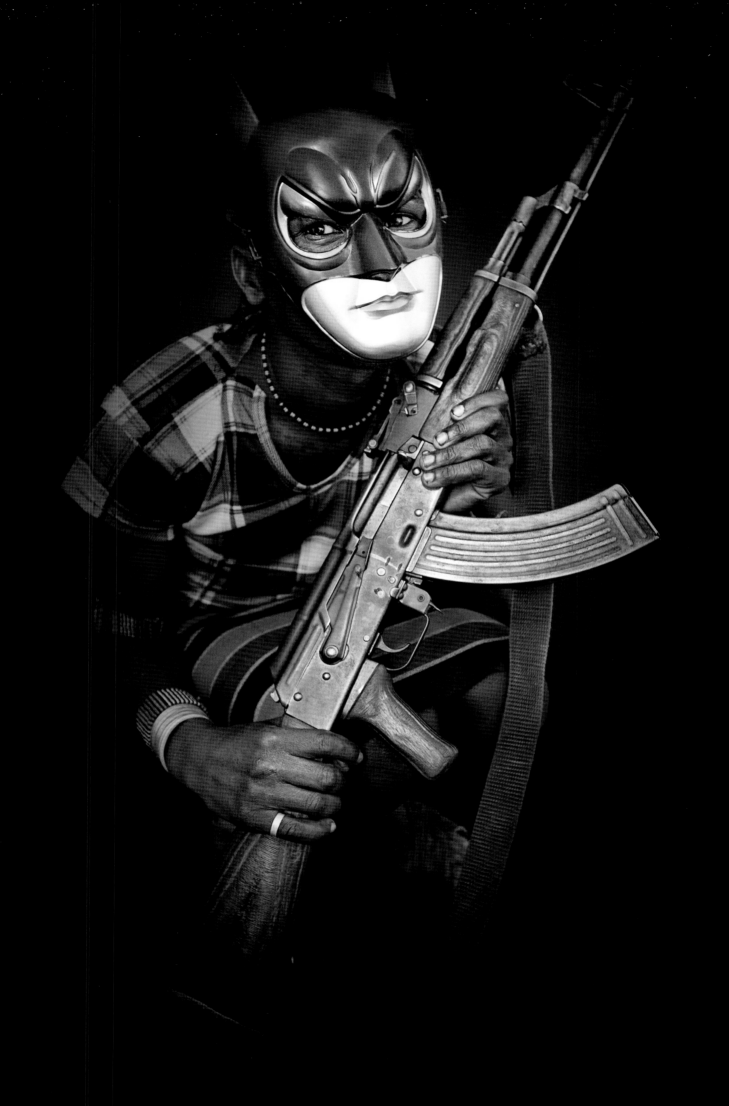

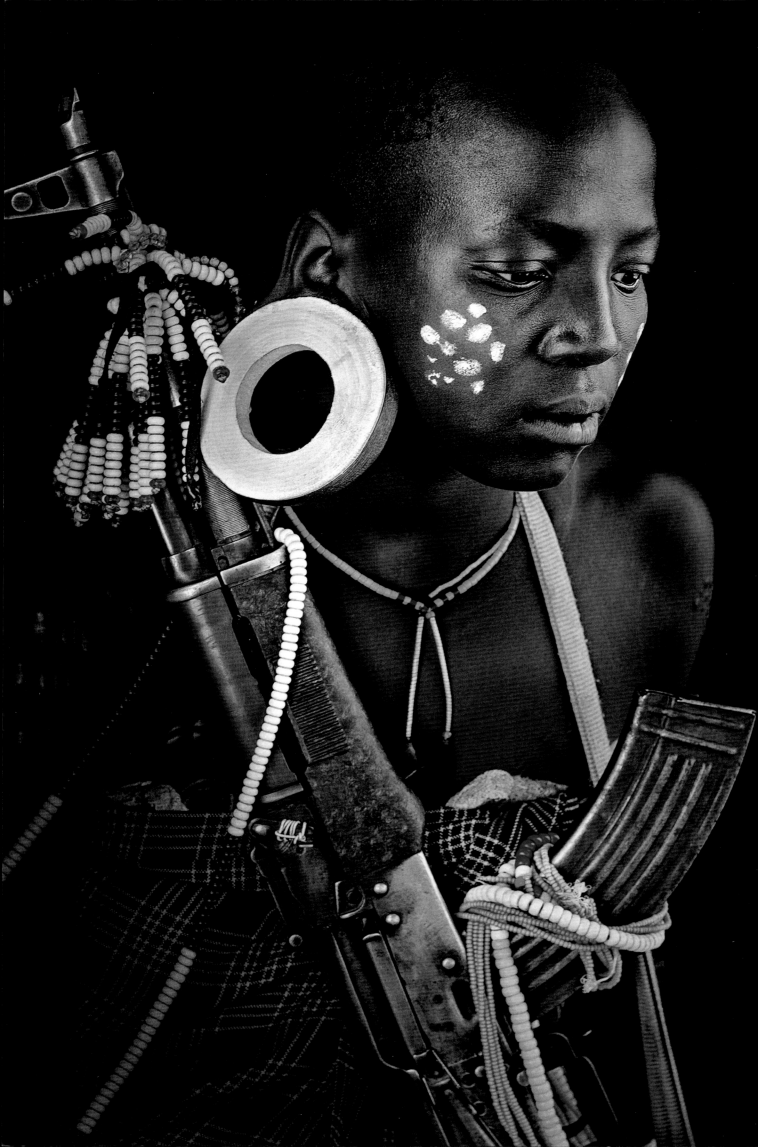

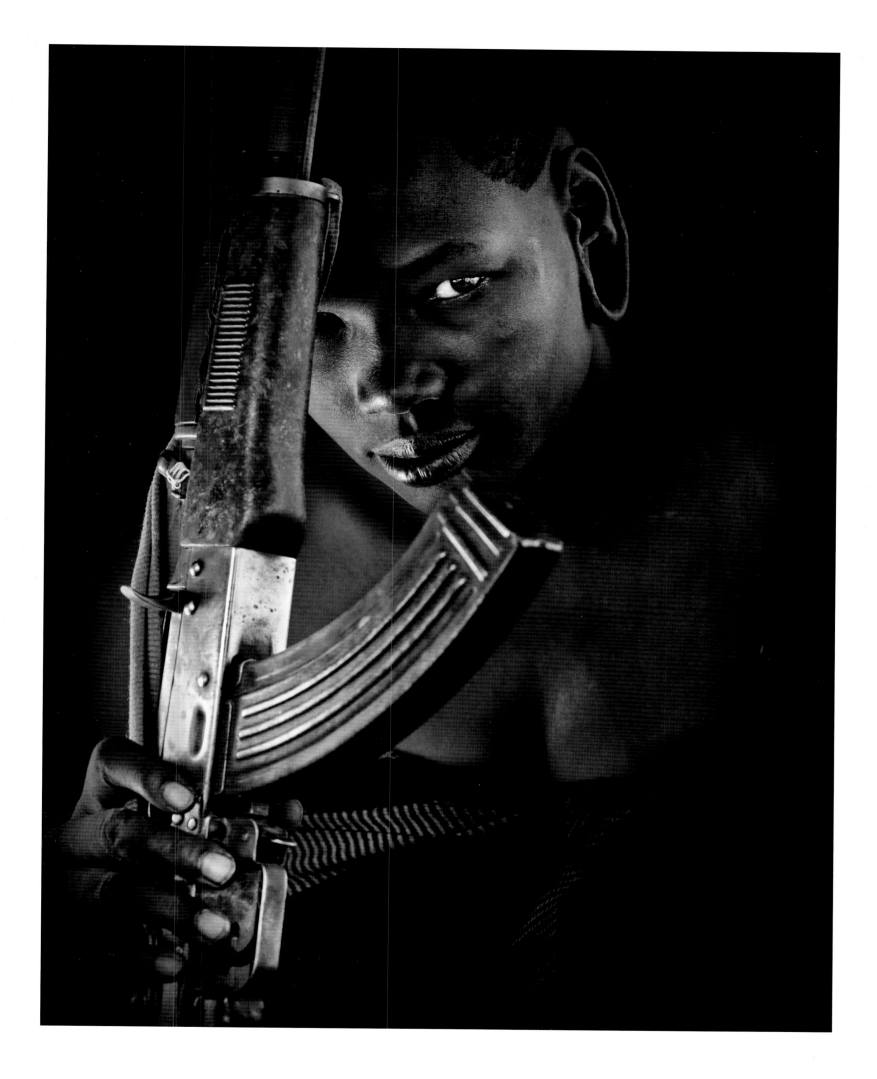

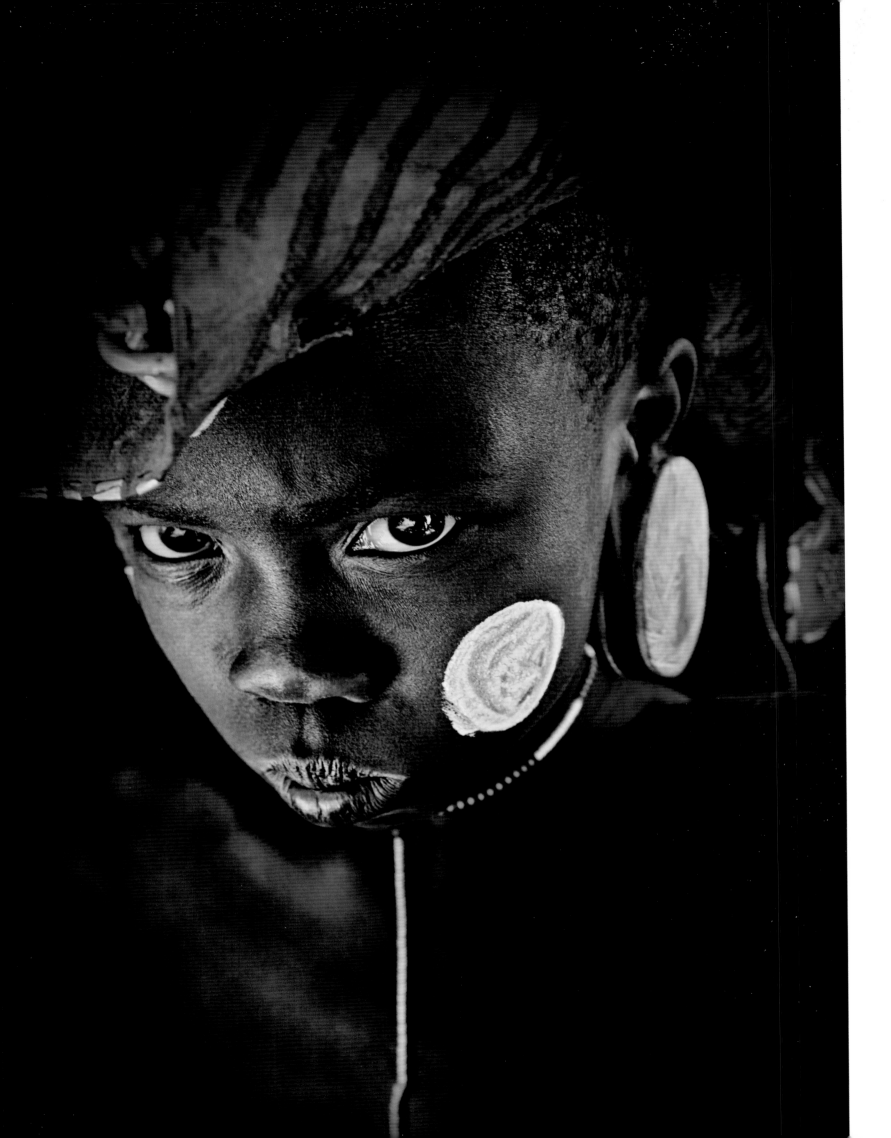

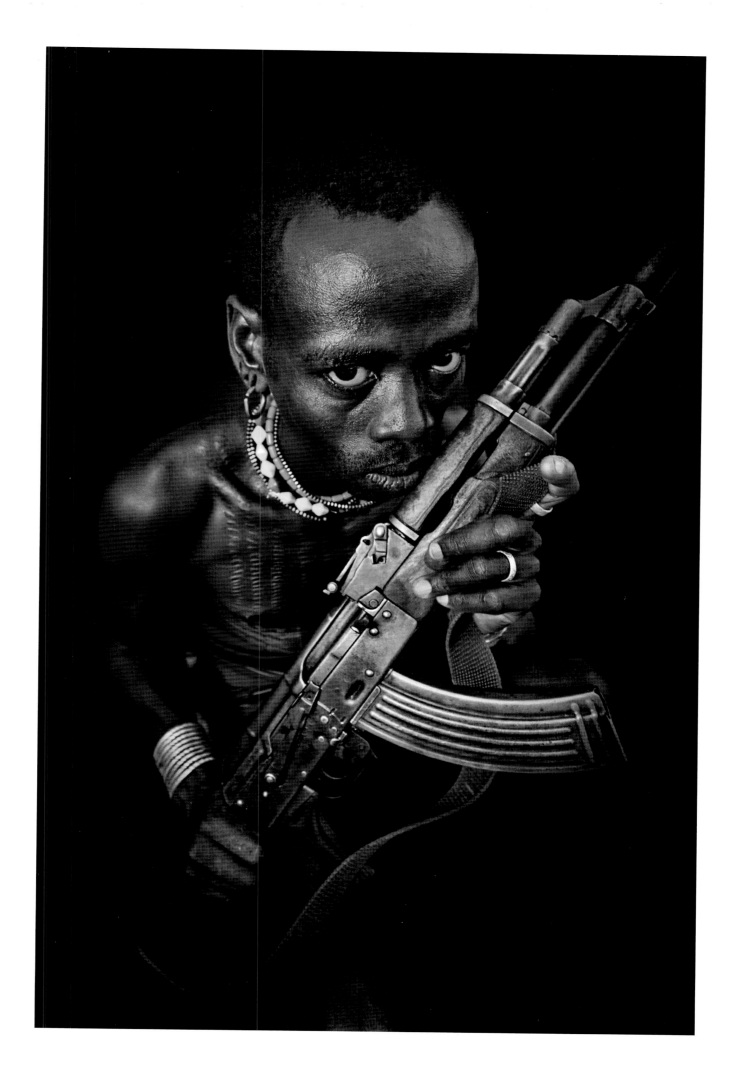

The history of jewelry is virtually as long as that of humanity itself, with remains having been found indicating that Neanderthals too decorated and adorned themselves with various types of object. But since Homo sapiens are usually thought to have originated in Africa it may be that human jewelry first appeared here. The African tradition to this day continues to inspire designers all over the world, who see unique appeal in its use of natural elements such as seashells, feathers, beads and stones. On the other hand, many Africans now adorn themselves with manufactured objects that we in the West would consider mere detritus: padlocks, nails, door handles, the spare parts of disposable plastic pens.

Following page on the left:

There is perhaps no bond more universal across world cultures than that between a mother and her child. Here we see visual echoes of the Western Madonna tradition of which Raphael's *Sistine Madonna* is a famous example.

Rechts:

Die Geschichte des Schmucks ist wohl so alt wie die Geschichte der Menschheit, denn Fundstücke zeigen, dass auch die Neandertaler sich mit verschiedenen Accessoires schmückten; Da der Homo sapiens vermutlich aus Afrika kam, gab es hier vielleicht auch den ersten Schmuck der Welt. Afrikanische Traditionen inspirieren Schmuckdesigner auf der ganzen Welt auch heute noch, vor allem was natürliche Elemente wie Muscheln, Federn, Perlen und Steine angeht. Ironischerweise schmücken sich viele Afrikaner inzwischen mit künstlichen Objekten, die wir im Westen als Abfall betrachten würden: Schlösser, Nägel, Türklinken, die Plastikdeckel von Kugelschreibern.

Folgende Seite links:

Es gibt vielleicht keine universellere Bindung zwischen den Kulturen der Welt als die zwischen einer Mutter und ihrem Kind. Hier sehen wir visuelle Anklänge an die westliche Madonnentradition, für die Raffaels *Sixtinische Madonna* ein berühmtes Beispiel ist.

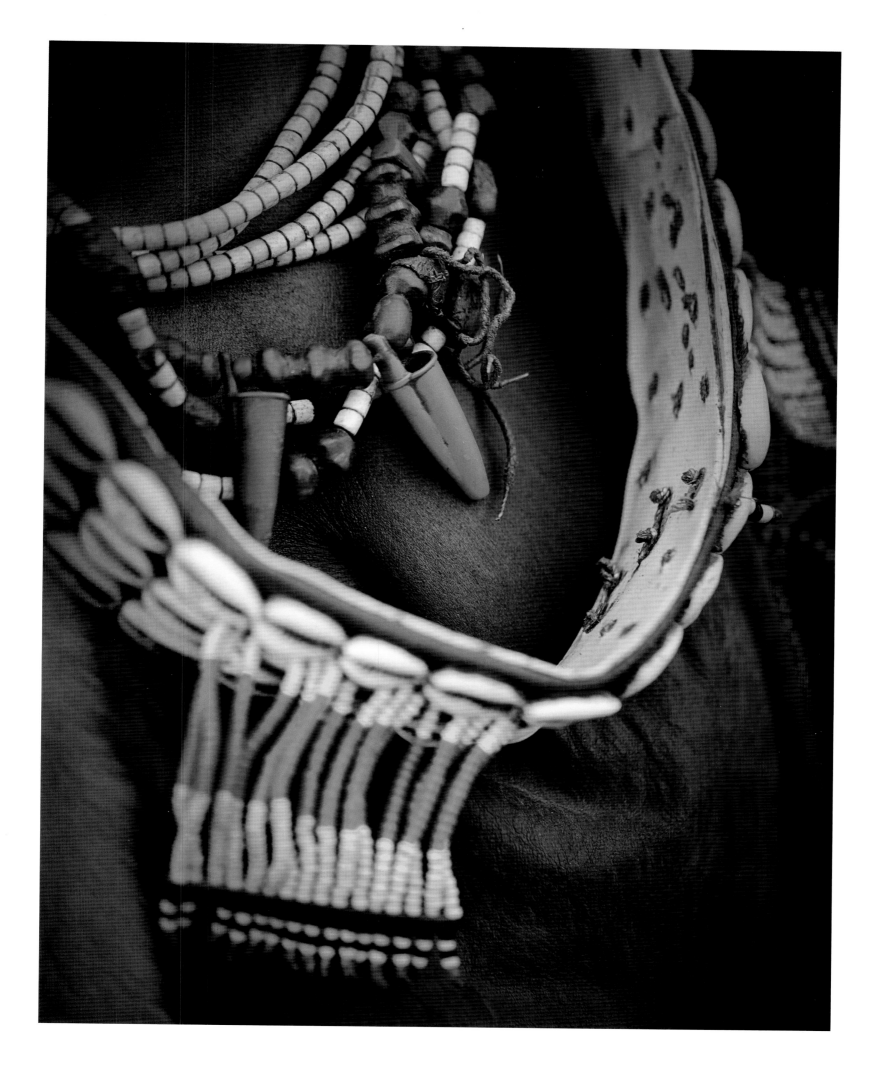

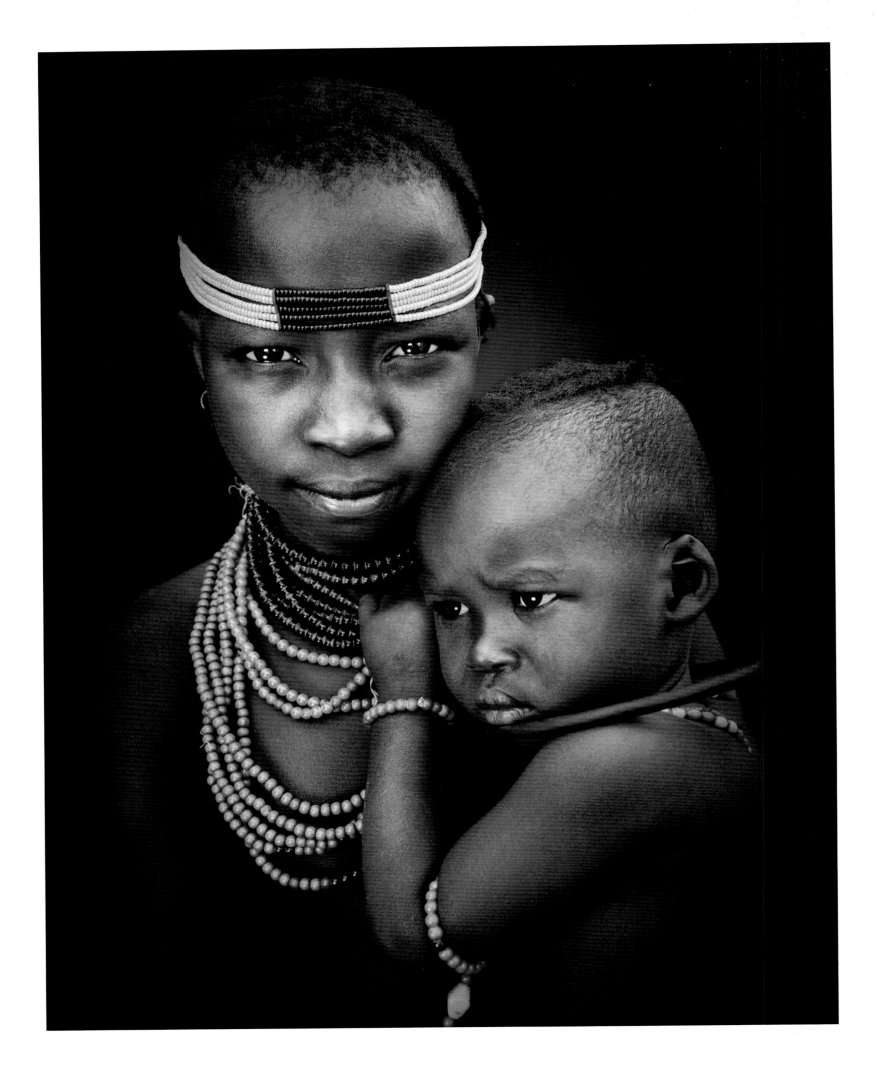

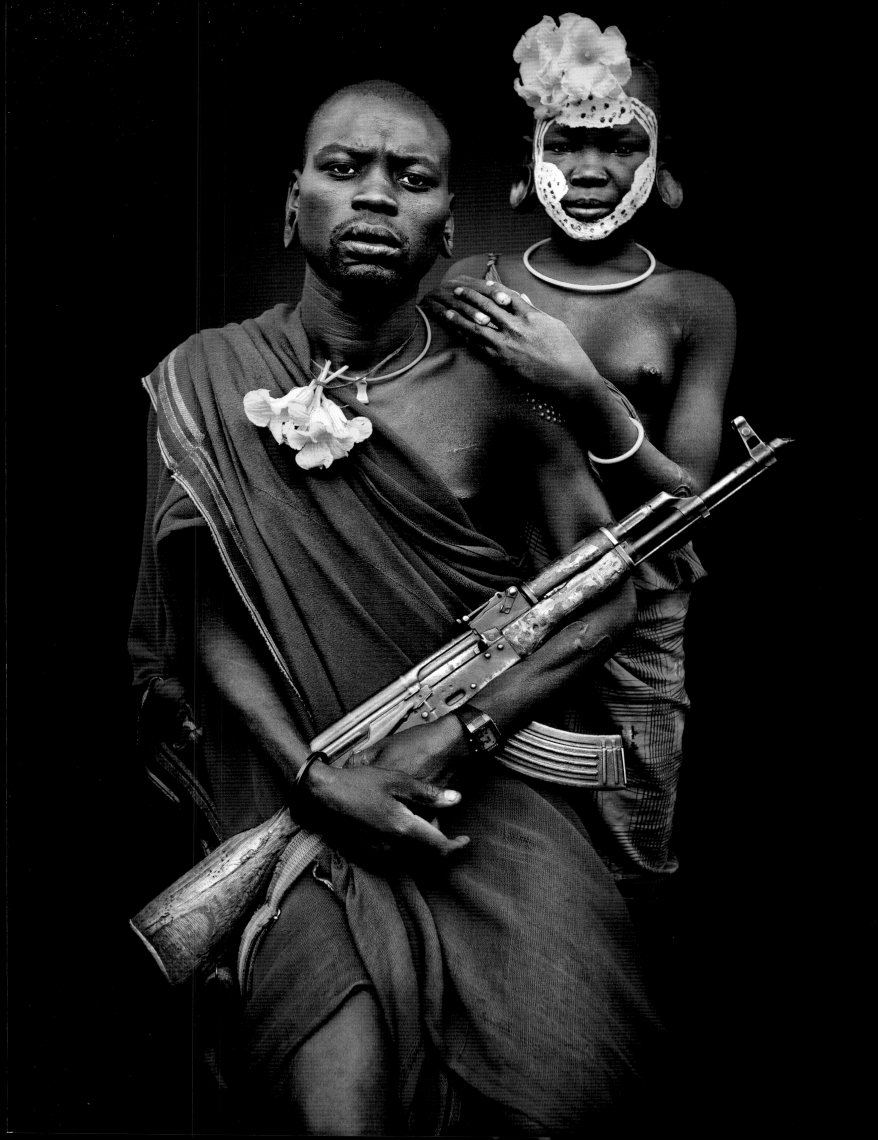

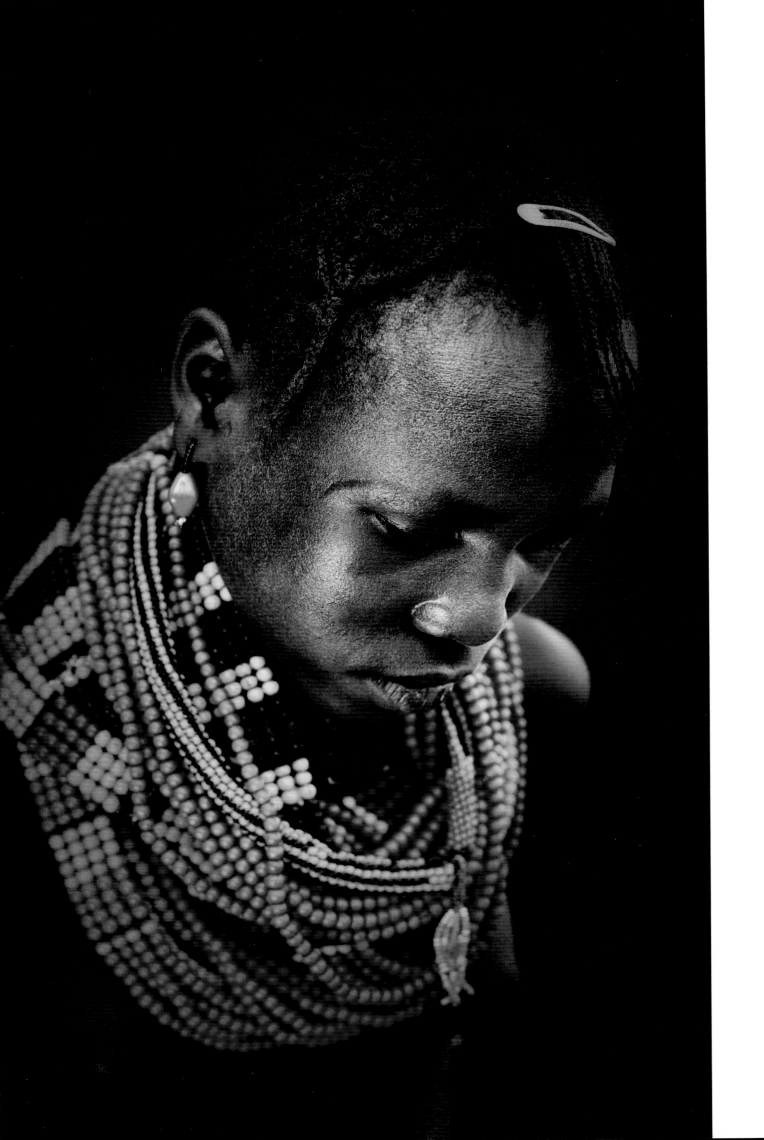

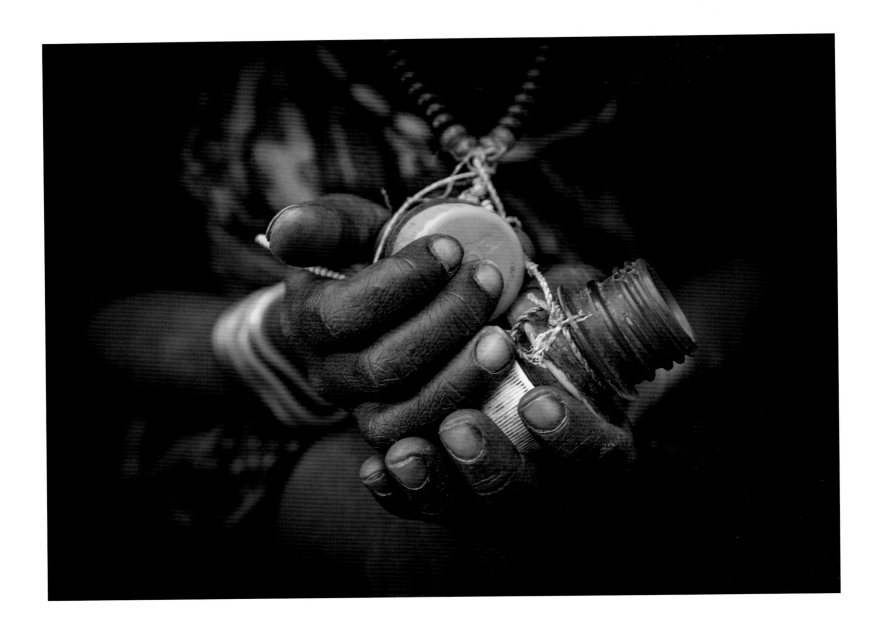

Top:

I asked a Mursi girl who appeared to be ten or eleven years of age if she would show me her prized possessions: those that she considered most fascinating, valuable and rare. Here's what she showed me, cupped in her small hands.

Right:

In the Omo Valley traditional weapons such as spears have to a significant degree been replaced by AK-47s (this is a common pattern throughout recent history across in many remote regions of the globe). The prestige that attaches to these weapons can be gauged from their high exchange values, with one gun often worth several cows.

Oben:

Ich bat ein Mursi-Mädchen, das vielleicht zehn oder elf Jahre alt war, ob es mir die Gegenstände zeigen könnte, die ihm am wichtigsten sind — Gegenstände, die es für besonders faszinierend, wertvoll oder selten hält. Sie zeigte mir das, was sie hier auf dem Bild in den Händen hält.

Rechts:

Im Omo-Tal sind traditionelle Waffen wie Speere in erheblichem Maße durch AK-47 ersetzt worden. Dieses Muster zeigt sich in der jüngeren Geschichte in vielen abgelegenen Regionen der Welt. Das Prestige, das mit diesen Waffen verbunden ist, lässt sich an ihrem hohen Tauschwert ablesen: Eine Waffe ist oft mehrere Kühe wert.

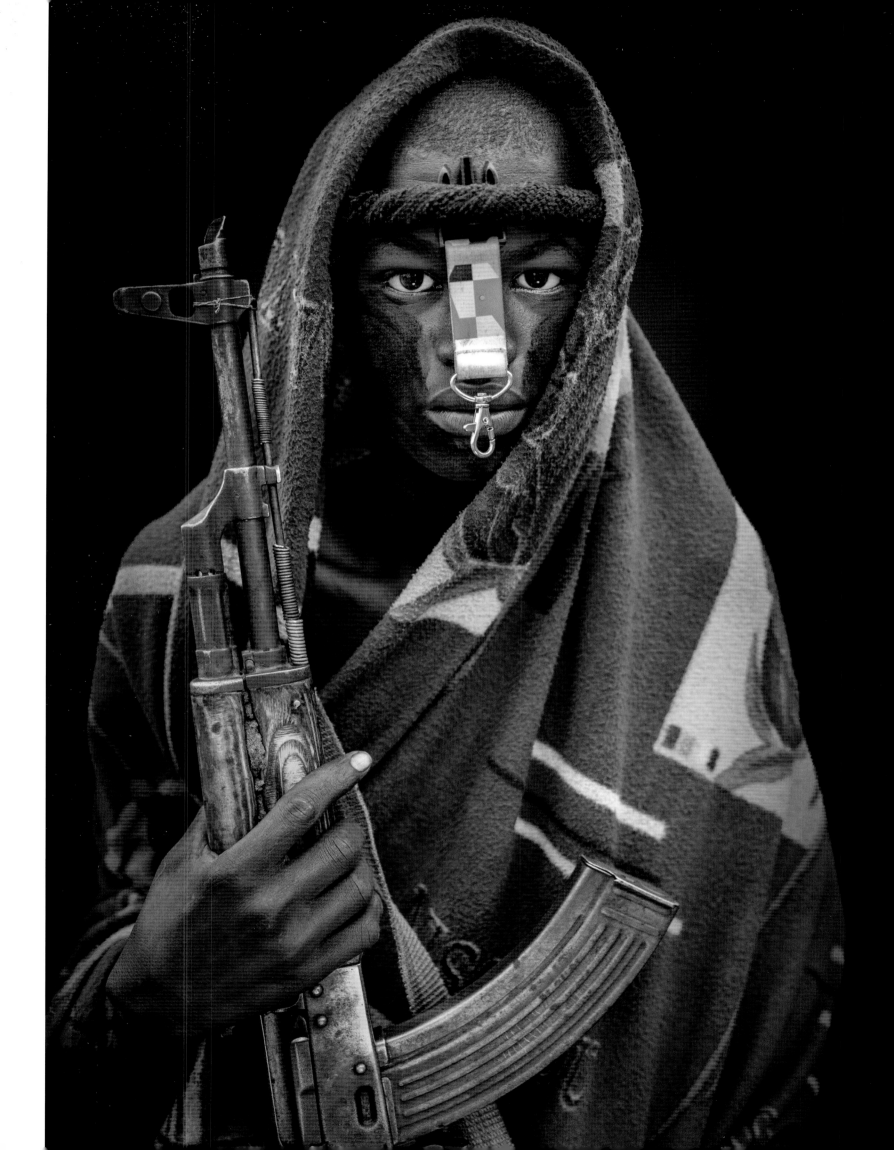

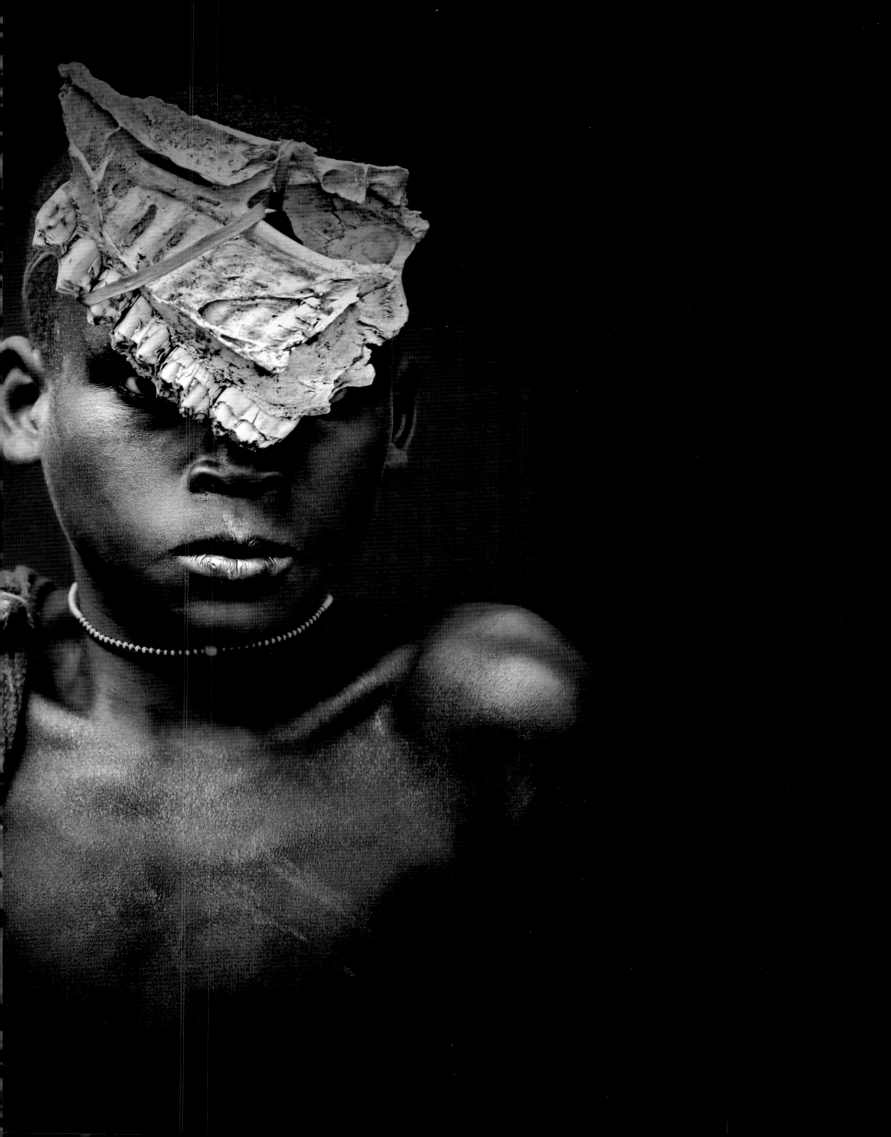

It's said that there are as many definitions of beauty as there are people in the world. In Western cultures we do not generally consider scars to be an attractive feature, and will often attempt to conceal them. But for a number of groups in the Omo Valley and across Africa elaborate and extensive patterns of scarification are deemed highly beautiful.

Man sagt, dass es so viele unterschiedliche Definitionen von Schönheit wie Völker auf der Erde gibt. In der westlichen Kultur gelten Narben meist als unattraktiv, und man versucht, sie zu verstecken. Doch für viele Völker im Omo-Tal und in ganz Afrika sind filigrane, großflächige Muster aus Narbengewebe überaus schön.

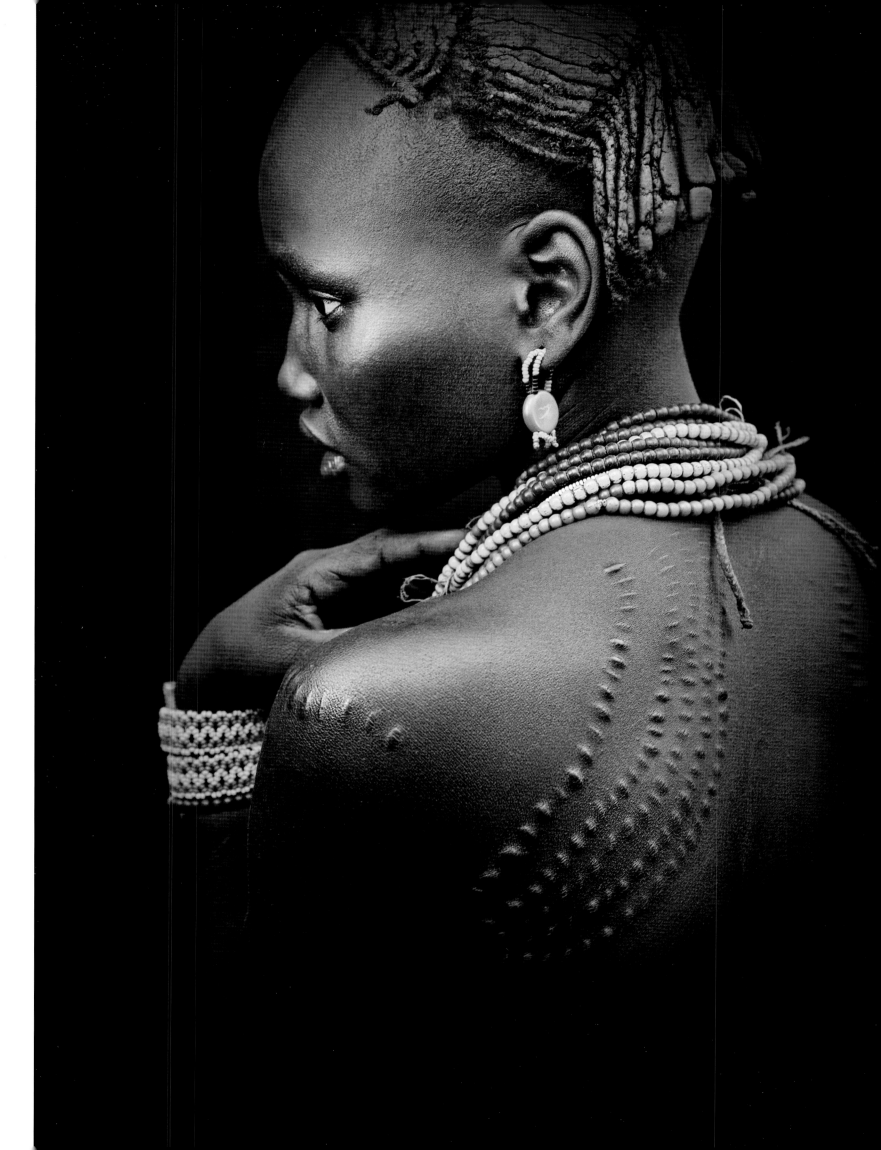

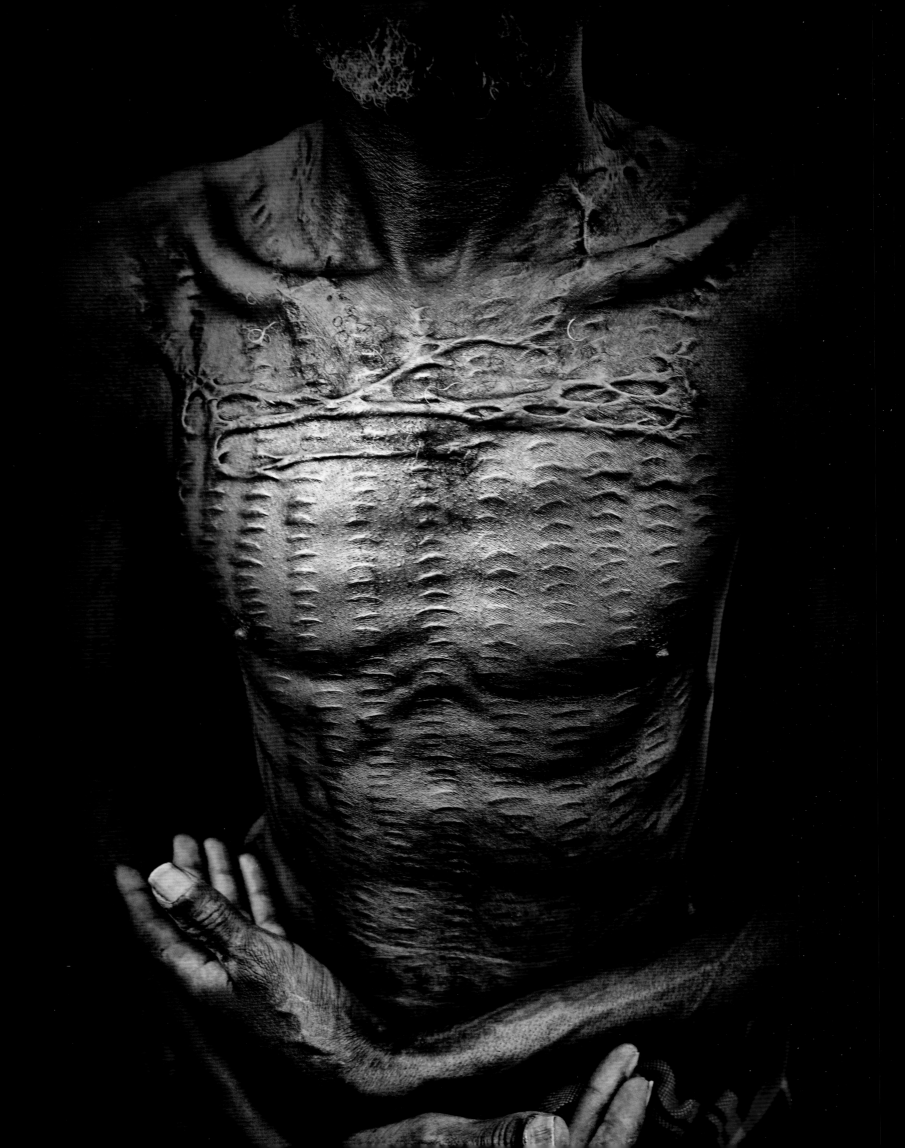

The scarification process is extremely painful and bloody, involving ash or cinders being rubbed onto open thorn, hook or blade wounds to increase the volume of scar tissue that will form over them. But the results are considered highly prestigious by a significant number of peoples, and can signify the courage of the scarred person or—as in the case of the Dassanach and Hamar photographed here—indicating the specific number of enemies a warrior has defeated in battle.

Die Vernarbung ist ein schmerzhafter und blutiger Prozess, in dem Asche oder Lösche auf offene Wunden, die von Dornen, Haken oder Messern verursacht wurden, gerieben werden, damit das Narbengewebe darüber erhabener wird. In vielen Völkern gelten die Ergebnisse als äußerst ehrwürdig, ein Beweis für den Mut der Person, die die Narbe trägt. Bei den Dassanach und Hamar, wie hier abgebildet, sind die Narben ein Zeichen für die Zahl der Feinde, die ein Krieger im Kampf besiegt hat.

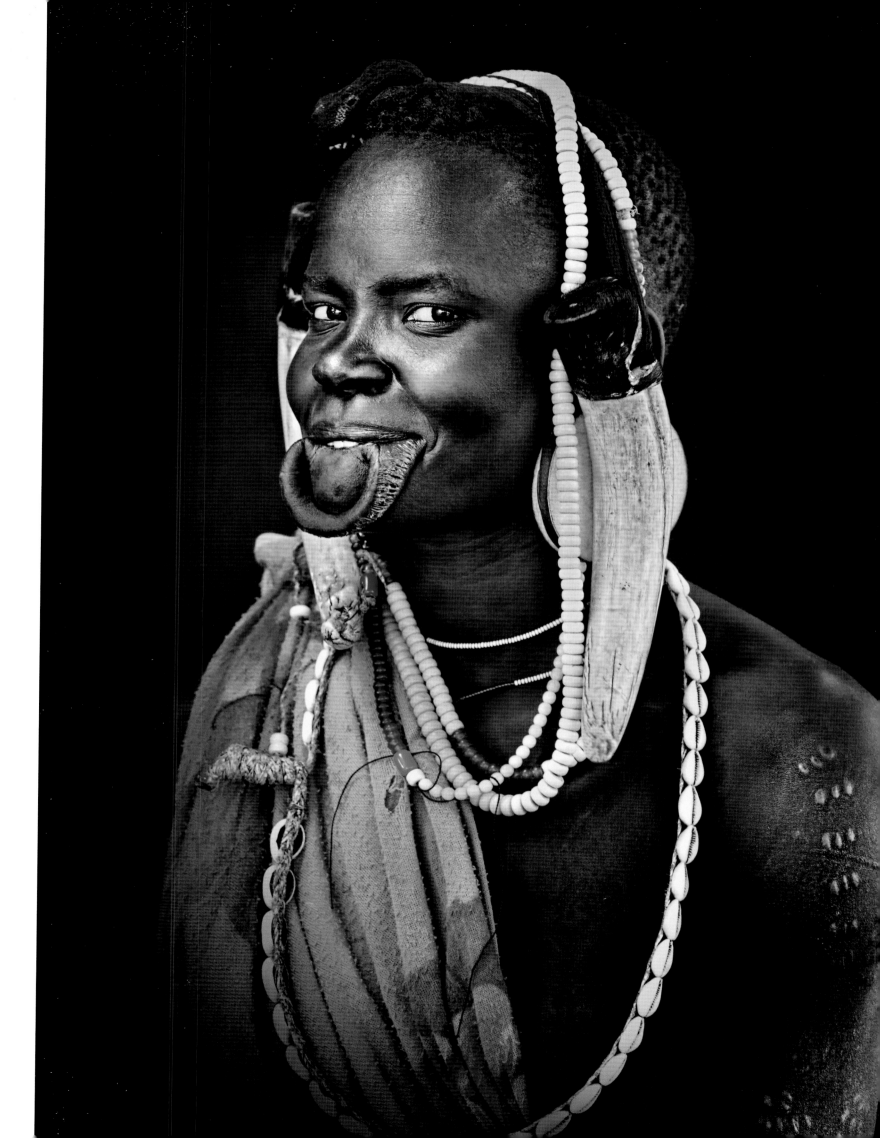

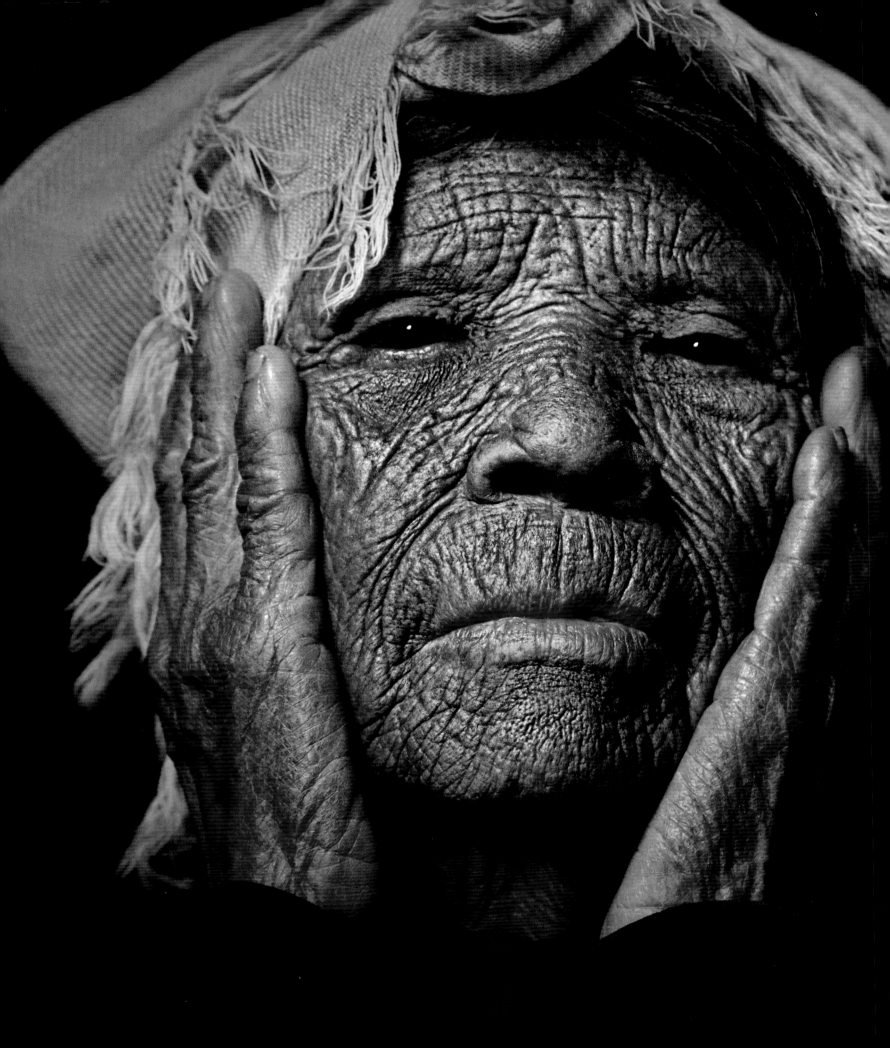

EAST

EAST

There is a large swath of inland Southeast Asia—a remote landscape of forested hills and mountains far from the region's major urban centers—that having seen only on a map or glimpsed in photographs one would likely imagine to be tranquil and timeless: a pocket of calm all but untouched by the pace and pollution of modernity. The cultures here, we might assume, would be indigenous ones whose ways of life stretched back unbroken and unchanged through unnumbered generations.

But the region is dense not only with hills and flora. Here there is also a manmade tangle of borders, with all the conflict and complexities they bring. The nexus of four nations—Thailand and Laos to the south, Myanmar and China above—this is an apparently remote part of the planet that partly as a result of existing at the margins has been convulsed by larger shifts in the continent

as a whole. China's dramatic industrialization; decades of violence and upheaval in Myanmar; Thailand's rise as a major tourist destination and hub; environmental damage from industrial activities, especially logging—all of these processes have marked this area and its peoples indelibly.

To consider this corner of the planet, in fact, which is the ancestral home of numerous indigenous groups yet also the meeting-place of a number of large modern nations all in different kinds of flux, is to see vividly embodied many of the issues that are in play anywhere that the globalized modern world comes into contact

A POCKET OF CALM ALL BUT UNTOUCHED BY THE PACE AND POLLUTION OF MODERNITY?

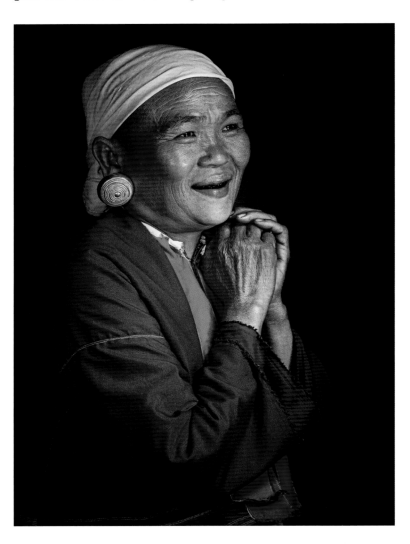

with populations still living in the ways they have known for centuries or millennia. Each of the peoples portrayed in these photographs model in their own ways the difficulties faced by many indigenous peoples in the face of Western culture's onslaught—yet each also testifies to the possibility of survival.

The Lisu are a Tibeto-Burman ethnic group thought to have originated in Tibet and now distributed across mostly wild and mountainous regions in China, Myanmar, Thailand and India's Arunachal Pradesh. Like many of the peoples represented in this book, the Lisu's traditional animist beliefs have largely given way to Christianity, or at least made significant adaptations to it. Yet despite this shift in religious practice much about traditional Lisu culture itself has proven resilient. A profound reverence for ancestors remains, and the high value placed on the community's history manifests in a form that is itself deeply traditional: to an extraordinary degree the Lisu's is a culture of sung music, and with song the medium in which they record and recount their history a rendition of a single one can fill an entire evening.

Perhaps more recognizable to Western readers will be the Chin peoples, native to Myanmar and found in far smaller numbers elsewhere in Southeast Asia—especially,

inevitably, those Chin tribes whose female members have their faces tattooed in elaborate patterns that register their tribal affiliation. (The origins of the practice are not known, though it may at first have been intended to deter other groups from attempting the kidnap of attractive females.) The Chin's adoption of Christianity has been even more comprehensive than the Lisu's, and adding to the pressures exerted on Chin culture has been particularly harsh treatment by the national government, including a ban on the traditional tattoos. Yet as is made clear by the pictures in this book, not least by some of these women's extraordinary tattoos, strong lines of cultural continuity and identification remain.

Among the other groups represented in these pages are the Palaung, a Mon-Khmer minority now for the most part Buddhist, and the Akha, remarkable among other things for their striking women's headdresses adorned with beads, silver coins, fur and feathers. But the situation of the Kayan in particular provides a vivid case-study in the difficulties that can arise when indigenous peoples come into contact with the world modernizing around them.

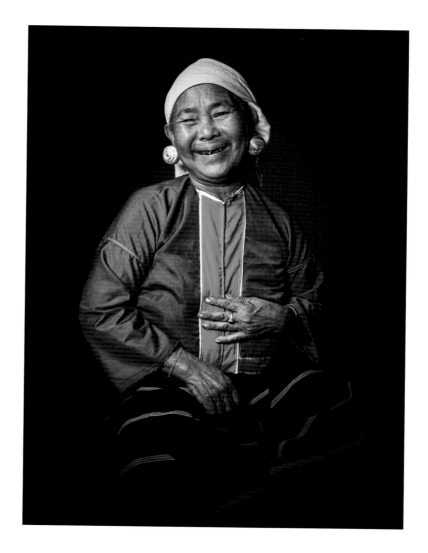

One of the Red Karen or Karenni peoples of Myanmar, the Kayan have attained a degree of international fame due to a sub-group often known as the Padaung (many prefer simply Kayan) whose female members wear neck-coils that give their necks the appearance of dramatic elongation. Many having been driven into Thai refugee camps by fighting between the army and rebel groups in Myanmar, these are the people who in the 1980s became a notorious object of western curiosity as the 'long-neck people', and the result has been a schism in the culture that poses difficult questions of tradition and progress. Many younger women are declining to perpetuate the neck-coil tradition, viewing it as a physically harmful relic best consigned to the past; yet the economic incentive to maintain the practice is for others irresistible, and naturally yet others continue the tradition out of a sense of cultural heritage.

OSTEN

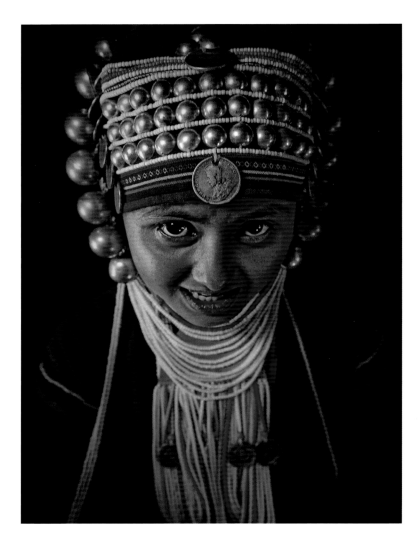

Ein breiter Streifen des Binnenlands in Südostasien – eine entlegene Landschaft voller bewaldeter Hügel und Berge, fernab von den urbanen Zentren dieser Region – sieht auf der Karte oder auf Fotografien betrachtet friedlich und zeitlos aus: Eine Oase der Ruhe, die von der Schnelllebigkeit und der Verschmutzung der Moderne unberührt blieb. Die Menschen hier, so möchte man annehmen, sind indigene Kulturen, die in den Bergen leben und deren Lebensweise sich über Generationen hinweg unverändert zurückerstreckt.

Doch die Region ist dicht besiedelt, und nicht nur von Hügeln und Pflanzenwelten. Komplexe Grenzverläufe ziehen sich durch das Gebiet und bringen Konflikte und Komplikationen mit sich. Hier treffen vier Nationen aufeinander – Thailand und Laos im Süden, Myanmar und China im Norden – und dieser entlegene Flecken Erde

wurde, zum Teil aufgrund seiner Lage zwischen den Fronten, von den großen Umbrüchen des Kontinents erschüttert. Chinas dramatische Industrialisierung; jahrzehntelange Brutalität und Aufstände in Myanmar; Thailands Aufstieg zu einer der größten Tourismusländer der Welt; Umweltschäden aufgrund von industrieller Aktivität, vor allem Waldrodung – all diese Faktoren haben diese Gegend und die hier lebenden Völker stark gezeichnet.

Dieses Gebiet ist das Land der Vorfahren zahlreicher indigener Gruppen sowie das Zentrum mehrerer großer, moderner Nationen, die sich alle im Umbruch befinden.

EINE OASE DER RUHE, DIE VON DER SCHNELLLEBIGKEIT UND DER VERSCHMUTZUNG DER MODERNE UNBERÜHRT BLIEB?

Hier sehen wir ein lebhaftes Beispiel für viele der Probleme, die sich immer dann, wenn auf unserem Planeten ein indigenes Volk mit westlicher Kultur konfrontiert wird, auftreten – doch wir sehen auch Lösungsansätze.

Die Lisu sind eine tibeto-birmanische ethnische Gruppe, die vermutlich ursprünglich aus Tibet kam und nun hauptsächlich in den Bergen zwischen China, Myanmar, Thailand und Arunachal Pradesh in Indien lebt. Wie viele der Völker, die in diesem Buch abgebildet sind, haben die Lisu ihren traditionellen Animismus weitgehend zugunsten des christlichen Glaubens aufgegeben. Doch trotz dieses religiösen Umschwungs erwiesen sich große Teile der Lisu-Kultur als sehr robust. Die Vorfahren werden verehrt, und die Geschichte der Gemeinschaft wird hochgeschätzt und traditionell bewahrt. Gesang ist ein zentraler Punkt der Kultur der Lisu, und sie zeichnen ihre Geschichte in Form von Liedern auf; das Singen eines Liedes kann einen ganzen Abend füllen.

Vielen westlichen Lesern sind vielleicht die Chin, ein Volk aus Myanmar, mit kleineren Gruppen in anderen südostasiatischen Ländern, etwas vertrauter. Die Frauen mancher Chin-Stämme tragen filigrane Gesichts-Tattoos, die ihre Zugehörigkeit zum jeweiligen Stamm zeigen.

(Der Ursprung dieser Tradition ist unklar, doch sie sollte ursprünglich möglicherweise fremde Gruppen davon abhalten, attraktive Frauen zu entführen.) Die Chin haben den christlichen Glauben noch bereitwilliger als die Lisu angenommen, und die nationale Regierung geht streng gegen viele kulturelle Eigenheiten der Chin vor, unter anderem mit einem Verbot der traditionellen Tattoos. Doch die Fotografien in diesem Buch zeigen, dass die großflächigen Tattoos weiter praktiziert werden, und dass trotz dieser Herausforderungen eine starke kulturelle Identifikation und Kohärenz weiterbesteht.

Andere Gruppen, die hier abgebildet wurden, sind die Palaung, eine Mon-Khmer-sprachige Minderheit, die heute größtenteils buddhistisch ist, und die Akha, die unter anderem für den beeindruckenden Kopfschmuck ihrer Frauen, besetzt mit Perlen, Silbermünzen, Fell und Federn bekannt sind. Doch vor allem die Kayan bieten ein perfektes Fallbeispiel für die Probleme, die entstehen können, wenn indigene Völker die Auswirkungen der modernen Welt, die sie umgibt, zu spüren bekommen.

Die Kayan gehören zu den Roten Karen oder Karenni-Völkern in Myanmar und sind bekannt für eine ihrer kleineren Gruppen, die Padaung (wobei viele die Bezeichnung Kayan bevorzugen). Weibliche Mitglieder dieser Gruppe tragen Messingspiralen, die den Hals extrem verlängert erscheinen lassen. Viele von ihnen kamen zwischen die Fronten der Armee und der Rebellen in Myanmar und wurden in thailändische Flüchtlingslager getrieben. In den 80er-Jahren wurden sie als „Giraffenhalsfrauen" zum Objekt westlicher Neugierde, was zu einer Spaltung innerhalb der Kultur führte, die schwierige Fragen bezüglich Tradition und Fortschritt aufwirft. Viele junge Frauen weigern sich, die traditionelle Spirale um den Hals zu tragen, und betrachten diese Praxis als schädlich, ein Relikt, das der Vergangenheit angehört. Doch der wirtschaftliche Anreiz, diese Tradition zu erhalten, ist nicht zu leugnen, und natürlich gibt es auch Frauen, die diese Tradition aus Liebe zu ihrem kulturellen Erbe weiterhin praktizieren.

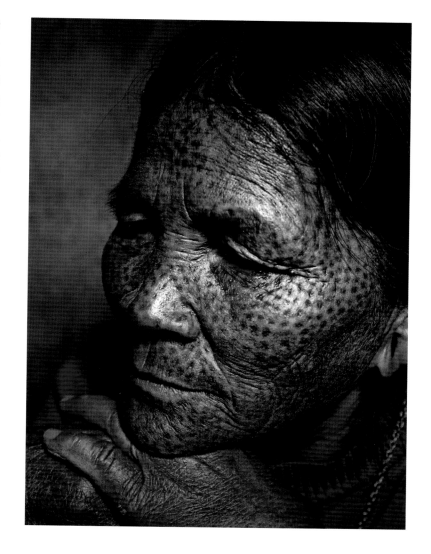

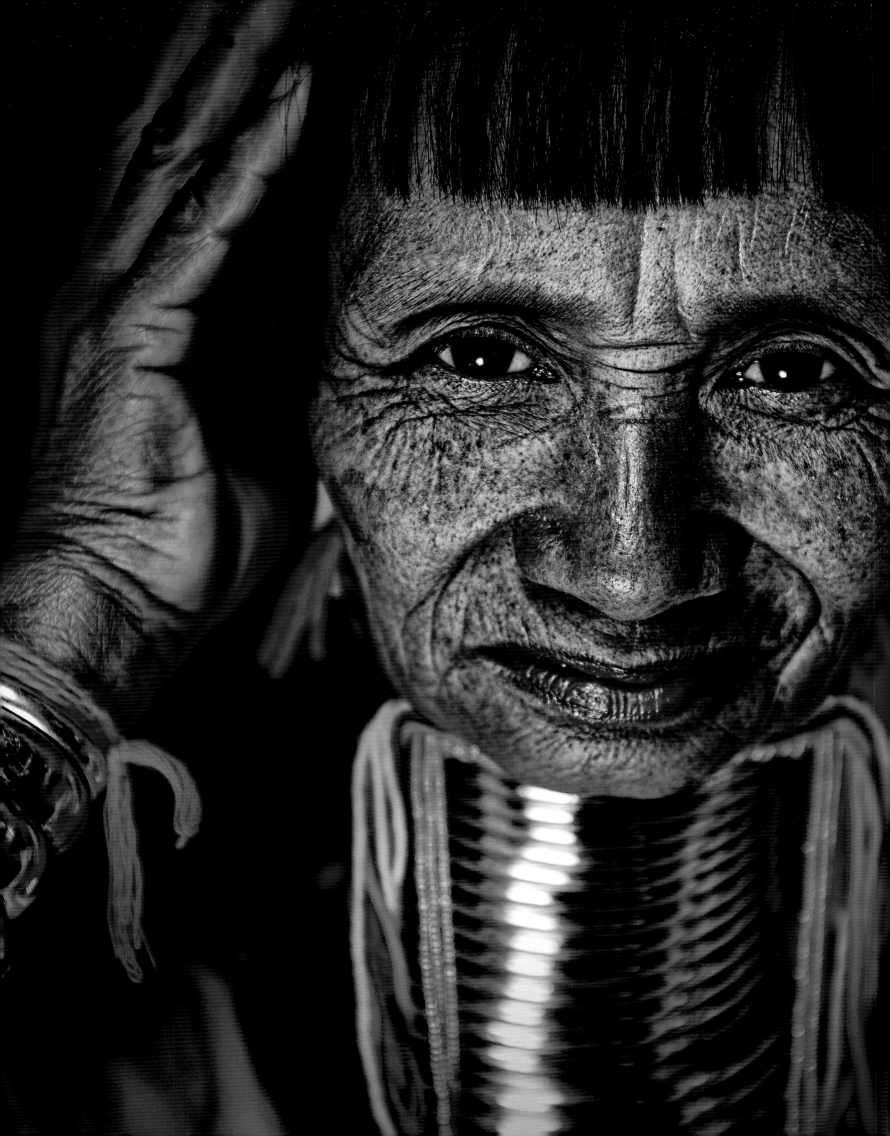

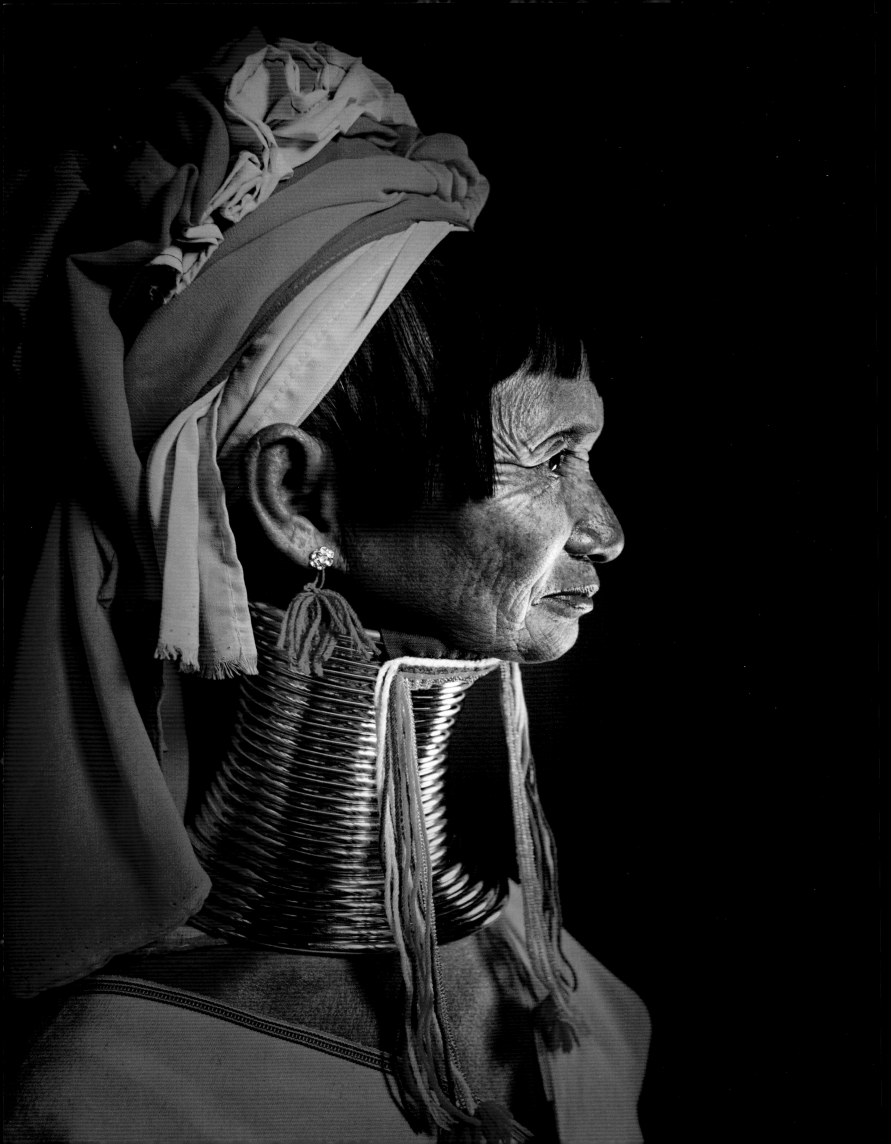

Left:

We still have no conclusive theory as to when and why Padaung women started using spiral necklaces to elongate their necks. Most women start wearing the necklaces during childhood. The custom is now often exploited to strengthen tourism: Since the end of the 1980s, many women who fled to Thailand or Vietnam were being held in faux-traditional villages and displayed as 'giraffe women'.

Links:

Wann und warum die Padaung-Frauen begannen, mit Hilfe von Spiralen ihren Hals zu verlängern, ist bis heute nicht abschließend geklärt. Meist beginnt die Nutzung des Schmuckes schon in der Kindheit. Geschäftemacher belebten damit den Tourismus: Zahlreiche Frauen, die seit Ende der 1980er Jahre nach Thailand oder Vietnam flüchteten, werden dort in Schaudörfern als „Giraffenhalsfrauen" vermarktet.

According to folklore, the Padaung people were born from a dragon-mother with a long, scaly neck. It is said that their society used to be matrilinear, that is to say material possessions and social rank were handed down from mother to daughter.

Einer Sage der Padaung nach stammt ihr Volk von einem weiblichen Drachen mit gepanzertem Hals ab. Außerdem soll ihre Gesellschaft früher „matrilinear" organisiert gewesen sein, Besitz und sozialer Stand wurden nur von Mutter an Tochter weitergegeben.

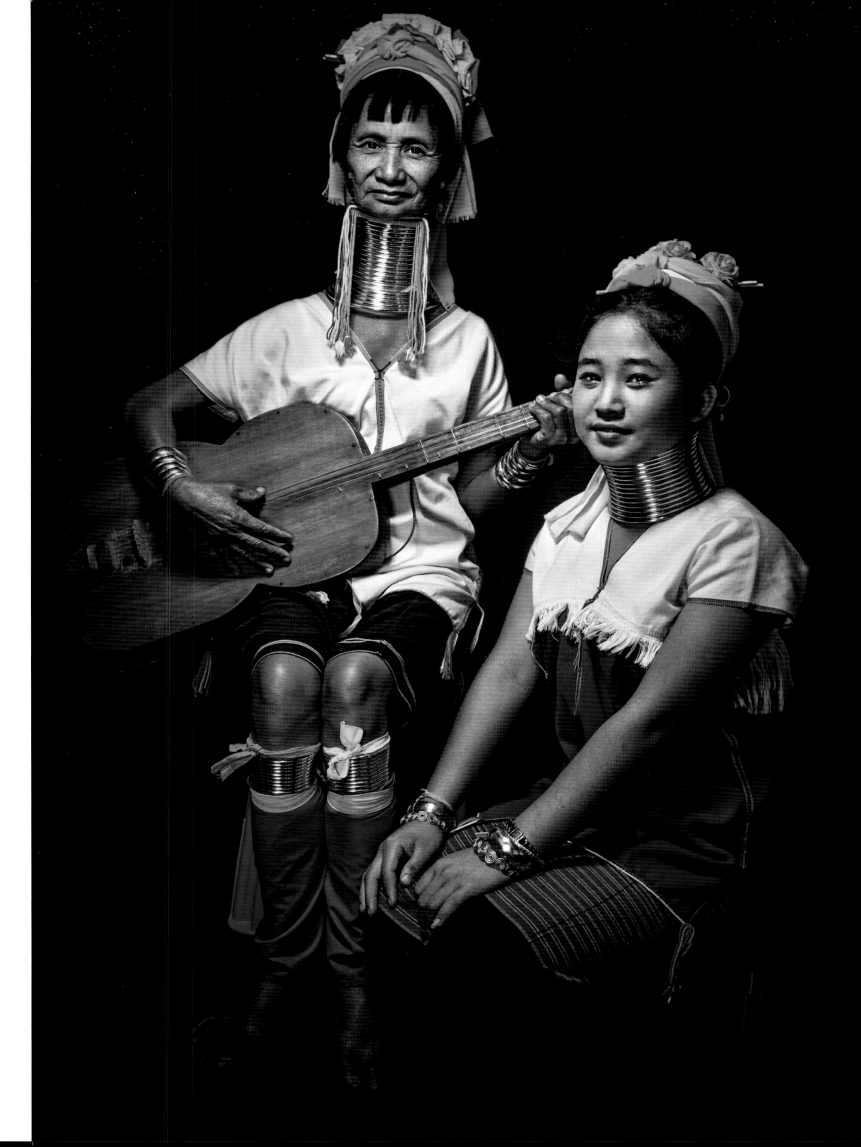

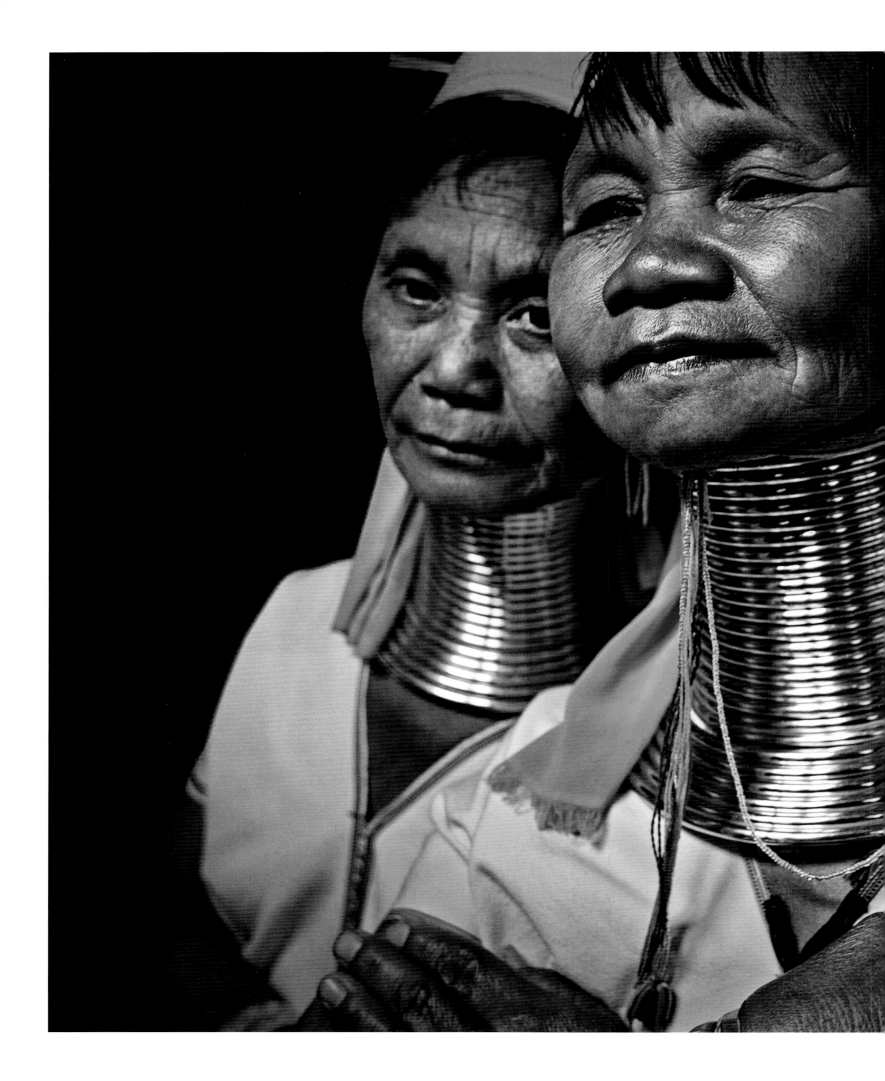

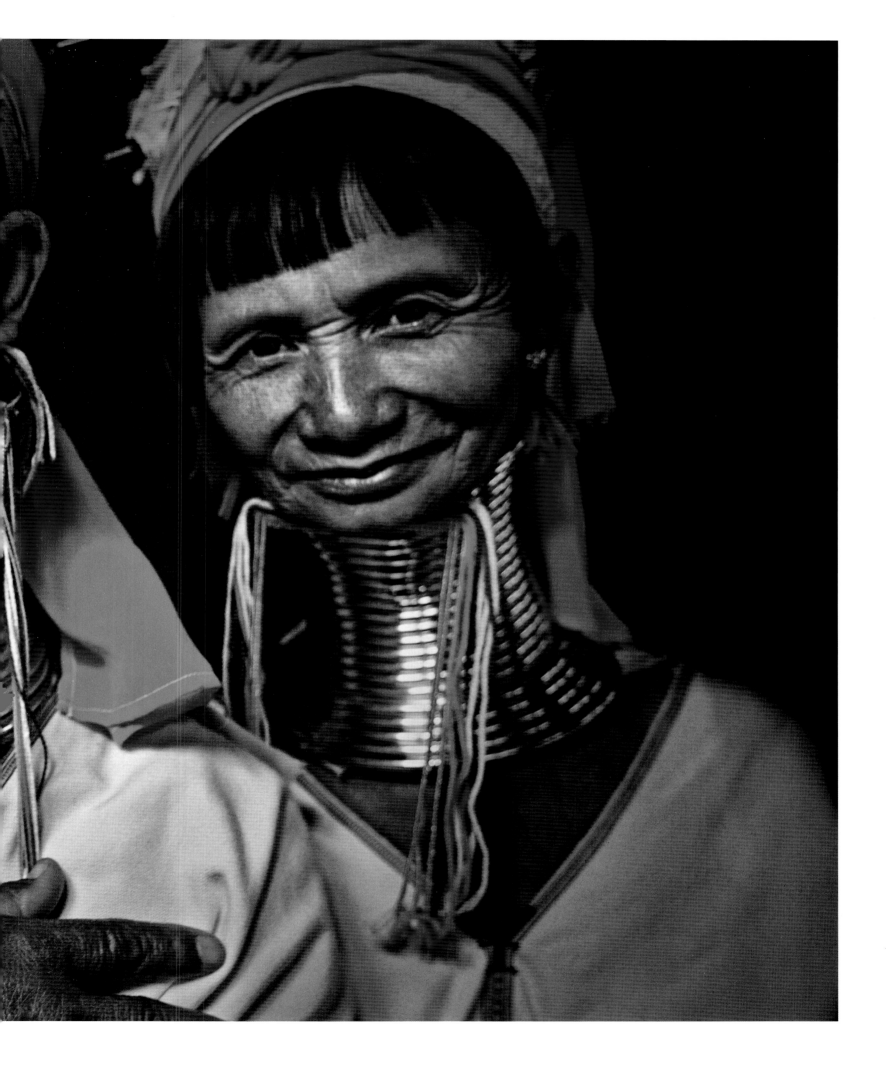

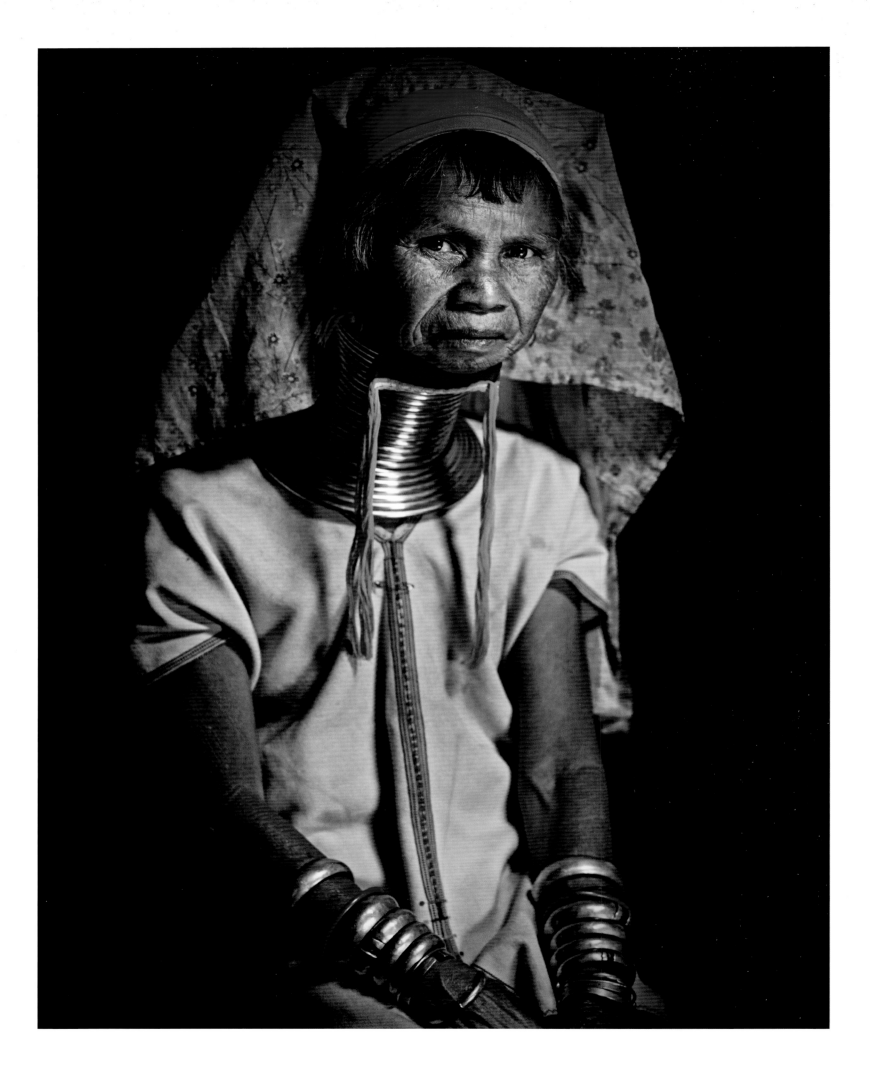

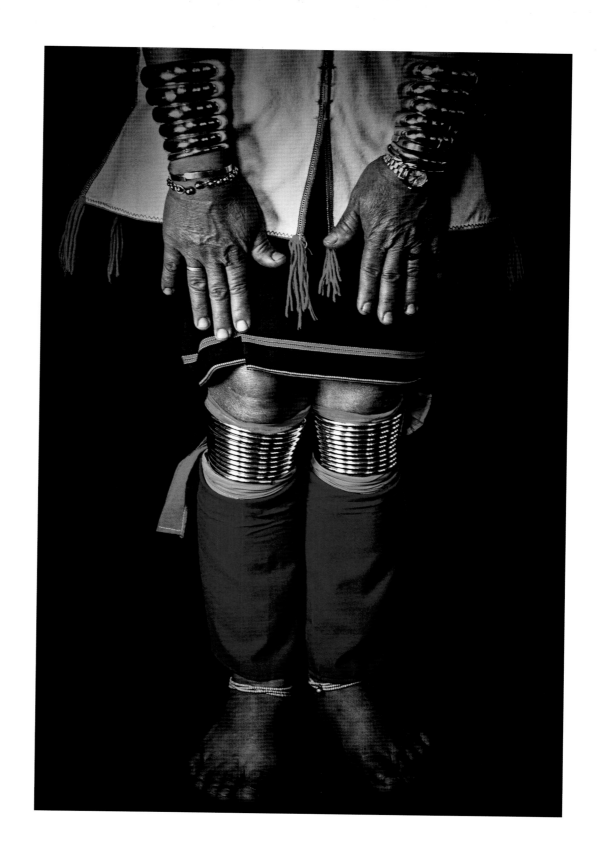

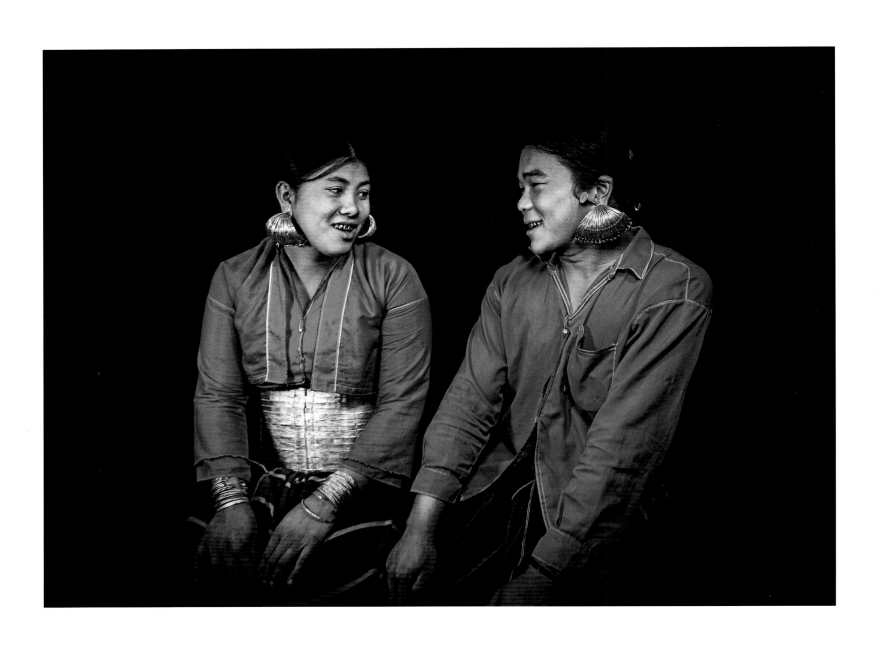

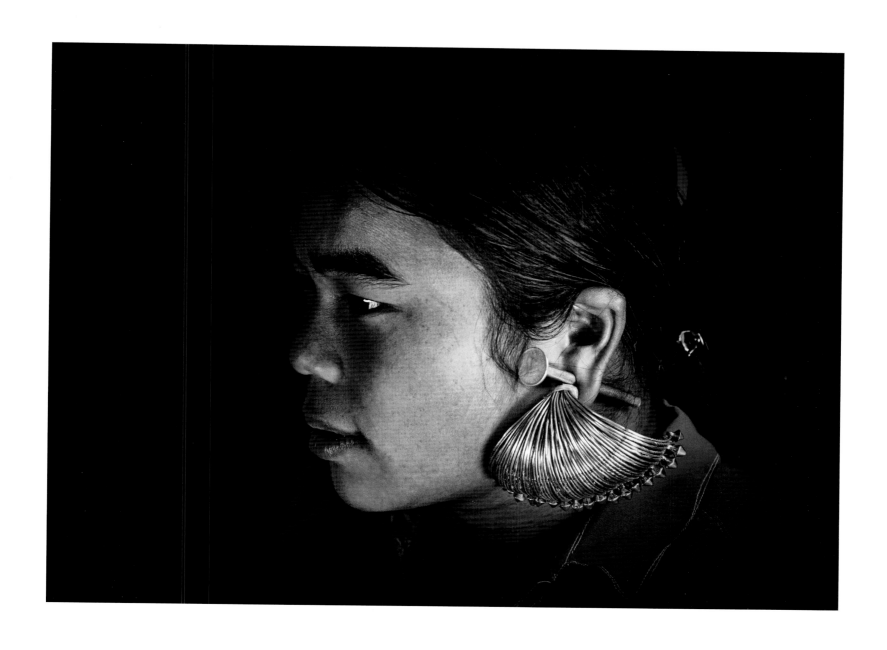

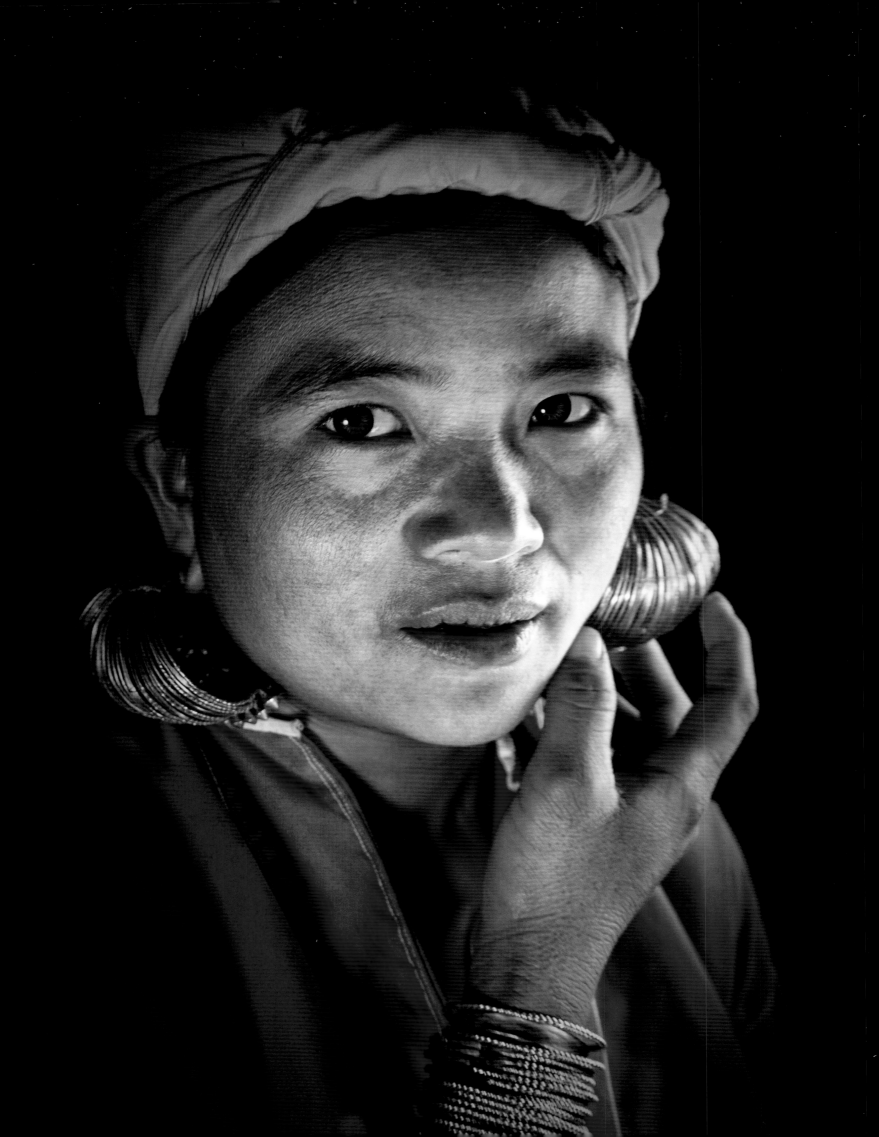

Left:

The Silver Palaung increasingly live not in the forests as they did for untold generations, but instead near to conurbations or local markets. One apt visual sign of the encounter this prompts between tradition and 'modernity' is the way that manufactured items are appropriated as jewelry—without any regard whatsoever for their original function!

Links:

Die Silver Palaung lebten über ungezählte Generationen hinweg im Wald, siedeln jedoch inzwischen immer öfter in der Nähe von Ballungszentren oder Märkten. Ein sehr passendes Symbol für das Zusammentreffen zwischen Tradition und Moderne ist der Schmuck, der aus umfunktionierten Alltagsobjekten besteht – und deren ursprünglicher Nutzen völlig außer Acht gelassen wurde!

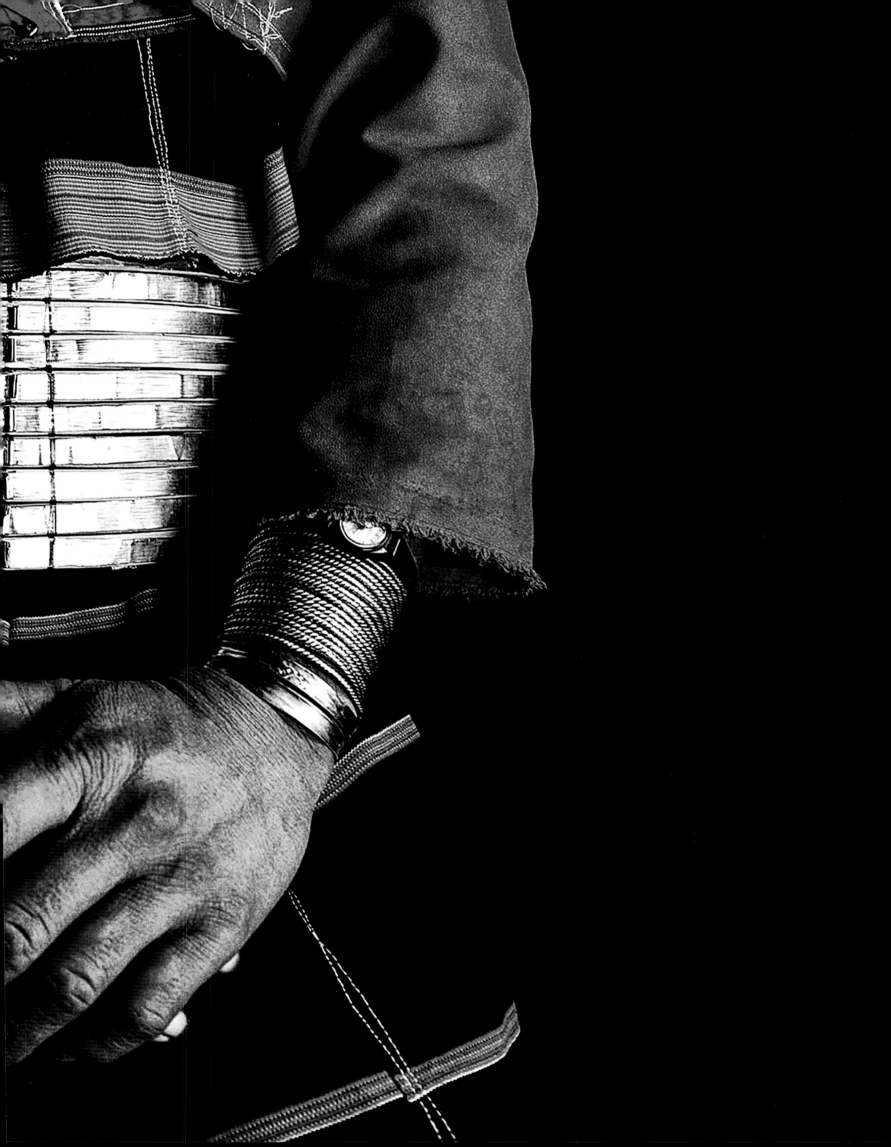

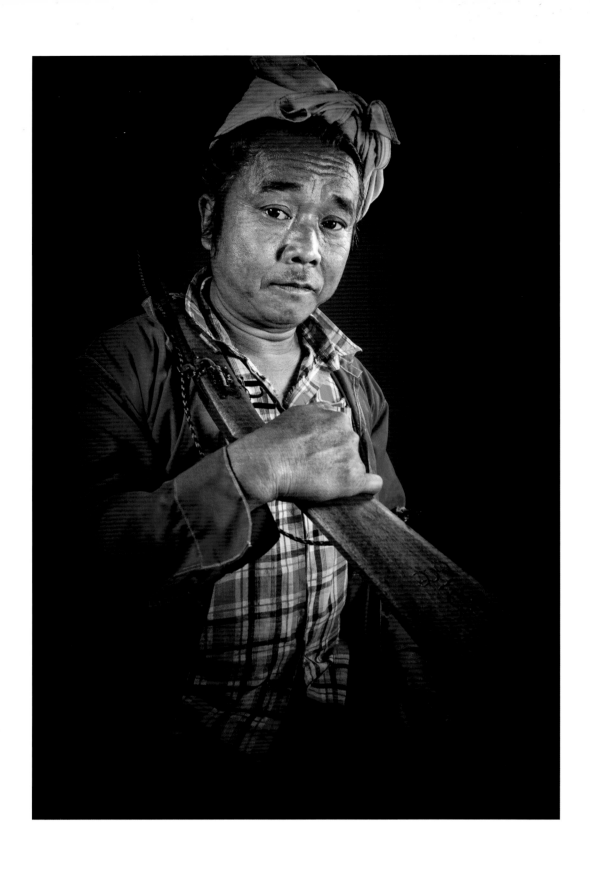

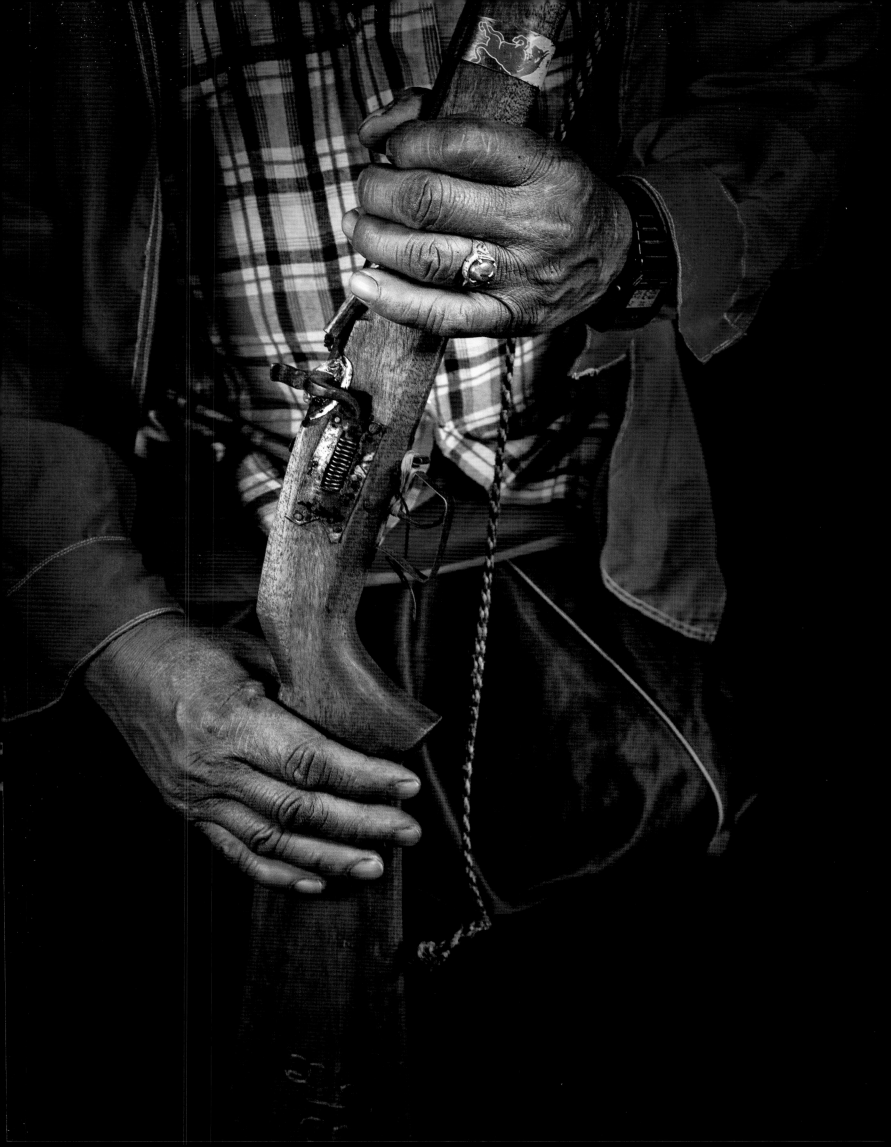

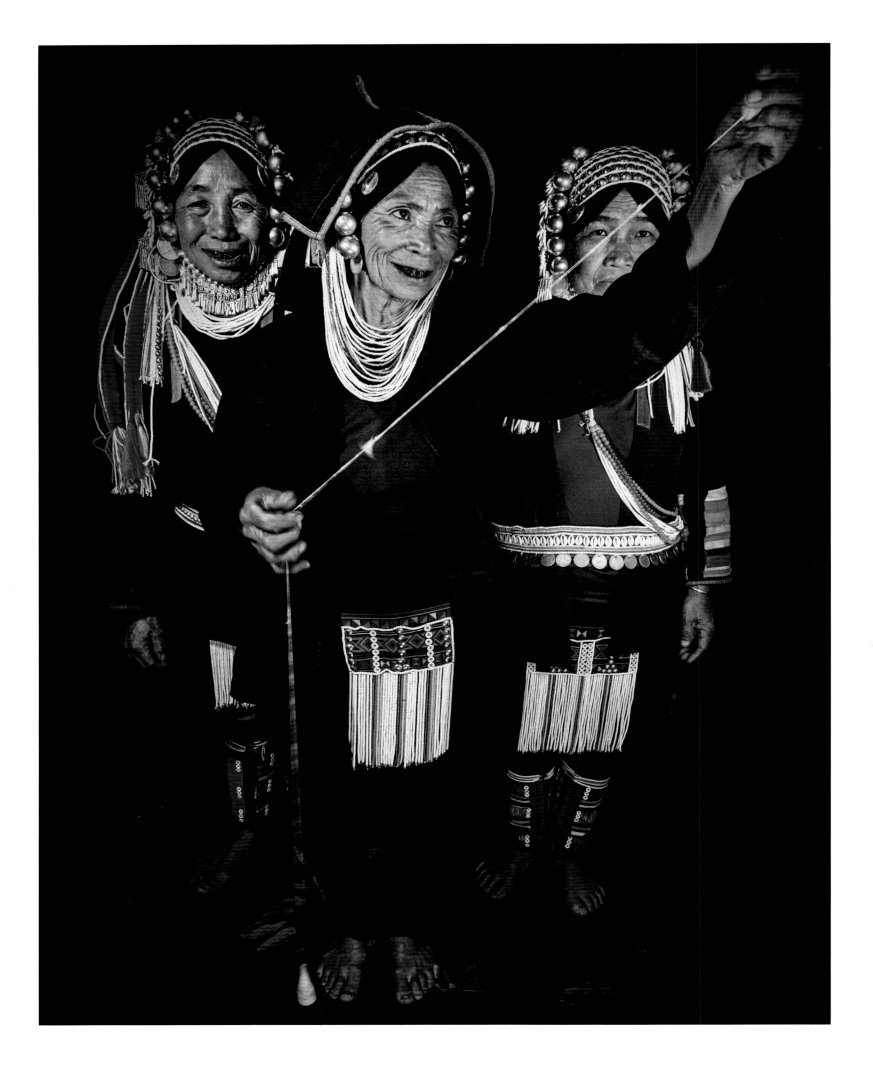

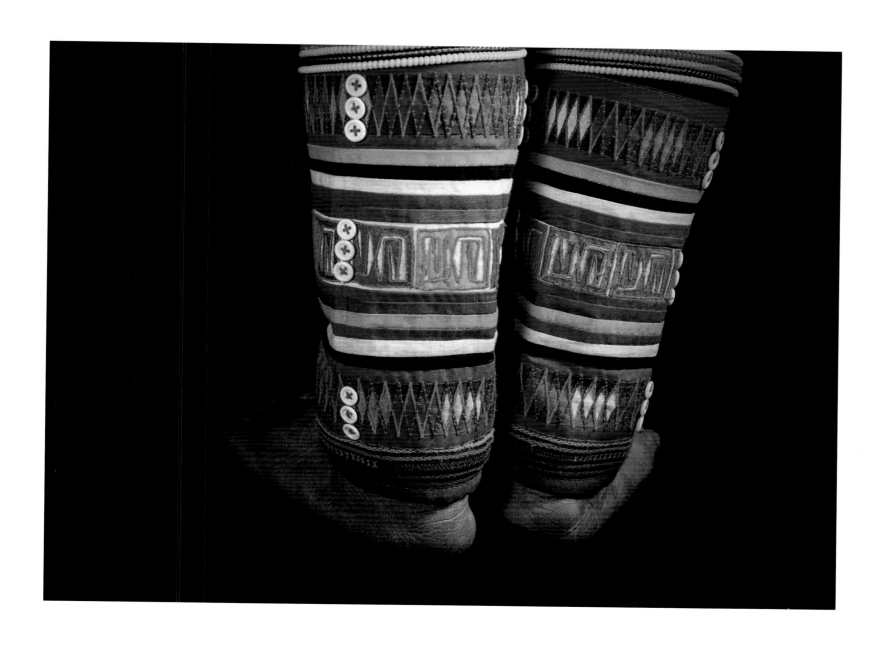

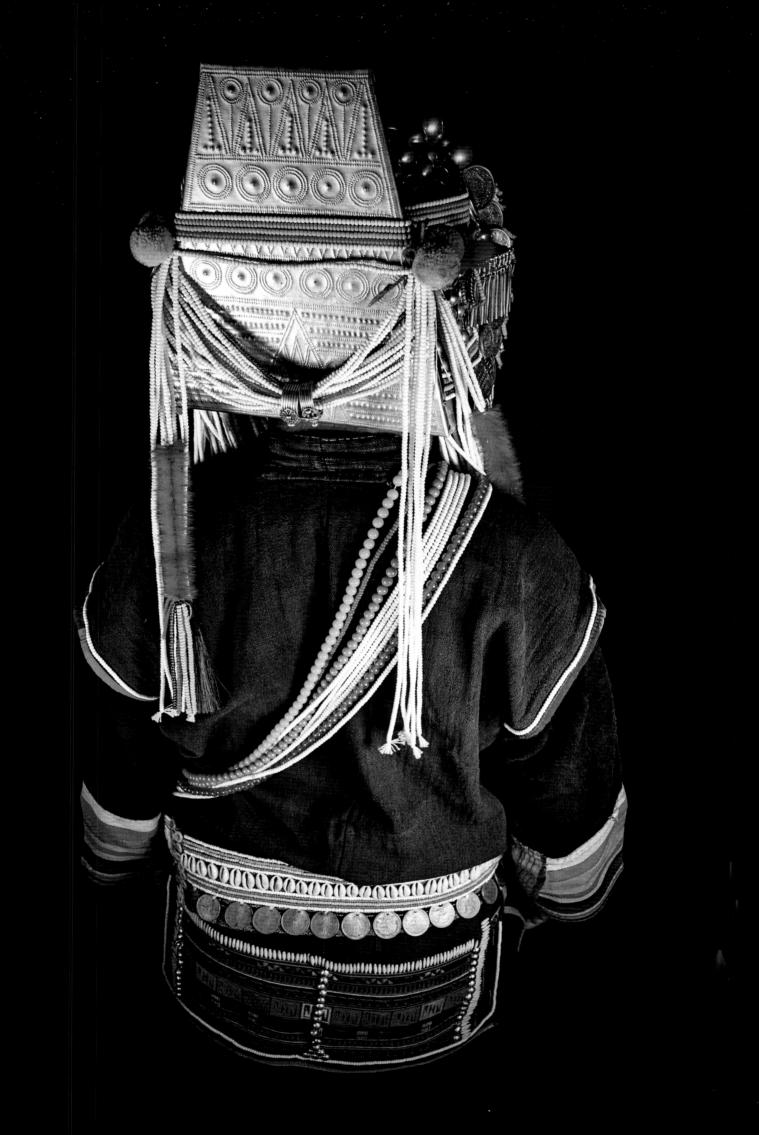

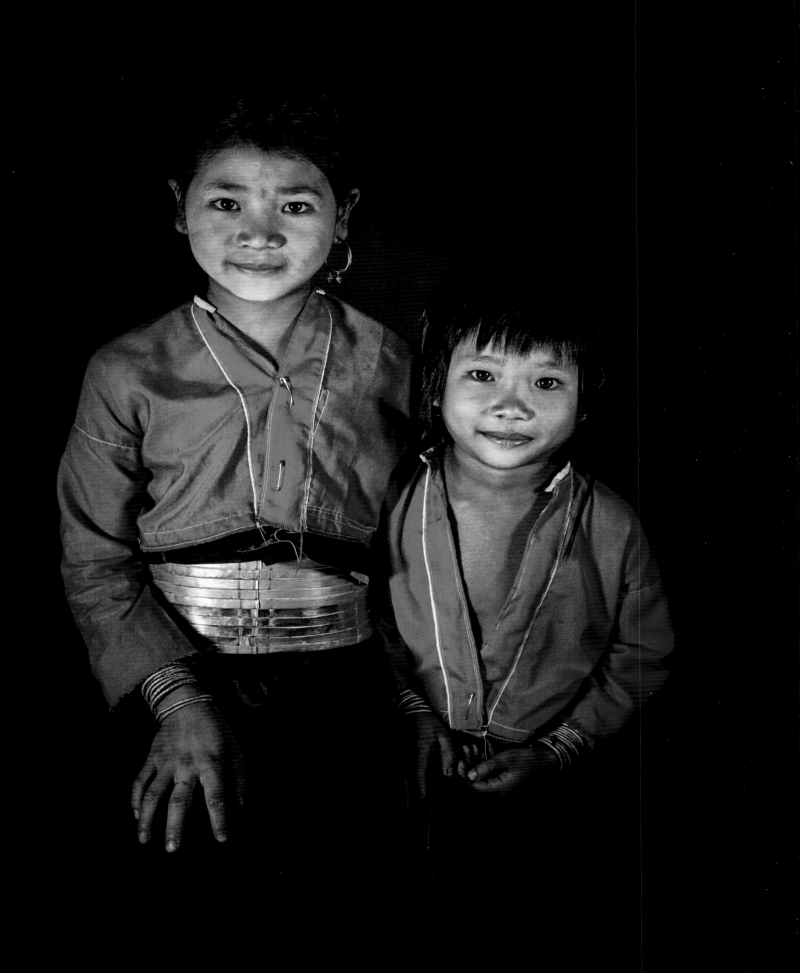

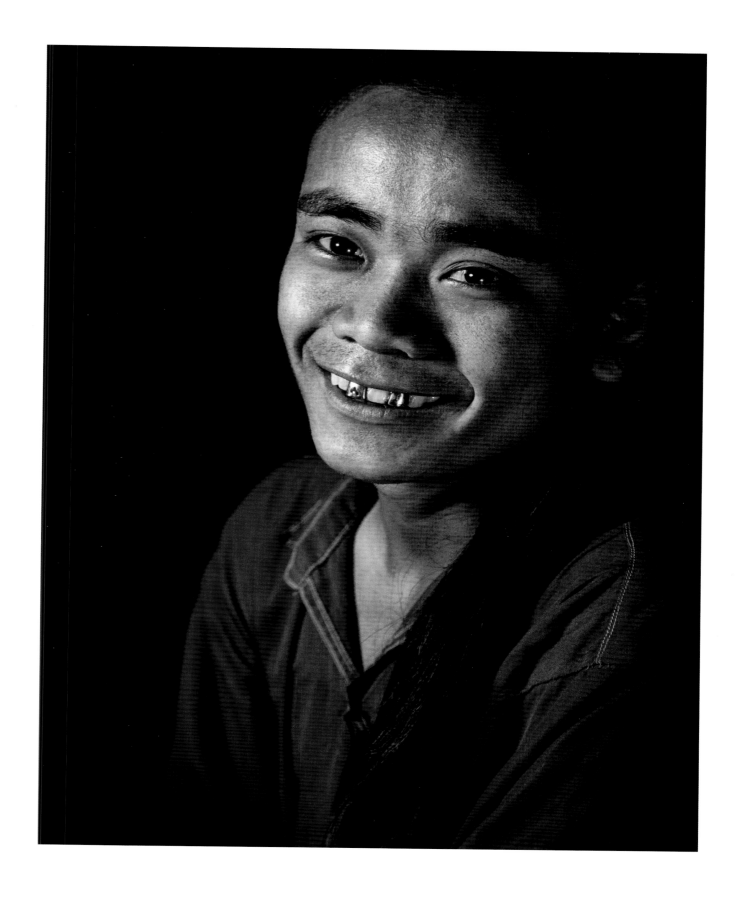

In this photograph the children's innocence and openness to the world really shines through—the flipside of the vulnerability that is common to all of us in our early years.

In diesem Bild erkennt man deutlich die Unschuld und Weltoffenheit der Kinder – die Kehrseite der Verletzlichkeit, die uns in jungen Jahren allen gemein ist.

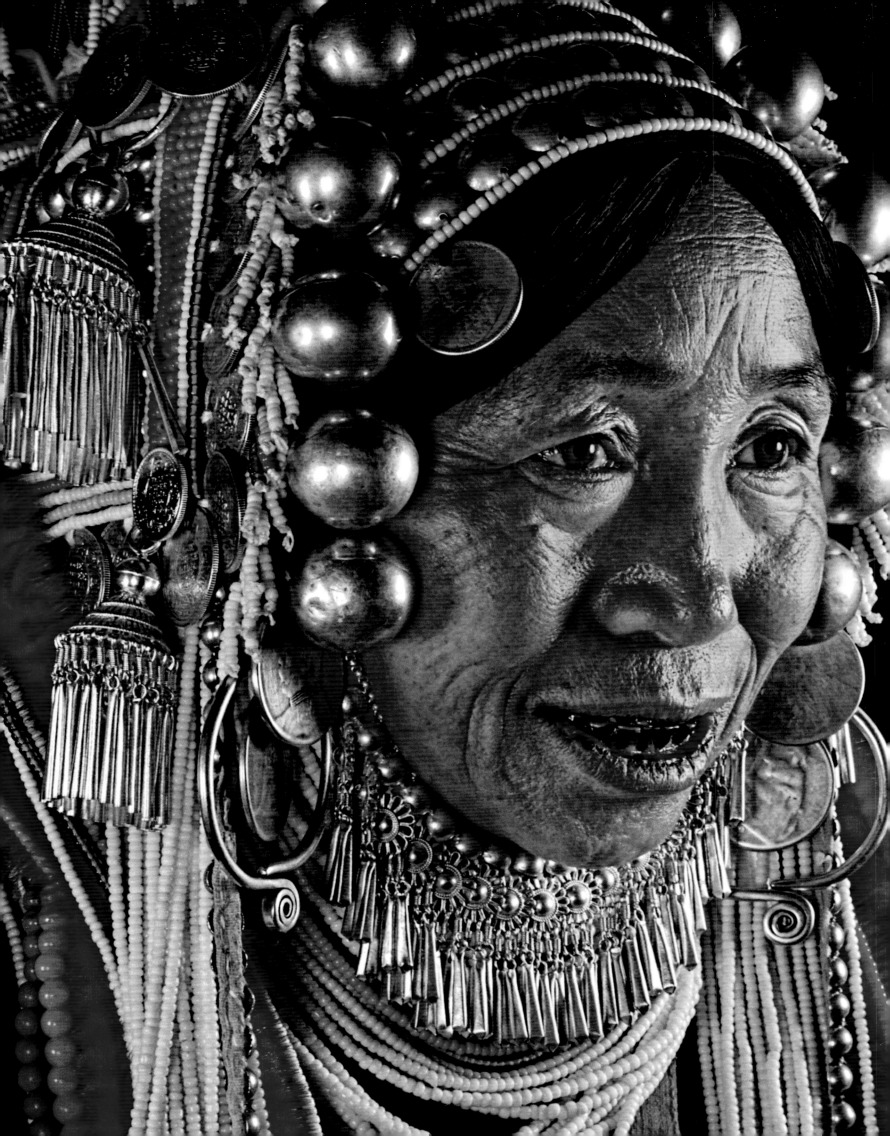

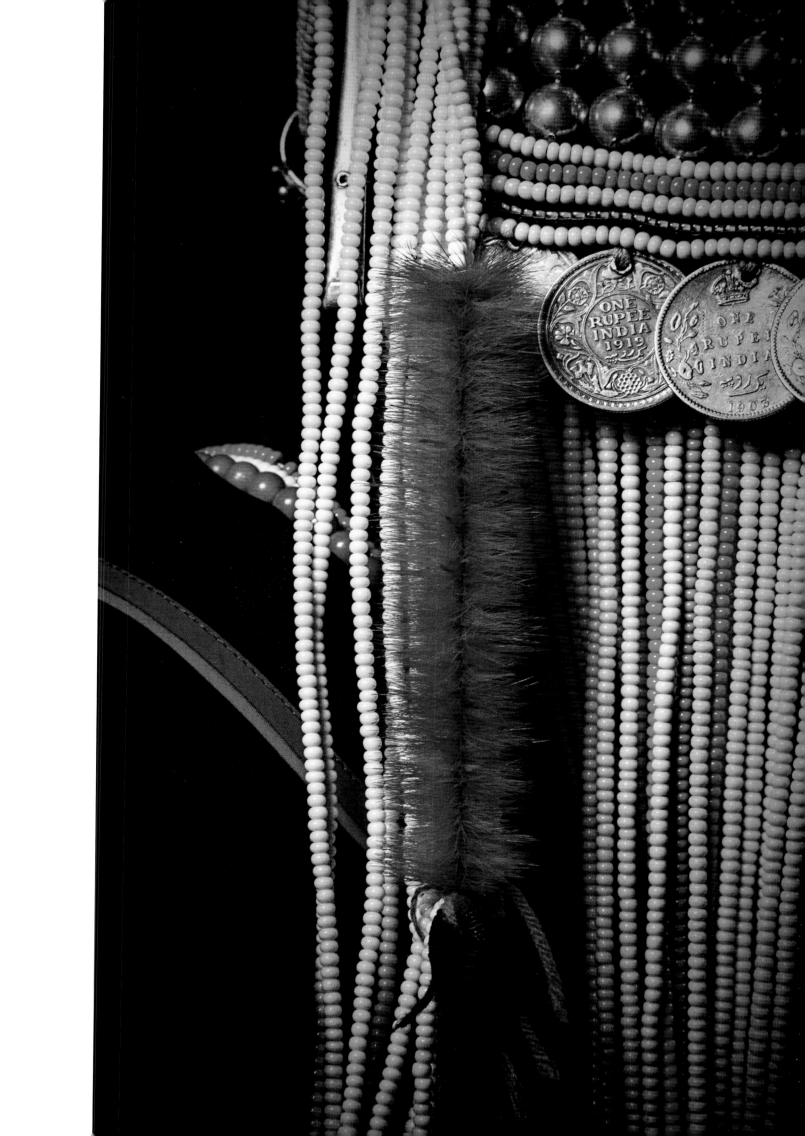

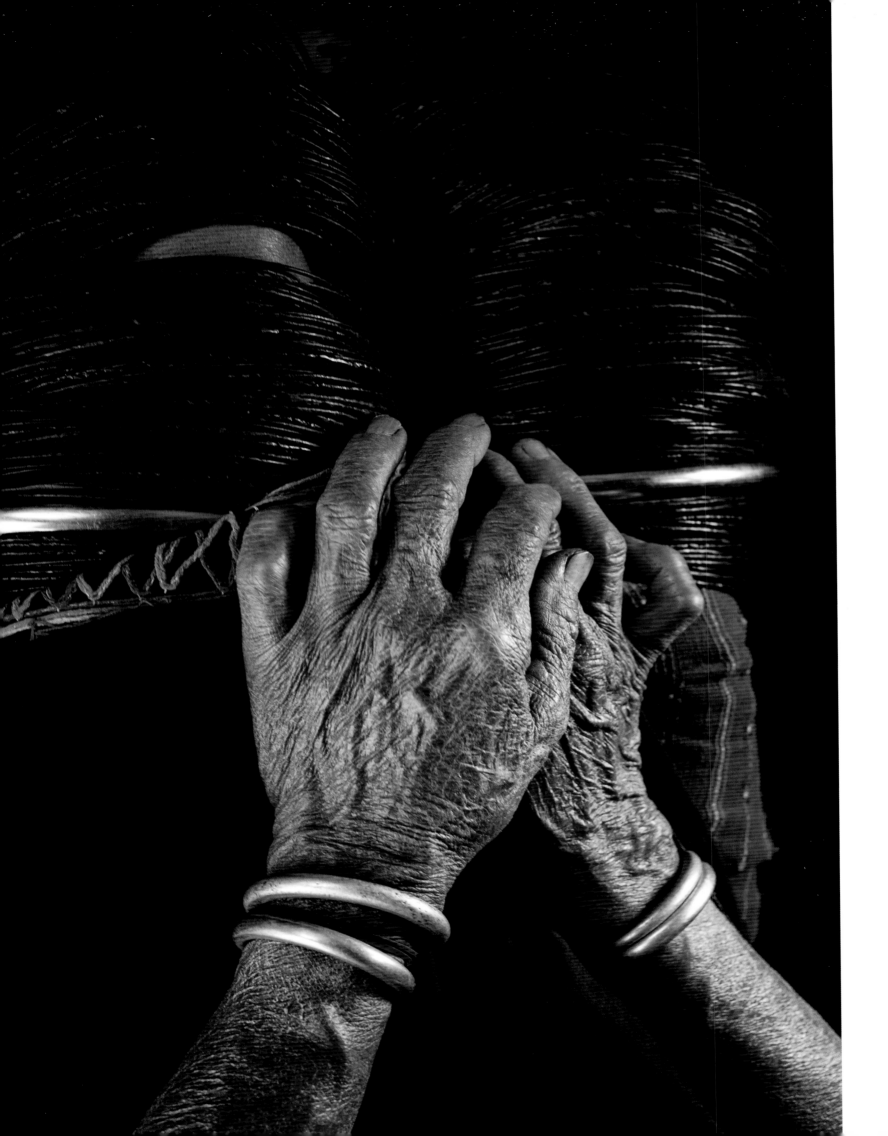

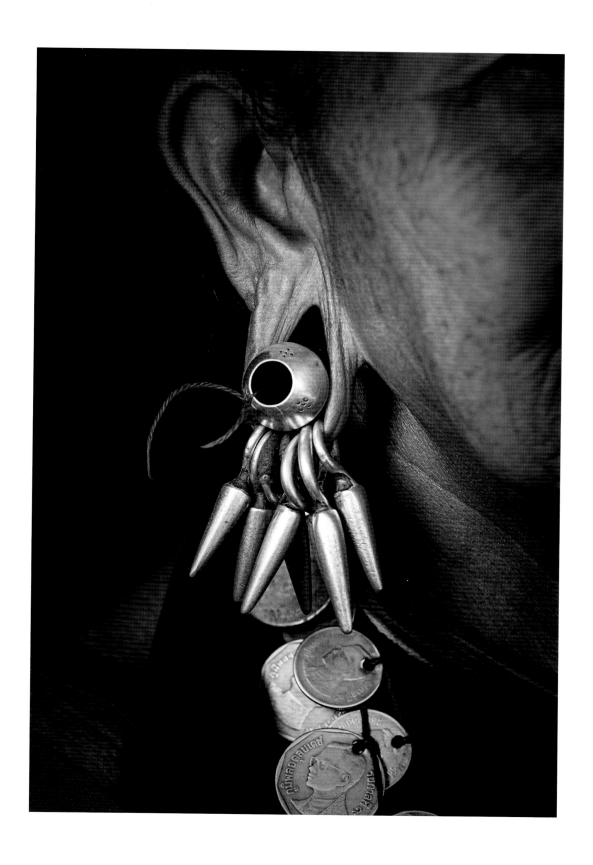

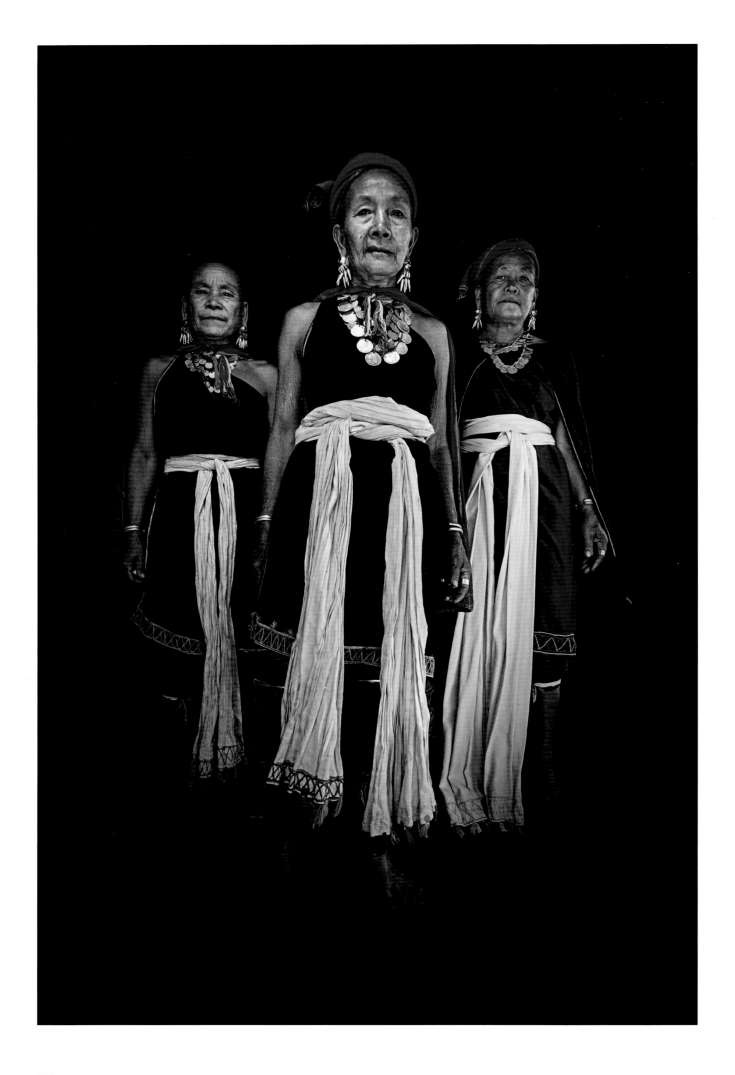

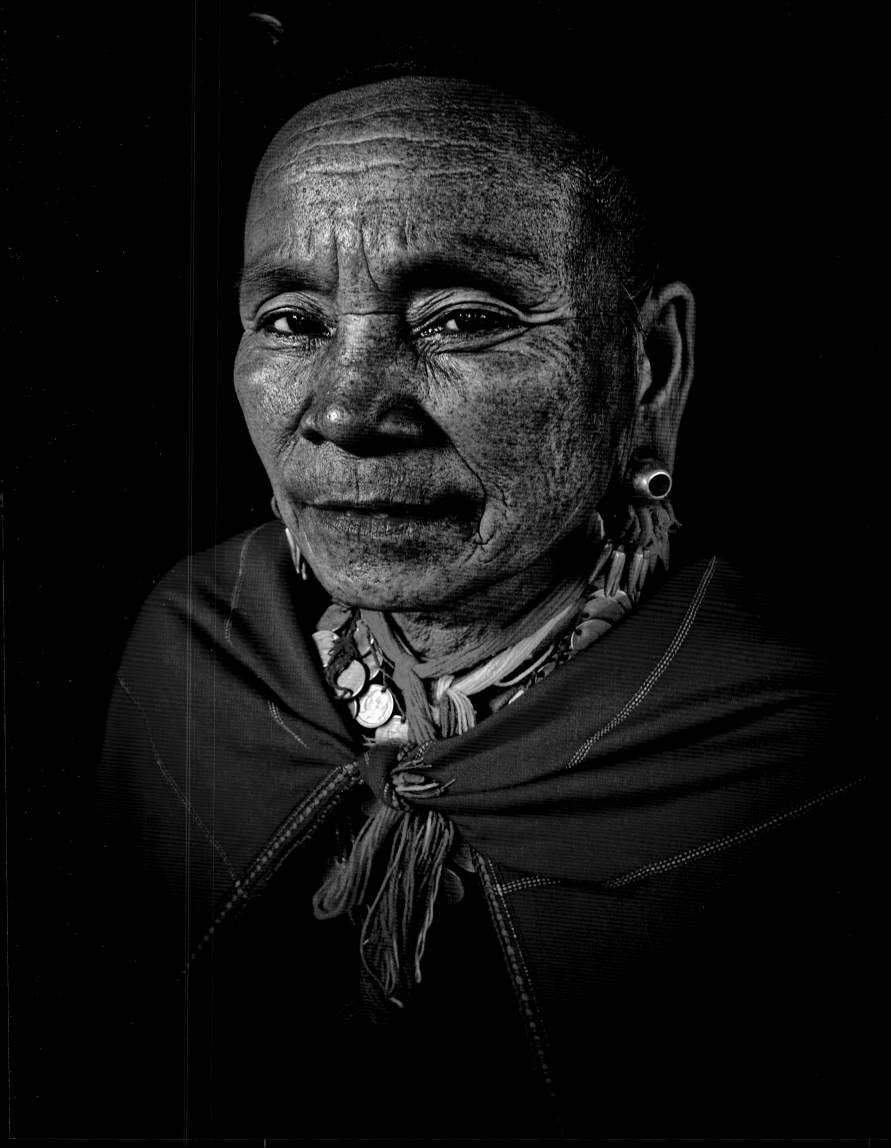

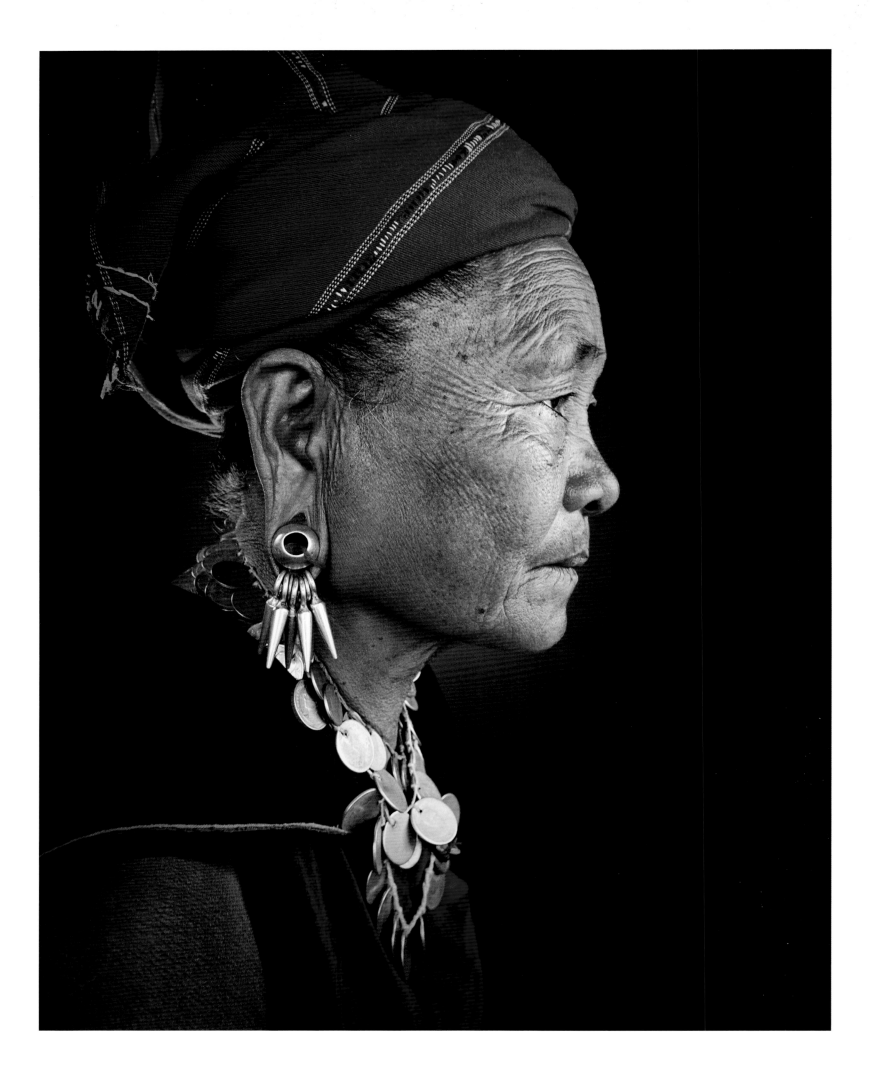

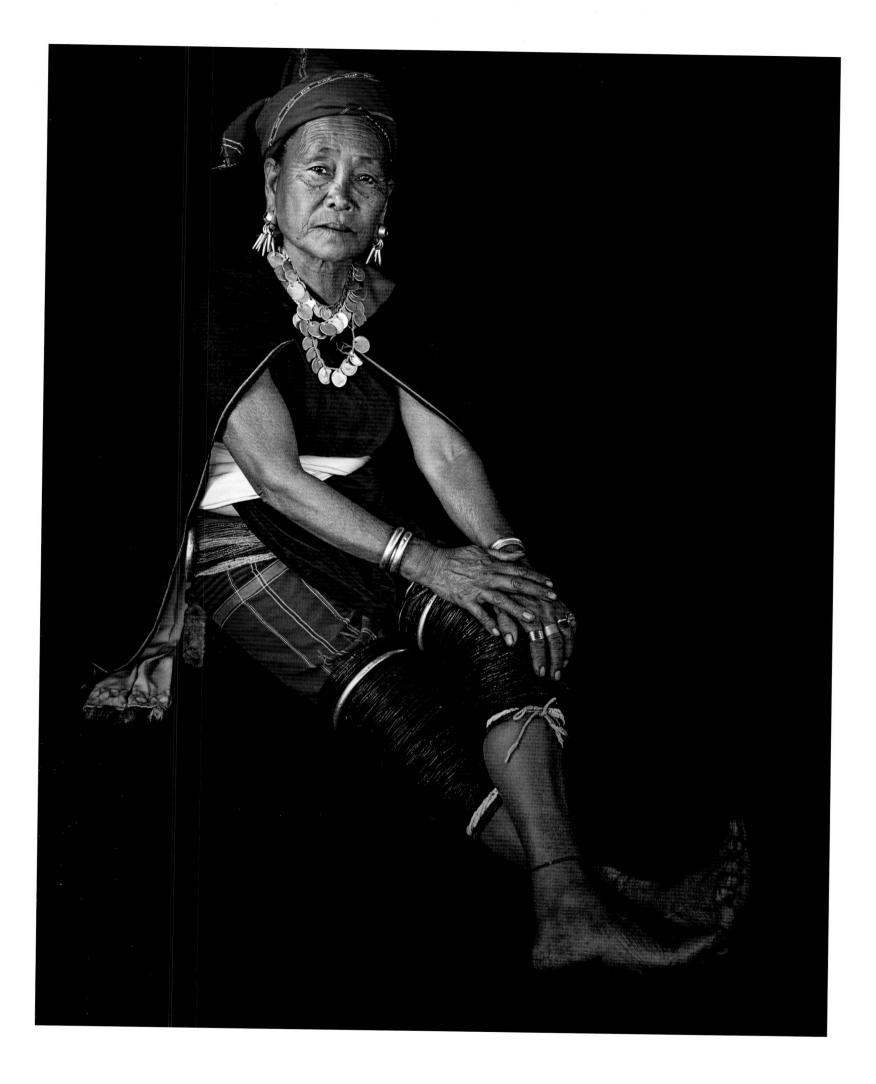

Most cultures have their own traditional musical instruments. String instruments are among the world's oldest known instruments. They may have originated from hunting bows when humans discovered that plucking the string produced different tones and pitches depending on how tightly the bowstring was strung.

Beinahe jede Kultur kennt ein typisches, traditionelles Musikinstrument. Gerade Saiteninstrumente zählen zu den ältesten Instrumenten überhaupt. Vermutlich gingen sie aus Jagdbögen hervor, als die Menschen bemerkten, dass sich die Töne beim Zupfen der Sehne variieren ließen, je nachdem, wie stark sie gespannt war.

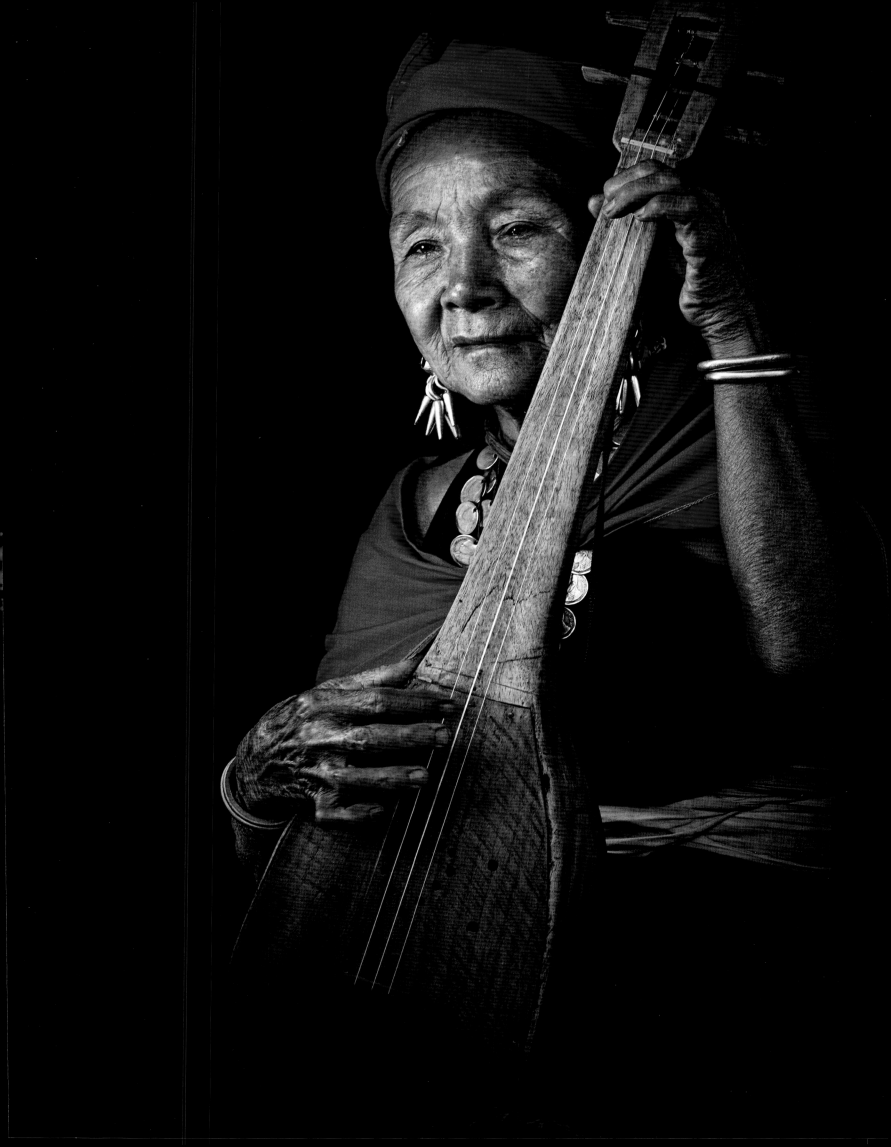

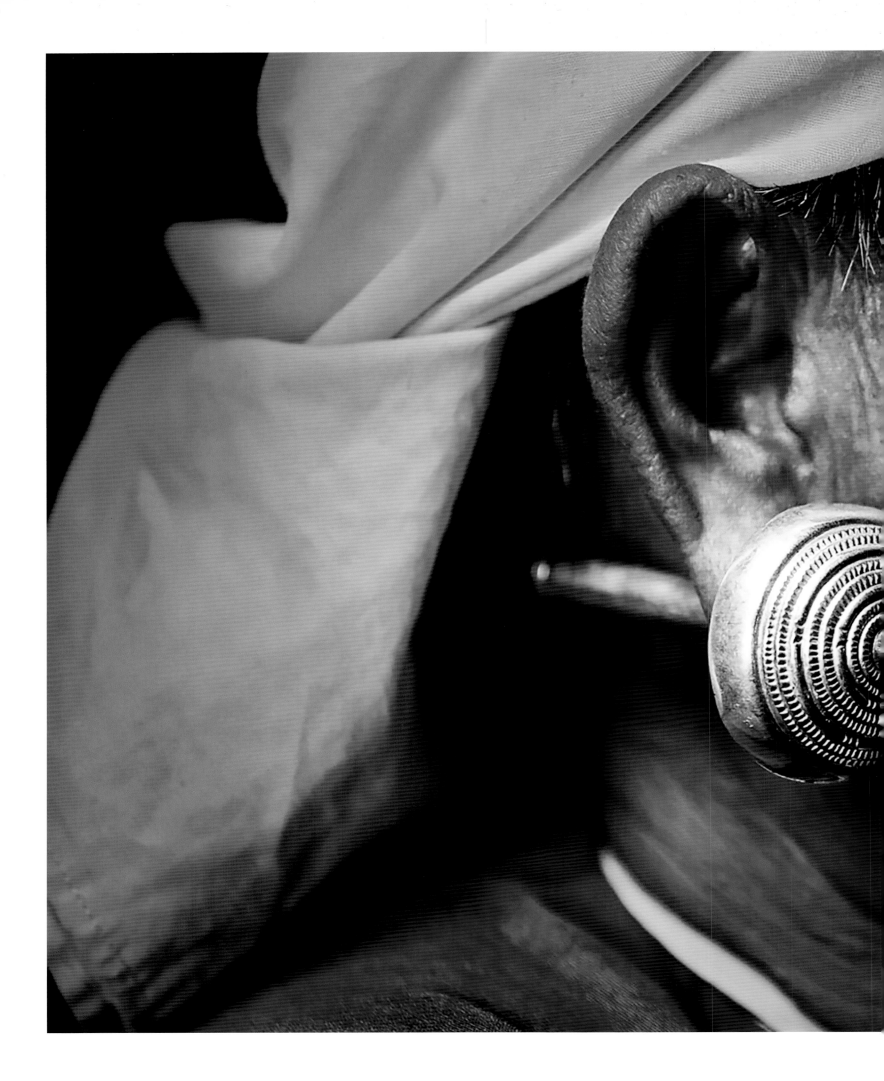

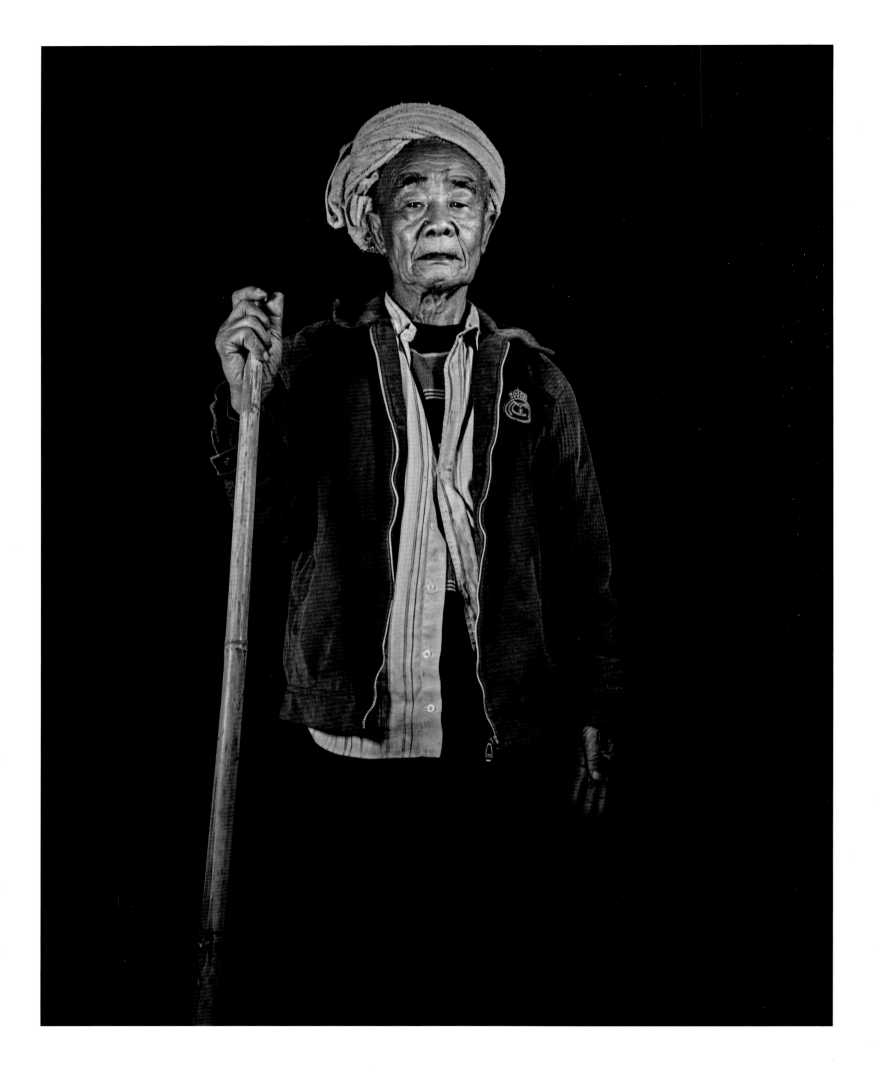

Many of these photographs show people of younger generations who are keen to embrace and emulate cultures other than their traditional ones. Older generations, on the other hand, often have strong ties to the past and feel vulnerable to such developments. But if in this regard experience does not necessarily lead to the capacity to adapt, this elder with his walking stick exudes robustness and wisdom.

Viele der Fotografien in diesem Buch zeigen Menschen der jüngeren Generationen, die anderen als ihren traditionellen Kulturen nacheifern. Ältere Generationen hingegen haben oft starke Bindungen an die Vergangenheit und fühlen sich gegenüber solchen Entwicklungen verwundbar. Wenn aber Erfahrung in dieser Hinsicht nicht unbedingt zu der Fähigkeit führt, sich anzupassen, strahlt dieser Ältere mit seinem Gehstock Robustheit und Weisheit aus.

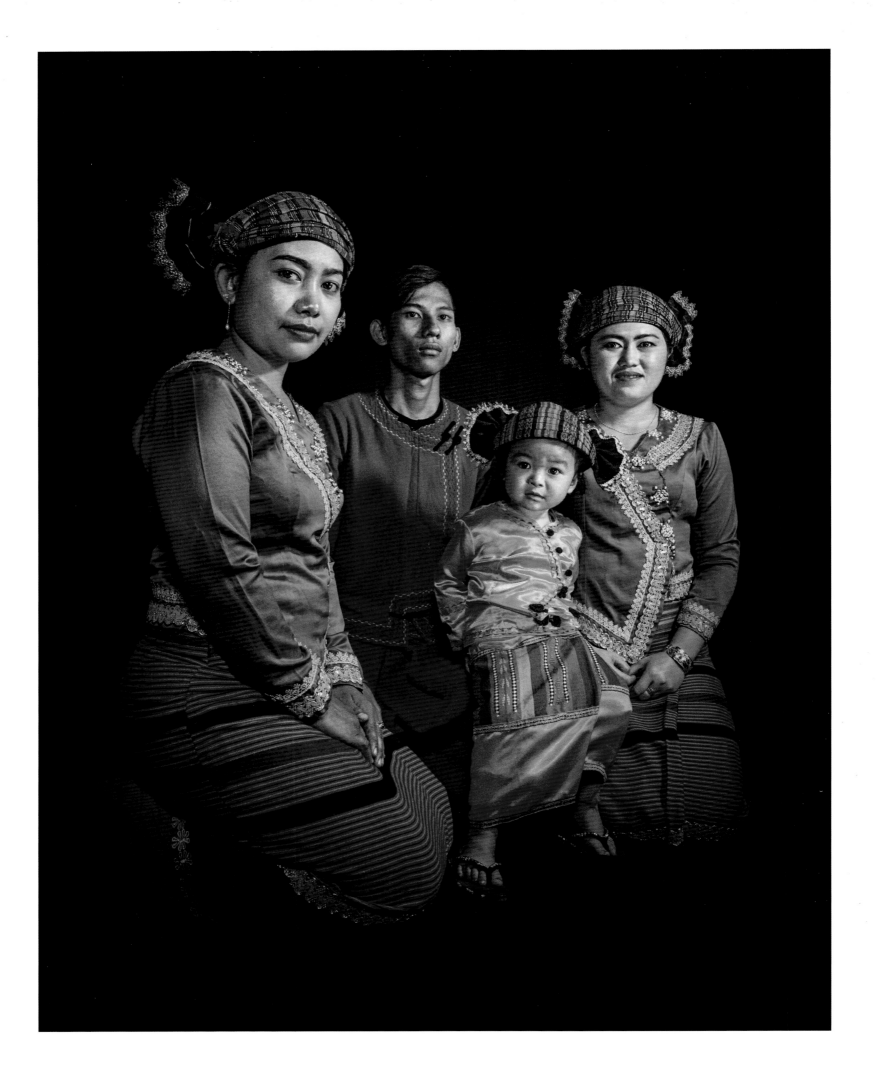

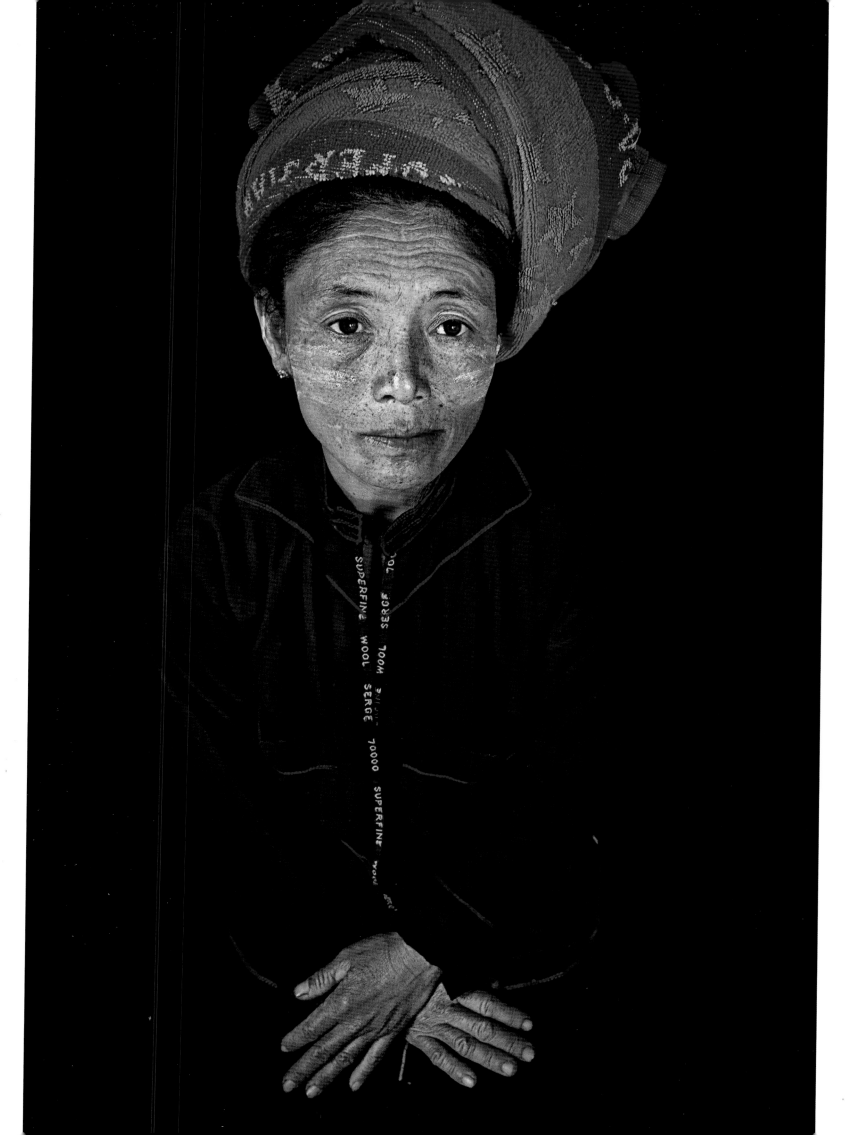

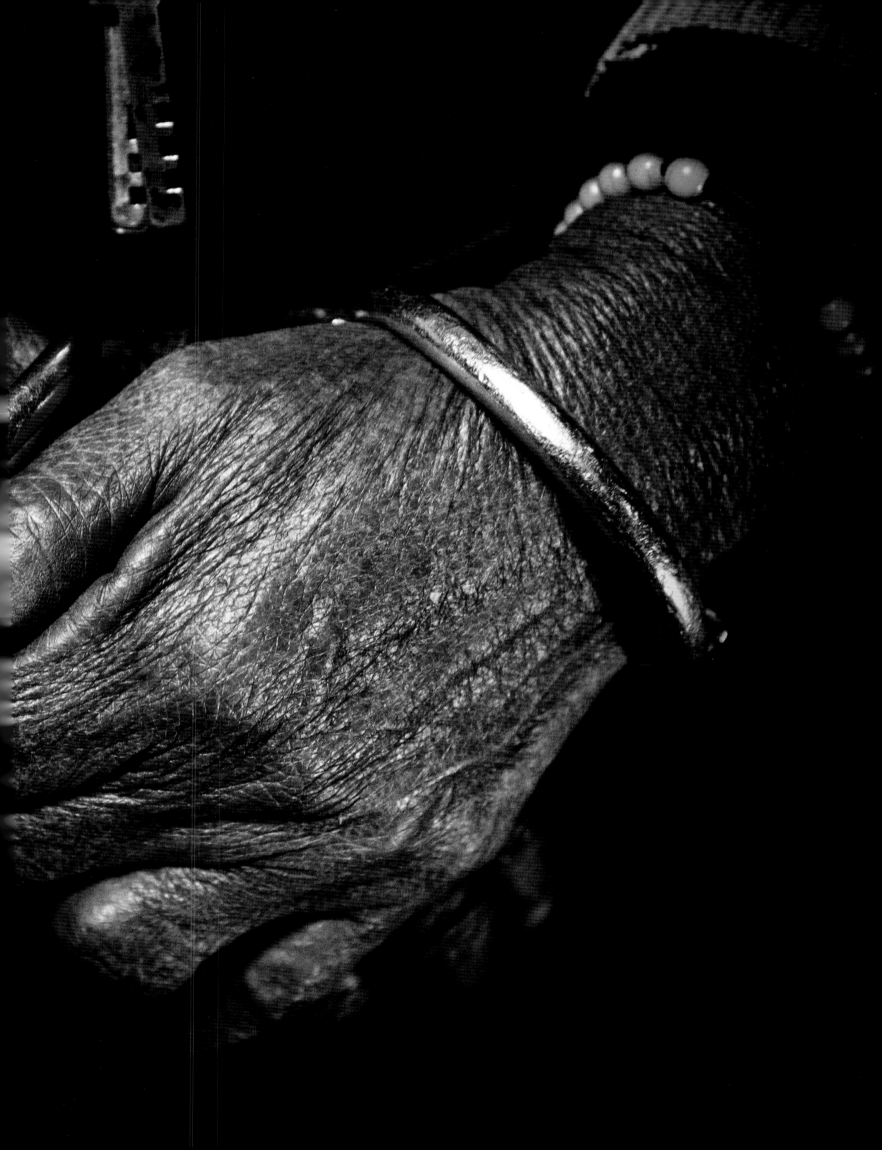

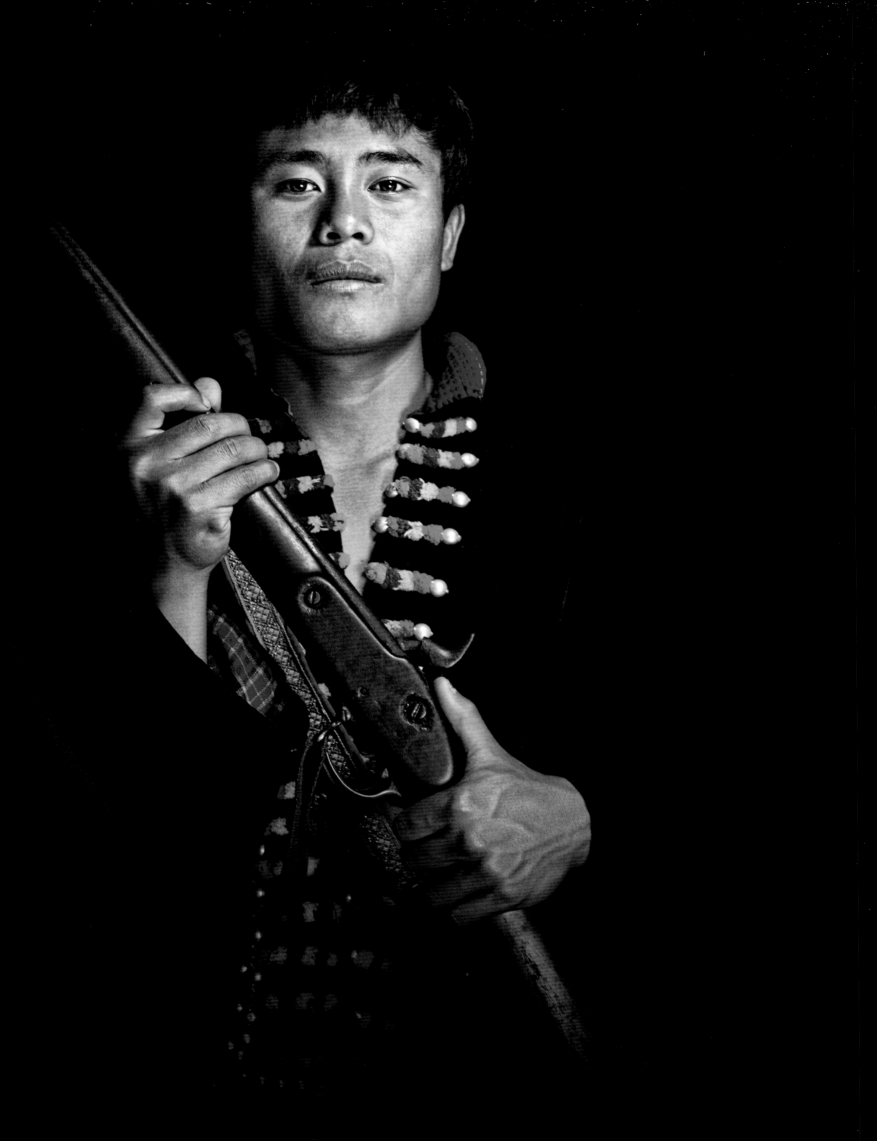

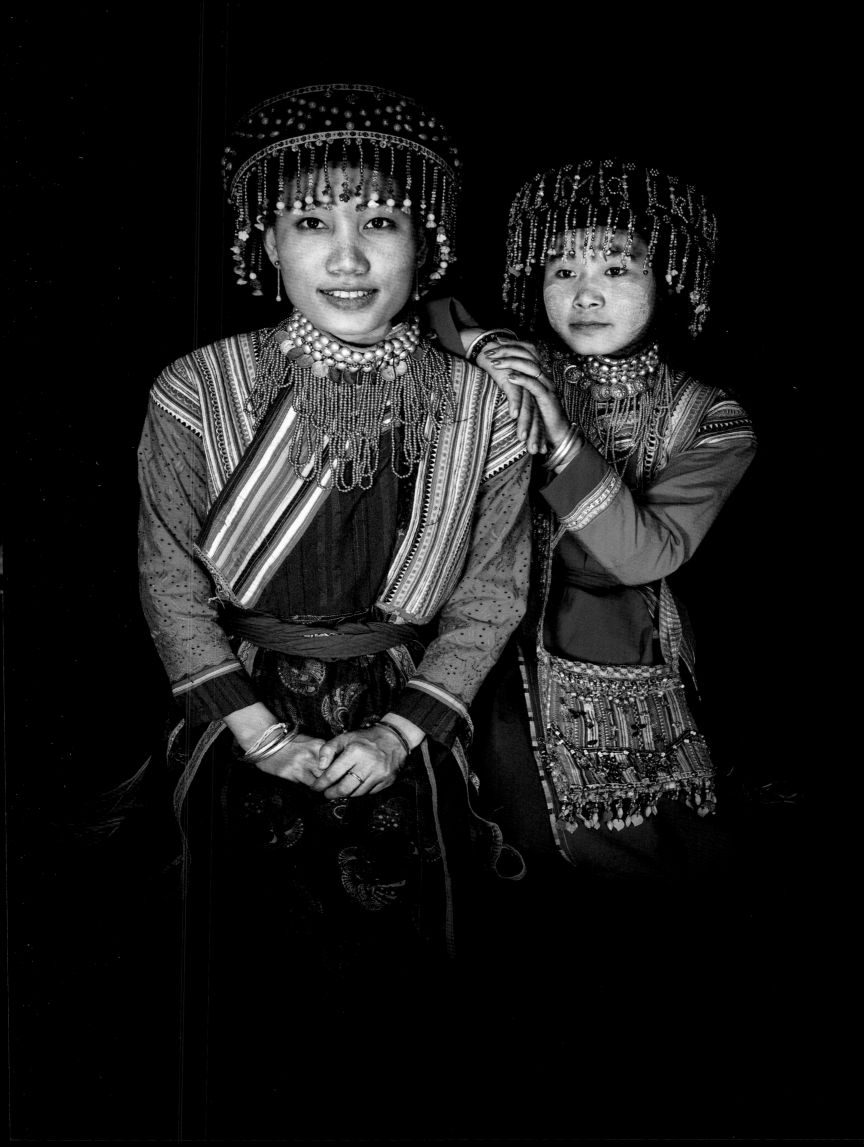

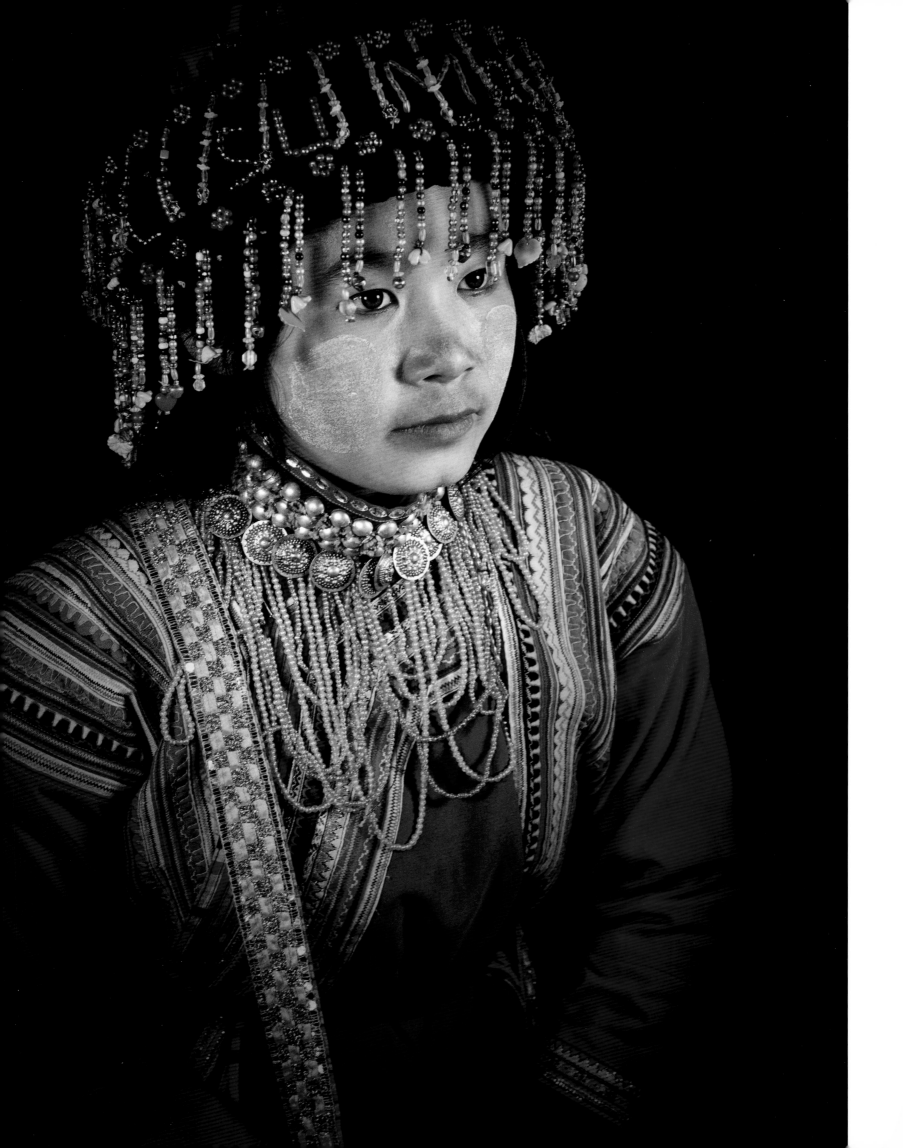

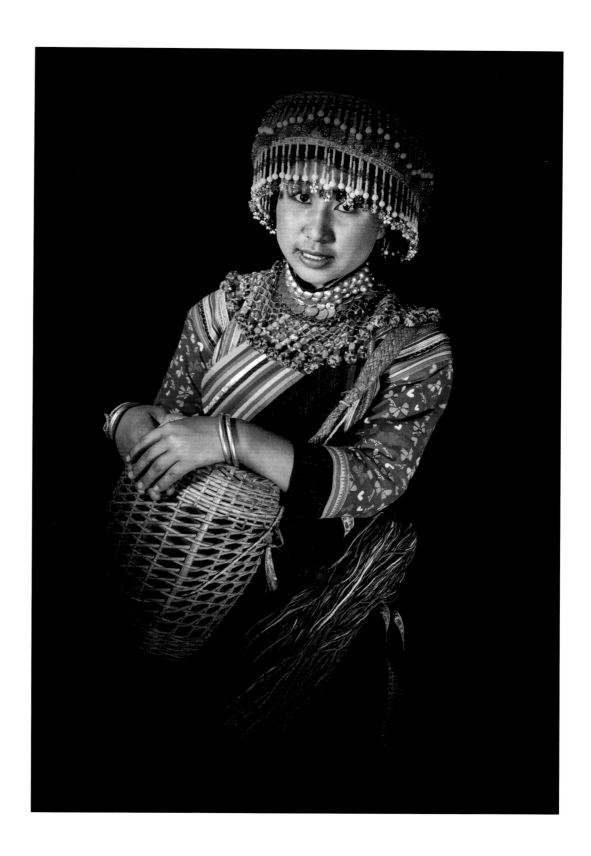

Traditional Lisu jewelry and textiles were produced using only natural materials and dyes. But now modern artificial materials such as plastics are incorporated into traditional designs, testifying to the continuing vitality and resourcefulness of those traditions and the people who practice them. Lisu culture is not a museum-piece but a way of life that continues to adapt and develop as all cultures must.

Links:

Der traditionelle Schmuck und die Kleidung der Lisu wurden mit natürlichen Materialien und Farben gefertigt. Inzwischen werden jedoch künstliche Materialien wie zum Beispiel Plastik mit verarbeitet, was die Findigkeit und die Kreativität des Volks beweist: Sie fertigen keine Ausstellungsstücke für Museen, sondern passen ihre Lebensweise dem Fortschritt an — wie viele andere Kulturen auch.

Right:

Traditional face tattoos are an increasingly rare sight amongst Chin women; only the elders still have this type of body art. In a few years, the practice may become entirely obsolete.

Rechts:

Die Tradition der Gesichtstätowierungen bei Frauen ist im Volk der Chin fast ausgestorben. Nur noch die Älteren schmücken sich mit ihnen. In einigen Jahren wird es vermutlich keine Frauen mit dieser Art Körperschmuck mehr geben.

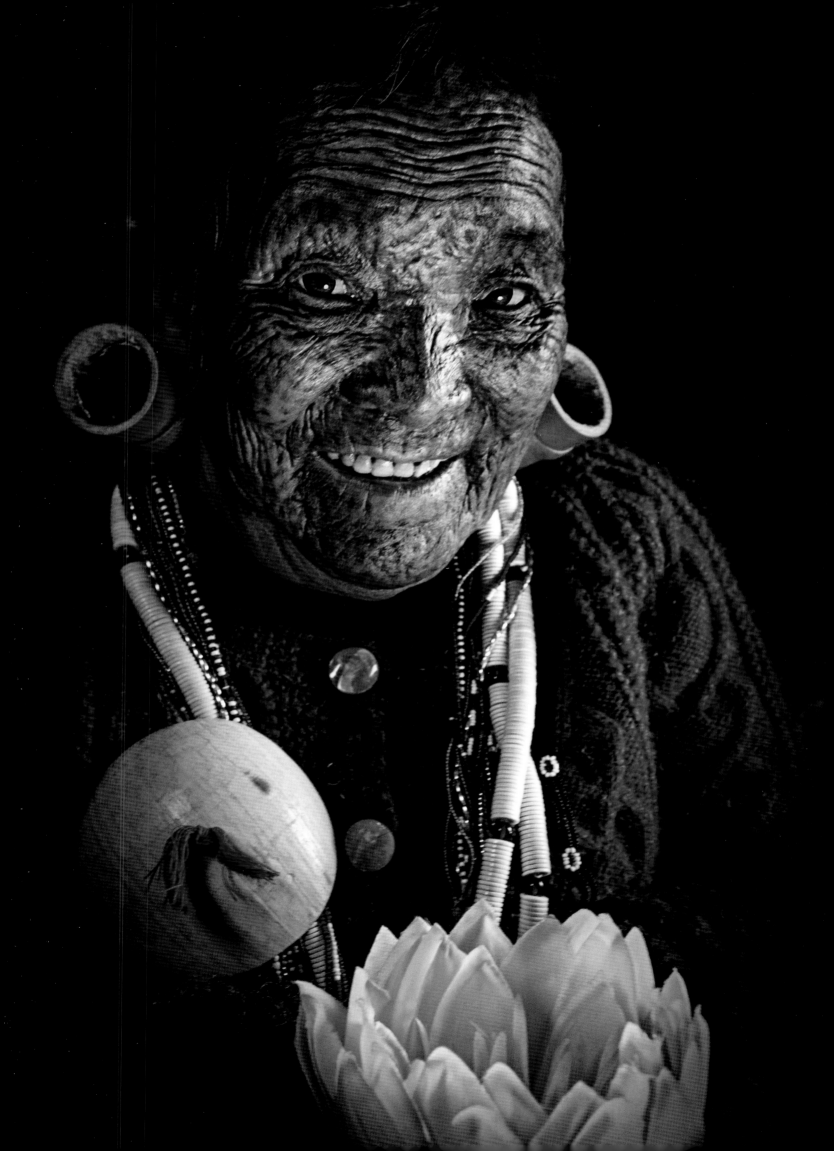

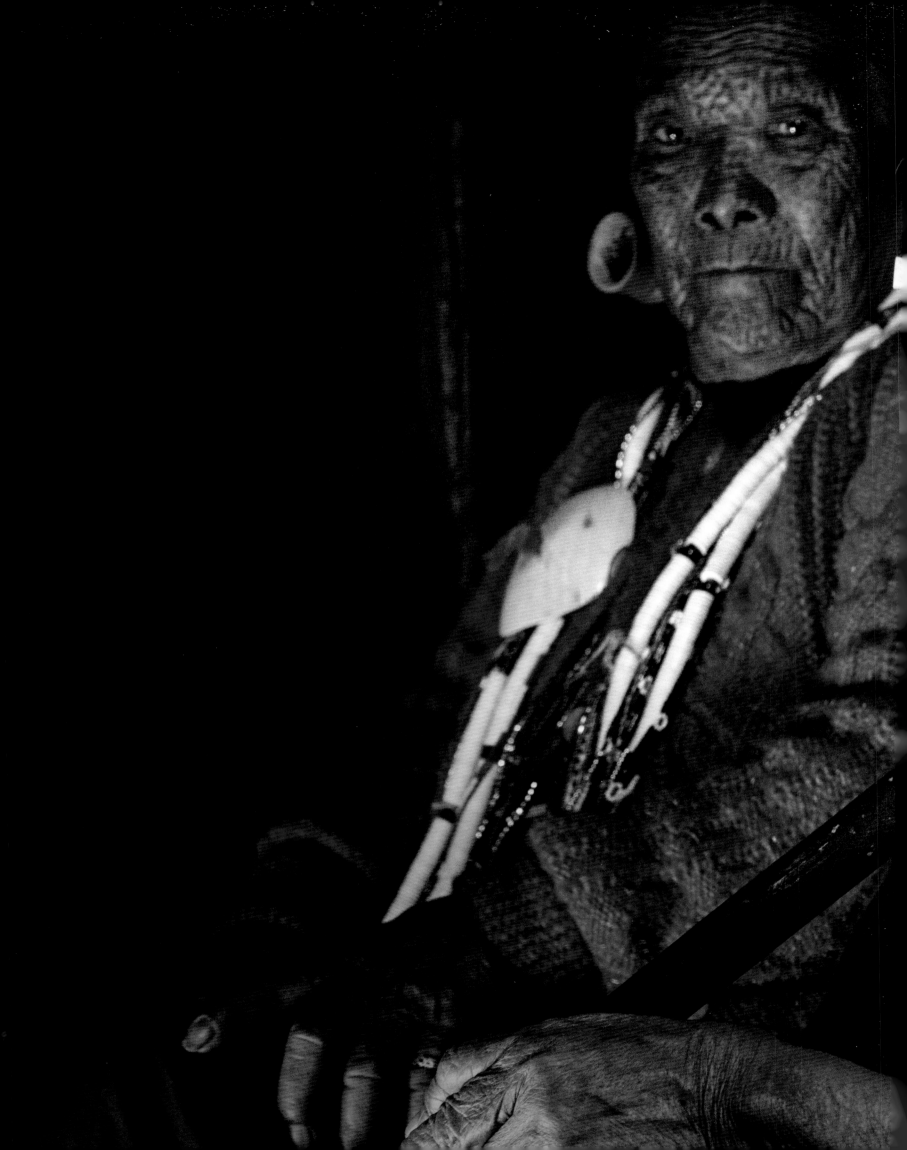

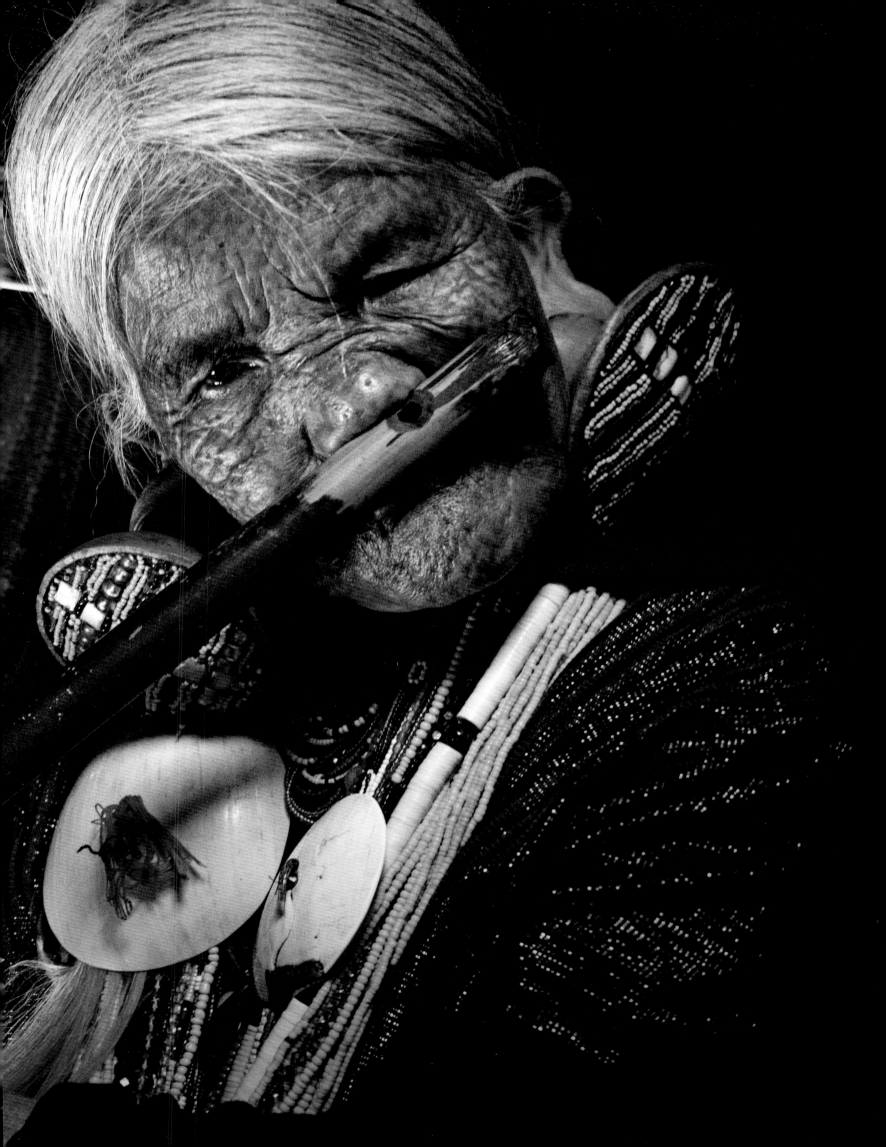

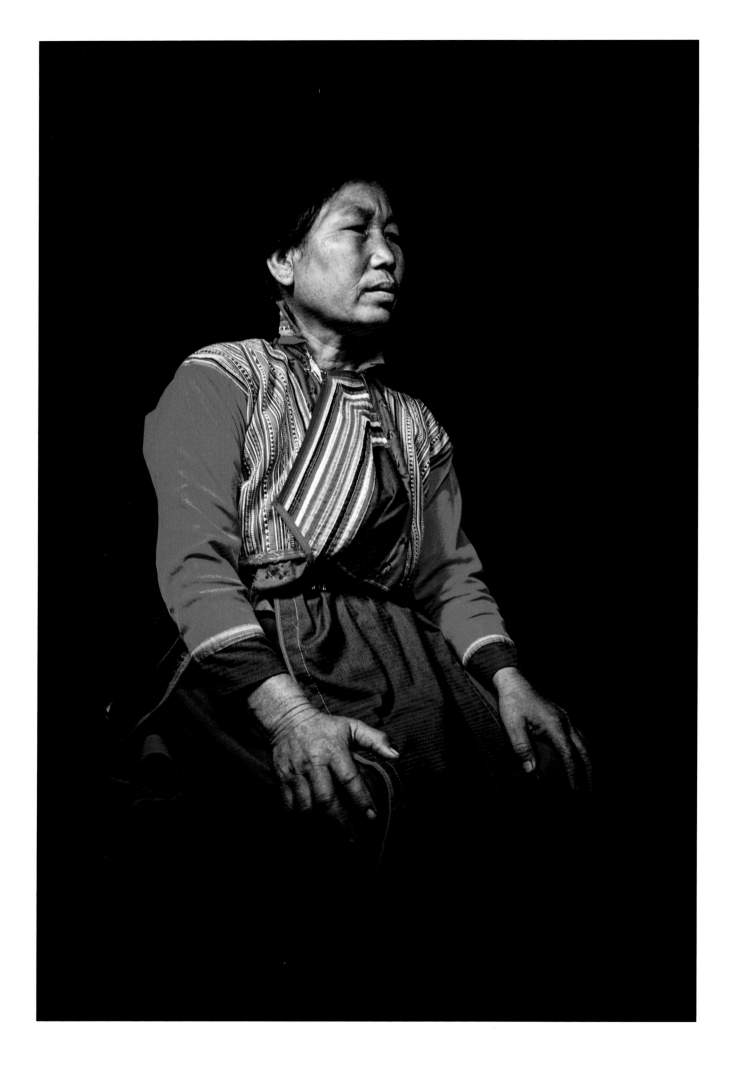

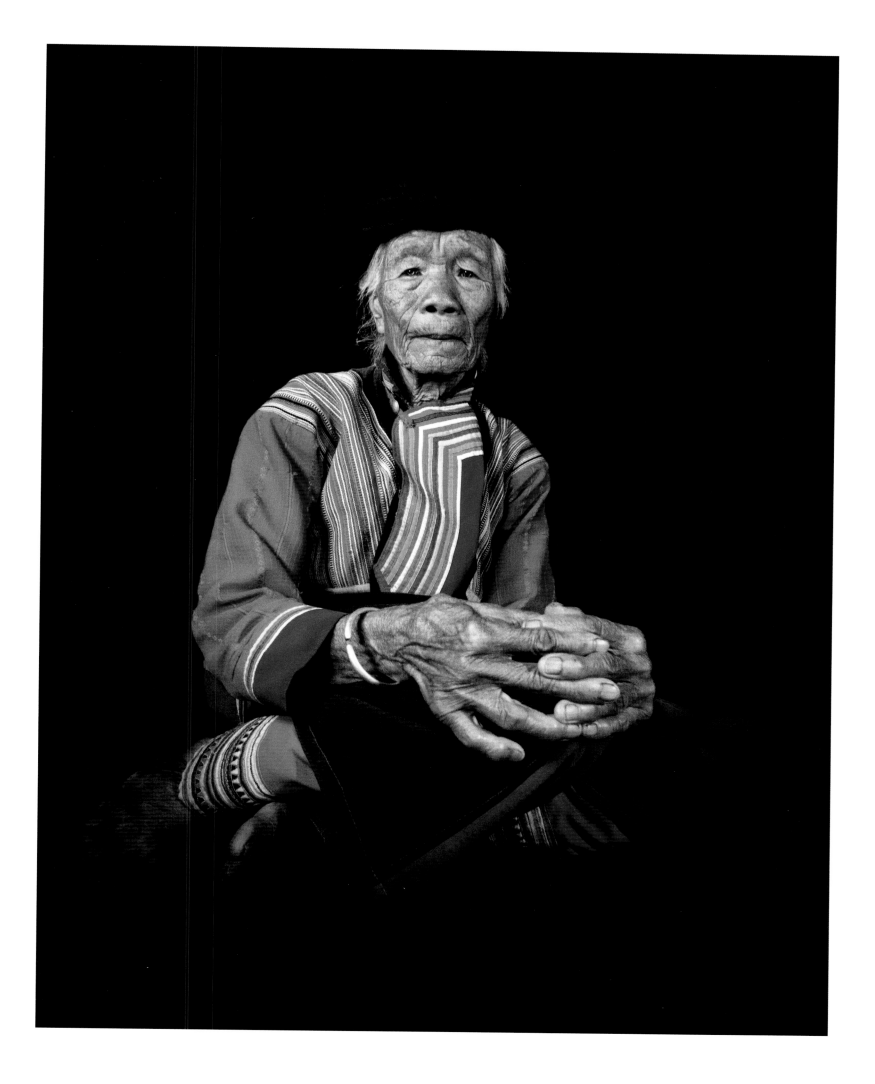

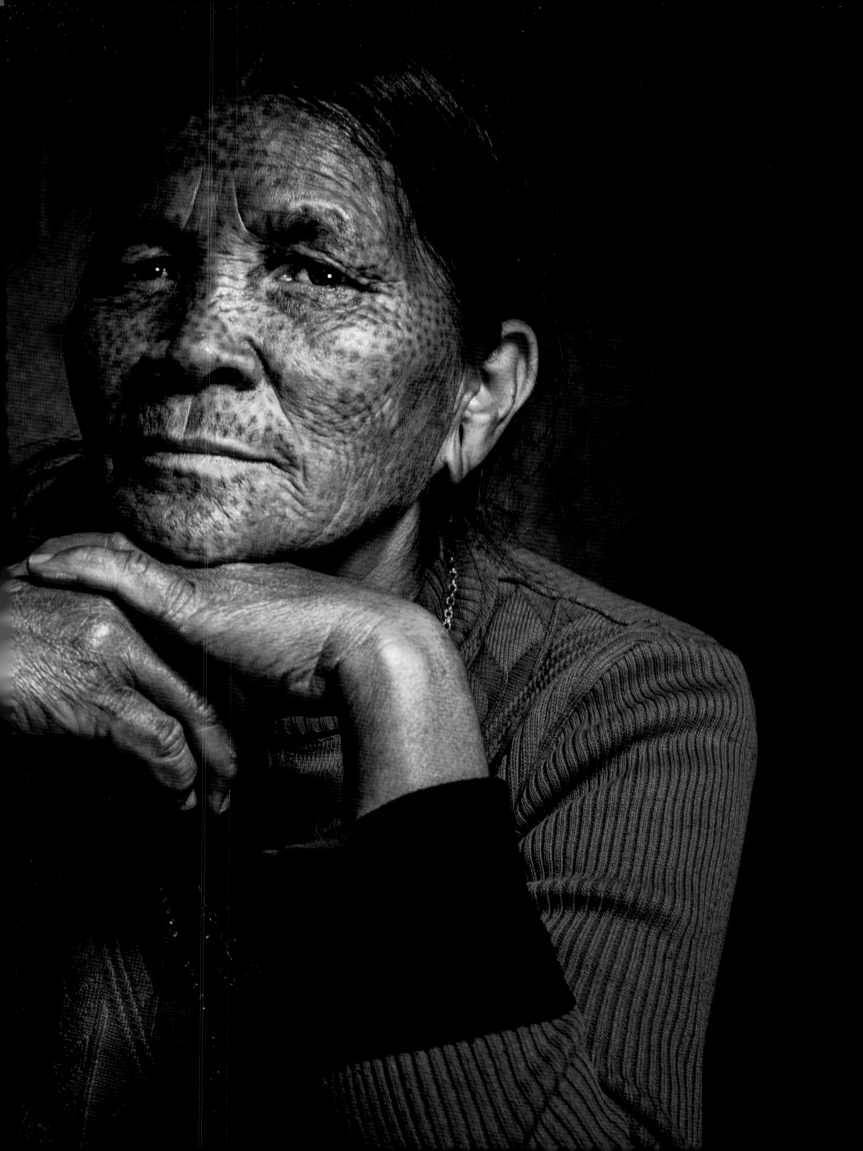

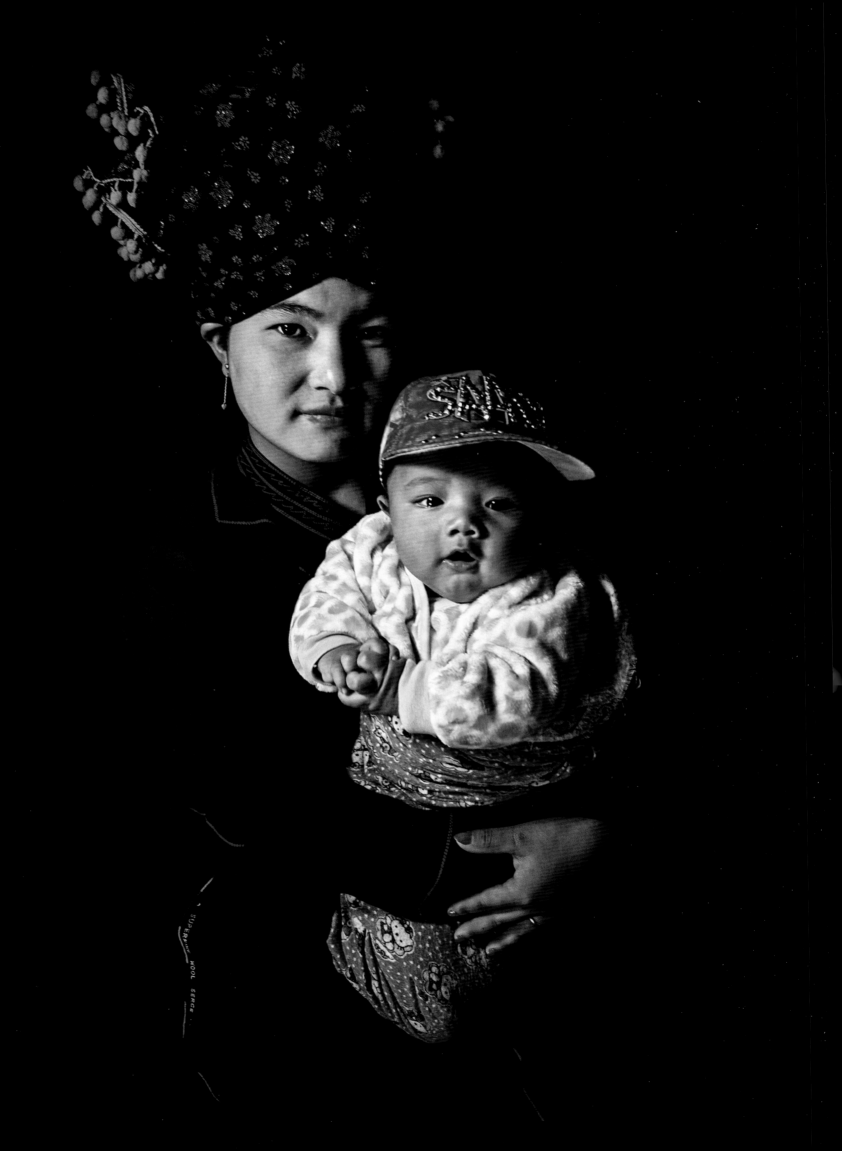

Here we see a vivid display of modernity merging with tradition, as happens every day in many places around the world. This image shows that the little boy will grow up in a new world yet have his roots firmly in tradition.

Hier zeigt sich die Verbindung, die die Moderne mit der Traditionen an vielen Orten der Welt eingeht. Der Kleine wird — wie auf diesem Bild angedeutet — in einer neuen Welt aufwachsen und seine Wurzeln doch in der Tradition haben.

NORTH

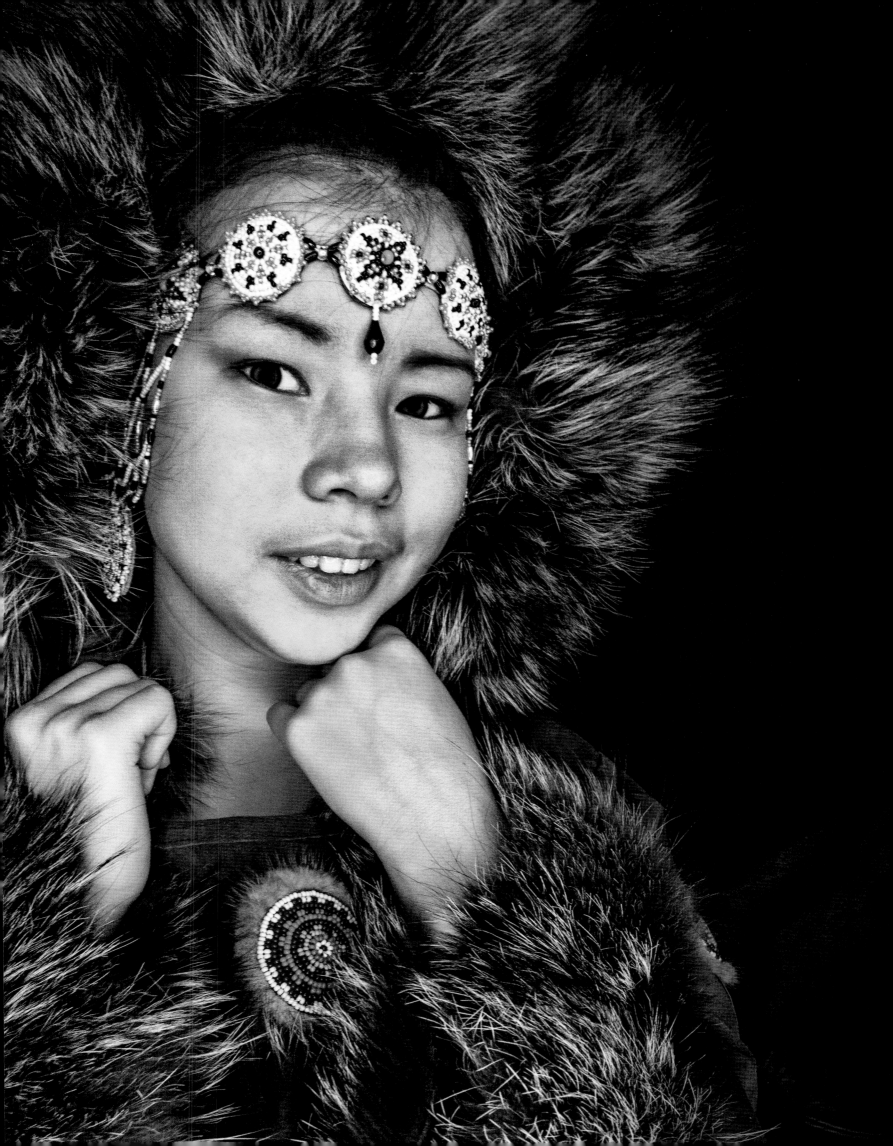

NORTH

My journey to meet many of the peoples depicted in this book carried me far from Russia and over innumerable national borders. To reach the Chukchi did not require that I cross a single one—but Russia contains multitudes, and I was still very far from anything like home.

Chukotka Autonomous Okrug is a region in Russia's remote far east, its Cape Dezhnev the mainland's easternmost point. To the north Chukotka is bordered by the Chukchi and East Siberian Seas, and to the southeast by the Bering Sea—with Alaska visible on clear days across the Bering Straight. To note that half of Chukotka lies within the Arctic Circle will likely conjure vistas of forbidding white, austere granite and perpetual cold. And extremity there is here, to be sure, Chukotka's weather conditions yielding bewildering shifts, punishing colds and more storms than anywhere else in Russia. But in

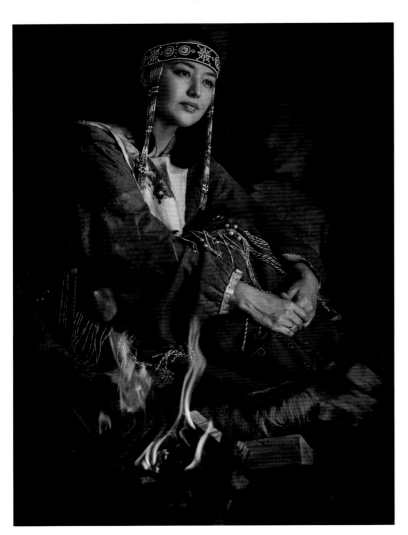

fact this extremely varied landscape is often numbered among the planet's most beautiful. As well as Arctic desert there is tundra and stunning bays and mountains—and vast expanses of taiga, the boreal or snow forest that covers upwards of 10% of the world's landmass.

Nevertheless. Lying along the path of the fabled Northwest Passage, Chukotka sits at the extreme margins of the habitable planet, among forbidding and unforgiving expanses that among outsiders for centuries were

IT'S THOUGHT THAT THE FIRST HUMAN PRESENCE HERE WERE MAMMOTH HUNTERS SOME 20,000 YEARS AGO.

known only to the most intrepid explorers or the most unlucky soldiers—many of whom never returned home. So it is all the more remarkable that there are peoples who call Chukotka home, and most numerous among these are the Chukchi.

It's thought that the first human presence here were mammoth hunters some 20,000 years ago—Wrangel Island to the northwest may have been the mammoth's final habitat—and hunting continues to be a staple of life in Chukotka. But with those prehistoric giants long extinct, in more recent millennia the region's hunters have pursued other game: inland principally reindeer, and for coast-dwellers marine mammals such as seals and whales. In fact, this distinction between inland and coastal is the primary one in Chukchi society as well, which has traditionally been divided into two groups corresponding to those areas and the ways of life associated with them.

The name Chukchi itself dates from around the seventeenth century, and means literally 'rich in deer'. But the aboriginal peoples of Chukotka also refer to themselves by a different term: Luoravetlan, or 'genuine people'. It is a name that suggests a robust sense of cultural self, and indeed the Chukchi have always been fiercely independent. Russian Orthodox missionaries appeared in the area in the early part of the eighteenth

century and had some apparent success in converting indigenous populations. But it is clear that the Chukchi have also maintained the animist religion and ritual practices that have structured their way of life time out of mind. And as we see from some of the photographs here, that way of life is truly striking. Their dwellings, known as yaranga, are low-slung skin tents that become sufficiently warm that inside people are typically naked; their kayaks are so swift in the water that manufacturers in the modern west have utilized elements of their design. The Chukchi's traditional weatherproof garments are made from (among other things) whale intestine and fish skin; traditional battle-garb is very imposing Laminar armour made from hardened animal pelts and wood. So central is music to Chukchi culture that each individual person has a song particular to them.

But after these many centuries of robust adherence to the old ways, in the twenty-first century the Chukchi find themselves in a position of the most serious precarity.

Today the Chukchi represent about a quarter of the region's population, numbering 15,000 or so: these are nearly all the world's Chukchi, with perhaps another 2000 living in neighboring okrugs or scattered around the globe, and only a small proportion continuing to live in the old ways. The damage really began in the twentieth century. Vast reserves of natural resources were discovered in the region, including rich gold fields, and Chukchi social and economic life was reorganized during the 1950s especially, as the Soviet regime encouraged indigenous peoples to move from their villages to larger settlements as part of the modernizing project. This resulted in seismic cultural shocks and losses that were only exacerbated by the processes of privatization that followed the demise of the Soviet Union. In fact the harsh geography and climate of Chukotka, which made mining here complex and expensive, helped the Chukchi to preserve their traditional way of life. But climate-change and the decreasing numbers of marine mammals have had significant negative impacts on the Chukchi, from the deer-breeders inland to those dwelling on the coast, placing their culture and traditions in fresh peril. Thus the way of life to which these photographs draw attention is a profoundly endangered one.

NORDEN

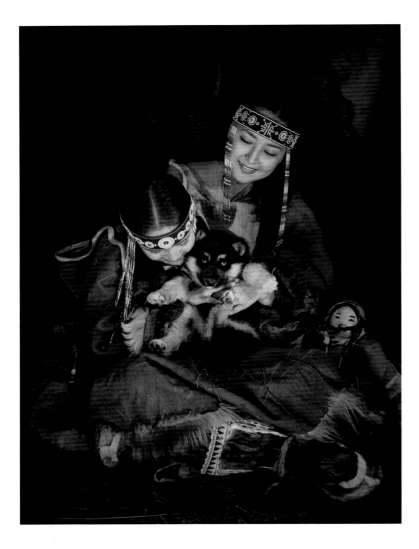

Um den hier abgebildeten Völker begegnen zu können, ließ ich Russland weit hinter mir und überquerte zahlreiche Grenzen. Um die Tschuktschen zu erreichen, musste ich keine einzige Landesgrenze überschreiten – doch Russland ist voller Facetten, und ich fühlte mich meiner Heimat sehr fern.

Der Autonome Kreis der Tschuktschen, kurz Tschukotka, ist eine Region im Osten Russlands; Teil Tschukotkas ist Kap Deschnjow, der östlichste Punkt des Festlands. Im Norden Tschukotkas liegen die Tschuktschensee und das Ostsibirische Meer, südöstlich befindet sich das Beringmeer – bei gutem Wetter kann man jenseits der Beringstraße Alaska sehen. Der Hinweis, dass Tschukotka zur Hälfte im arktischen Polarkreis liegt, wird Assoziationen mit unerbittlichen, marmorglatten Schneelandschaften und beißender Kälte hervorrufen, und tatsächlich ist

Tschukota eine Region der Extreme, mit verwirrenden Wetterumschwüngen, gnadenloser Kälte und mehr Orkanen als in irgendeiner anderen Region Russlands. Doch die vielfältige Landschaft wird oft als eine der schönsten der Welt bezeichnet. Abgesehen von der arktischen Wüste gibt es hier auch Tundra sowie atemberaubende Buchten und Berge – und die Taiga, den Schnee- bzw. borealen Nadelwald, der sich über mehr als 10% der Landmasse unseres Planeten erstreckt.

Doch Tschukotka, das an der berühmten Nordwestpassage liegt, ist trotz aller Schönheit an der äußersten Grenze dessen, was als bewohnbar gelten kann, zwischen widrigen, gnadenlosen Landschaften, die bei Außenstehenden jahrhundertelang nur von den Forschern mit dem größten Mut oder von den Soldaten mit dem größten Pech durchquert wurden – viele von ihnen kehrten nie zurück. Umso bemerkenswerter ist es, dass es Völker gibt, die Tschukotka ihr Zuhause nennen, und die zahlreichsten unter ihnen sind die Tschuktschen.

Man geht davon aus, dass die erste menschliche Besiedelung hier vor etwa 20.000 Jahren durch Mammutjäger stattfand – die Wrangelinsel im Nordwesten war möglicherweise der letzte Lebensraum des Mammuts – und die Jagd ist noch immer ein wichtiger Bestandteil des Lebens in Tschukotka. Da diese prähistorischen Giganten längst von der Erdoberfläche verschwunden sind, spezialisierten sich die Jäger dieser Region in den letzten Jahrtausenden auf andere Beute: auf dem Land hauptsächlich auf Rentiere und in den Küstenregionen vor allem auf Meersäuger wie Robben und Wale. Diese Unterscheidung zwischen Festland und Küste ist sehr wichtig in der Gesellschaft der Tschuktschen. Diese besteht aus zwei verschiedenen Gruppen, die jenen beiden Regionen und den mit ihnen verbundenen Lebensweisen entsprechen.

Der Name Tschuktschen geht auf das 17. Jahrhundert zurück und bedeutet wörtlich übersetzt „reich an Rentieren". Doch die Ureinwohner Tschukotas haben noch einen anderen Namen für ihr eigenes Volk: Luoravetlan, oder „echtes Volk". Dieser Name weist auf ein starkes kulturelles Selbstbewusstsein hin, und tatsächlich waren die Tschuktschen immer schon ein extrem unabhängiges Volk. Im 16. und 17. Jahrhundert, als die Russen aus dem

Westen kamen und einen größtenteils erfolglosen Unterwerfungsversuch unternahmen, der sich bis ins frühe 19. Jahrhundert ziehen sollte, versetzten die Tschuktschen den kolonialisierenden Gruppen verheerende Niederlagen. Russisch-orthodoxe Missionare erschienen Anfang des 18. Jahrhunderts in der Region und hatten ei-

HEUTE REPRÄSENTIEREN DIE TSCHUKTSCHEN MIT RUND 15.000 EINWOHNERN ETWA EIN VIERTEL DER BEVÖLKERUNG.

nige Erfolge in der Missionierung der Bevölkerung, doch insgesamt bewahrten die Tschuktschen ganz offensichtlich den Animismus und die Rituale, die ihre Lebensweise seit jeher bestimmten. Wie wir anhand dieser Bilder sehen können, ist diese Lebensweise faszinierend. Ihre Unterkünfte, sogenannte Yarangas, sind flache Lederzelte, in denen es so warm wird, dass die Menschen in ihnen meistens nackt sind. Ihre Kajaks bewegen sich so schnell im Wasser, dass Designer im modernen Westen einige ihrer Bauelemente übernahmen. Die traditionelle wasserabweisende Kleidung der Tschuktschen besteht unter anderem aus Wal-Darm und Fischleder; Traditionelle Kriegsausrüstung ist eine beeindruckende Schuppenrüstung aus verstärktem Tierfell und Holz. Musik spielt eine so zentrale Rolle in der Kultur der Tschuktschen, dass jede Person ein individuelles, persönliches Lied hat.

Heute repräsentieren die Tschuktschen mit rund 15.000 Einwohnern etwa ein Viertel der Bevölkerung der Region: Das sind fast alle Tschuktschen der Welt, wobei vielleicht weitere 2000 im benachbarten Okrug oder über den ganzen Globus verstreut leben. Nur noch ein kleiner Teil lebt nach der traditionellen Lebensweise. Der Niedergang begann im 20. Jahrhundert. In der Region wurden riesige Vorkommen an natürlichen Ressourcen entdeckt, darunter reiche Goldfelder. Das soziale und wirtschaftliche Leben der Tschuktschen wurde vor allem in den 1950er-Jahren neu organisiert, als das Sowjetregime die indigenen Völker im Rahmen eines Modernisierungsprojekts ermutigte, aus ihren Dörfern in größere Siedlungen umzuziehen. Dies führte zu einem Kultur-

schock, der durch die Privatisierungsprozesse nach dem Untergang der Sowjetunion nur noch verschärft wurde. Und doch gibt es auch Lichtblicke: Die raue Geographie und das Klima Tschukotkas, die den Bergbau verkomplizierten und verteuerten, halfen einigen Tschuktschen, ihre traditionelle Lebensweise zu bewahren. Heute jedoch haben vor allem der Klimawandel und die abnehmende Zahl der Meeressäuger erhebliche negative Auswirkungen, von den Hirschzüchtern im Landesinneren bis zu denen, die an der Küste leben. Er bringt die Kultur und Traditionen der Tschuktschen erneut in Gefahr. Daher ist die Lebensweise, auf die diese Fotos aufmerksam machen, zutiefst gefährdet.

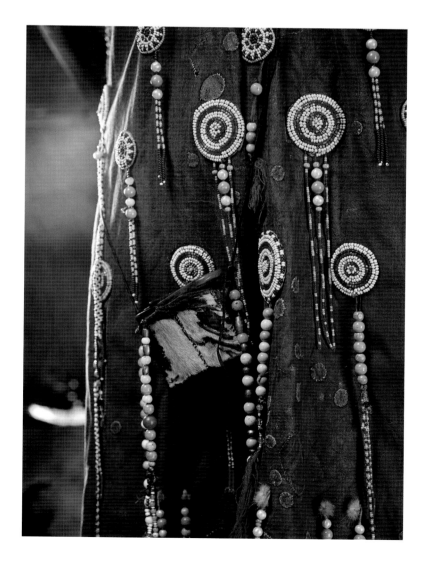

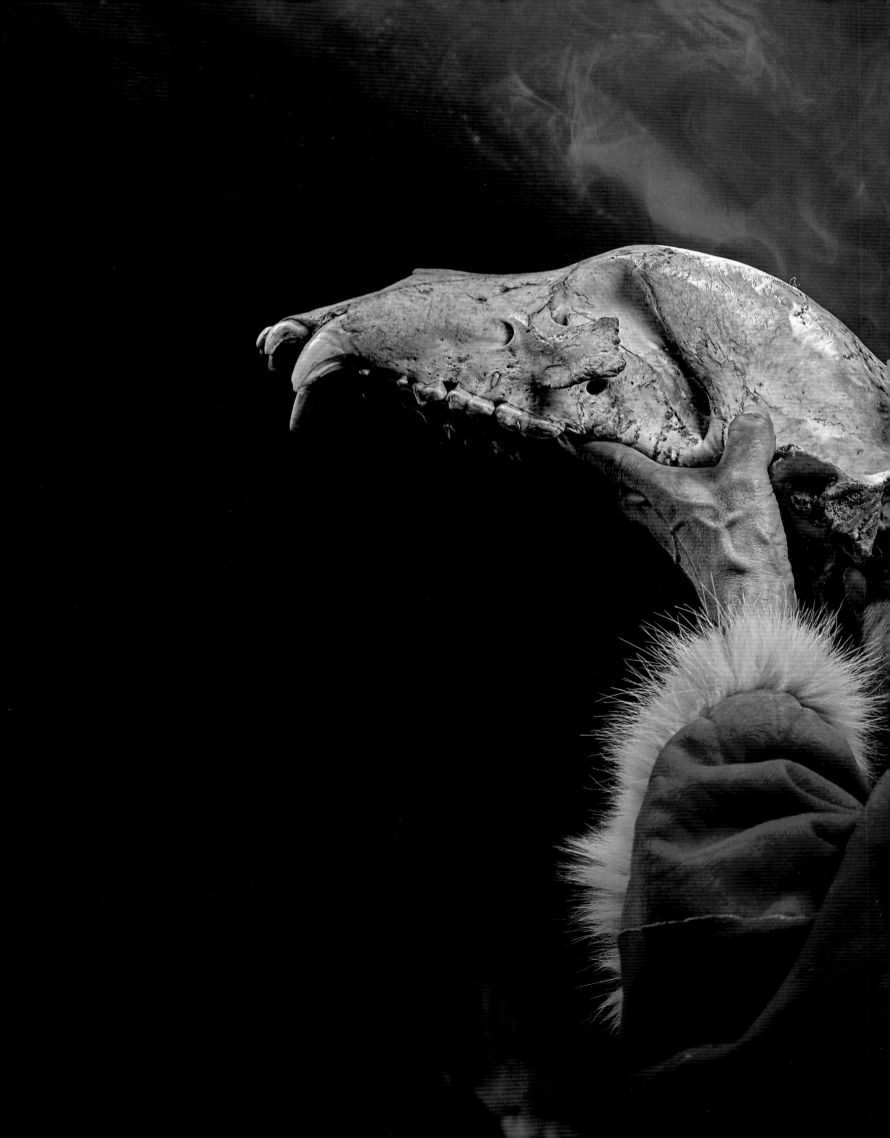

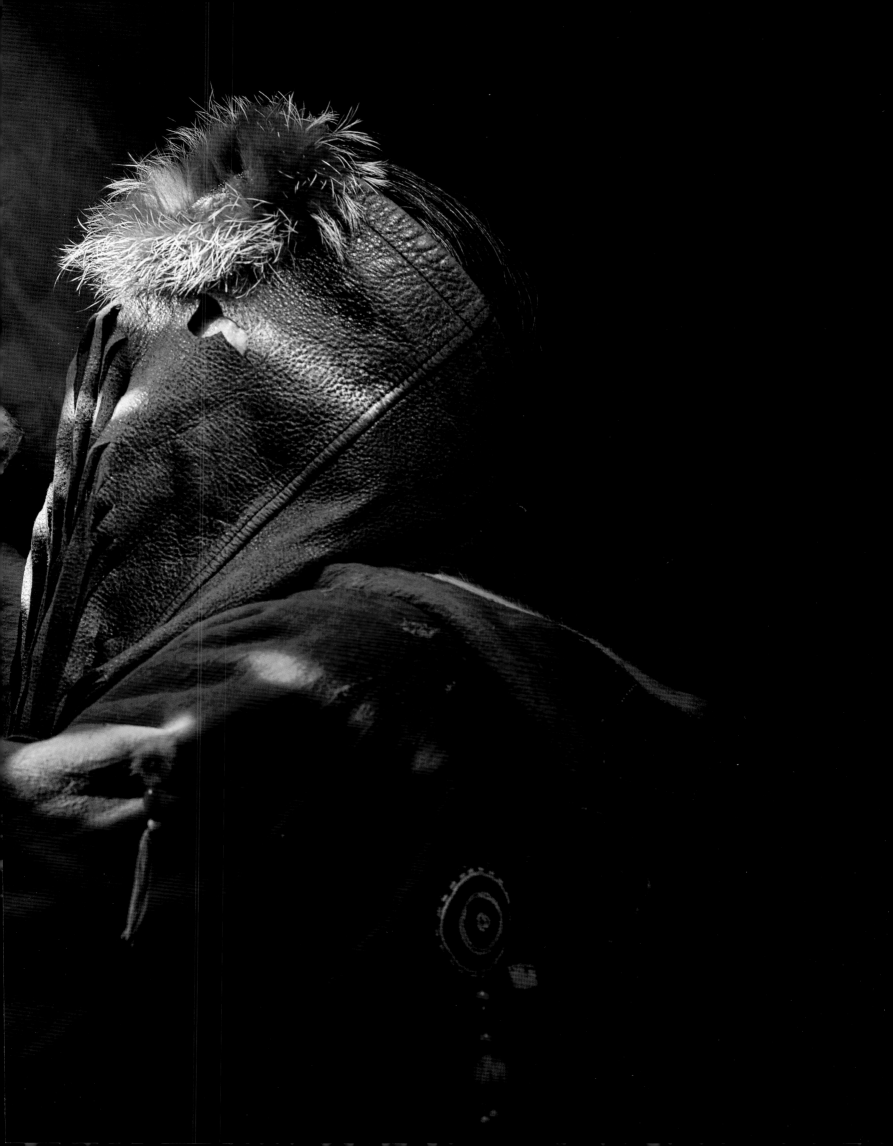

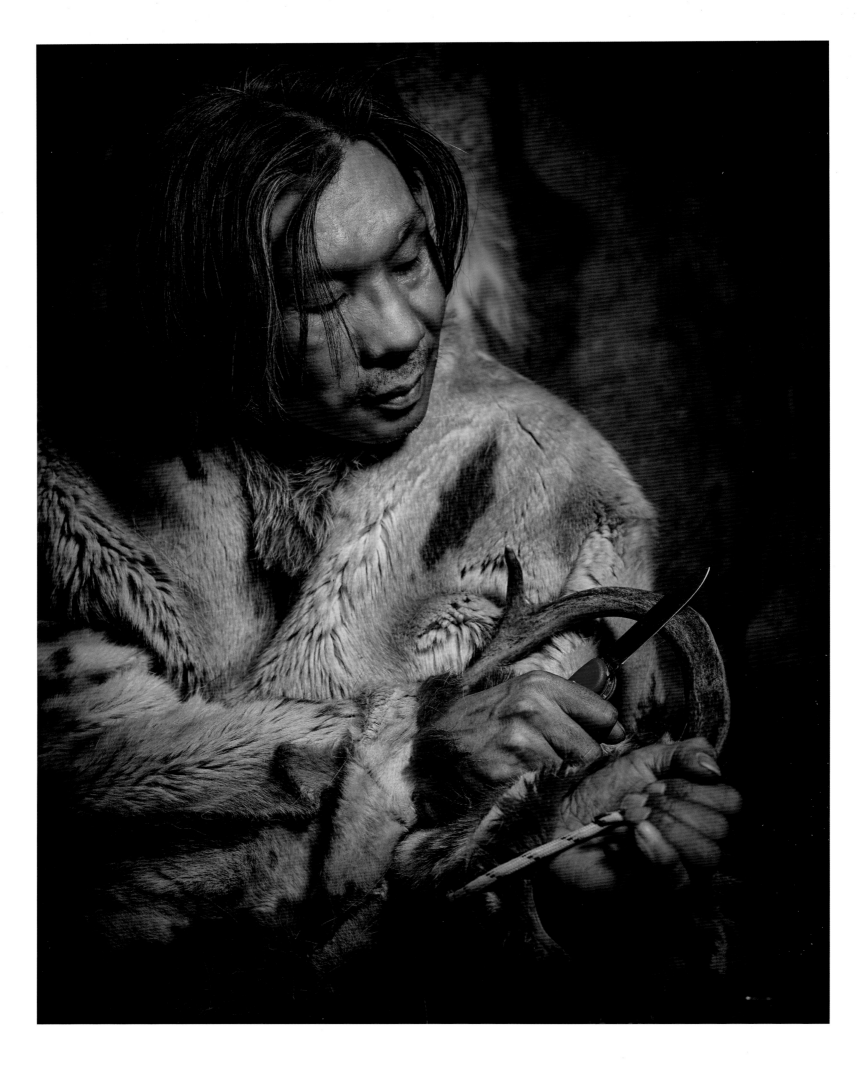

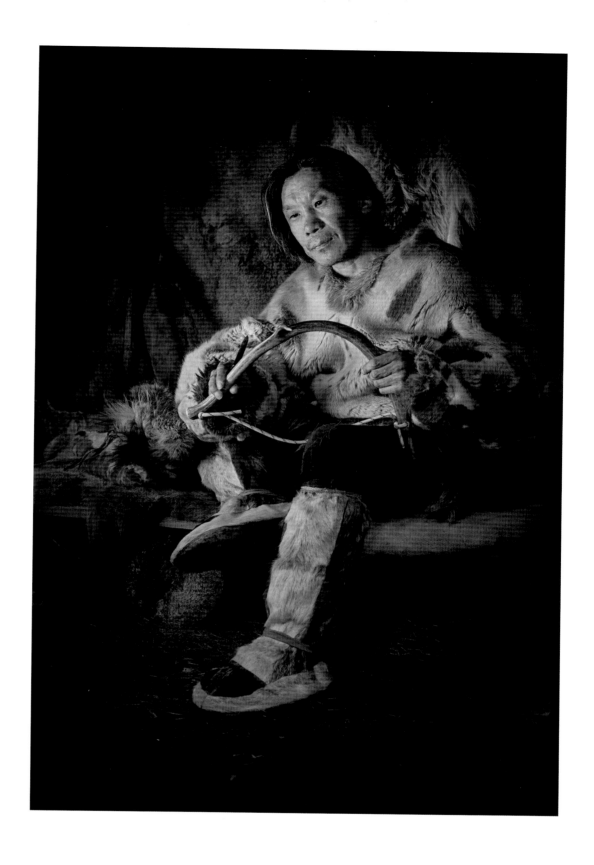

Right:

Gift-giving was one strategy employed by missionaries in their efforts to convert the Chukcha to Christianity. But the condescending attitude this implies was ill-founded, and in fact we might conclude that it is the missionaries who come out of the story looking hapless or naive: for very often after receiving the gifts it seems that the Chukcha would immediately continue worshipping their traditional spirits.

Rechts:

Geschenke gehörten zu den Strategien, die die Missionare anwandten, um die Tschuktschen zum Christentum zu bekehren. Doch ihre überhebliche Art war völlig unangebracht, und tatsächlich waren es die Missionare, die in dieser Geschichte als dumm und naiv dastehen: Nachdem die Tschuktschen ihre Geschenke erhalten und sich der Form halber der neuen Religion gewidmet hatten, gingen sie dazu über, wieder ihre traditionellen Geister anzubeten.

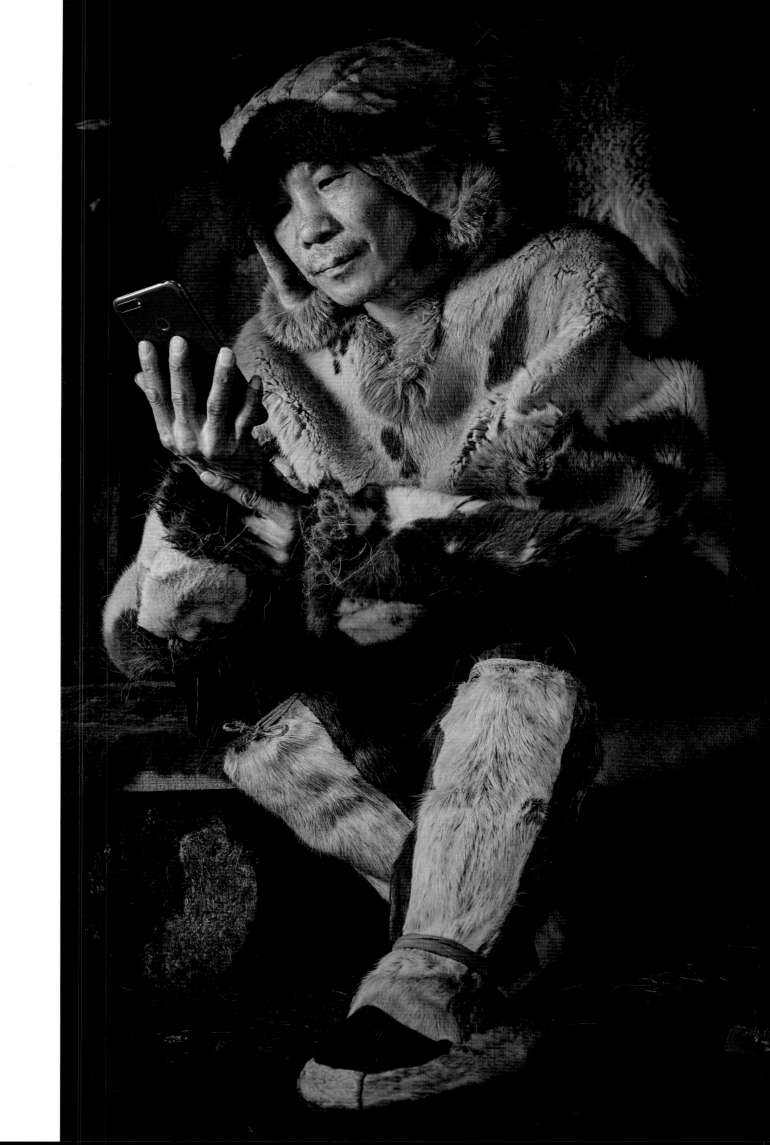

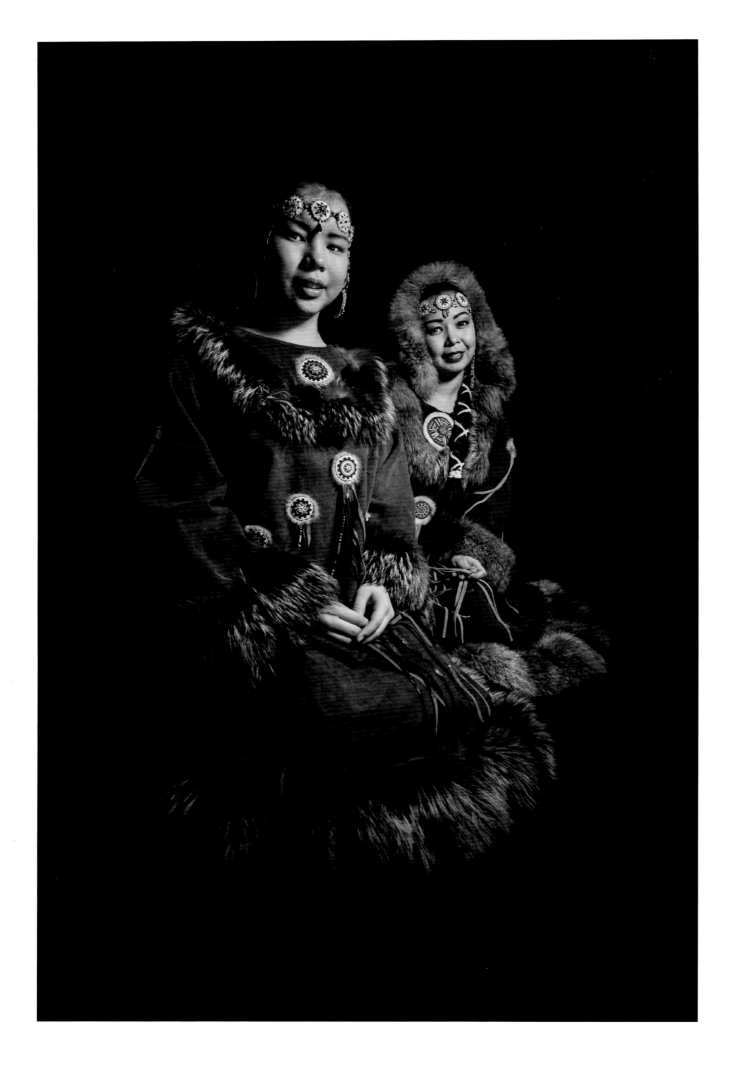

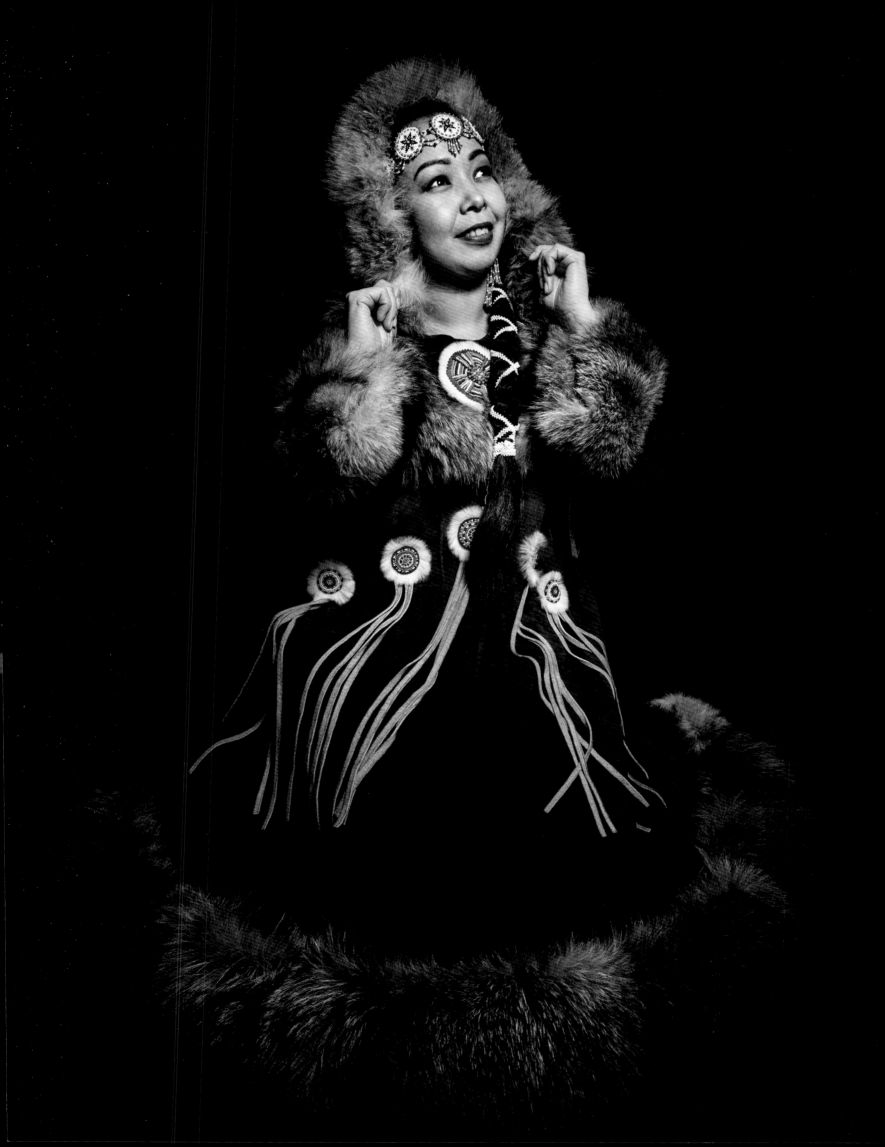

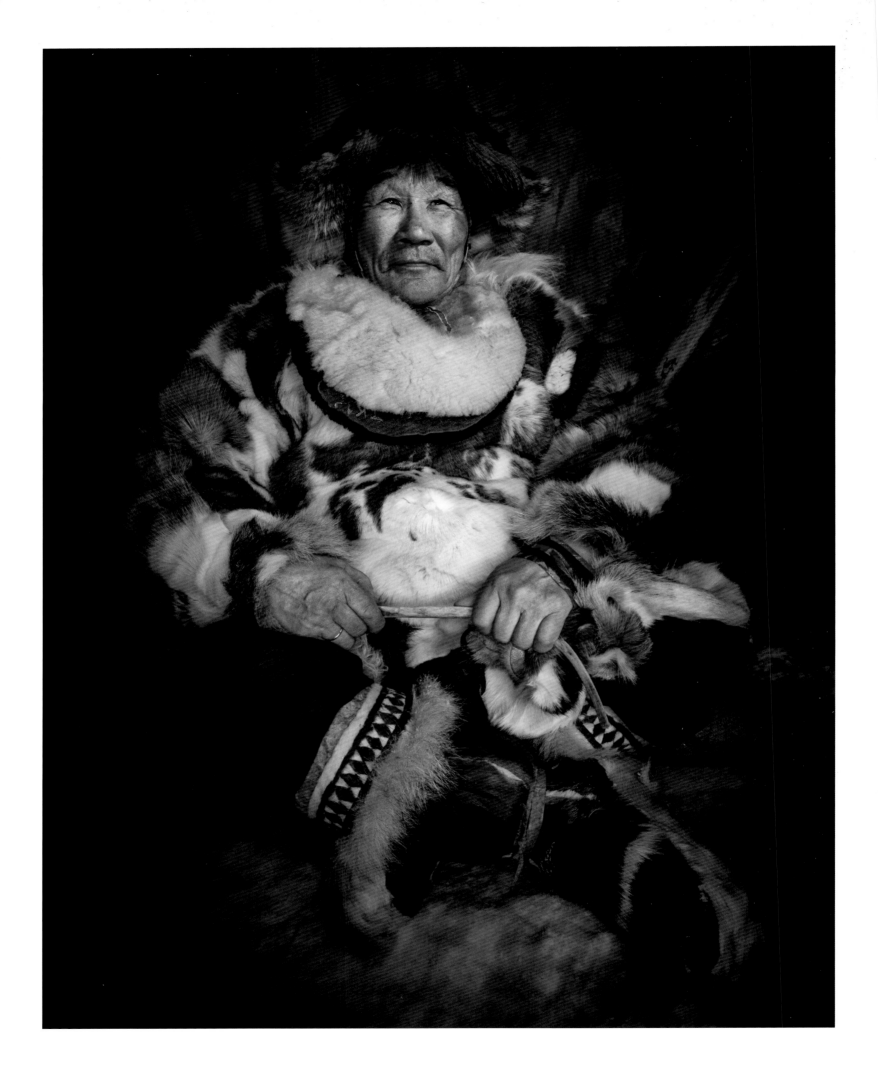

Previous page on the right:

Though modern cosmetics have arrived in Chukotka in recent decades, once if Chukchi women decorated their faces they did so with tattoos depicting either human figures or patterns. For these there were two methods. In the first, a thread soaked in paint made from a mix of soot or powdered coal and animal fat (sometimes with urine and powdered graphite added as well) was drawn through the skin with a needle; in the second the desired pattern was pricked into the skin and soot rubbed into the resulting wounds. This is a practice that now seems to have fallen completely out of use.

Vorherige Seite rechts:

In den letzten Jahrzehnten ist auch die moderne Kosmetik in Tschukotka angekommen; Früher schmückten weibliche Tschuktschen ihre Gesichter mit Tattoos, die Muster oder menschliche Figuren zeigten. Es gab zwei Methoden: In der ersten wurde ein Faden, getränkt mit einer Färbung aus Asche oder geriebener Kohle und Tierfett (manchmal gemischt mit Urin und gemahlenem Graphit) mit einer Nadel durch die Haut gezogen. In der zweiten Methode wurde das Muster in die Haut gestochen und Asche in die Wunden gerieben. Diese Tradition wird heute fast gar nicht mehr praktiziert.

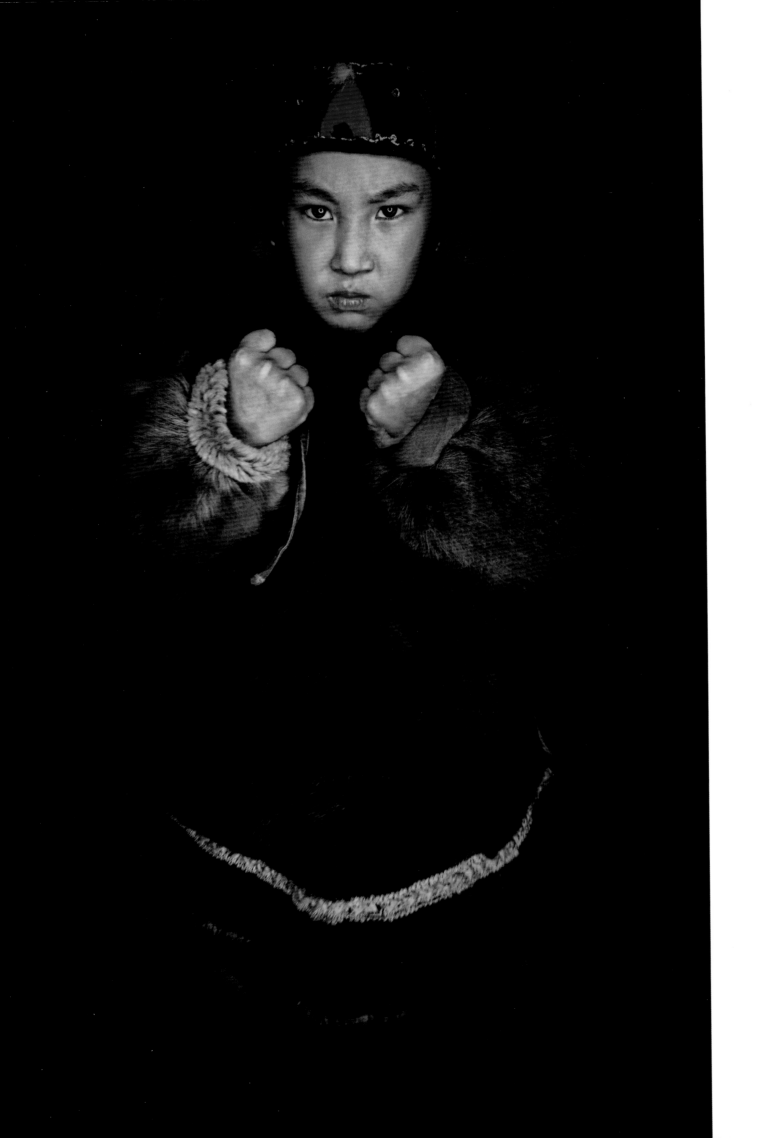

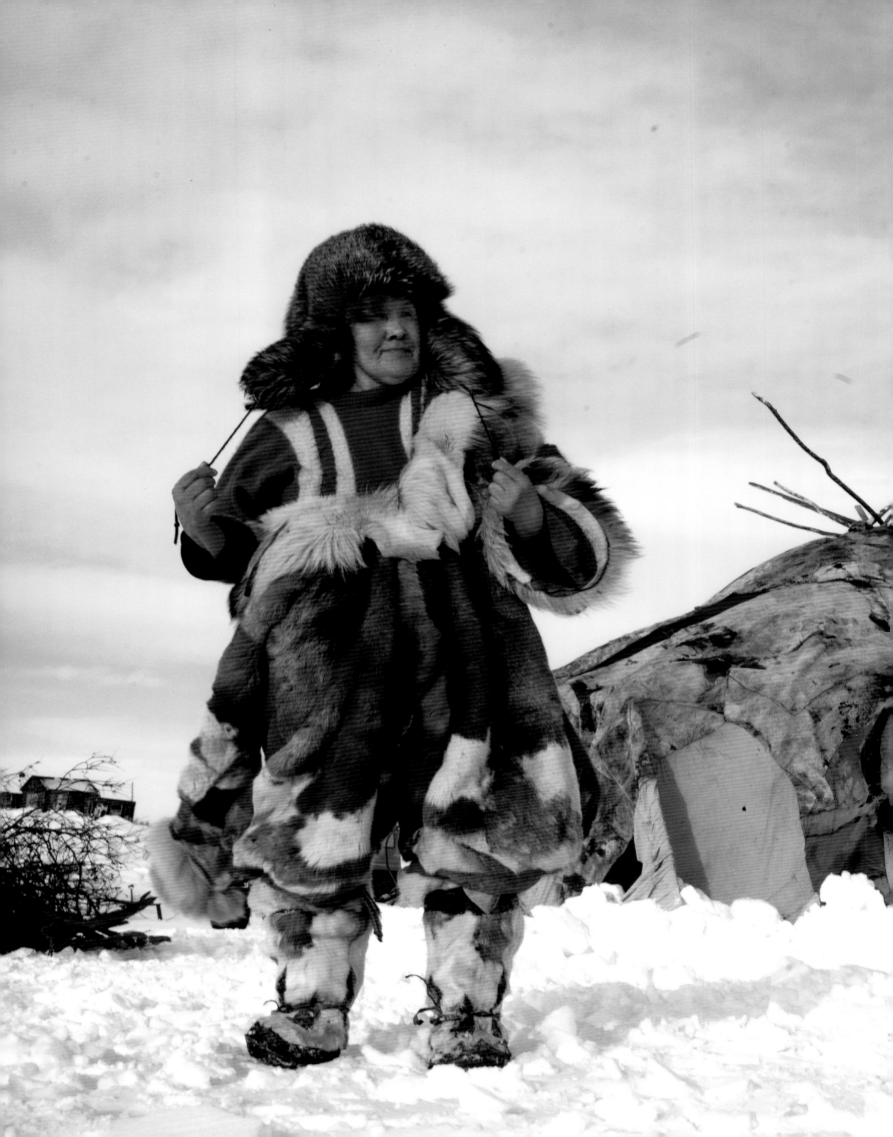

Previous page:

One sign of the unconscious condescension with which we in the 'developed' world often view indigenous peoples is our assumption that they continue in their traditional ways only owing to a lack of access to modern innovations. But in fact traditional Chukchi leather and fur garb—for example—are often better suited to the extreme conditions in which they live than anything modern technology has to offer.

Right:

Yarangas are the mobile tent-homes that are the traditional dwelling of the Chukchi, and each uses around 35 deerskins; erecting one is exclusively the task of women and is a serious undertaking requiring several hours of concerted effort.

Vorherige Seite:

Eines der überheblichen Vorurteile, die wir im „entwickelten" Westen in Bezug auf indigene Völker haben, ist, dass diese ihre Traditionen nur deswegen aufrecht erhalten, weil sie keinen Zugriff auf moderne Innovationen haben. Tatsächlich aber ist die traditionellen Leder- und Fellkleidung viel besser geeignet für die extremen Bedingungen als alles, was moderne Technologie zu bieten hätte – und das ist nur ein Beispiel von vielen.

Rechts:

Yarangas sind die mobilen Zelt-Häuser und die traditionelle Behausung der Tschuktschen. Jedes einzelne von ihnen besteht aus etwa 35 Rentierledern. Das Aufstellen ist ein schwieriger, oft stundenlanger Prozess, der nur den Frauen vorbehalten ist.

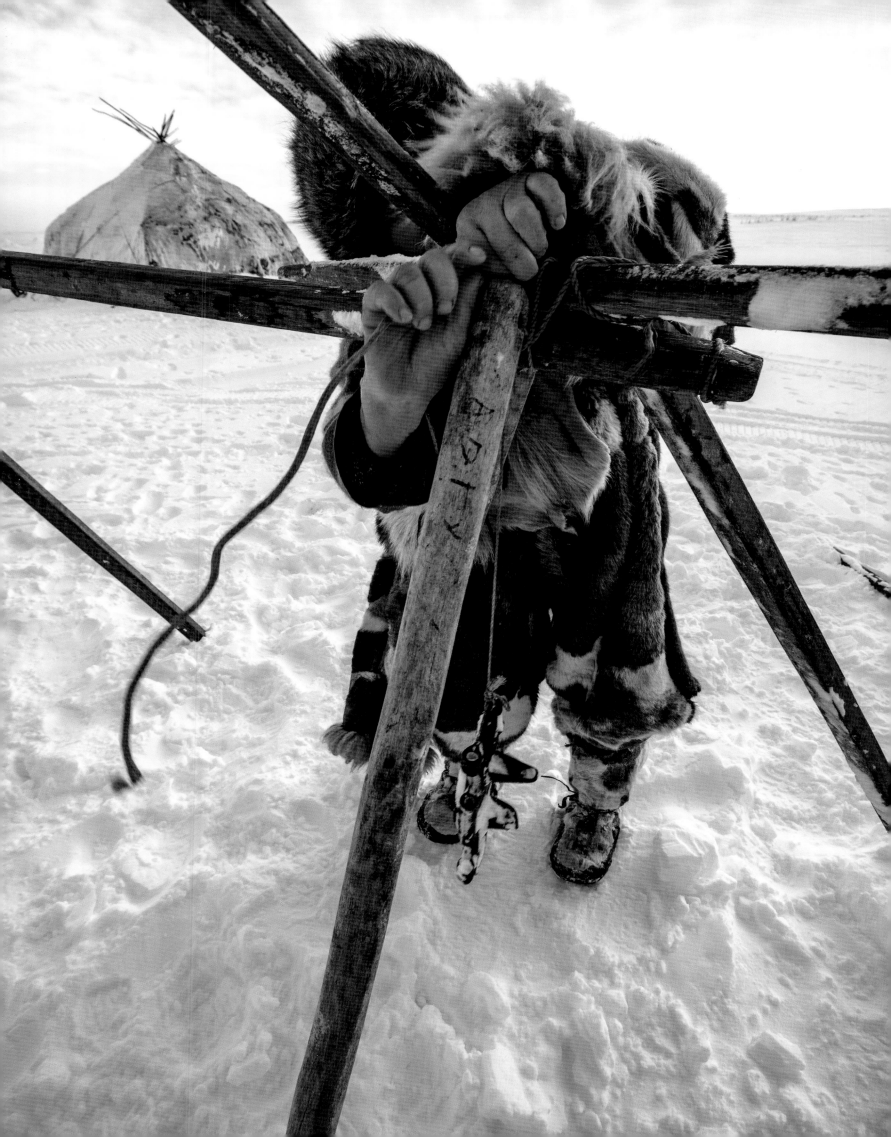

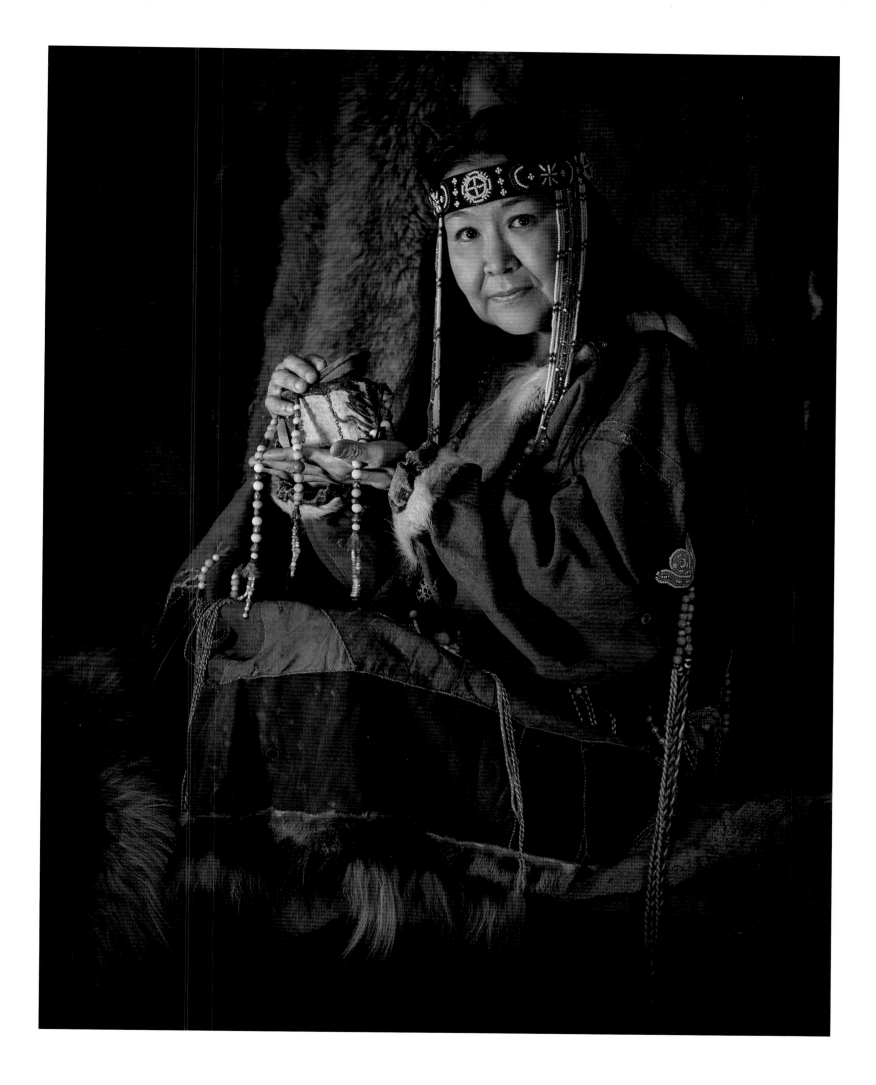

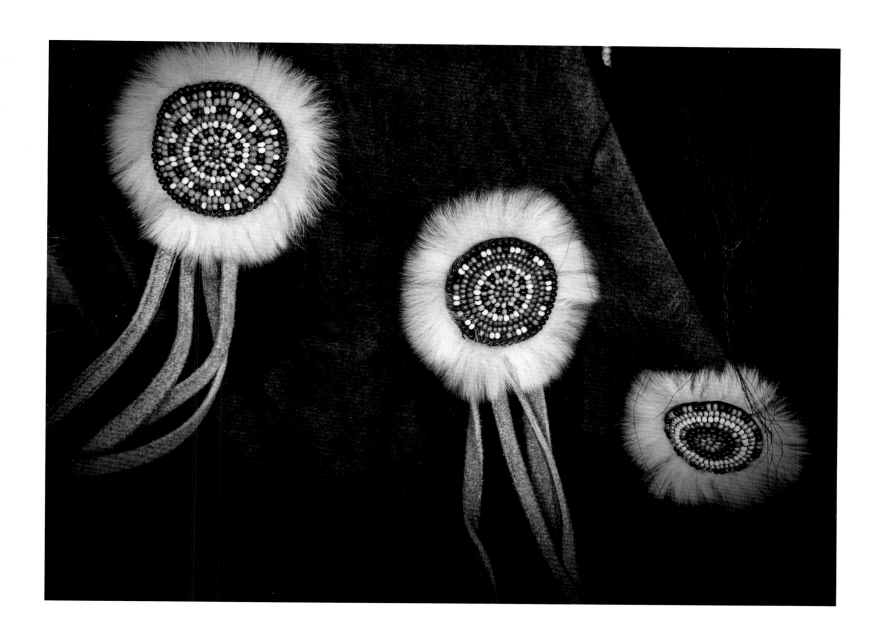

Top:

Traditional Chukcha beads are cylindrical and disk-shaped, expertly hand-carved from animal bone and painted with natural dyes. Those beads were time-consuming to produce and therefore quite expensive, with a handful of them equal in value to a large reindeer. Increasingly, however, Chukcha ladies use modern-day materials, and keep the old beads as valued treasures.

Oben:

Traditionelle Tschuktschen-Perlen sind zeit- und arbeitsaufwändig in der Produktion — sie sind handgeschnitzt aus Tierknochen und mit natürlichen Farben bemalt — und daher sind sie auch heute noch sehr wertvoll; nur eine Handvoll davon kostet so viel wie ein großes Rentier. Heutzutage werden oft synthetische Materialien verwendet, doch die traditionell gefertigten Perlen werden noch immer als überaus wertvolle, bedeutenden Gegenstände geschätzt.

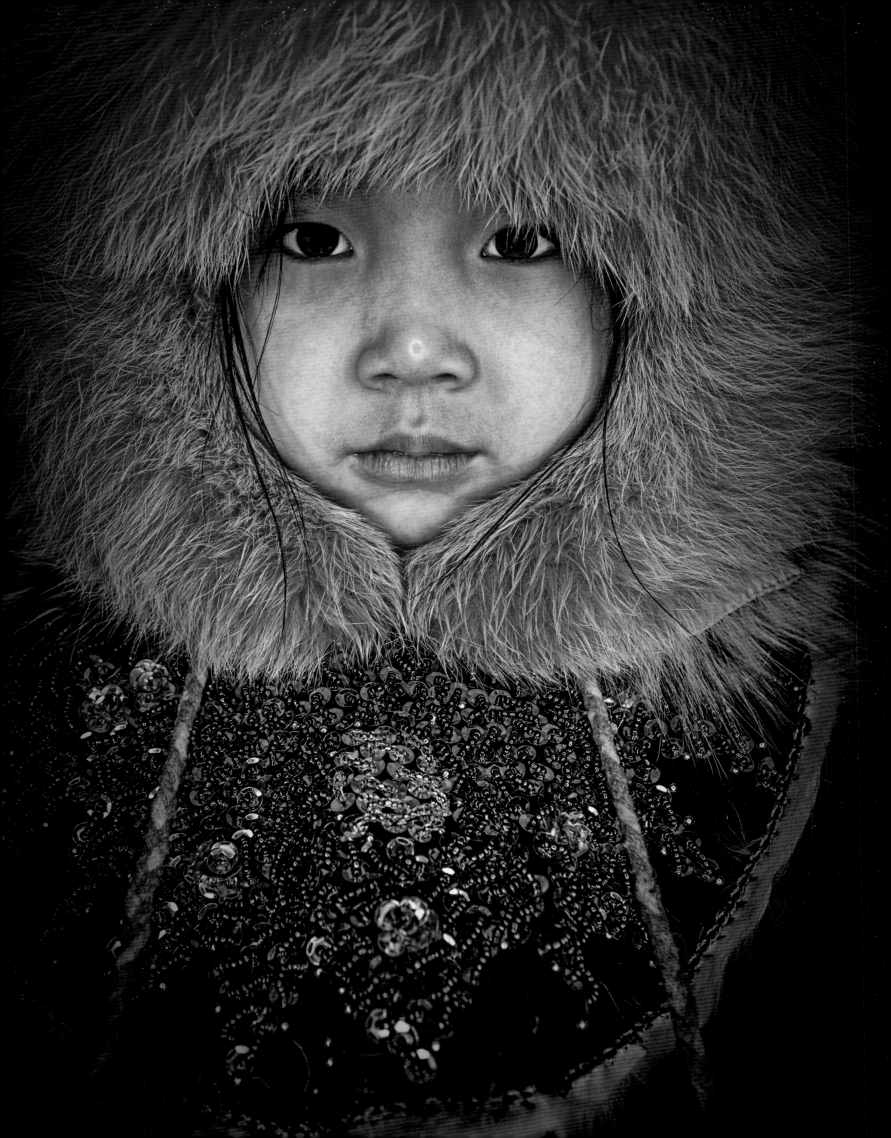

Left:

Though perhaps not to the same degree as our own in the West, the fashions of indigenous peoples are always developing and changing. Once nearly all Chukchi clothing was made from leather and fur, and a child's hat perhaps from otter or wolverine paws. But as we can see here there is a new trend for colourful modern materials that often come from far away—in many cases from China.

Links:

Die Mode der indigenen Völker entwickelt und ändert sich ständig, wenn auch vielleicht nicht so schnell wie die des Westens. Früher wurde die traditionelle Kleidung der Tschuktschen aus Leder und Fell gefertigt, und die Mütze eines Kindes vielleicht aus Otterleder oder Marderfell. Doch wie wir hier sehen gibt es einen neuen Trend zu farbigen, modernen Materialien, die aus weit entfernten Orten kommen — oft aus China.

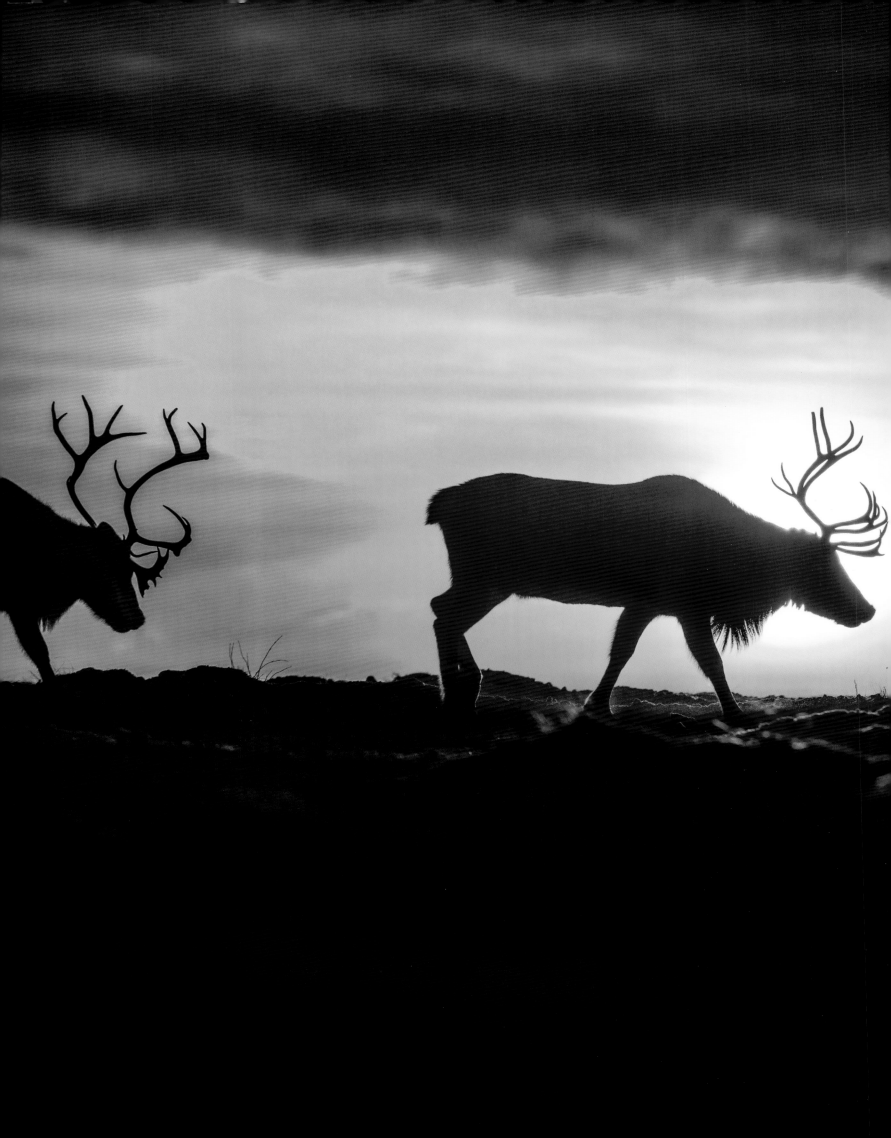

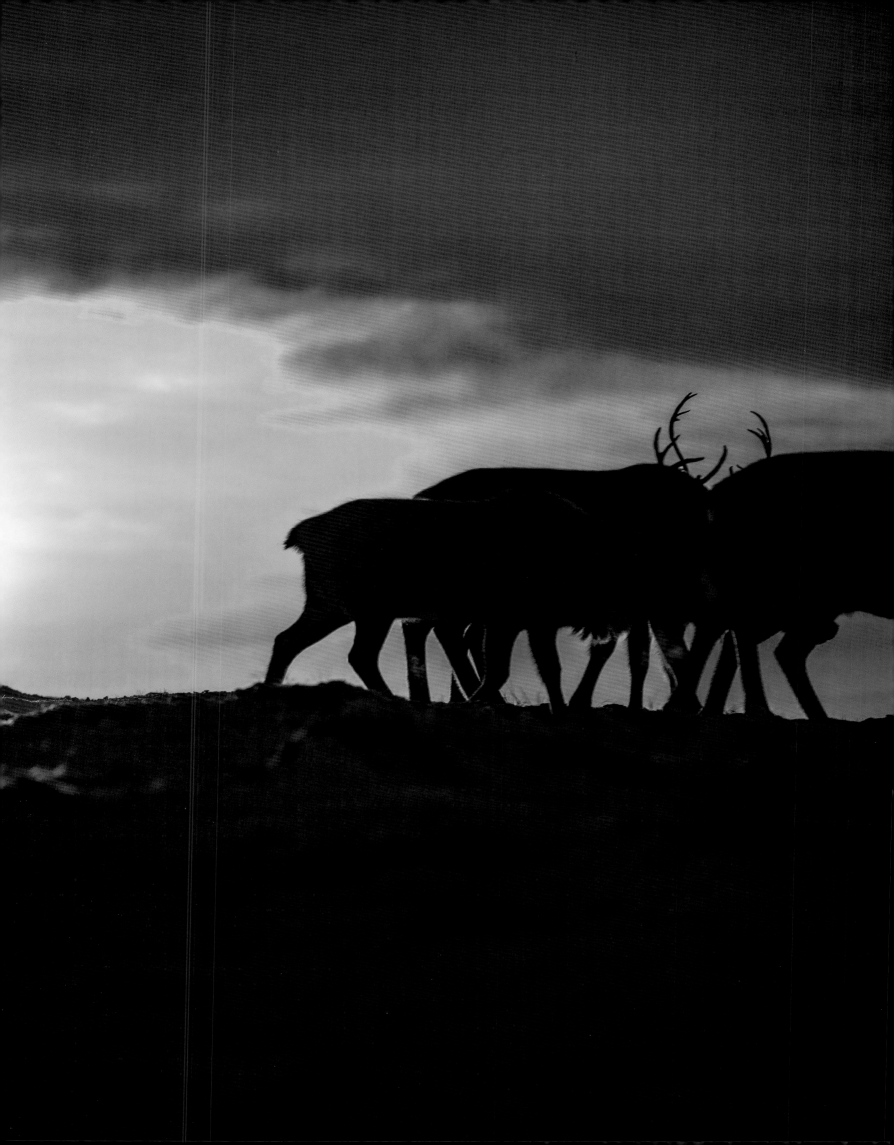

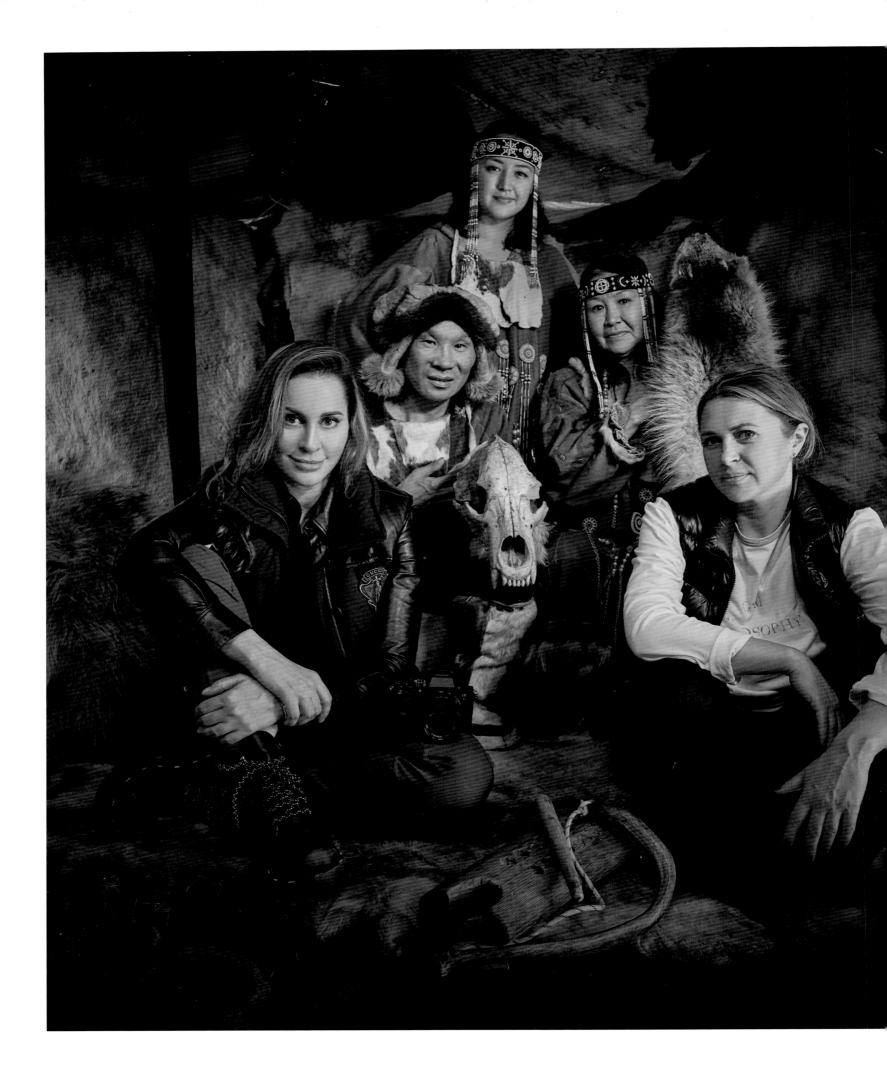

ABOUT THE AUTHOR

Olga Michi was born in Havana/Cuba in a Russian family as the daughter of a military officer. She studied civil law and worked in the Russian Foreign Ministry at the Faculty of International Relations. Since then her fascination for history, politics and diplomacy has determined the direction of her travels and her professional photography training.

Today Olga works as a photographer on all continents, organized difficult expeditions to Central America, Africa and Indonesia, lived with indigenous peoples, dived with Nile crocodiles, white sharks and orcas. She is presenter and co-author of the Russian TV show *Extreme Photographer*, produced international award-winning documentaries and photo exhibitions. Her documentary film *Small People. Big Trees* received several of the most important awards at film festivals (Hot Springs Documentary Film Festival, HumanDOC, EKOFILM, ...).

ÜBER DIE AUTORIN

Olga Michi wurde in Havanna/Kuba in einer russischen Familie als Tochter eines Militäroffiziers geboren. Sie studierte Zivilrecht und arbeitete im russischen Außenministerium an der Fakultät für internationale Beziehungen. Seitdem bestimmt die Faszination für Geschichte, Politik und Diplomatie die Richtung ihrer Reisen und ihrer professionellen Fotoausbildung.

Olga arbeitet heute als Fotografin auf allen Kontinenten, organisierte schwierige Expeditionen nach Mittelamerika, Afrika und Indonesien, lebte bei indigenen Völkern, tauchte mit Nilkrokodilen, weißen Haien und Orcas. Sie ist Moderatorin und Co-Autorin der russischen TV-Show *Extreme Photographer*, produzierte international preisgekrönte Dokumentationen und Fotoausstellungen. Ihr Dokumentarfilm *Small People. Big Trees* erhielt mehrere der wichtigsten Auszeichnungen auf Filmfestivals (Hot Springs Documentary Film Festival, HumanDOC, EKOFILM, ...).

ACKNOWLEDGMENTS

I express my deepest appreciation to my team, Ms. Svetlana Ignatenko and Mr. Maxim Koveshnikov. Svetlana was by my side throughout our expeditions—she was my lighting assistant for our photoshoots and she organized our life away from home. I'd like to emphasize her talent for finding a common language with every person we photographed—and her sense of humor that made our work easier and brighter. I would also like to extend my heartfelt gratitude to Maxim Koveshnikov for organizing and smoothly running all our projects under the *Olga Michi* and *Olga Michi Productions* brands. I am sincerely grateful to him for his commitment, friendship and support of all my ideas and endeavors.

I am deeply grateful to the project curators, Mr. Artem Loginov and Prof. Alexey Loginov; their contribution to *Vulnerable* is invaluable. Thank you very much for believing in me and in my work.

I am grateful to Ms. Natalia Kuzmina, our graphic designer, for her wonderful work in processing our photographs.

I would like to express my sincere gratitude to Ms. Anzhelika Kanavina and Mr. Nikolai Kanavin for their genuine interest in my photographic projects, for their support and for generously sharing their knowledge and experience with me.

I am also grateful to Victor Potapov for his elegant translations of all the Russian texts for *Vulnerable*.

I am deeply grateful to my publisher teNeues for this wonderful edition of *Vulnerable*. My gratitude goes to, among others, Ms. Veronica Reisenegger, Mr. Pit Pauen, Mr. Bernhard Kellner and Mr. Roman Korn. Thank you very much for making this book a reality.

My heartfelt thanks to Ms. Tatiana Mertens and Mr. Thomas Mertens for their help in publishing this book. You have made an invaluable contribution towards making my dream come true.

I would also like to express my gratitude to our guides for leading us into the culture of the tribes and into the world they live in. First and foremost, my thanks go to Mr. Melaku Tesfa and his team. Dear Melaku, thank you for your warmth and for your love for your fellow countrymen—your love was an inspiration to us when we were working with the proud representatives of these ethnic groups. A special thank you to Ms. Ida Ruchina, head of the Red Cross organization in Chukotka, who is so passionate about the future of the Chukchi people and who works tirelessly to protect it. Ida was our guide who helped us to discover the ice world of Chukotka. She helped us in organizing the expedition—and even shared our living quarters there. My thanks goes to Mr. Anatoly Tyneru, whose detailed explanations and stories about the Chukchi people's concept of the soul brightened up the Northern part of our project. My gratitude goes to Mr. Mikhail Rezyapkin, an ethnographer with the Moscow State University, for his support and supervision of our Chukotka expedition—and also for sharing his findings and knowledge of Chukchi culture, accumulated over many years of research. A special word of thanks goes to Mr. Alexander Kholopov for organizing the expeditions to Myanmar and to the border areas in Ethiopia and South Sudan—and for his assistance during the trips. Thank you for ensuring our safety and security, Alexander!

Great thanks to the team of cameramen who followed us on our trips: Mr. Denis Evseev, Mr. Alexander Menshov, Mr. Vyacheslav Vdovkin, Mr. Alhas Tvanba, Mr. Damir Abdrakhmanov, and Mr. Oleg Zlobin.

Special thanks goes to Mr. Ilya Koruchanov and Mr. Dmitry Gaenko for their work on our short videos describing the expeditions to Myanmar, Ethiopia and Chukotka.

I want to express my gratitude to my family and to the families of my dear Svetlana Ignatenko and Maxim Koveshnikov. I am deeply grateful to you for your support, patience and inexhaustible love.

This book is devoted with love not only to all the amazing representatives of the following ethnic groups: Mursi, Surma, Karo, Dassanach, Hamar, Chin, Pa'O, Lisu, Karen, Kayaw, Silver Palaung, Akha women, Women of the Shan State, Chukchi, but to humankind in general—because the majority of captions under the photographs in this book do not relate to one specific person or tribe, but rather to everyone on this most beautiful, unique and diverse planet.

—Olga Michi

DANKSAGUNG

Mein tiefster Dank gilt meinem Team, Frau Svetlana Ignatenko und Herrn Maxim Koveshnikov. Svetlana war während all unserer Expeditionen an meiner Seite – sie war meine Belichtungsassistentin bei den Fotoaufnahmen und sie organisierte unseren Alltag auf Reisen. Ihre Gabe, eine gemeinsame Sprache mit jeder der abgelichteten Personen zu finden, sowie ihr Humor, der unsere Arbeit leichter und angenehmer machte, zeichnen sie aus. Maxim Koveshnikov organisierte und koordinierte all unsere Projekte für die *Olga Michi-* und *Olga Michi Productions*-Marken. Auch ihm möchte ich meinen Dank für sein Engagement, seine Freundschaft und seine Unterstützung bei all meinen Ideen und Projekten aussprechen.

Den Projektkuratoren, Herrn Artem Loginov und Prof. Alexey Loginov, gilt mein Dank für ihre wertvollen Beiträge zu *Verletzlich* und für ihren Glauben an mich und meine Arbeit.

Ich bedanke mich bei Frau Natalia Kuzmina, unserer Grafikdesignerin, für ihre hervorragende Arbeit bei der Nachbearbeitung unserer Fotografien.

Mein tiefster Dank gilt Frau Anzhelika Kanavina und Herrn Nikolai Kanavin für ihr ehrliches Interesse an meinen Fotografie-Projekten, für ihre Unterstützung sowie ihr Wissen und ihre Erfahrung, die sie so großzügig mit mir teilten.

Victor Potapov hat alle russischen Texte für *Verletzlich* gekonnt ins Englische übertragen – auch ihm danke ich vielmals.

Ich danke meinem Verlag, teNeues Media, und sämtlichen Mitarbeitern für diese wunderschöne Ausgabe von *Verletzlich*. Frau Veronica Reisenegger, Herr Pit Pauen, Herr Bernhard Kellner und Herr Roman Korn haben maßgeblich zur Entstehung des Buches beigetragen.

Mein tiefster Dank geht an Frau Tatiana Mertens und Herrn Thomas Mertens für ihre Hilfe bei der Veröffentlichung dieses Buches. Ihre Unterstützung bei der Realisierung meines Traumes war unverzichtbar.

Ich bedanke mich vor allem bei unseren Guides, die uns in die Kulturen ihrer Stämme und in ihre Welt geführt haben. Zunächst möchte ich Herrn Melaku Tesfa und seinem Team meinen Dank aussprechen. Lieber Melaku, vielen Dank für deine Wärme und für die Liebe, die du deinem Stamm entgegenbringst – deine Liebe war uns Inspiration und Vorbild, wenn wir mit den stolzen Repräsentanten und Repräsentantinnen der unter-schiedlichen ethnischen Gruppen arbeiteten. Mein Dank gilt auch Frau Ida Ruchina, der Vorsitzenden des Roten Kreuzes in Tschukotka, die sich so überzeugt und unermüdlich für die Zukunft der Tschuktschen einsetzt. Ida war unser Guide, sie eröffnete uns die Eiswelt der Tschuktschen, half uns bei der Organisation der Expedition, und wohnte dort sogar in der Unterkunft mit uns. Ich danke Herrn Anatoly Tyneru, dessen detaillierte Erklärung zum tschuktschischen Verständnis der Seele den nördlichen Teil unseres Projekts erhellte. Herr Mikhail Rezyapkin ist Ethnologe an der Staatlichen Universität Moskau. Er unterstützte und betreute unsere Tschukotka-Expedition und teilte sein Wissen und seine über jahrelange Forschung hinweg gewonnenen Kenntnisse über die Kultur der Tschuktschen mit uns – wir sind ihm sehr dankbar. Besonderer Dank gilt auch Herrn Alexander Kholopov, der unsere Expeditionen nach Myanmar und in die Grenzregionen Äthiopiens und im Südsudan organisierte und uns während unserer Reisen unterstützte. Danke, dass du stets für unsere Sicherheit gesorgt hast, Alexander!

Ein großer Dank gilt dem Kamerateam, das uns auf unseren Reisen begleitete: Herr Denis Evseev, Herr Alexander Menshov, Herr Vyacheslav Vdovkin, Herr Alhas Tvanba, Herr Damir Abdrakhmanov und Herr Oleg Zlobin.

Mein besonderer Dank geht an Herrn Ilya Koruchanov und Herrn Dmitry Gaenko für ihre Arbeit an den kurzen Videos, welche die Expeditionen nach Myanmar, Äthiopien und Tschukotka festhielten.

Ich möchte meiner Familie und den Familien von Svetlana Ignatenko und Maxim Koveshnikov meinen Dank aussprechen. Euere Unterstützung, Geduld und unendliche Liebe bedeuten mir sehr viel.

Dieses Buch ist mit Liebe gewidmet nicht nur den wunderbaren Repräsentantinnen und Repräsentanten der folgenden ethnischen Gruppen: Mursi, Surma, Karo, Dassanach, Hamar, Chin, Pa'O, Lisu, Karen, Kayaw, Silver Palaung, Akha Frauen, Frauen des Shan-Staats, Tschuktschen – sondern der gesamten Menschheit. Denn der Großteil der Bildbeschreibungen in diesem Buch bezieht sich nicht auf eine einzelne Person oder einen Stamm, sondern auf jeden Menschen auf diesem einzigartigen und vielfältigen Planeten.

Olga Michi

IMPRINT

© 2020 teNeues Verlag GmbH
Photographs © 2020 Olga Michi. All rights reserved.

Foreword by Artem Loginov
Translations by Judith Kahl (German),
Victor Potapov (English)
Design by Robin Hopp, Robert Kuhlendahl
Editorial coordination by Roman Korn
Production by Nele Jansen
Color separation by Robert Kuhlendahl

ISBN 978-3-96171-298-4 (English Cover)
ISBN 978-3-96171-300-4 (German Cover)

Library of Congress Number: 2020935921

Printed in Italy by Lito Terrazzi s.r.l.

Bibliographic information published by the Deutsche
Nationalbibliothek
The Deutsche Nationalbibliothek lists this publication
in the Deutsche Nationalbibliografie; detailed
bibliographic data are available on the Internet at
http://dnb.dnb.de.

Published by teNeues Publishing Group

teNeues Verlag GmbH
Werner-von-Siemens-Straße 1
86159 Augsburg, Germany
Phone: +49-(0)2152-916-0
e-mail: books@teneues.com

teNeues Verlag GmbH
Munich Office
Pilotystraße 4, 80538 Munich, Germany
Phone: +49-(0)89-90 42 13-200
e-mail: bkellner@teneues.com

teNeues Verlag GmbH
Berlin Office
Mommsenstraße 43, 10629 Berlin, Germany
Phone: +49-(0)152 08 51 10 64
e-mail: ajasper@teneues.com

teNeues Publishing Company
350 7th Avenue, Suite 301, New York
NY 10001, USA
Phone: +1-212-627-9090
Fax: +1-212-627-9511

teNeues Publishing UK Ltd.
12 Ferndene Road, London SE24 0AQ, UK
Phone: +44-(0)20-3542-8997

www.teneues.com

teNeues Publishing Group
Kempen
Berlin
London
Munich
New York

teNeues

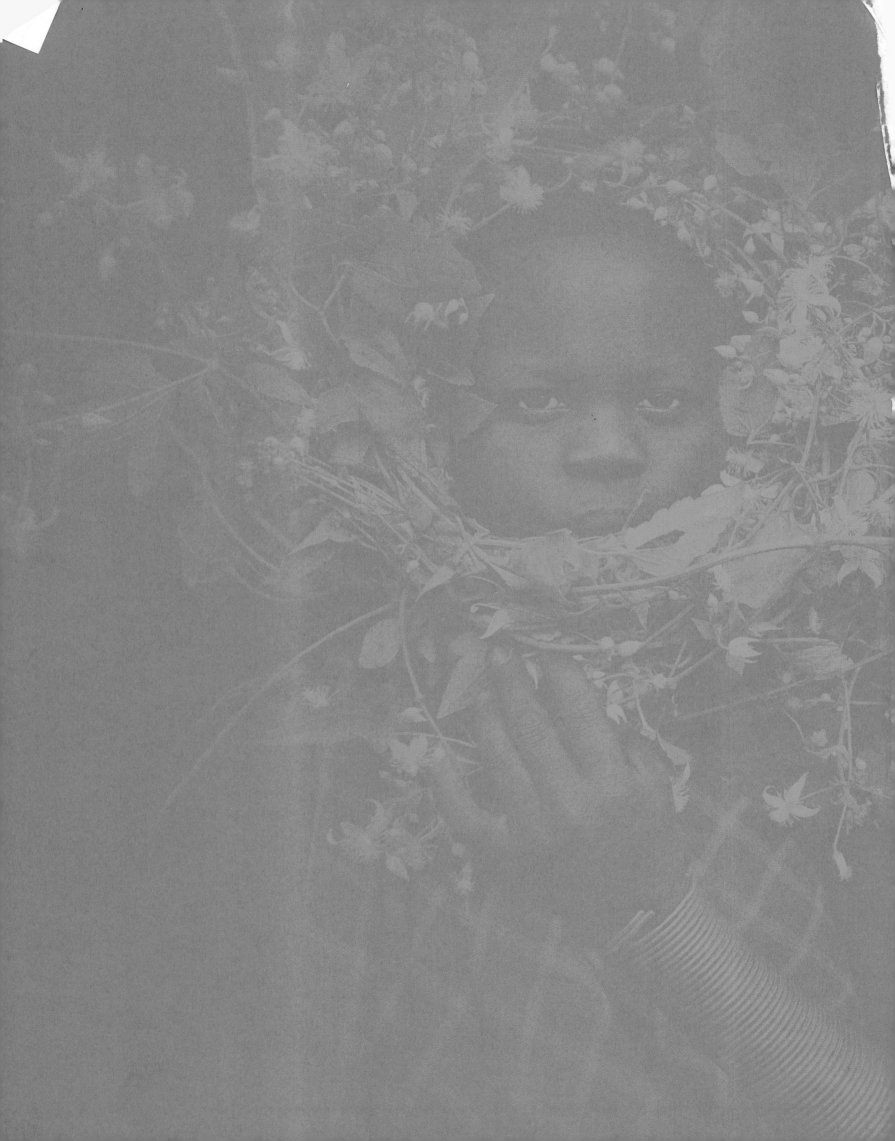